EARTH VIEW

EXTRAORDINARY IMAGES OF OUR PLANET FROM THE LANDSAT NASA/USG SATELLITES

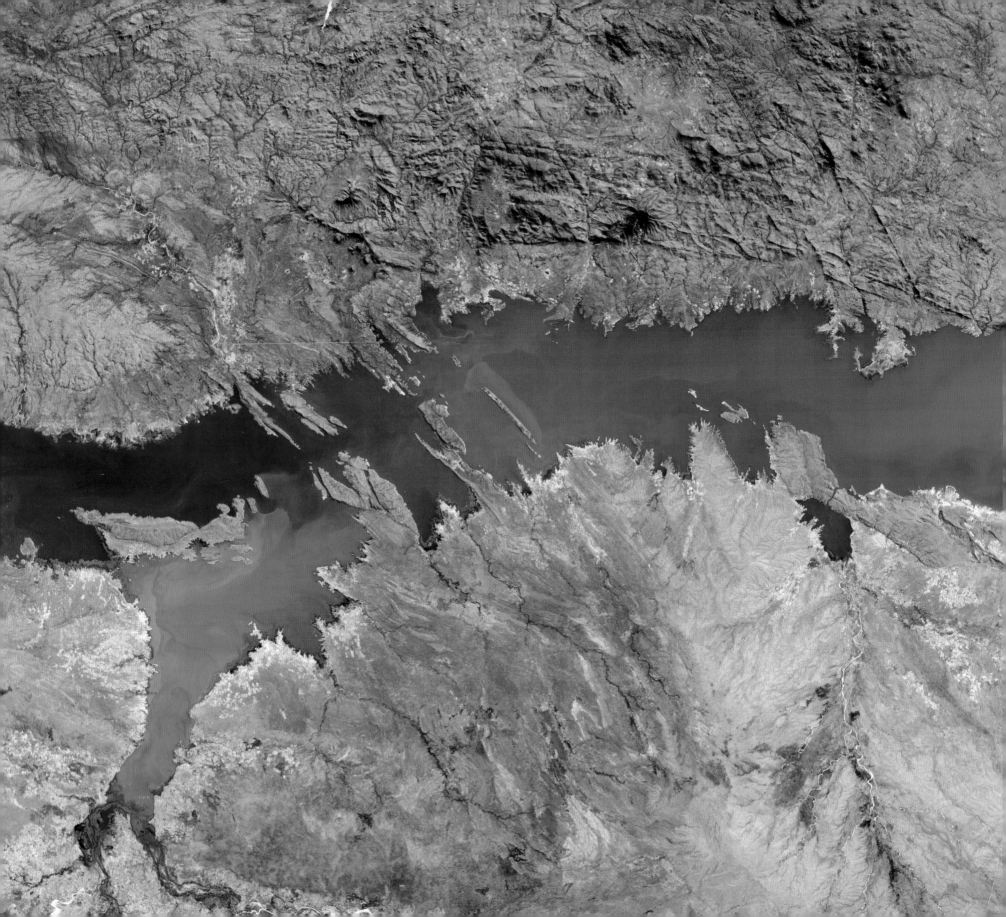

EARTH VIEW

EXTRAORDINARY IMAGES OF OUR PLANET FROM THE LANDSAT NASA/USG SATELLITES

CARLTON
BOOKS

THIS IS A CARLTON BOOK

This edition published in 2018
by Carlton Books Limited
20 Mortimer Street
London W1T 3JW

A CIP catalogue record for this book is available from the British Library.

ISBN 978 1 78739 066 9

Caption text: Tim Dedopulos
Design: Natasha Le Coultre
Picture Research: Steve Behan
Production: Emily Noto

Printed in China

Page 2: Mozambique's Cahora Bassa, the fourth-biggest artificial lake in Africa, sends electricity
almost 900 miles (1,448km) to South Africa through some highly inaccessible terrain.

Page 6: This false-colour image of Louisiana's Atchafalaya Swamp, the USA's largest wetland,
highlights water and land boundaries, clearly showing sediment patterns and farmed plots.

CONTENTS

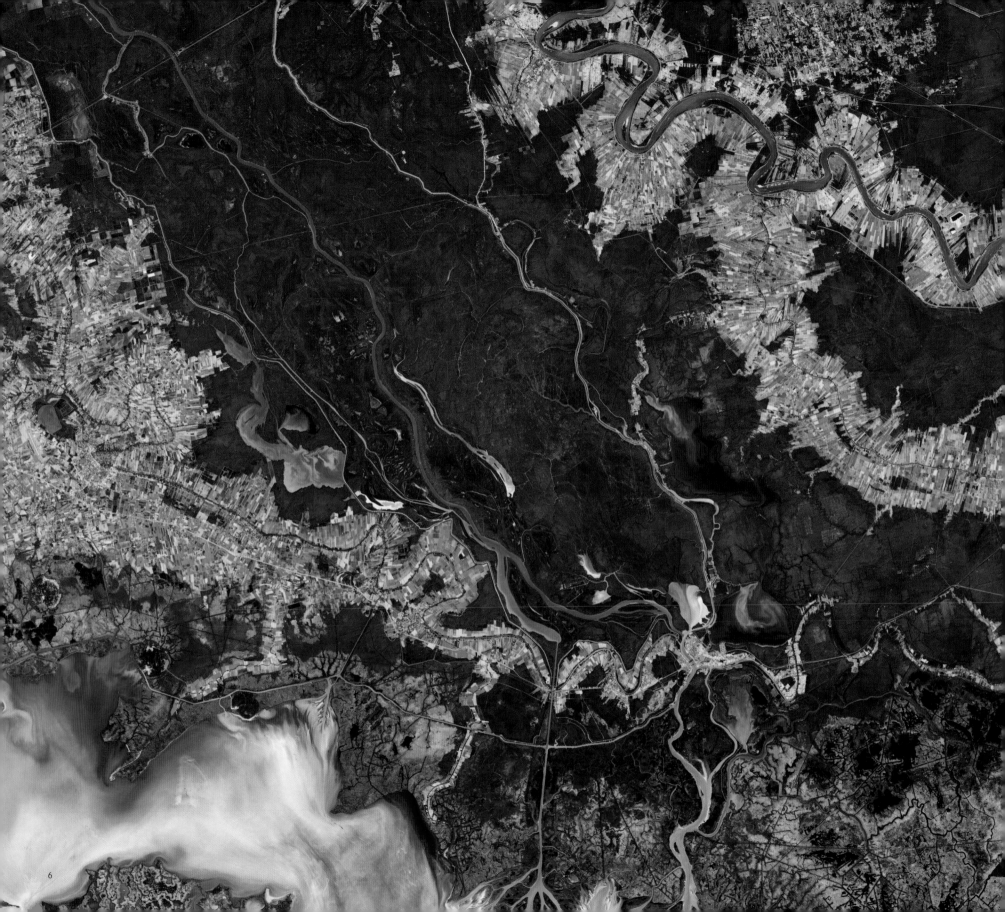

FOREWORD

I was deeply honoured to receive the request to write the foreword for this photographic book *Earth View,* as it serves to highlight and inform a much broader community of the incredible Earth observation satellite program known as Landsat.

As the name implies, the Landsat mission was designed to look back at the Earth's land surface from the unique vantage point of outer space to monitor the natural and human-induced changes that occur over time. In fact, a Landsat satellite has been in orbit, imaging the Earth's surface continuously for over 45 years – since late July 1972. It has created the longest land surface record in existence, yielding an invaluable "digital family photo album" of the Earth's surface features.

In the process of repetitively imaging the Earth's surface, the scientific community has learned a great deal about our incredible "Blue Marble". Using Landsat imagery, the geologic concept of plate tectonics was more easily validated, agricultural crop productivity and the areal extent and harvesting of forest land has been monitored over local, regional, continental, and global scales, as well as the devastation caused by volcanic eruptions, earthquakes, hurricanes, tornadoes, tsunamis and floods. Truly, the enhanced knowledge provided by such long-term, consistent monitoring of Earth surface phenomena has had a positive impact on millions of people, yielding actions over time that have saved countless thousands of lives.

In 2011, the Landsat data archive joined the Gutenberg Bible, Tolstoy's personal library, Ireland's Book of Kells, and nearly 300 other entities inscribed on the United Nations Educational, Scientific, and Cultural Organization (UNESCO)'s memory of the World Register, a record of international documentary collections selected on the basis of global significance and outstanding universal value. Referring to Landsat's archive and why it should be protected for the benefit of all humanity, the nomination submitted to UNESCO for consideration noted, "Scientists worldwide recognize that there exists only one accurate image record, spanning over four decades, of the Earth's land surfaces, coastlines, and reefs at a scale revealing both natural and human-induced change."

With this additional background information, I hope you understand that the stunning satellite imagery that you will see in *Earth View* is a lot more than just "pretty pictures" – but I also hope you enjoy them as such nevertheless.

DARREL L. WILLIAMS, PHD
FORMER NASA LANDSAT PROJECT SCIENTIST

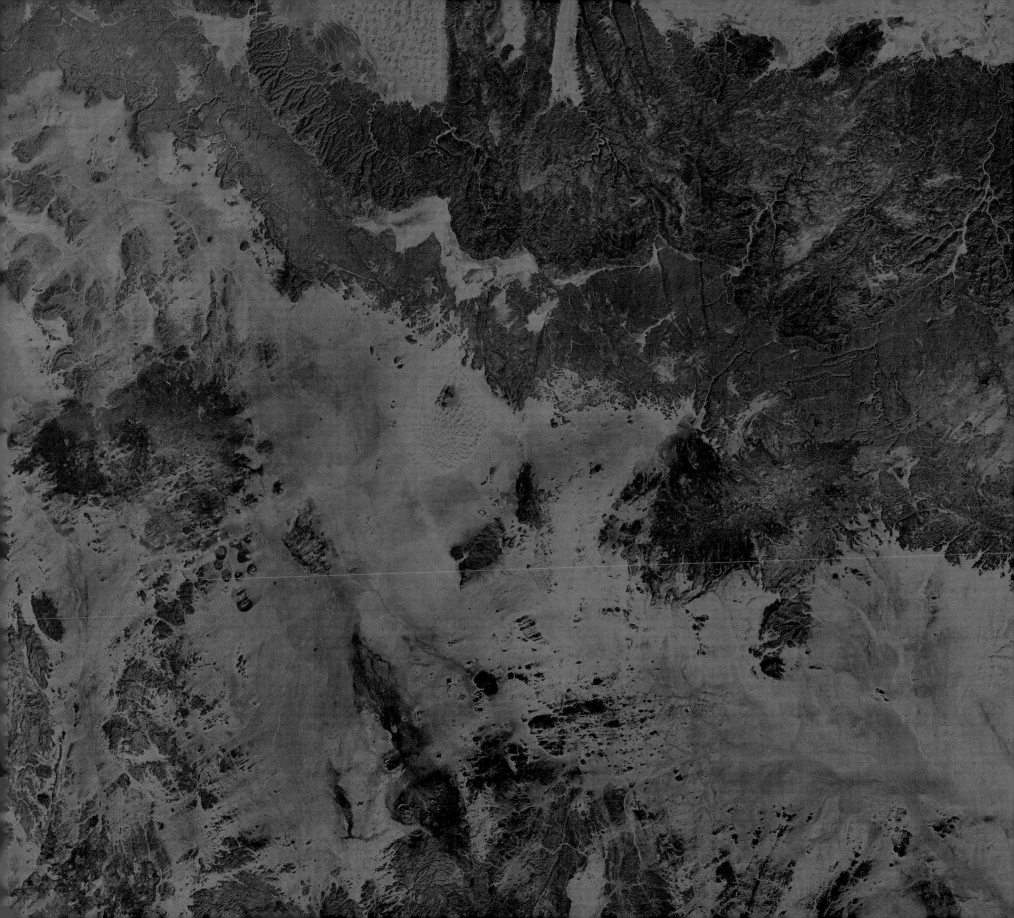

NATURAL
WONDERS

BELOW: Cloud-filled canyons in the valleys along Peru's south coast. These valleys, through which the Yauca and Acarí rivers flow into the Pacific, are among the deepest on Earth.

OPPOSITE: The Kebira Crater is a circular topographical feature found in the Sahara desert. Scientists who discovered the feature argue that it is an extraterrestrial impact crater.

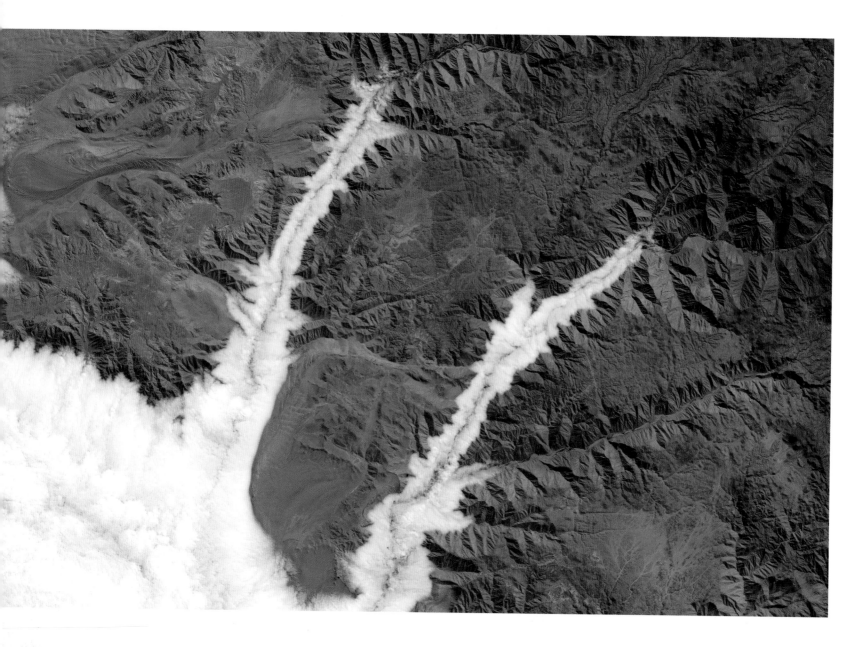

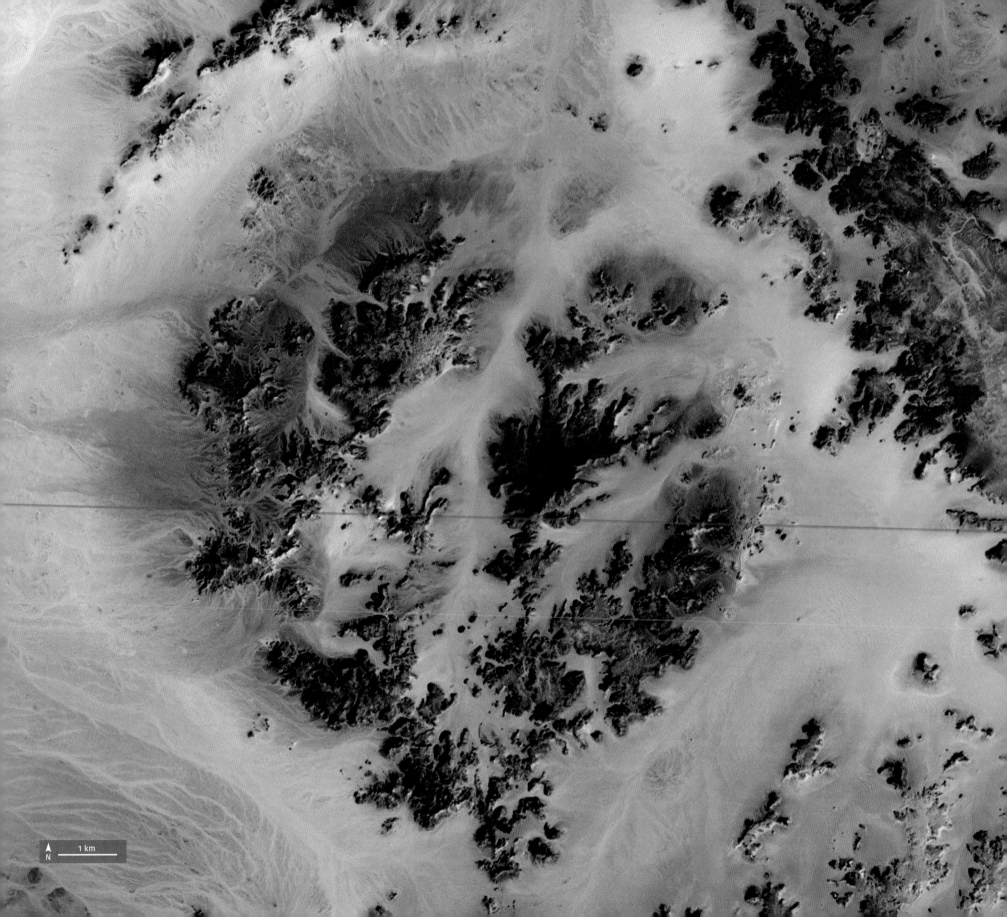

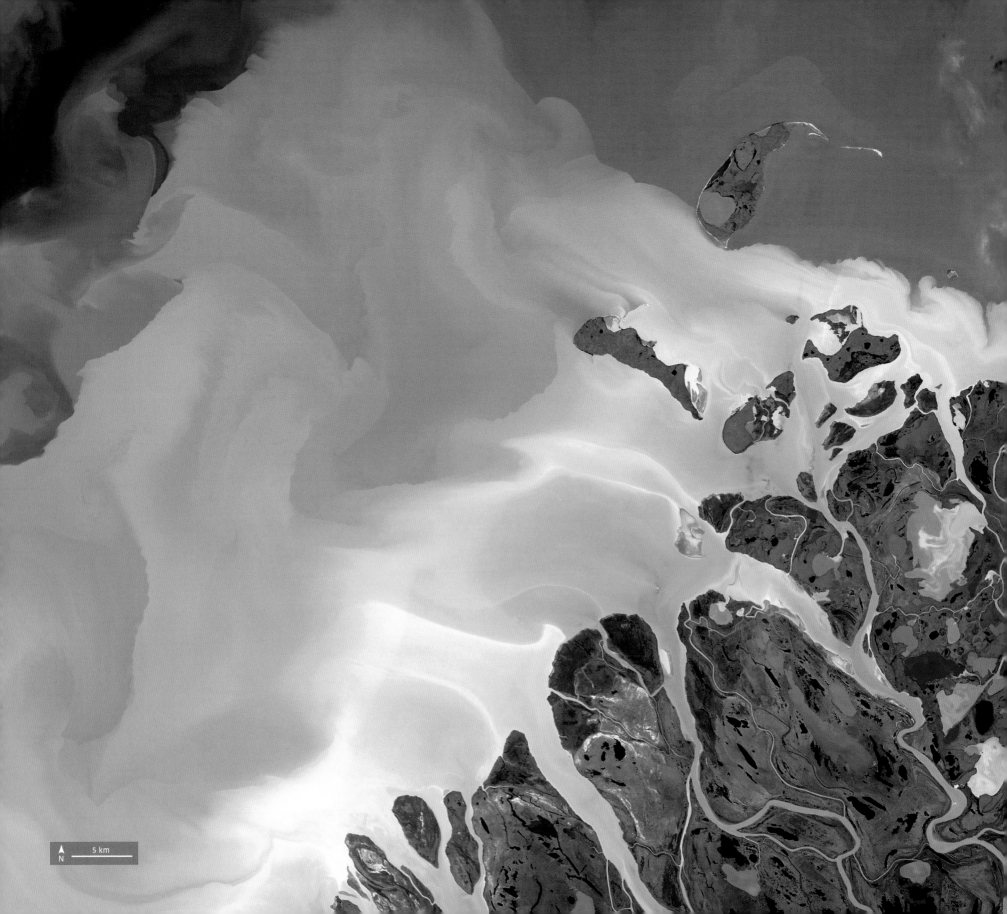

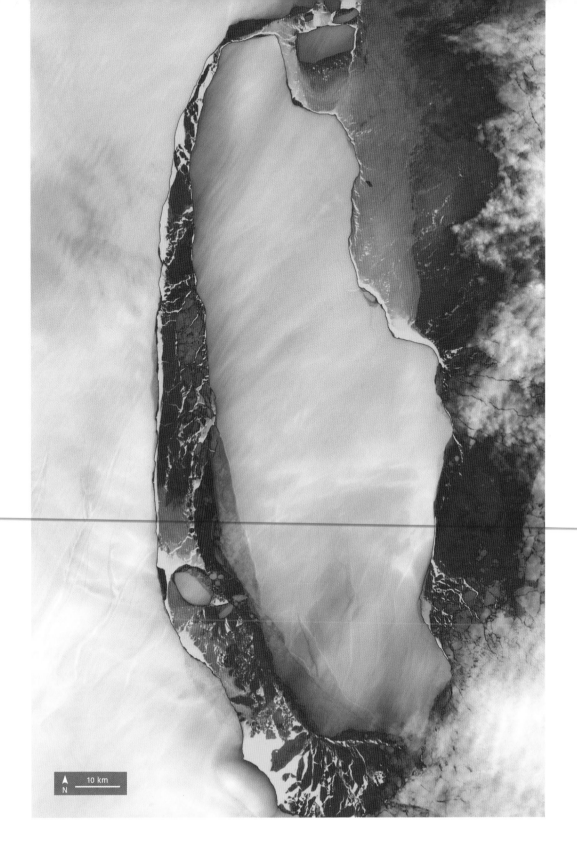

OPPOSITE: The Mackenzie River, the largest and longest in Canada, meets the Arctic Ocean, draining a vast area almost the size of Indonesia.

RIGHT: A new, massive iceberg named A-68 breaks away from the ice shelf Larsen C on the east side of the Antarctic Pensinsula.

10 km

N

RIGHT: The Karakoram mountain range in northern Pakistan is the most heavily glaciated part of the world outside the polar regions. In this false-colour image snow appears red and the rock and soil is cyan.

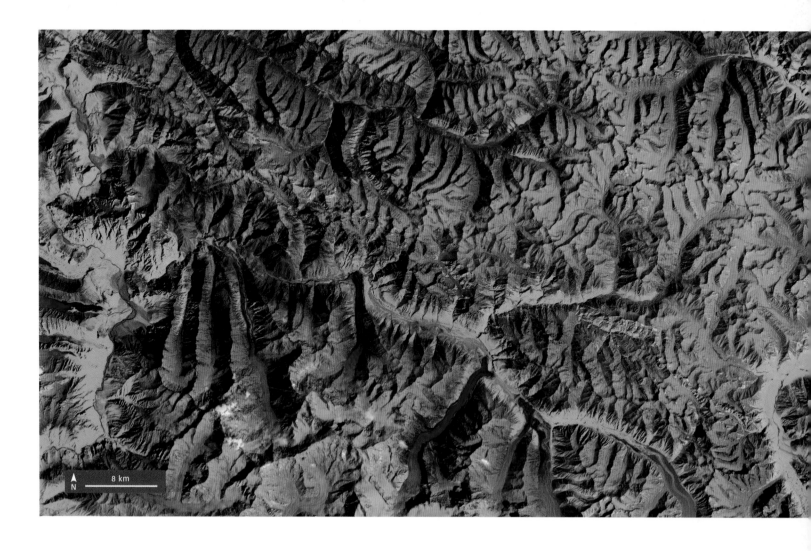

OPPOSITE: Part of the Sahara Desert, Tassili n'Ajjer National Park in southeastern Algeria is a UNESCO World Heritage Site. This image, made using a combination of infrared, near-infrared and visible light, reveals the dramatic rock formations for which the park is renowned.

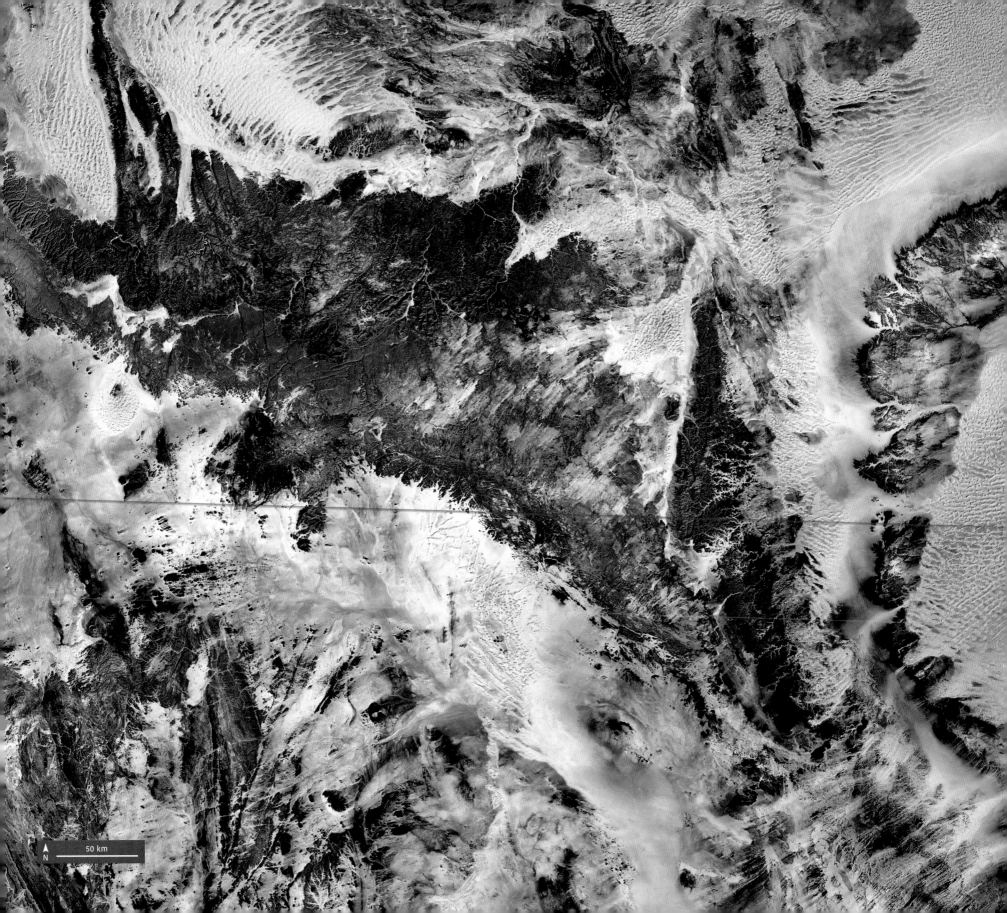

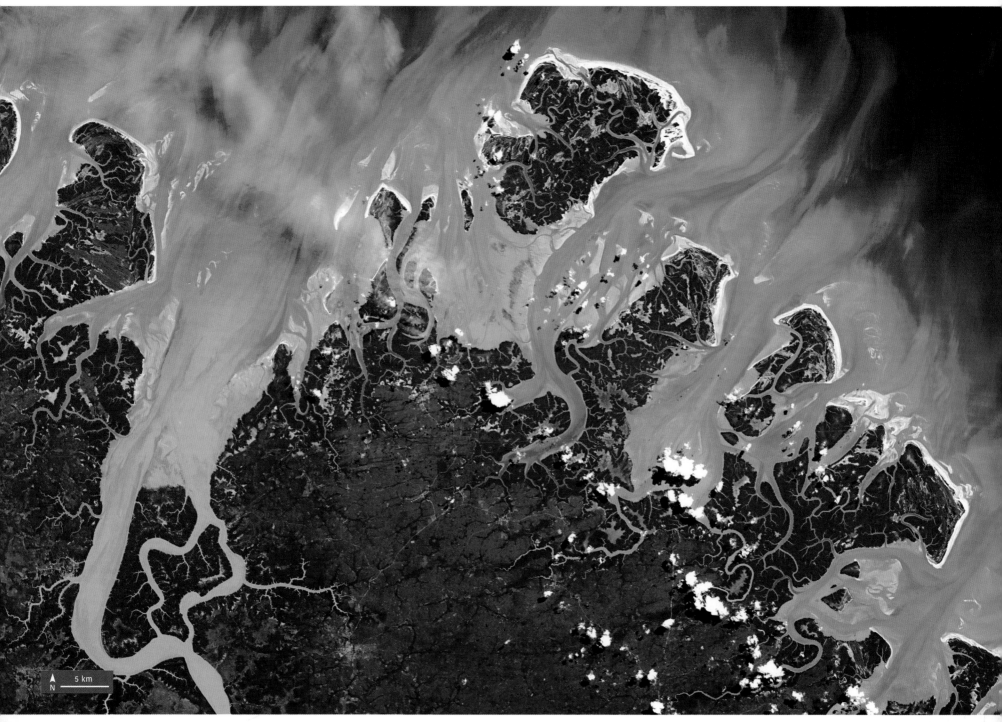

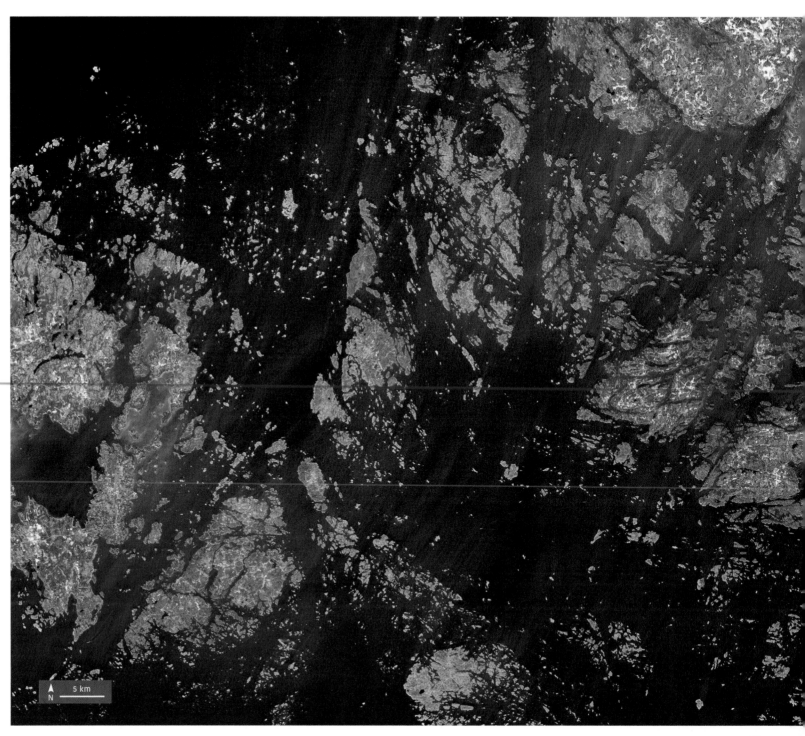

OPPOSITE: These barrier islands off Brazil's north-eastern coast protect the Turiaçu river basin from the worst of the Atlantic's rage. They're not new, but were only identified in 2006 as satellite data improved.

RIGHT: Finland's autonomous Åland Islands are the remains of a granite sheet hundreds of millions of years older than the dinosaurs. Glaciers smoothed and shattered it into over 6,000 islets, most too small to live on.

5 km
N

RIGHT: Little is known about these lakes, which show as black spots in this image of the megadunes of the Badain Jaran desert in northern China. The tallest of these dunes rival the Empire State Building in New York.

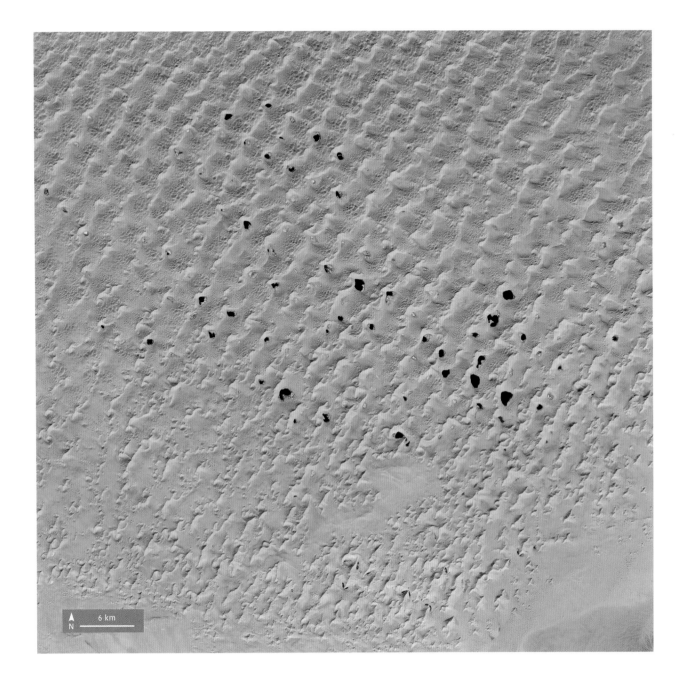

6 km
N

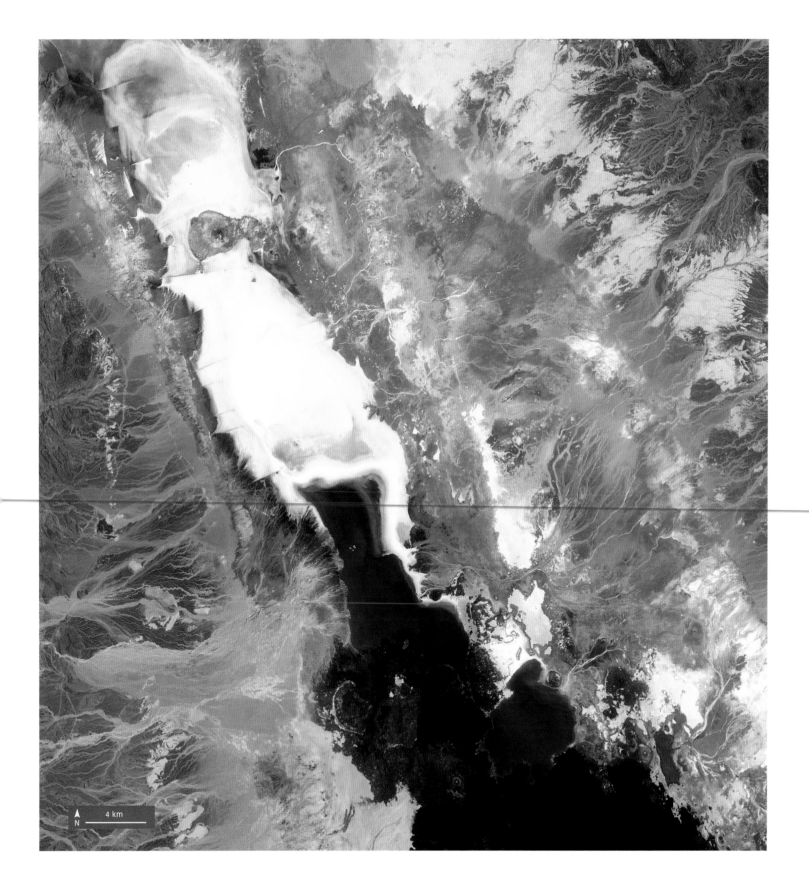

LEFT: The Danakil Depression of Ethiopia lies at the edge of tectonic plates pulling apart. Consequently, you'll find strange sights here – blue lava, hot yellow springs, and boiling mud lakes.

4 km
N

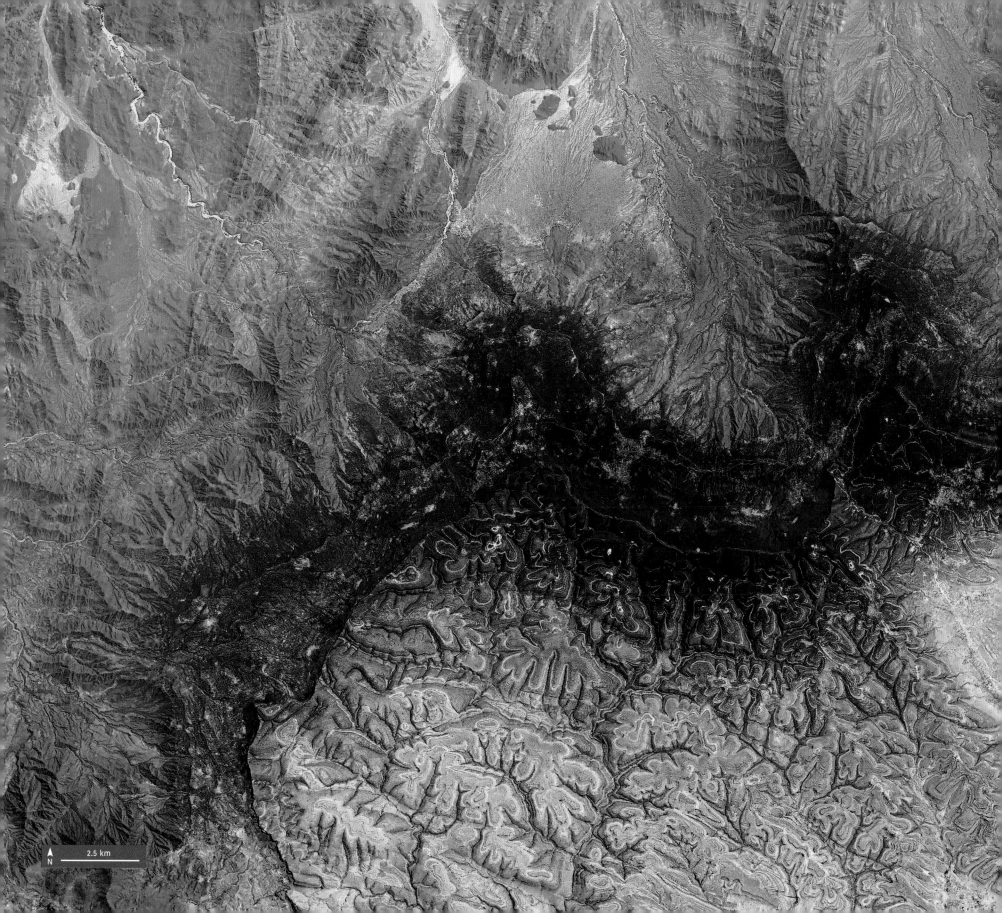

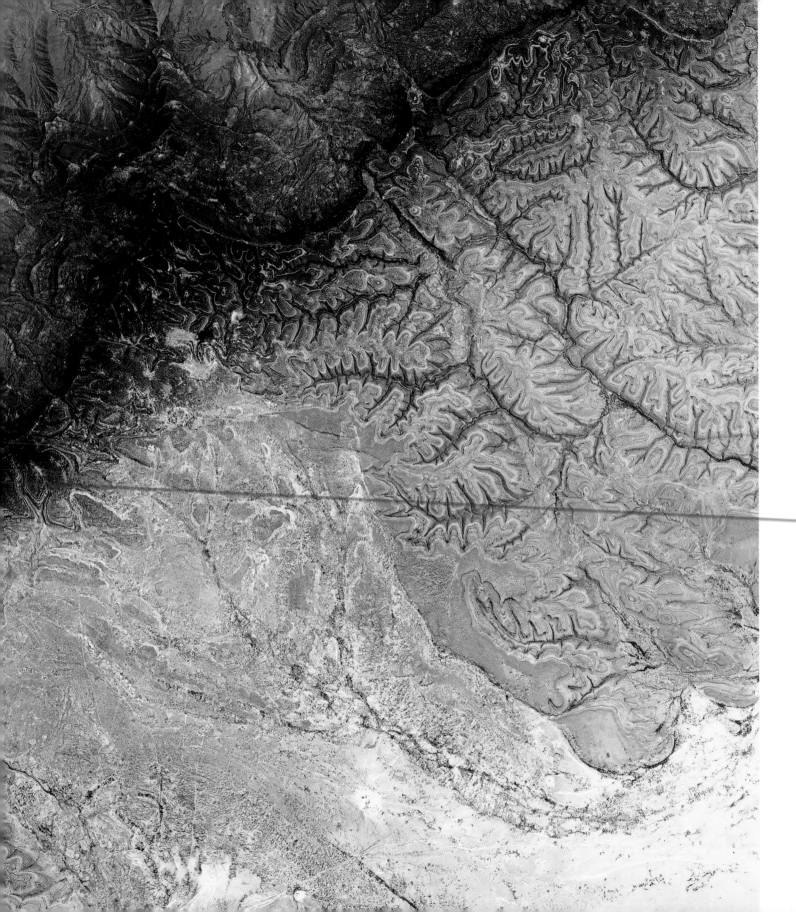

The Cal Madow mountain range cuts through arid northern Somalia, parallel to the Gulf of Aden. The slopes receive about 30 inches (76cm) of rain a year, enough to support forests strong in frankincense and myrrh.

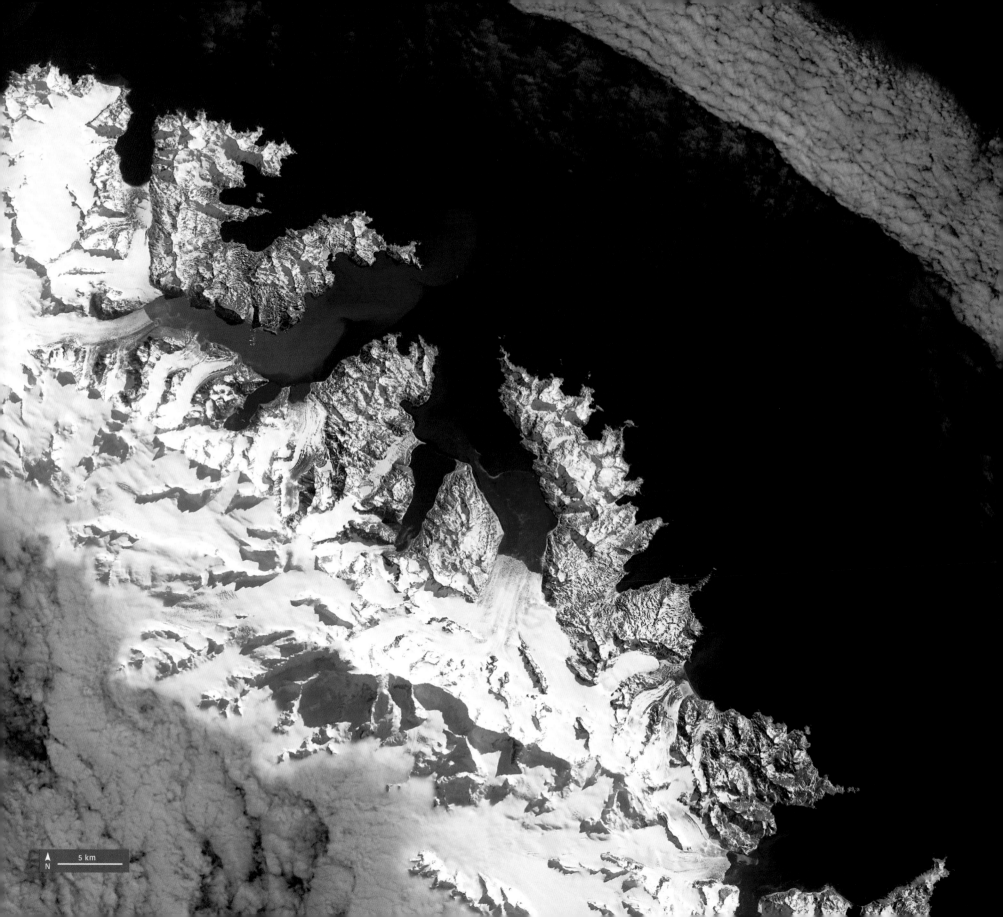

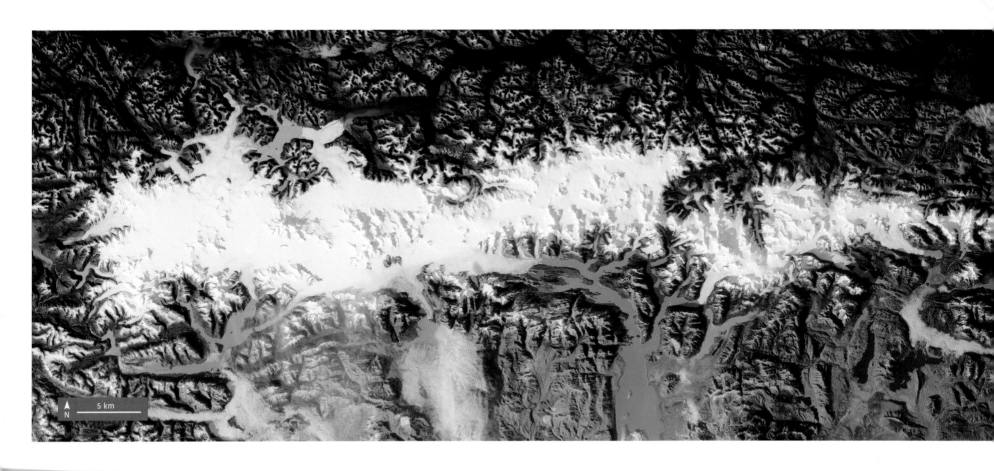

5 km

ABOVE: The Southern Patagonian Ice Field straddles the Chile–Argentina border. It is Earth's second-biggest ice field outside of the poles, and its glaciers are melting at some of the fastest rates in the world.

OPPOSITE: The British overseas territory of South Georgia and the South Sandwich Islands lies in the south Atlantic. The islands are heavily glaciated, as this shot of South Georgia shows, and used as an Antarctic research station.

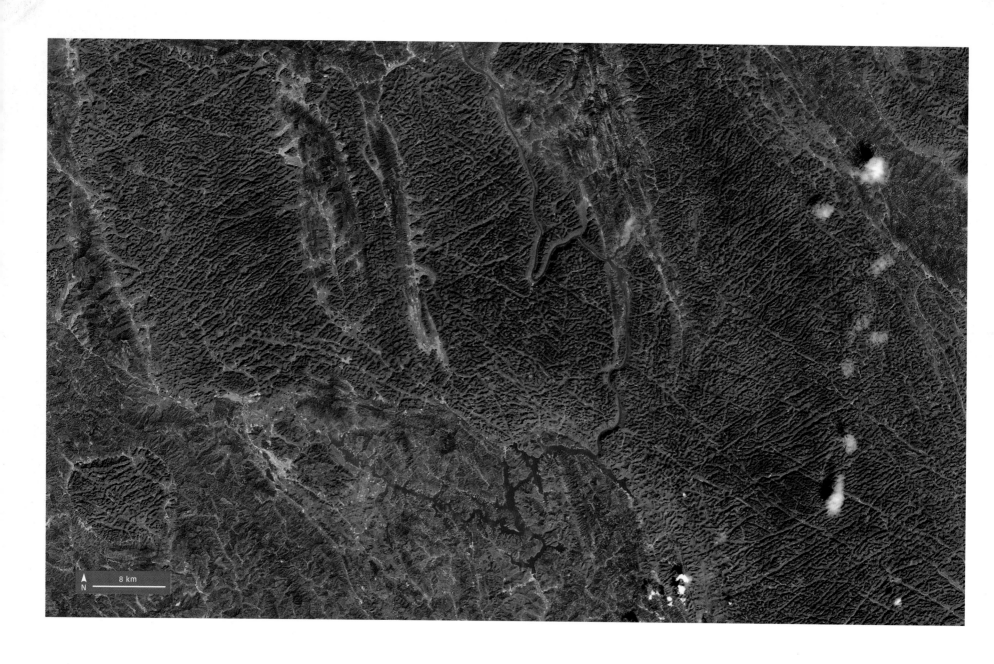

8 km

N

ABOVE: China's Guanxi Province, in the country's south-east, is dominated by cone karst mountains, the local limestone and dolomite bedrock having been carved into channels and stipples by rains and springs.

OPPOSITE: The Sierra Nevada range, just south of Granada in Spain, contains Mulhacén, the tallest mountain in continental Europe after the Alps and the Caucasus Mountains. The range is a designated biosphere reserve.

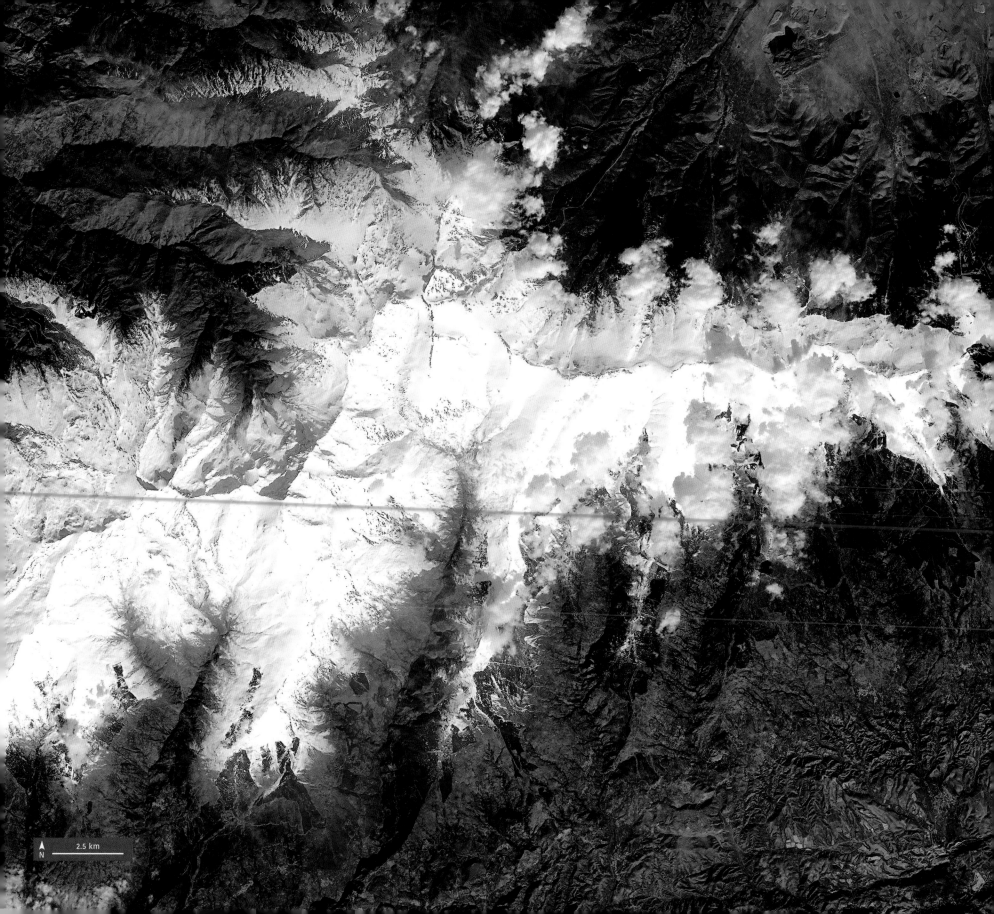

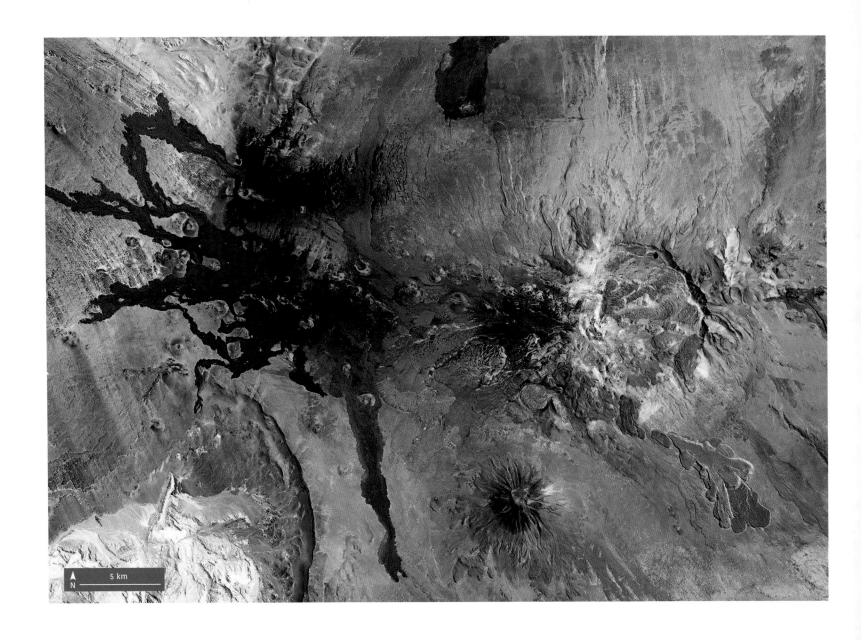

ABOVE: Payún, the circular
shape to the right of this
image, is a huge volcano in
the Argentinian Andes. Left is
a field of volcanoes and flows
known as Las Volcanes. Bare
rock is orange in this shot,
and lava black.

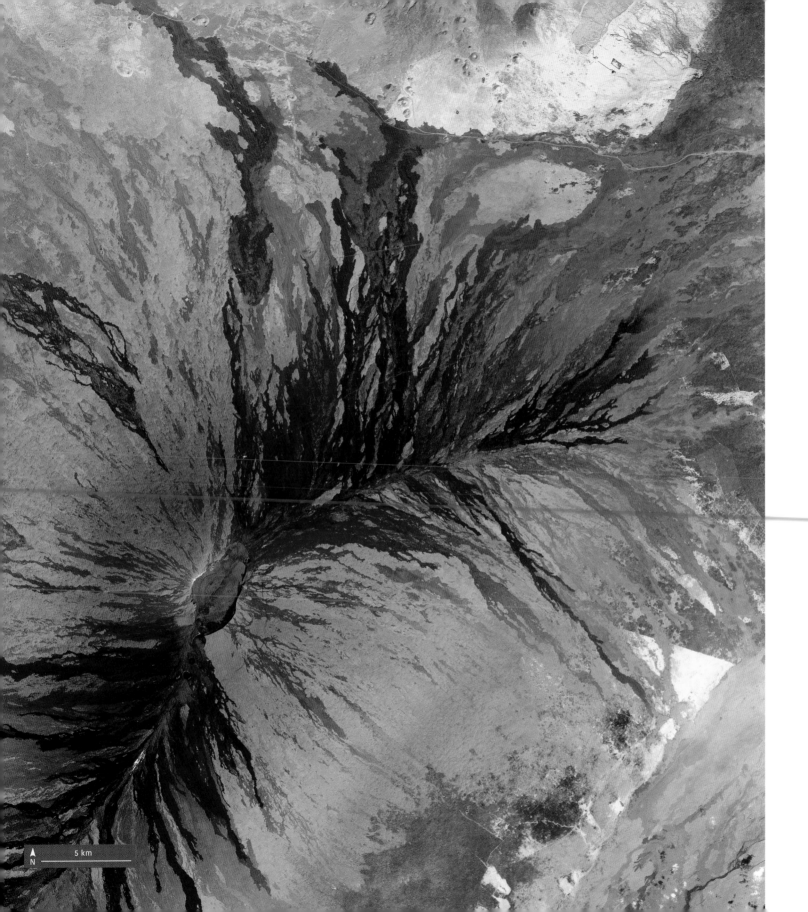

LEFT: Mauna Loa, at the heart of Hawaii's Volcanoes National Park, is the largest volcano in the world, over 13,000 feet (3,962m) above sea level. But it starts on the sea floor, almost 30,000 feet (9144m) below. Its lava spills scrawl across the land.

5 km

N

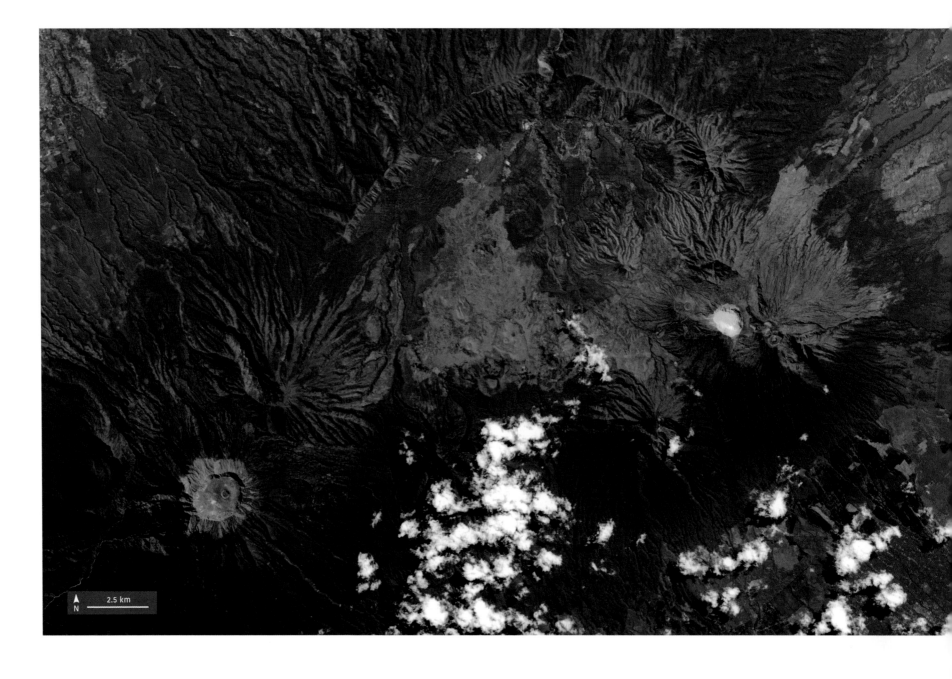

2.5 km
N

ABOVE: The island of Java is highly volcanic, with 45 active peaks and many more dormant. The Ijen caldera, the turquoise lake to the right, is very high in sulphuric acid, and is the largest lake of acid in the world.

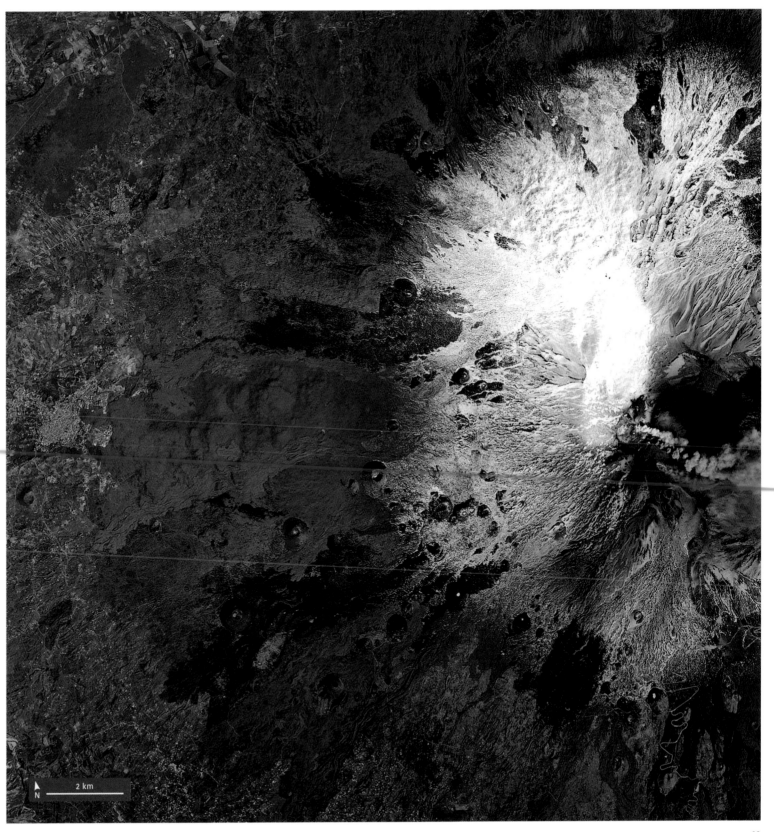

RIGHT: Mount Etna on the Italian island of Sicily, is one of the world's most active volcanoes. It is seen smoking to the right of this image, with its forests standing out against the winter snow.

2 km

N

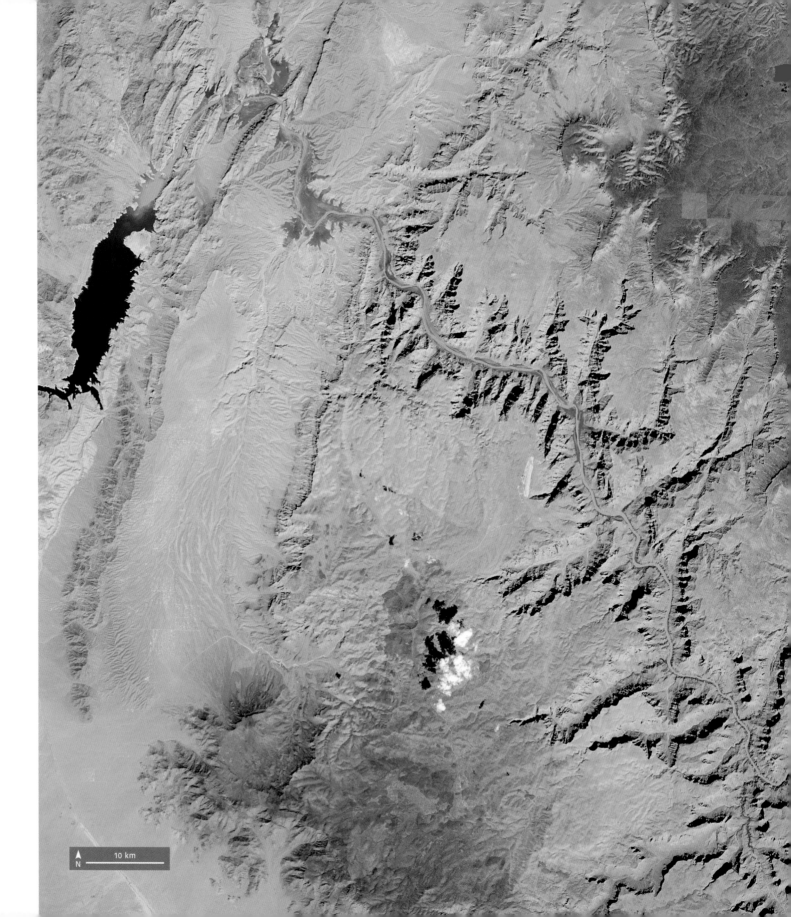

The Colorado River cuts a deep, winding channel through the plateaus of Arizona in the USA. From the right of the image, the line of dark shadow follows the river to the rapids of Lava Falls. Near the centre, the famous Grand Canyon is more than 6,000 feet (1,829m) deep. Lake Mead, beginning near the far left, is the border with the state of Nevada.

N
10 km
N

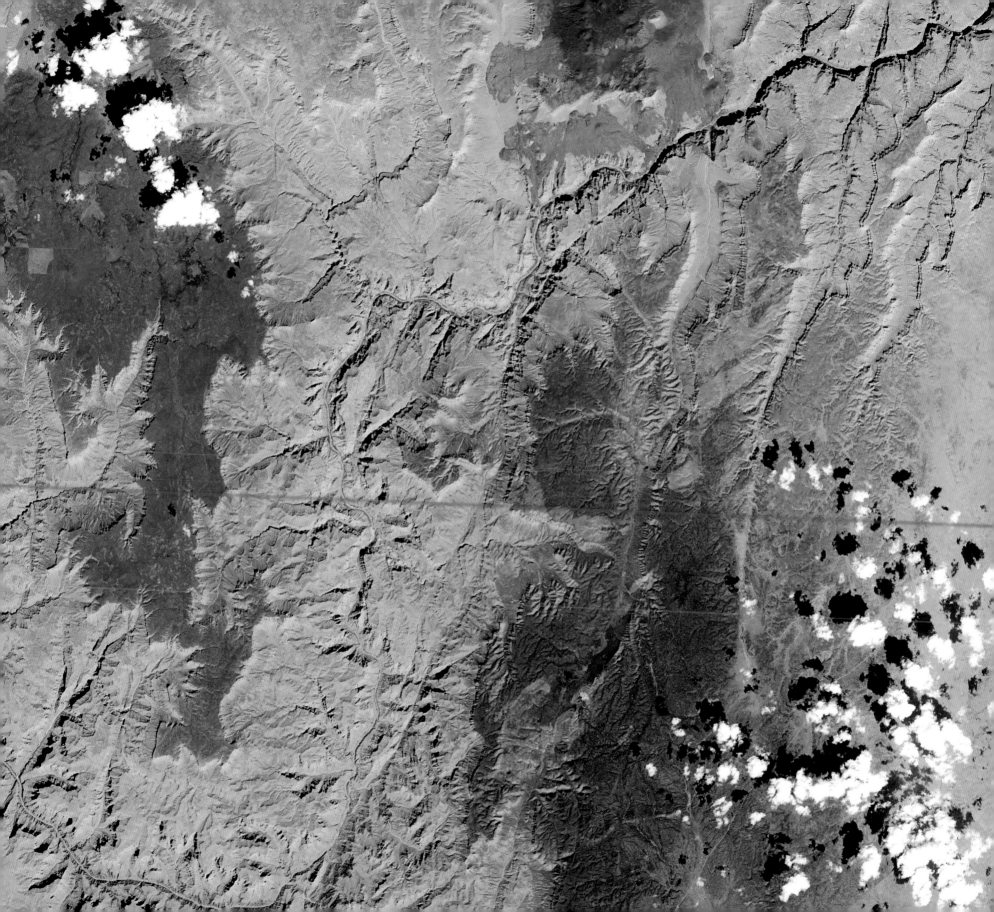

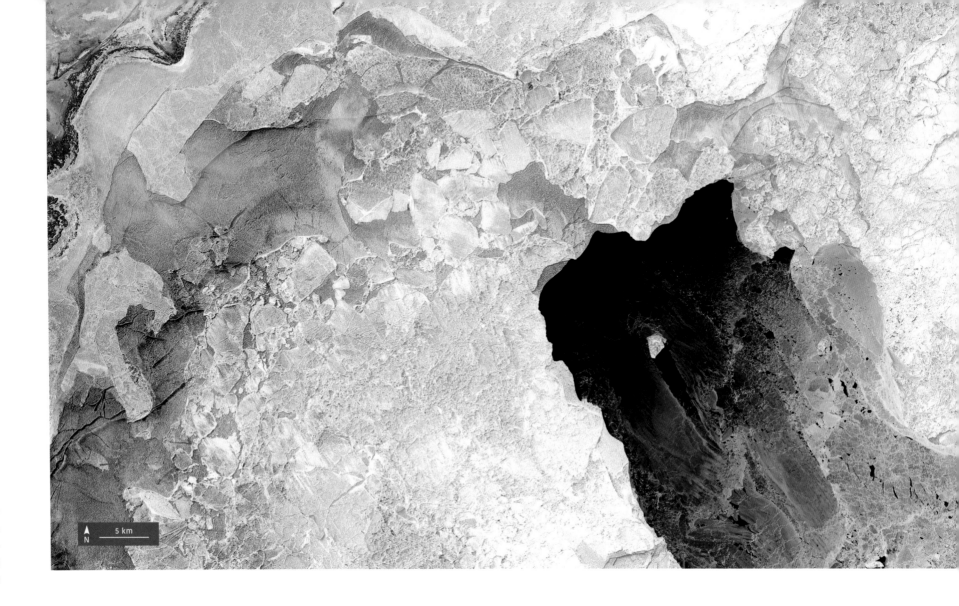

ABOVE: Kazakhstan's western coast, at the very top left, meets the Caspian Sea. It's just a few metres deep off-shore, so the ice is thick. Covering the rest of the image is a region of hummocked ice, where patches collide and slide over each other. The green shows thin, free-floating ice. The lonely white chunk is probably a bit of older ice that has grounded in place.

BELOW: China's largest freshwater lake, Poyang Hu in Jiangxi Province, has a typical surface area of 1,400 square miles (3,626 square km). Aggressive industrial sand mining has devastated local wildlife.

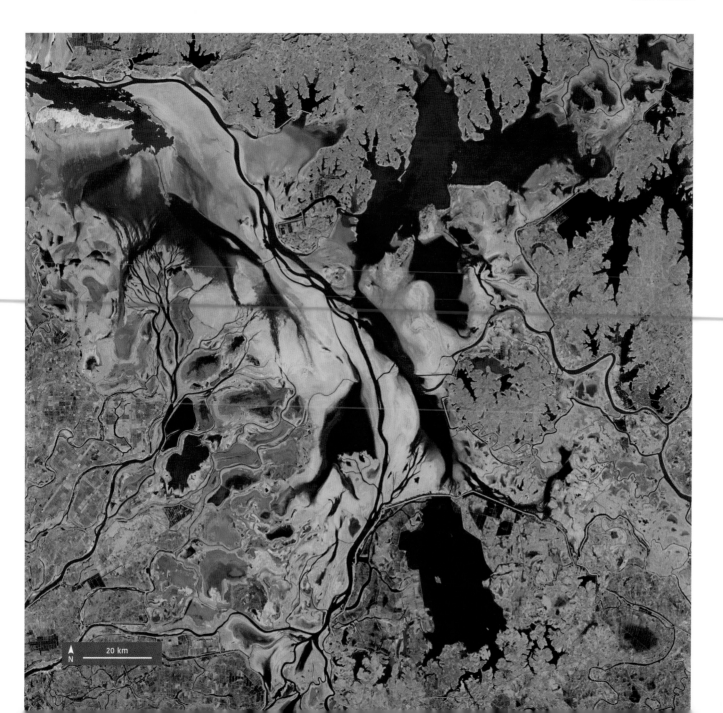

20 km
N

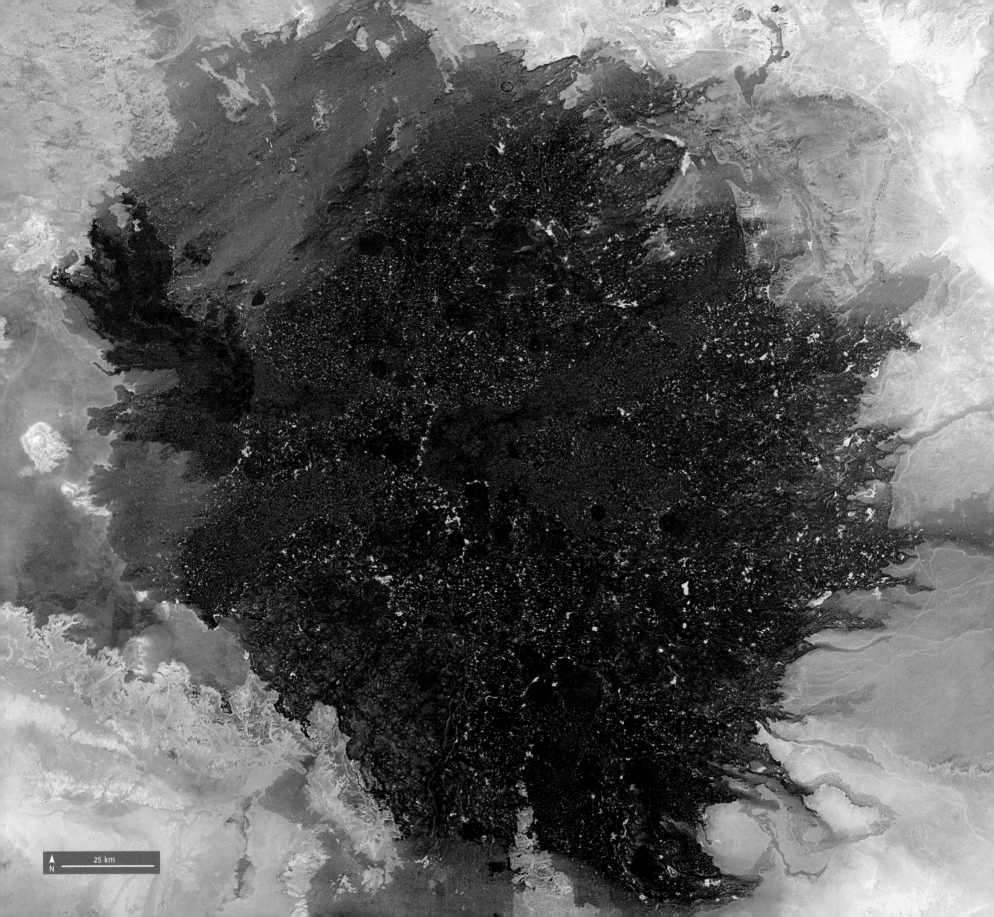

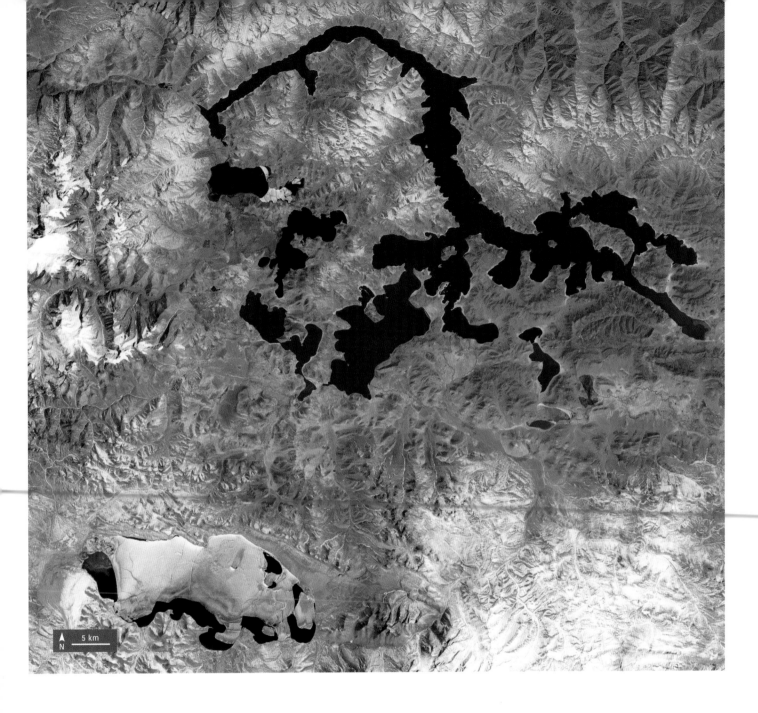

LEFT: The Tibetan Plateau, known as The Roof of the World, is more than 3 miles (5km) above sea level. Lake Puma Yumco is the mostly frozen lake bottom left. Its ice looks like an animal floating above the plains.

OPPOSITE: The Haruj volcanic field covers 17,000 square miles (44,030 square km) of plateau in Central Libya. More than 120 vents formed the area over the last five million years. Bright spots are sand collected in hollows.

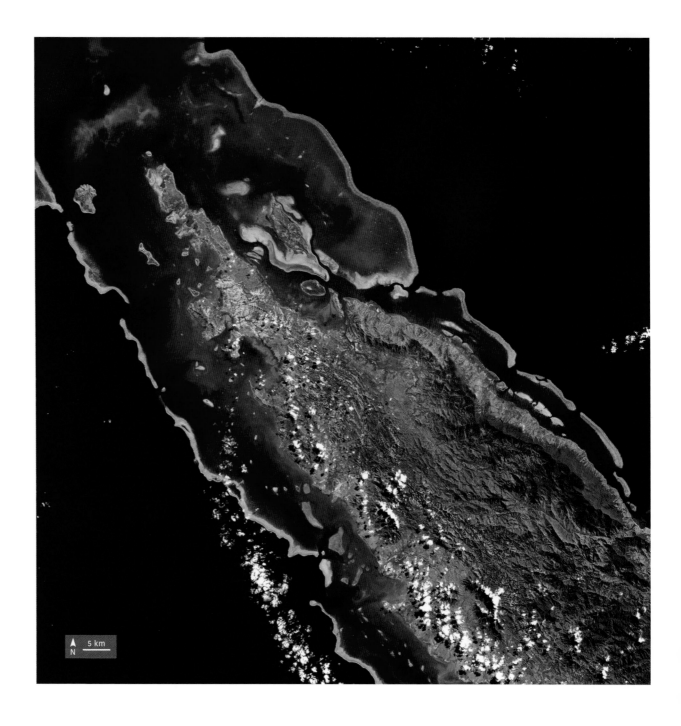

ABOVE: The archipelago of
New Caledonia lies 750 miles
(1,207km) east of Australia,
and is currently governed by
France. The shallow waters
around the islands contain the
world's third-largest coral reef,
visible here as pale blue lines.

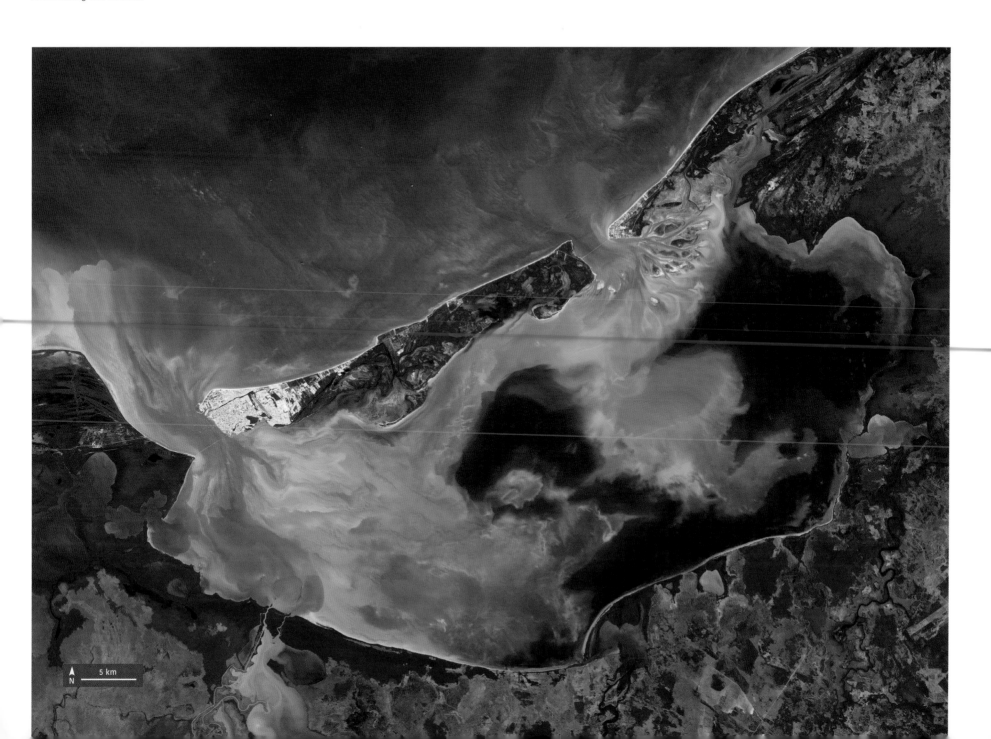

BELOW: The Laguna de Términos, guarded by the narrow Isla de Carmen, Is Mexico's biggest coastal lagoon. Its pale swirls are areas of inflow, from the sea to the right of the island, and from rivers along the bottom.

5 km

N

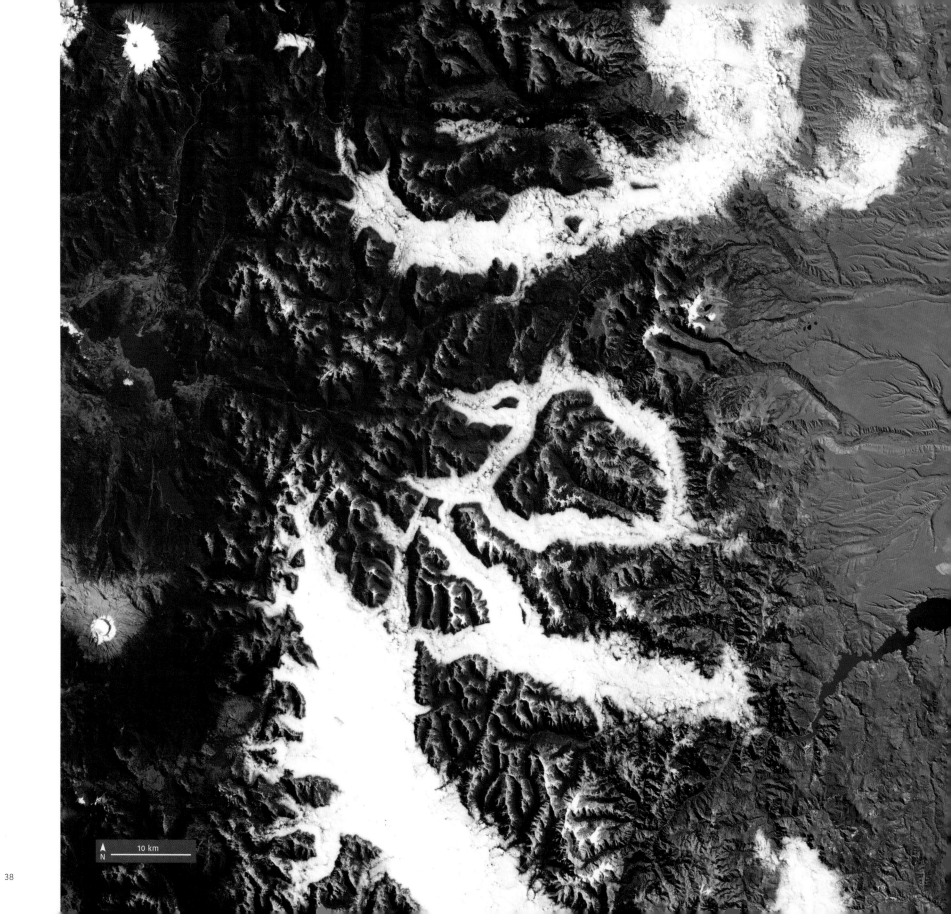

10 km

N

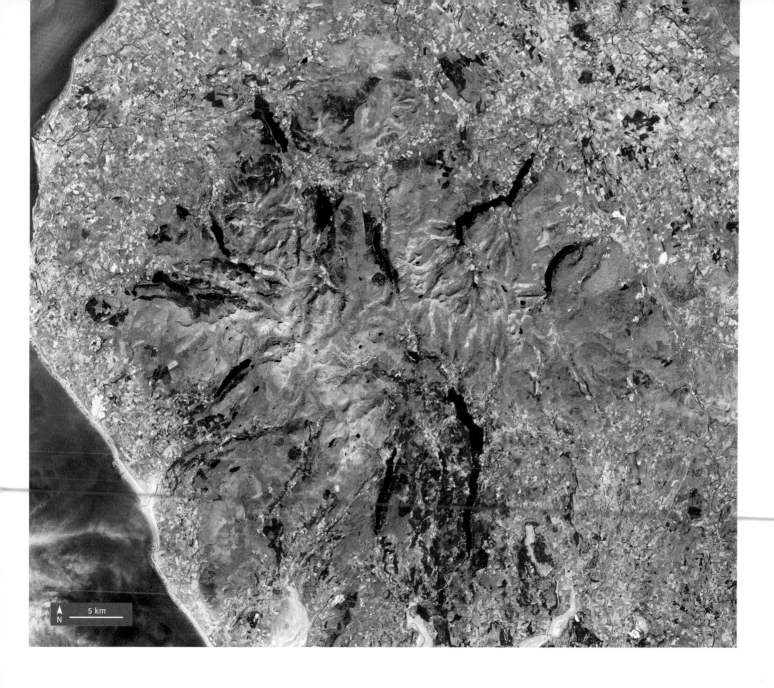

LEFT: Clustered amid the green and white stippling of agricultural fields, England's famous Lake District lies in the Cumbrian Mountains. There are fourteen major lakes in the district, carved by glaciers two million years ago.

OPPOSITE: The Argentinean Lake District is a popular tourist destination in the lower Andes, and offers amazing views. The white flows are fog, not ice. It forms in the mountains after sunset, and falls to collect in the steep valleys.

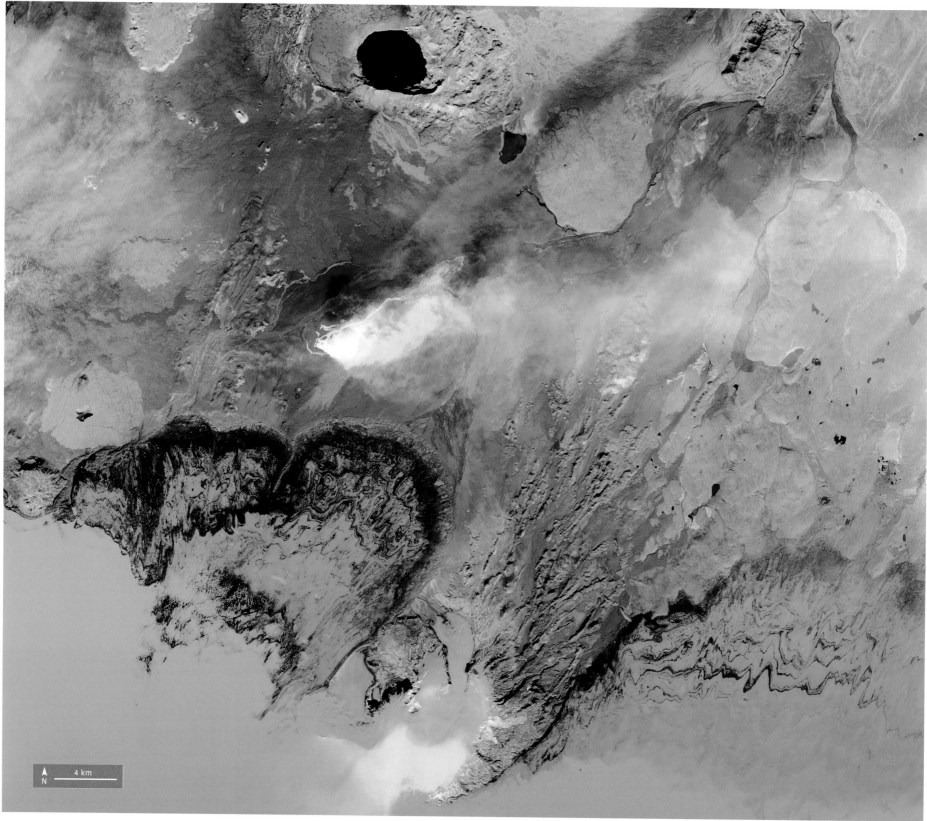

OPPOSITE: This image of Iceland's Holuhraun lava field shows 2014's extensive eruptions in process. The smoking orange stripe in the centre of the image is the fresh lava flow. Snowy areas appear in turquoise.

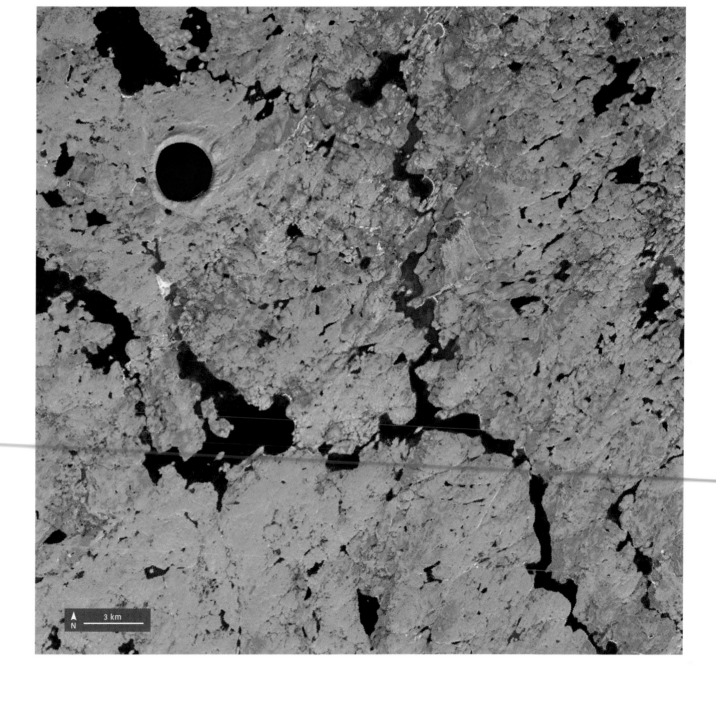

RIGHT: The circular lake in the top left of this image is Pingualuit Crater in northern Quebec, in Canada. It is more than 2 miles (3.2km) wide and almost 900 feet (274m) deep, and was formed by a meteorite strike 1.4 million years ago.

3 km

N

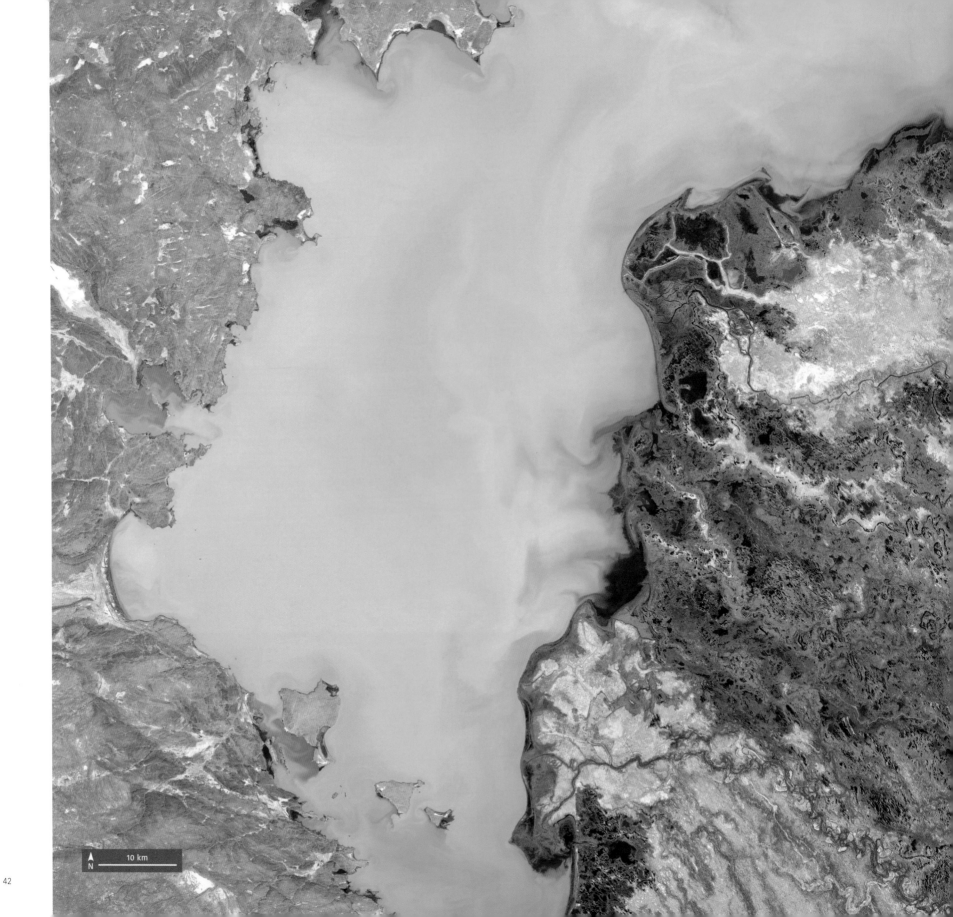

10 km
N

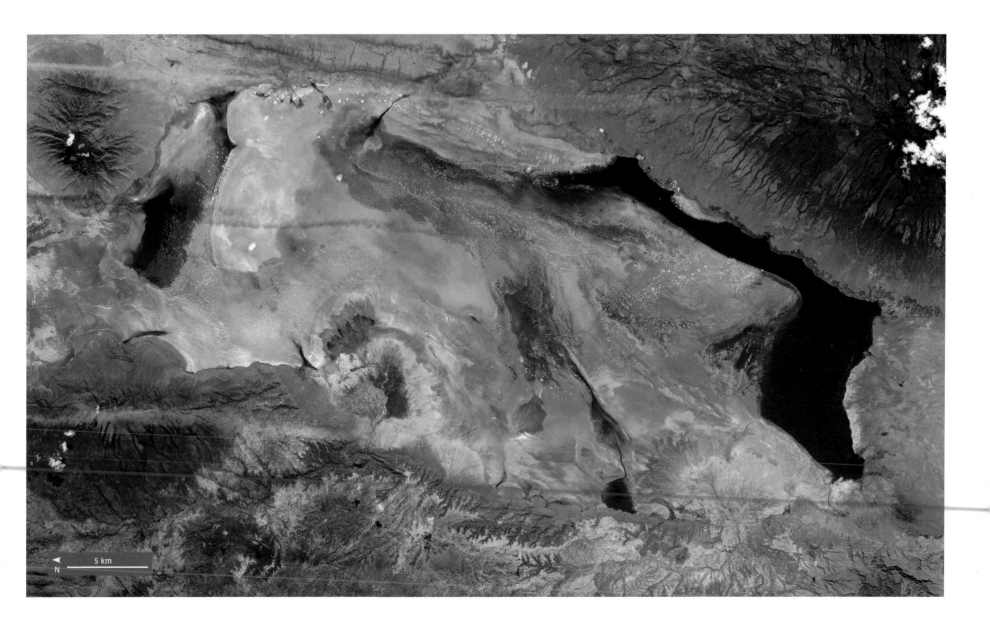

5 km

N

OPPOSITE: Kazakhstan's Lake Balkhash is the earth's fifteenth-largest lake, and the biggest in central Asia. The lighter, sedimented water to the lake's left is fresh enough to drink, but to the right, the water is too salty.

ABOVE: Lake Natron in northern Tanzania is salty and alkaline, unsuitable for most life. The bright reds and oranges are haloarchaea, shallow-water microbes that thrive here. The lake is seen in March here, near its yearly driest.

BELOW: Most of Bangladesh lies within the delta of the Ganges. The delta is covered with the Sundarbans, a vast mangrove forest that is the home of the Bengal tiger. Some 120 million people live here.

OPPOSITE: The tannin-stained waters of the Nottaway River on this image's bottom edge flow into Rupert Bay in northern Quebec. Here they meet the lighter browns of tidal sediment before darkening out into the sea.

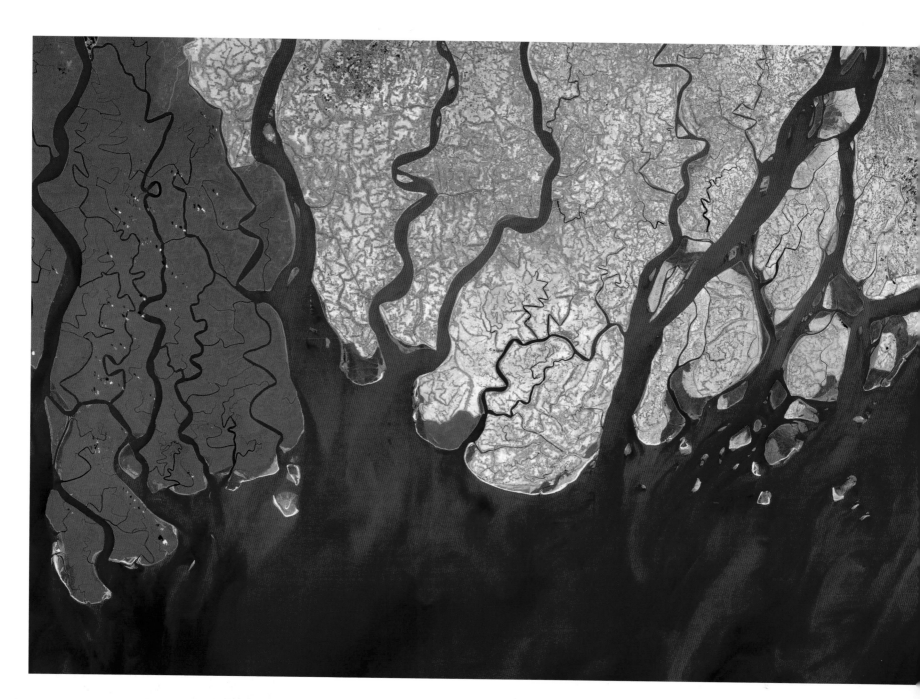

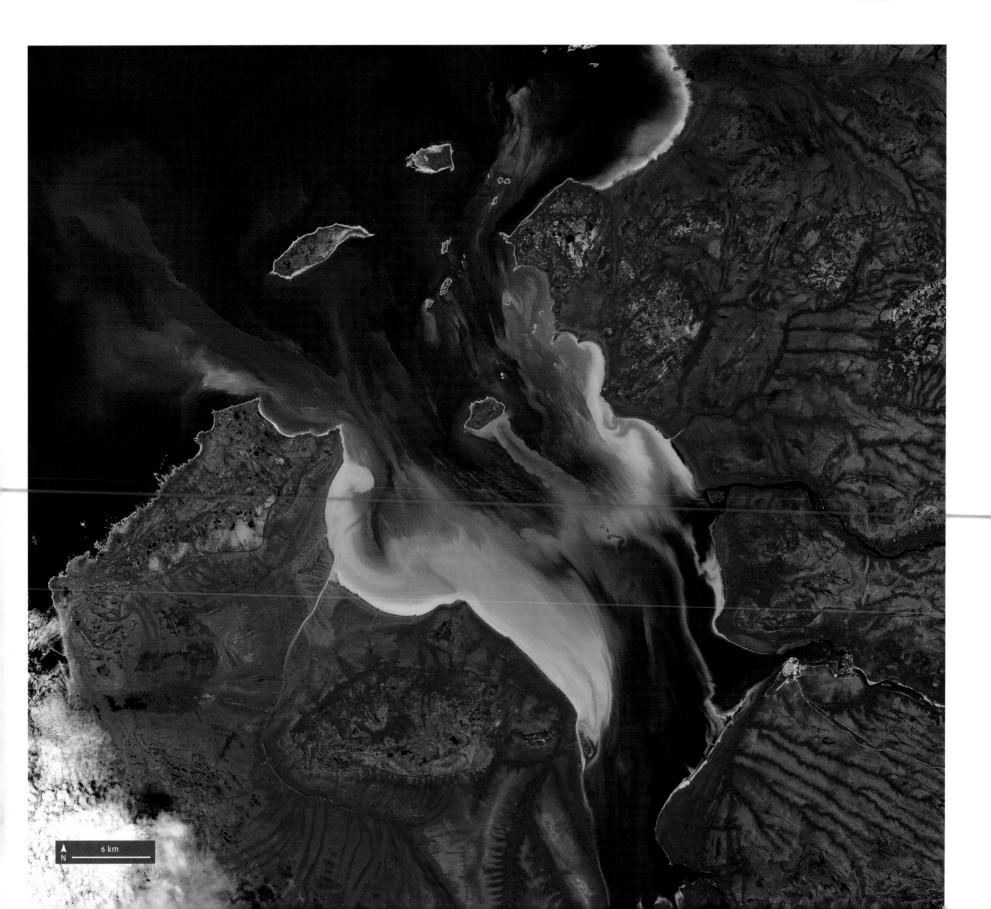

6 km

N

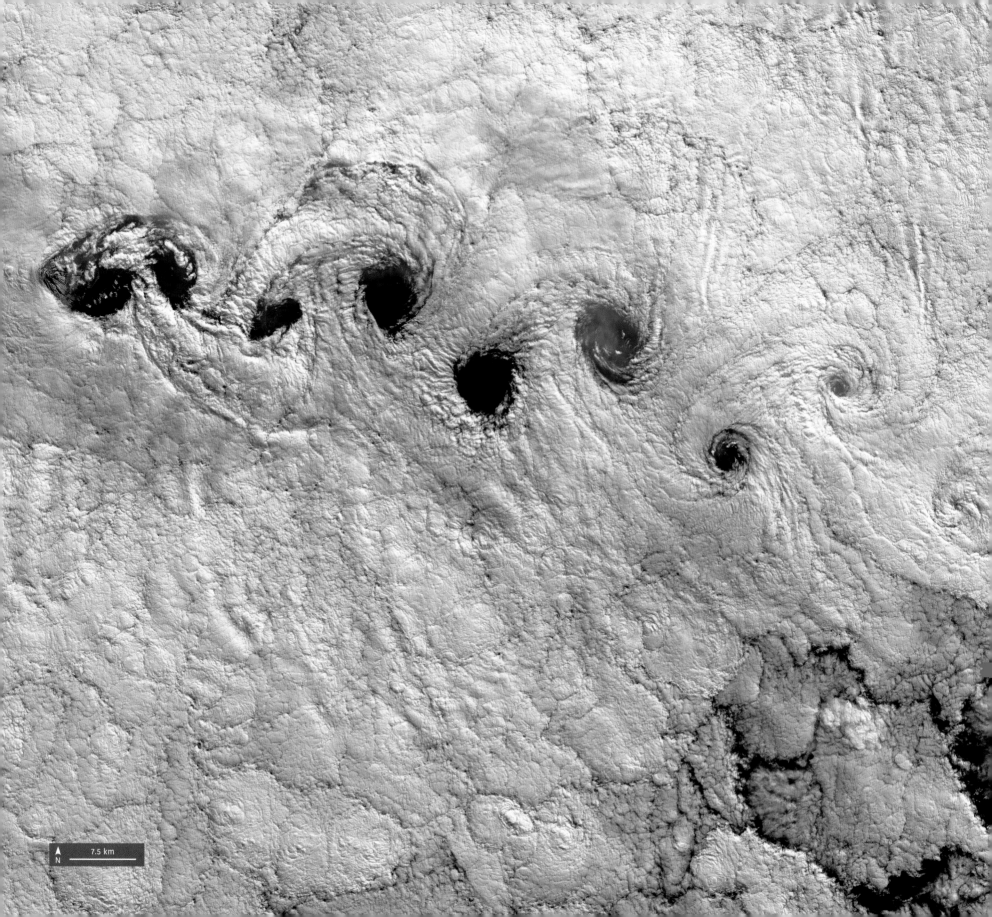

OPPOSITE: These curious cloud swirls are Von Kármán Vortices. They form in chains when wind flow gets broken by a sudden, blunt rise, such as a tall ocean island – in this case, the remote Tristan da Cunha in the south Atlantic.

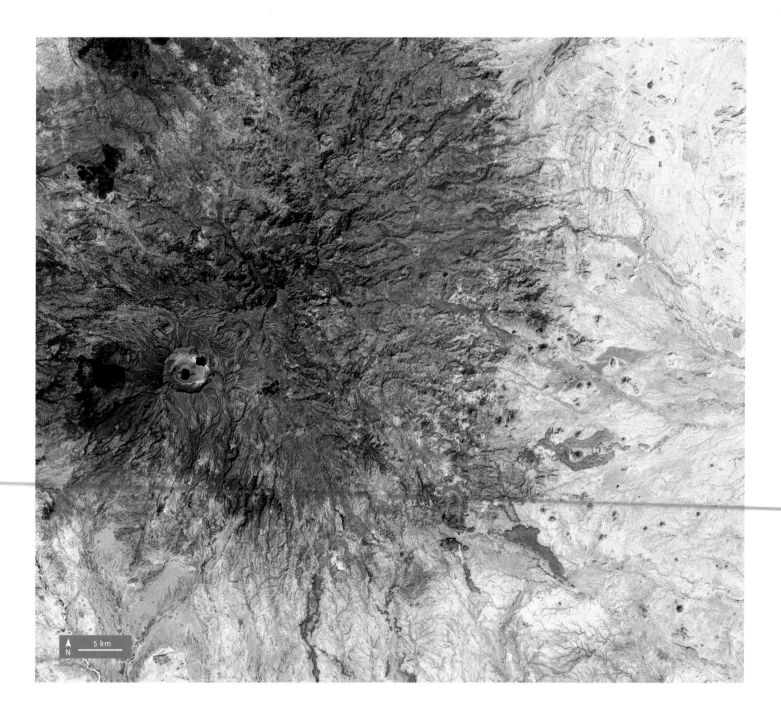

5 km

ABOVE: The Jebel Marra is an extensive volcanic field in the west of Sudan, on the south edges of the Sahara Desert. The Deriba Caldera is the summit of the Jebel Marra, visible here as a lake-spotted crater on the left.

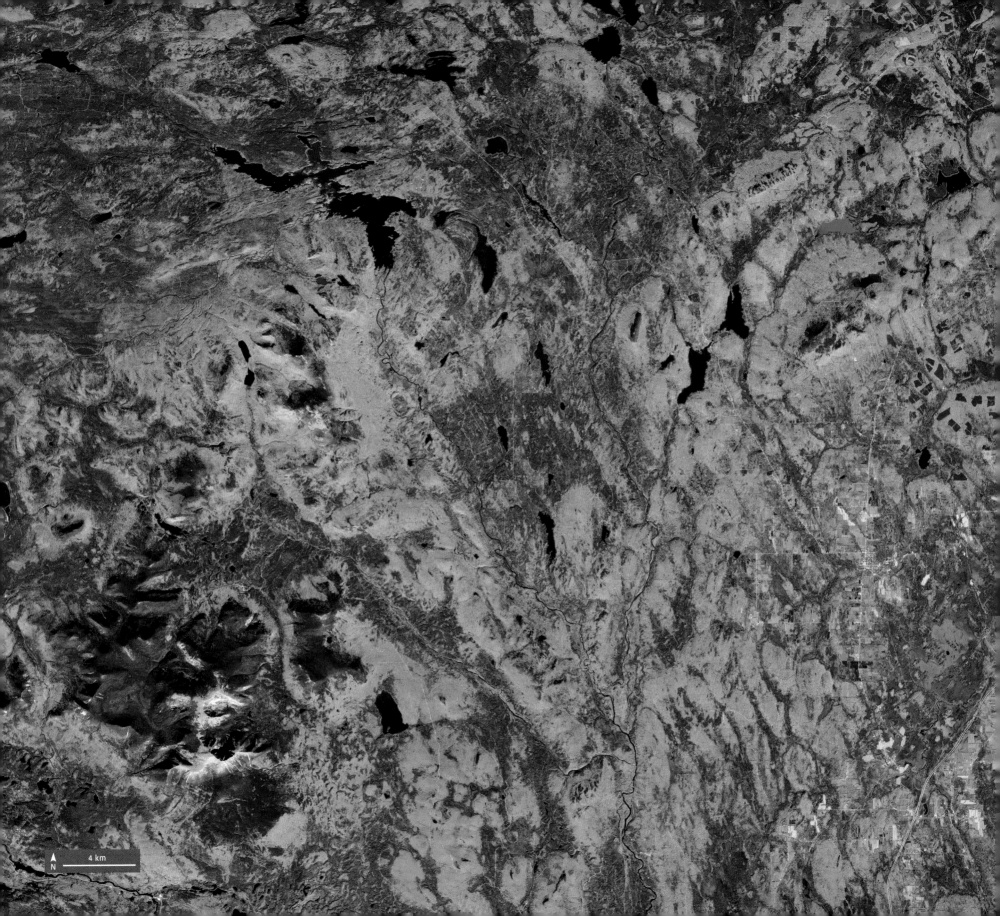

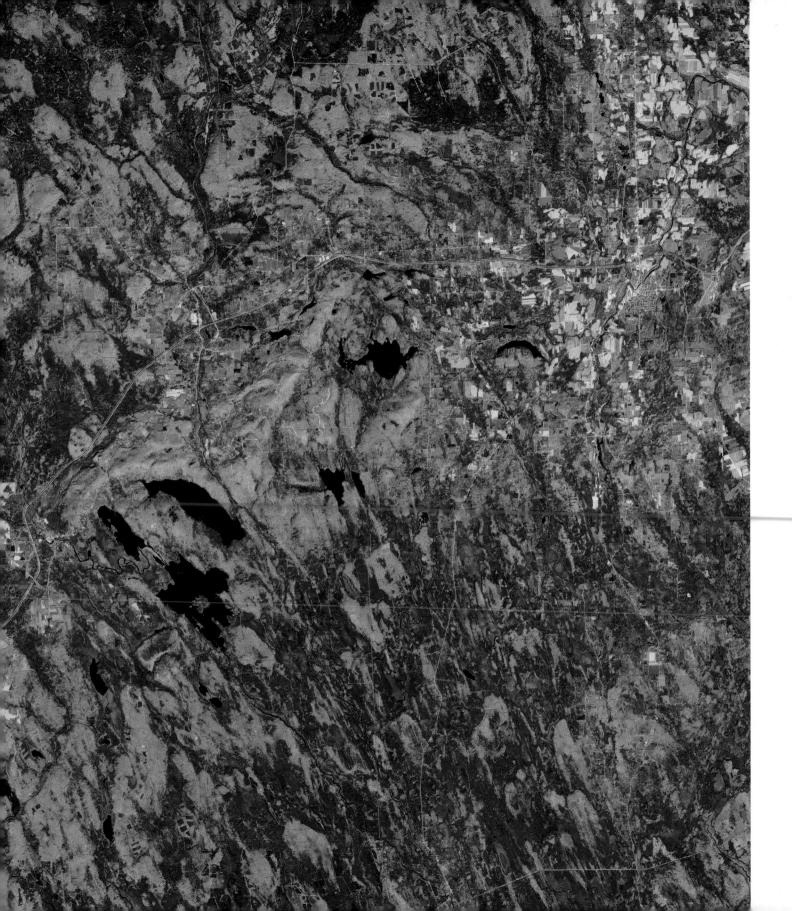

Maine's Mount Katahdin, the dark green and white peak left of centre here, is the tallest part of the state at 5,269 feet (1,605m). Below its rich evergreens, the higher ridges and plateaus of the 200,000 acre (809 square km) Baxter State Park show autumn colours, with lower areas remaining green. Outside the park proper, fields show as pale greens and creams.

NATURAL WONDERS

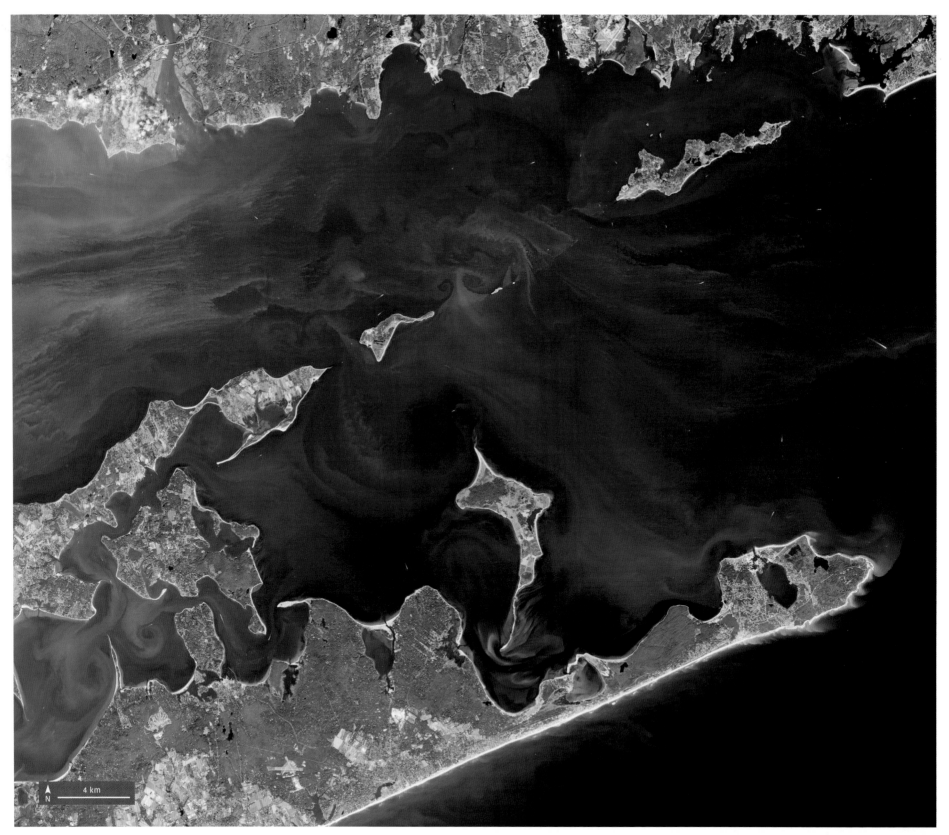

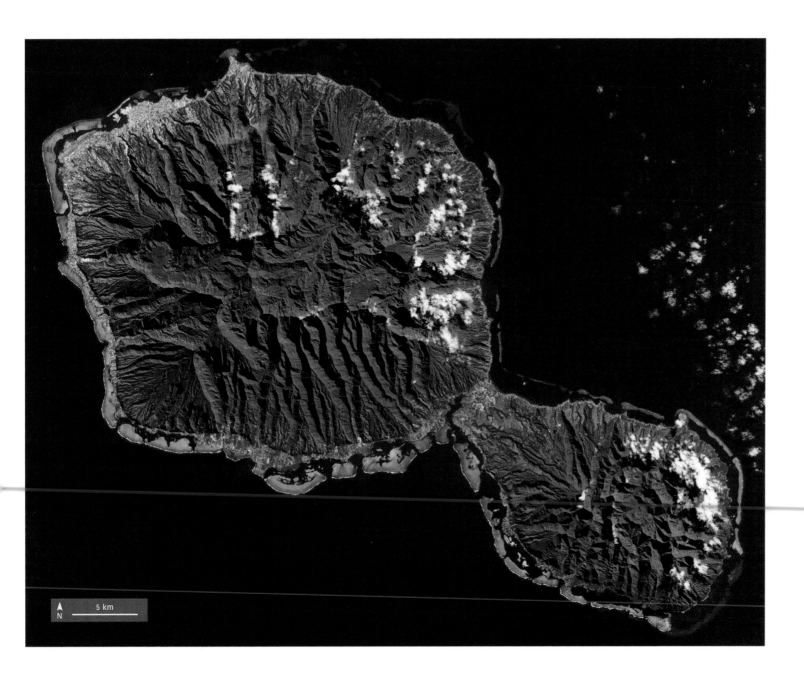

LEFT: The dual island of Tahiti is the heart of French Polynesia, with almost 200,000 inhabitants. The island is volcanic, and its larger part, Tahiti-Nui, has the taller peak. The smaller part, Tahiti-Iti, is mostly uninhabited.

OPPOSITE: New York's Long Island stretches away from the US mainland, out into the Atlantic Ocean. It was created by glacial outflow, and is constantly shaped and reshaped by the sea. The Connecticut coast is to the north.

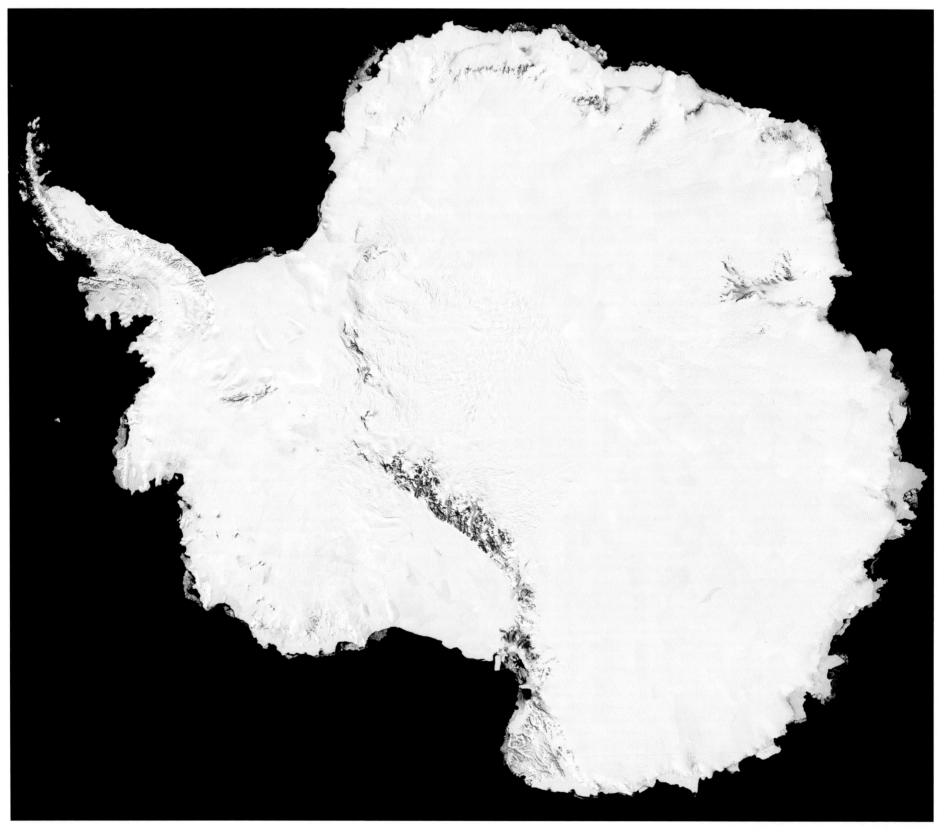

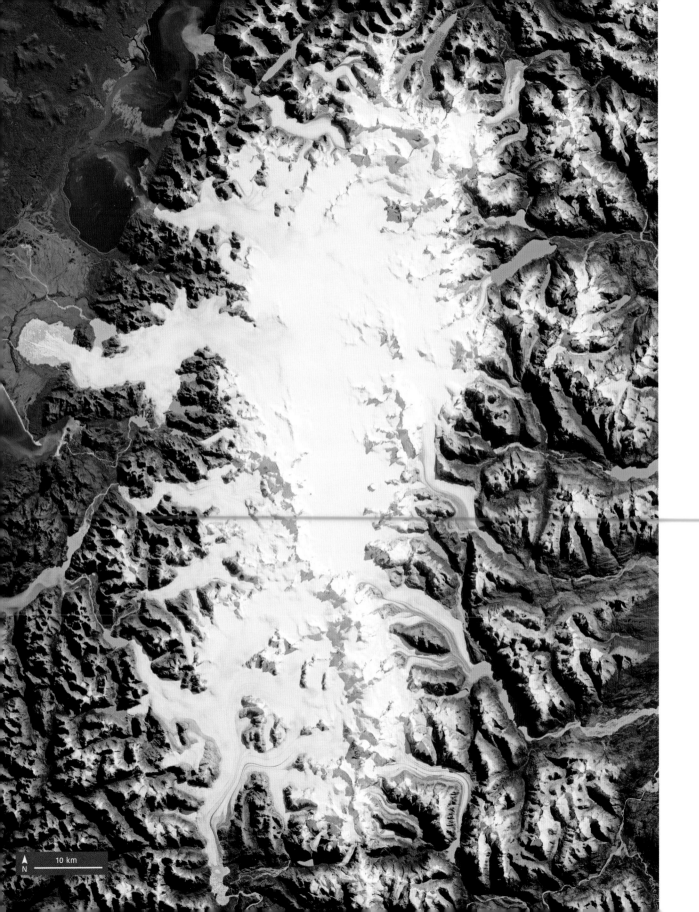

10 km
N

FAR LEFT: This image of Antarctica's 5.4 million square miles (14 million square km) was stitched together from over 1,000 satellite photos. At last count, the world's driest, coldest, and windiest continent had seen the birth of just 11 people.

LEFT: The North Patagonian Ice Field in Chile covers about 1,500 square miles (3,880 square km) of the Andean mountains. Like its larger South Patagonian fellow, it is losing ice at some of the fastest rates anywhere on Earth.

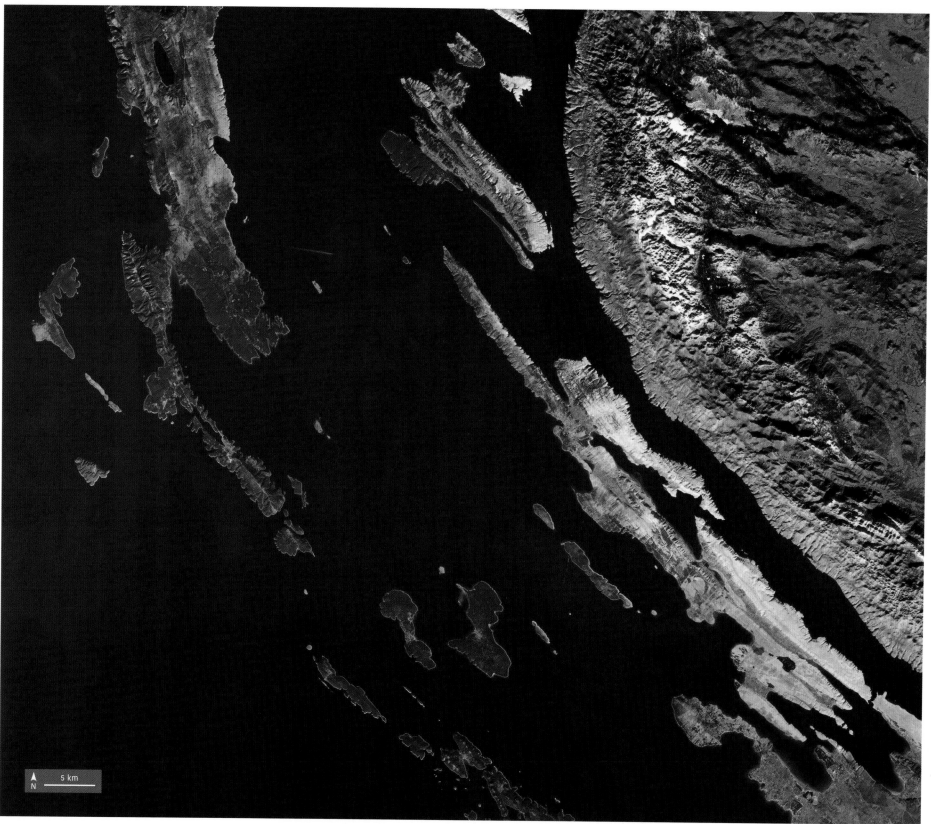

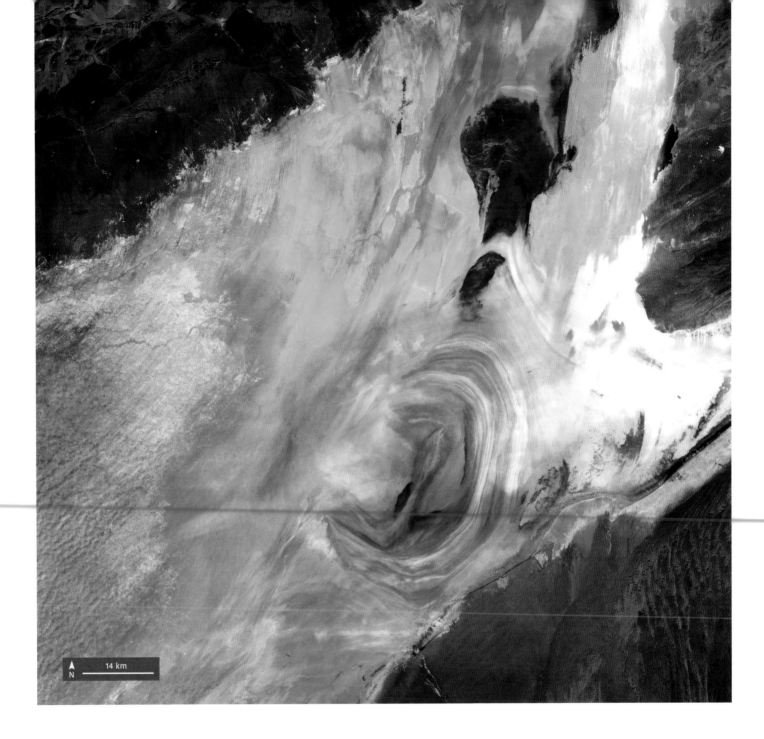

OPPOSITE: The coast of Croatia gives way to the Mediterranean's Adriatic Sea in a series of dramatic islands that make up the Dalmatian archipelago. The coastal mountains of the Croatian Highlands are visible to the top right.

RIGHT: Lop Nur is a former salt lake found in the northwest China region of Xinjiang. It was known as "The Wandering Lake", owing to its shifting position in various basins; however, it dried up in the early 1970s. With it, surrounding forest and vegetation has also been lost.

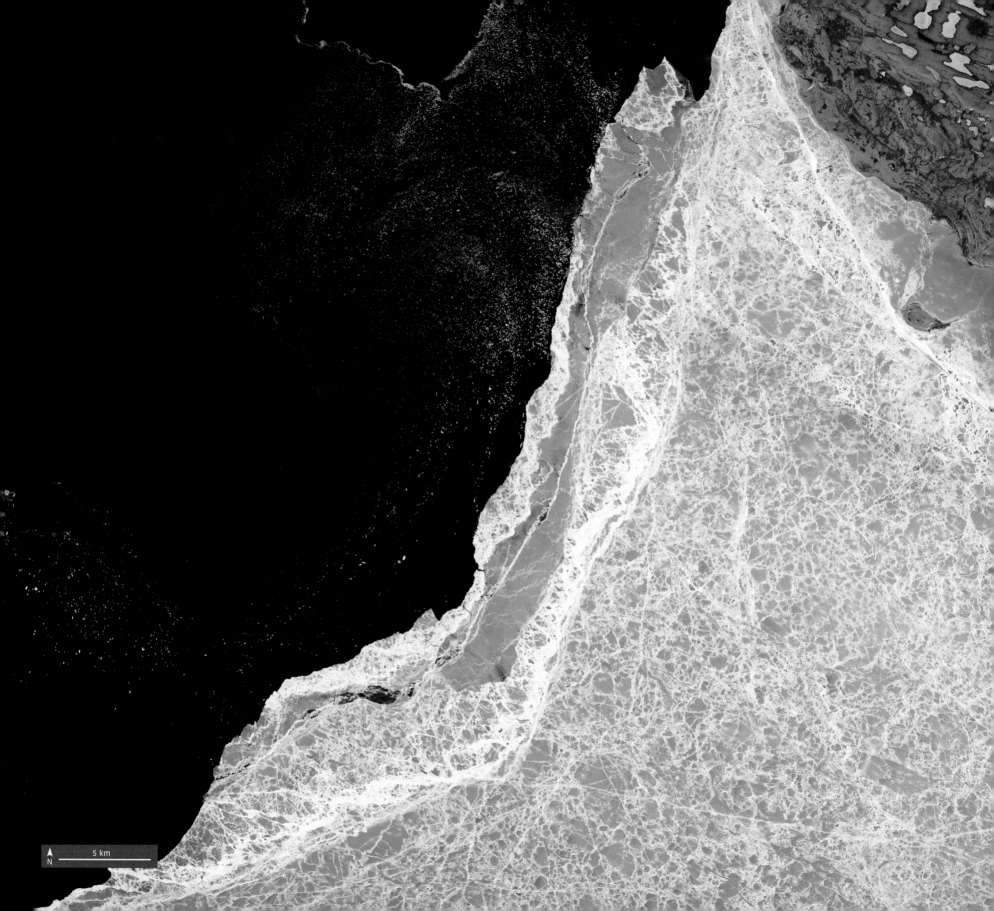

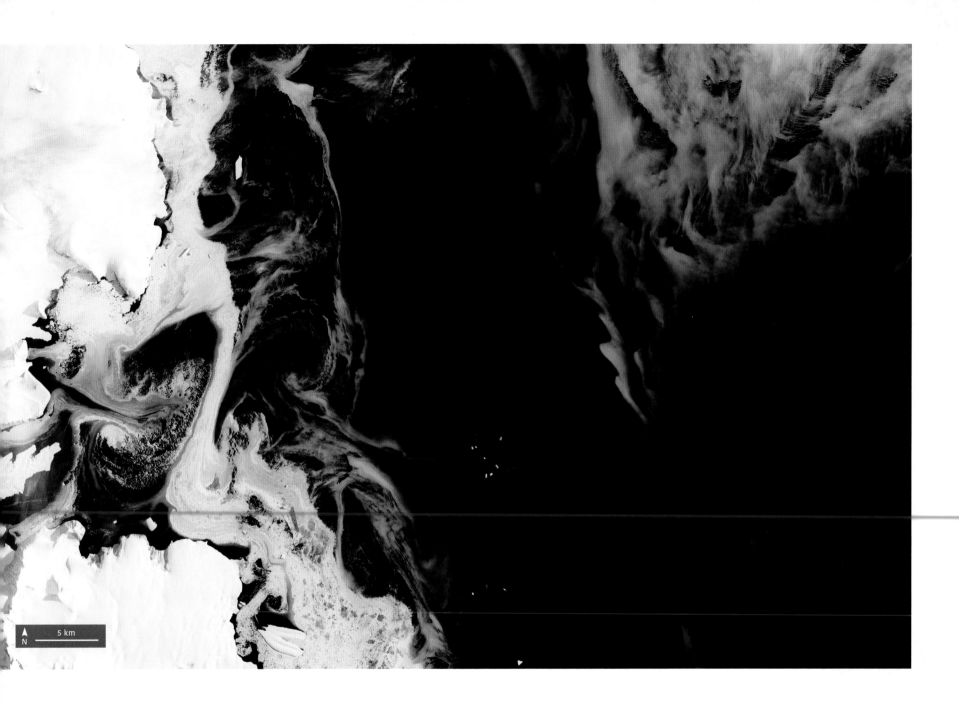

5 km

OPPOSITE: The differences
in colour as ice ages
are starkly visible in
the Amundsen Gulf off
Canada's coast. The blue
ice is years old. The grey ice
is new and thin, and won't
last. The white is snow,
collected in cracks.

ABOVE: Green ice off the
coast of Antarctica's
Granite Harbor is thought
to be due to microalgae,
a type of microscopic
plankton that is able to
thrive in the waters of
the region during warmer
times of the year.

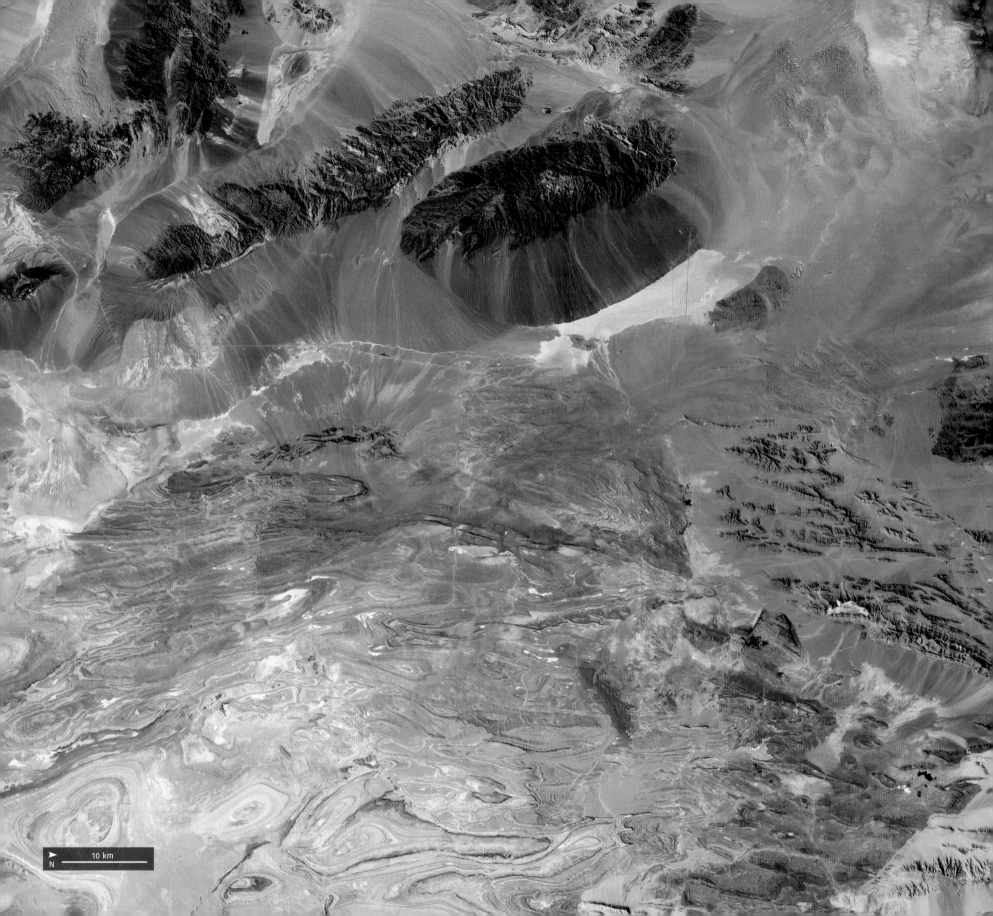

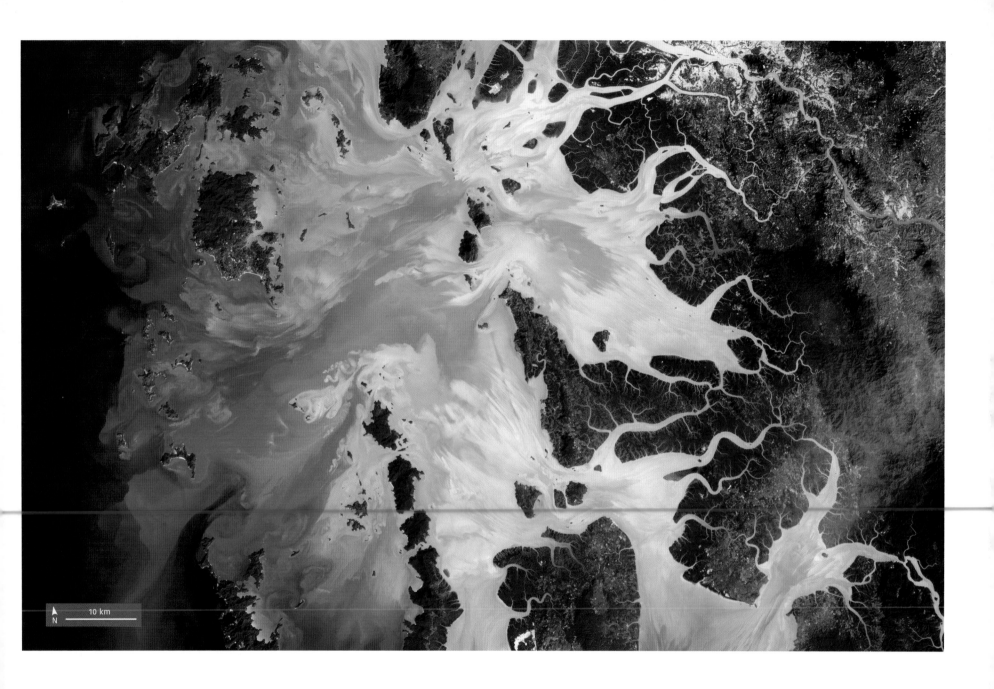

10 km
N

OPPOSITE: In this image of the border area between Iran's Yadz and South Khorosan provinces, both near and shortwave infrared light make different strata of rock simpler to pick out and identify.

ABOVE: The waters of the Mergui Archipelago, off Myanmar's southern coast, are whitened with sands and other sediments. The water gradually swirls back to a deep blue as these settle.

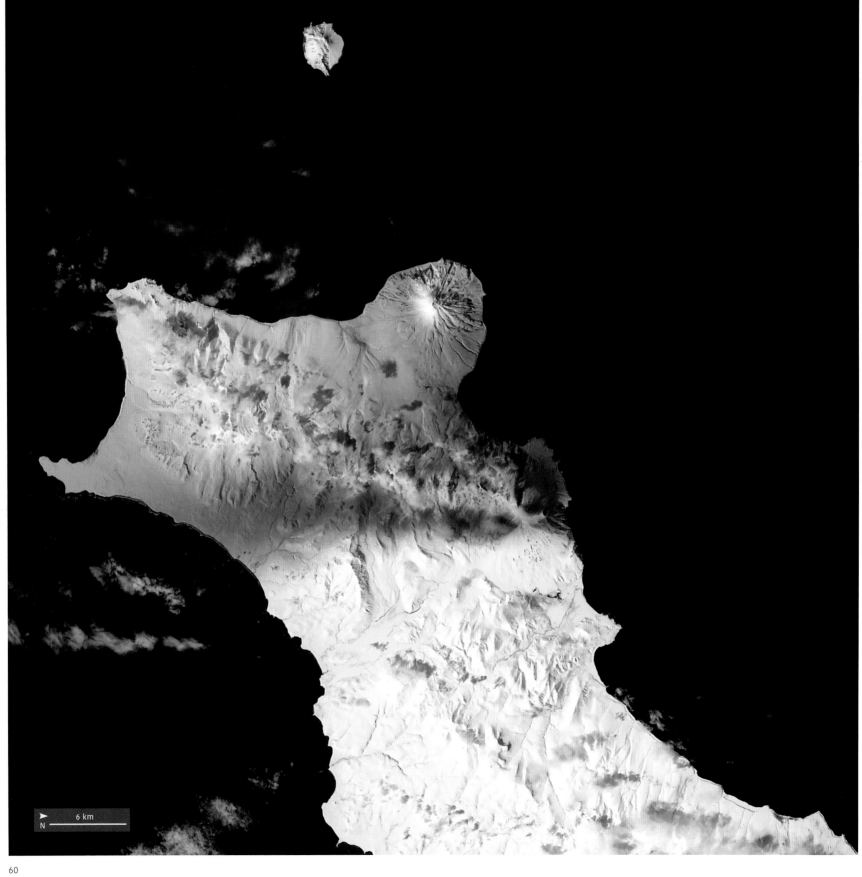

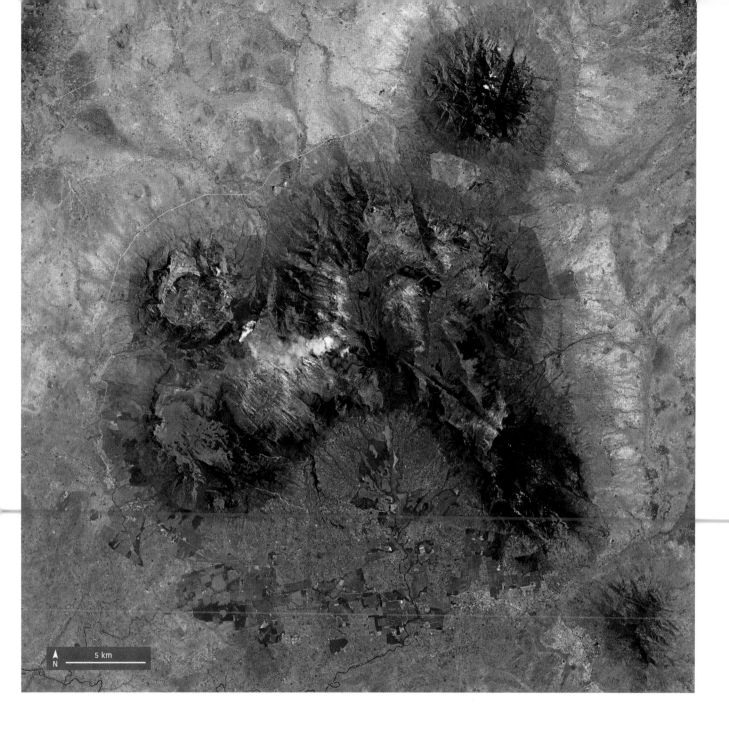

LEFT: The Mulanje Massif in southern Malawi is a sprawling, multi-lobed plateau of twenty granite and syenite peaks that thrusts up some 4,500 feet (1,370m) above the surrounding densely-populated plains.

OPPOSITE: The dark streaks across the centre of this image are smoke pouring from Chikurachki, a volcano in the Kuril Islands, Russia, which erupted at the end of March 2016.

N
5 km

Massanutten Mountain, at the centre of this image, is a long, bifurcated mountain in the Shenandoah Valley, in the American state of Virginia. Fort Valley cuts it into sections in its northerly half, and the Shenandoah River winds back and forth along both sides of the mountain. The famous Blue Ridge mountains are to the right of the image.

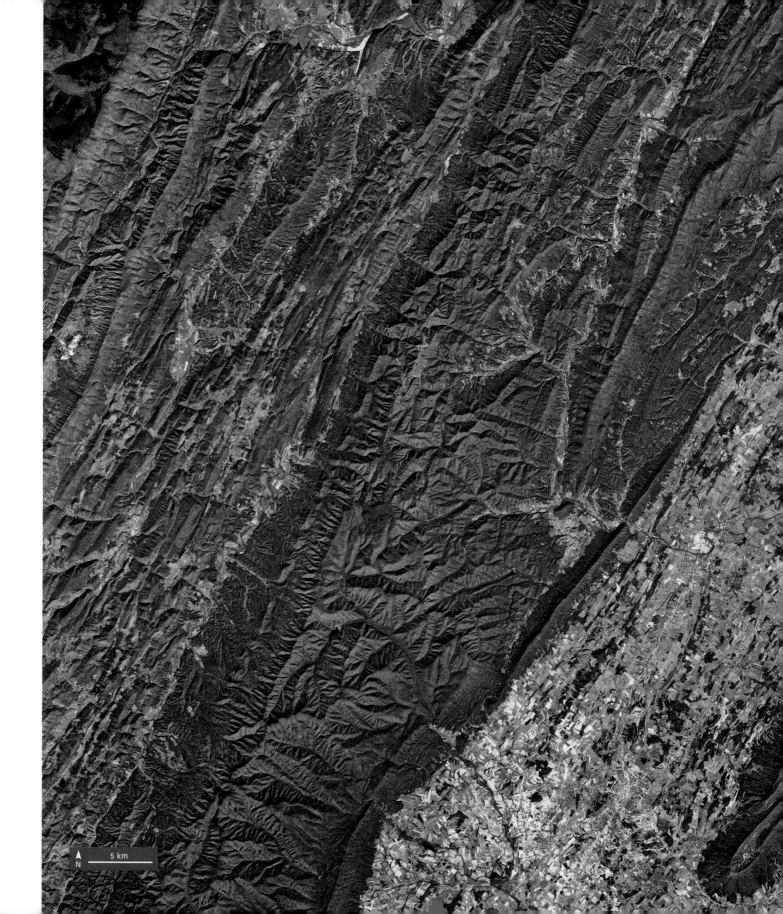

5 km

N

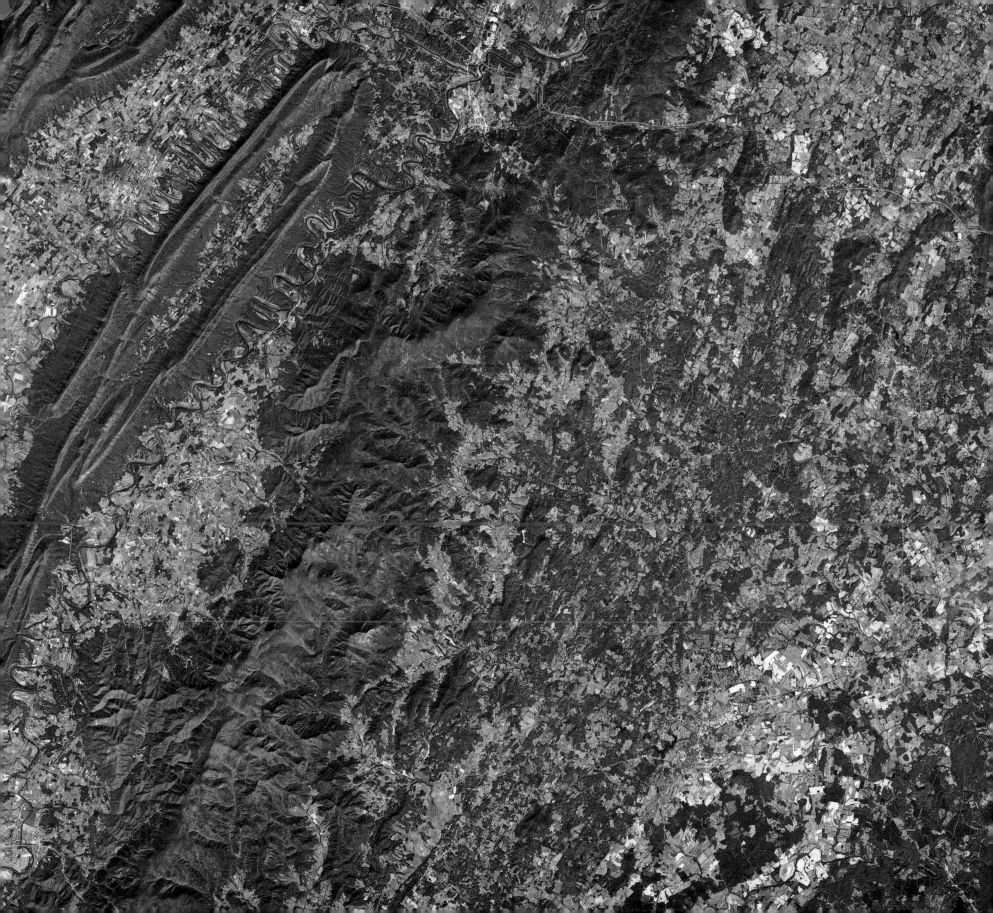

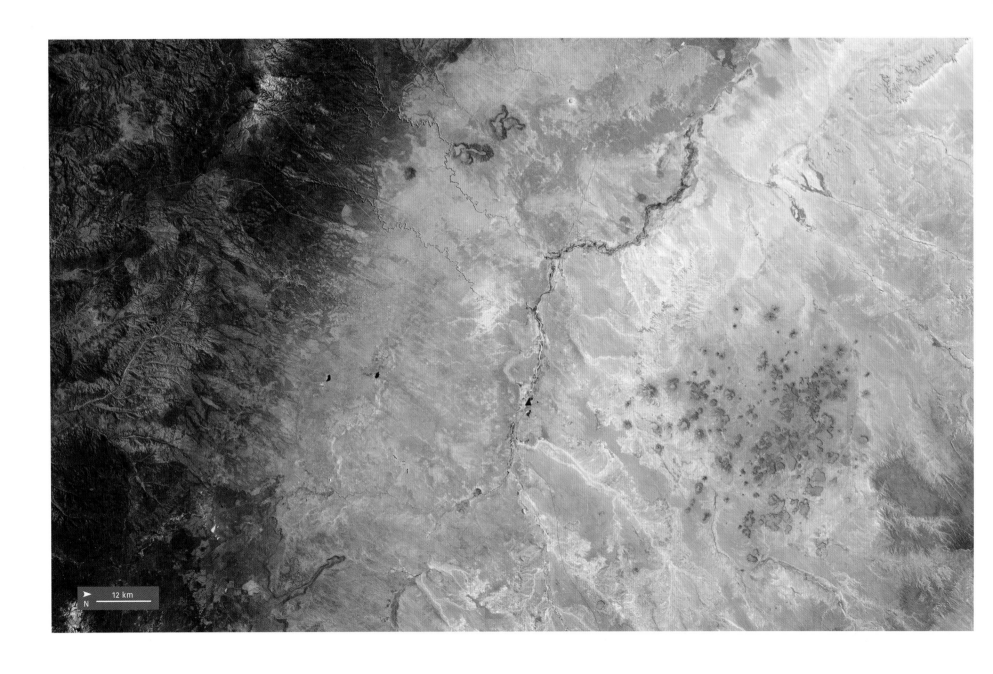

Compare these two images of Arizona's Painted Desert, a region of badlands that takes its name from the bands of clays and mudstones that make up its striated landscape. The natural colour image is to the left, but the right, false-colour image clearly shows vegetation in greens, and damper soils in blue tones.

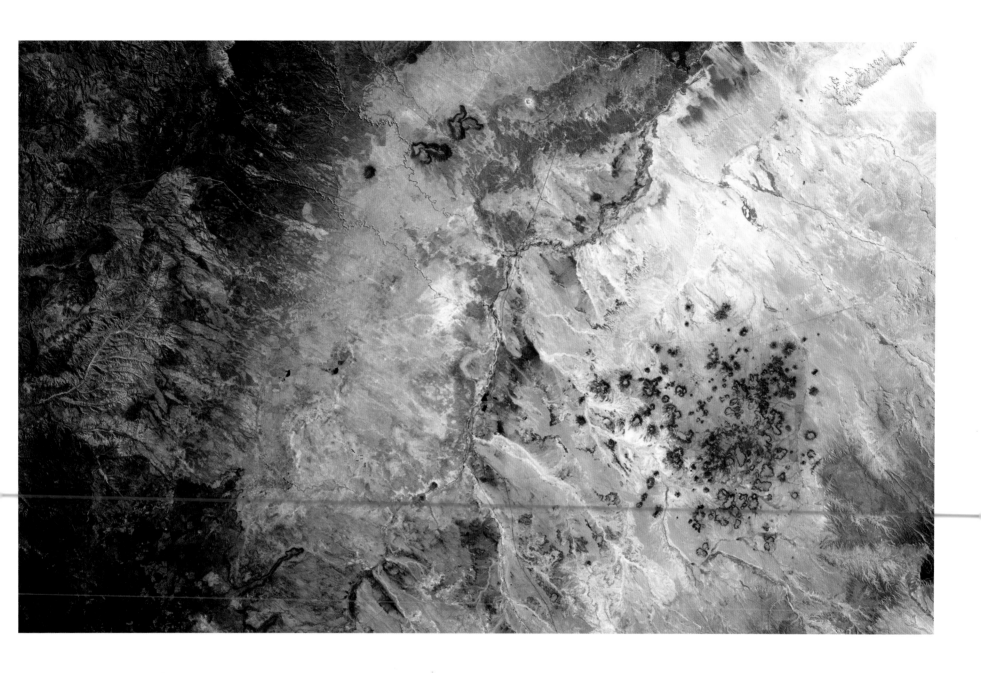

RIGHT: Namibia lies along the
Atlantic coast of southern Africa.
This tongue of the Namib Desert
to the west gets its orange
colour from iron in the sands.
The mountains of the Central
Plateau are to the east.

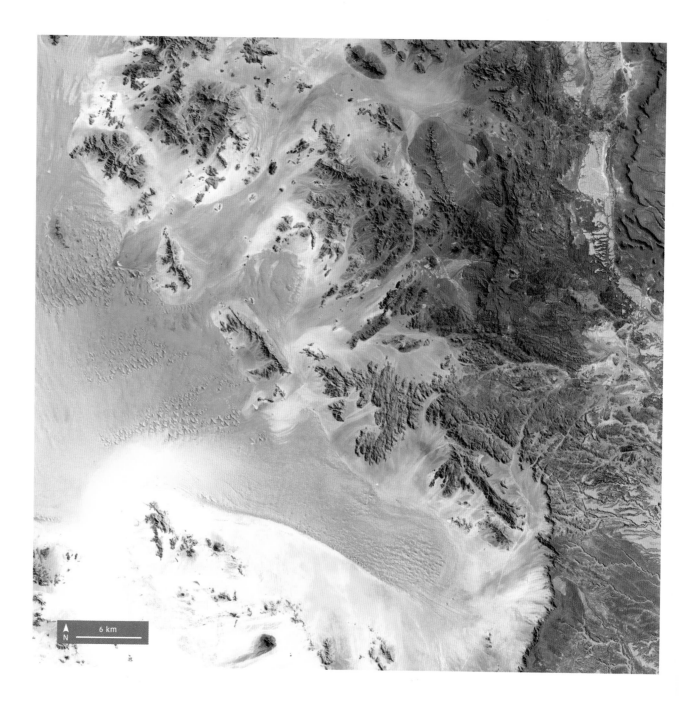

6 km

N

OPPOSITE: Nearly 300 feet
(91m) below sea level,
California's Death Valley is
one of the hottest and driest
spots on Earth. This false-
colour image shows plants
in green, but blues are salt
pans, not water. Browns and
reds are bare ground.

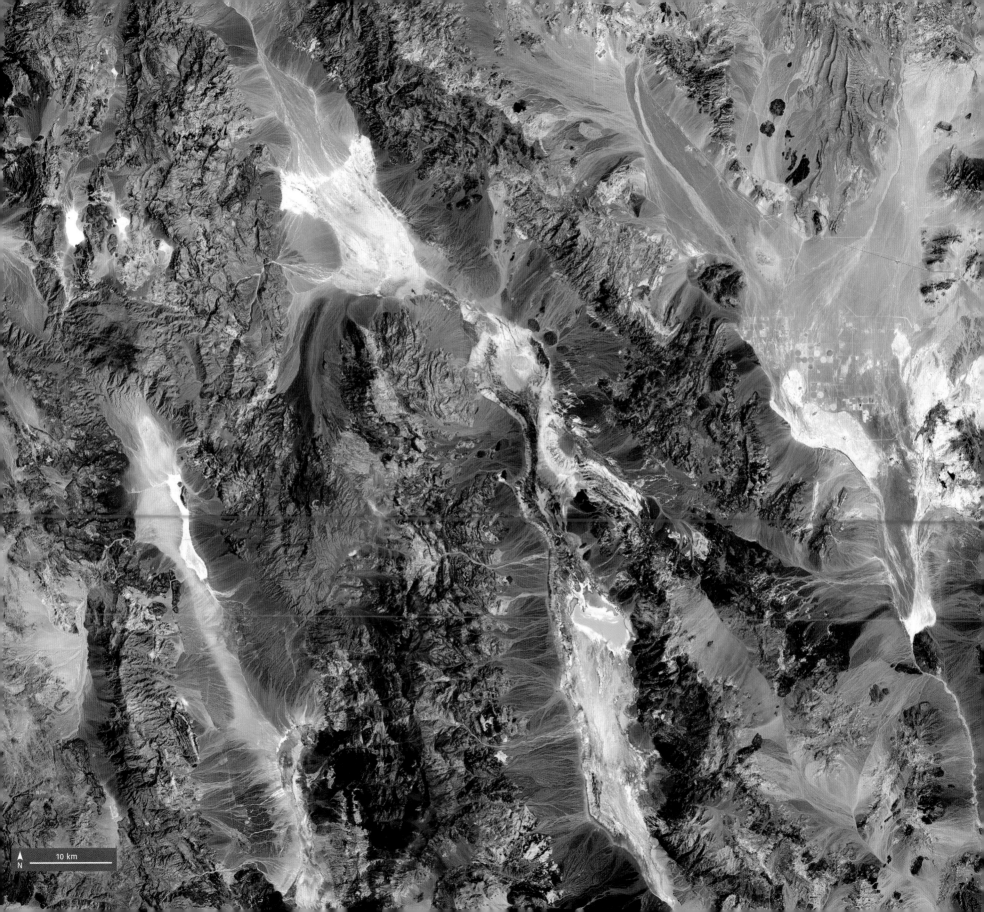

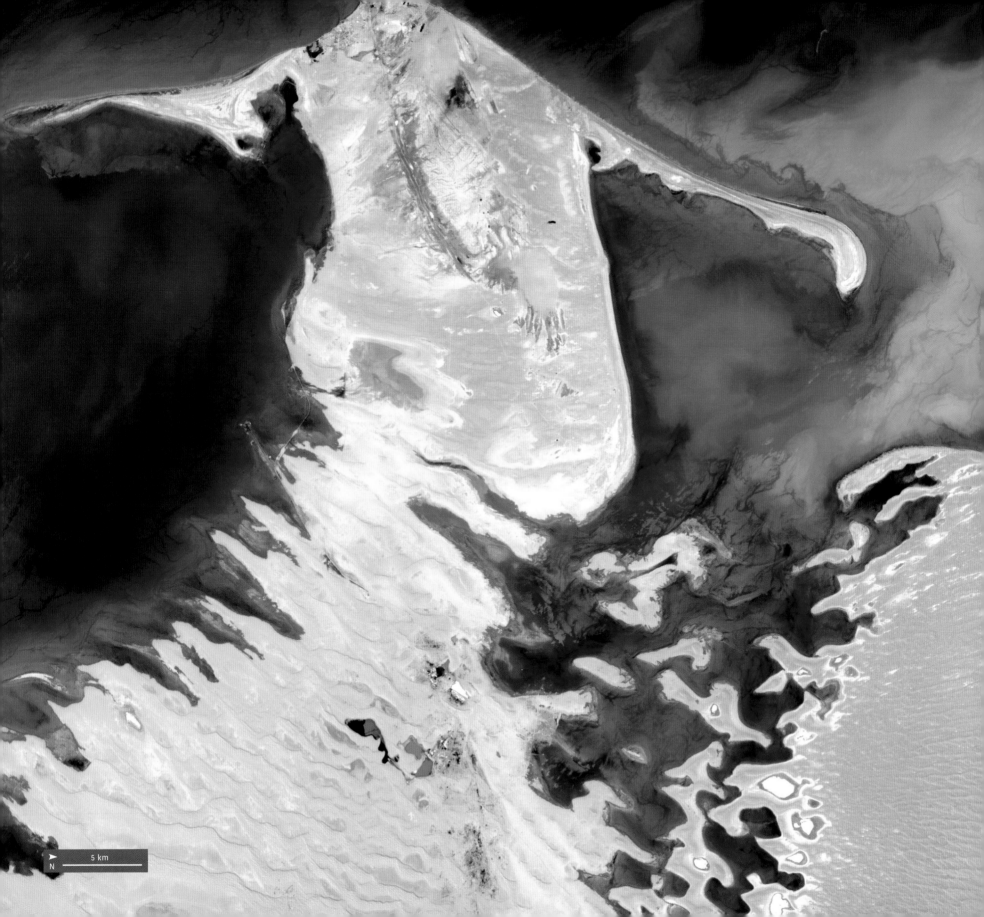

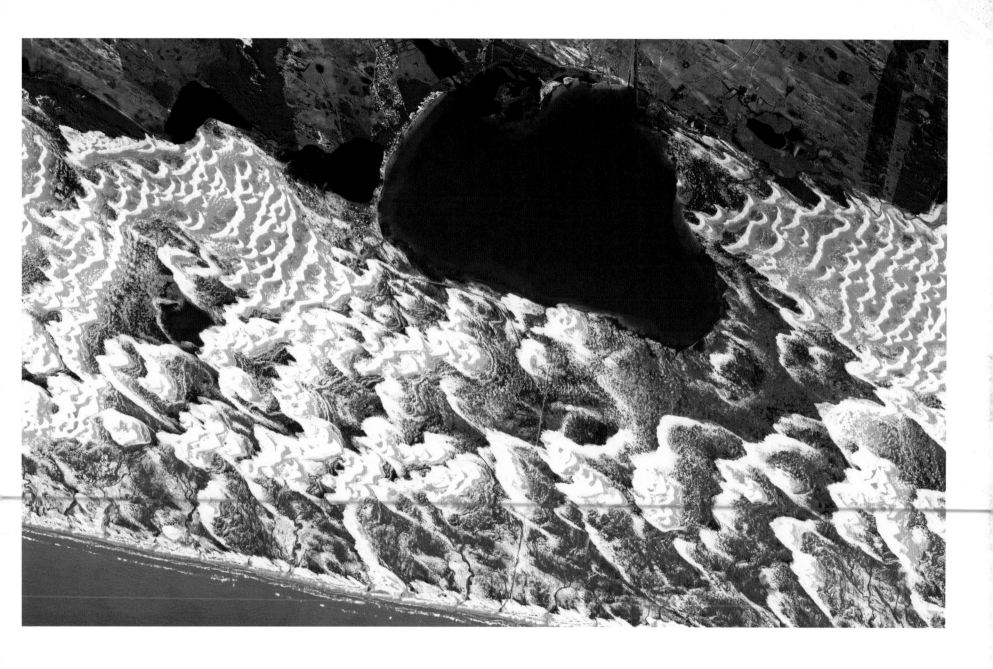

OPPOSITE: The strange, arrow-head shape of Turkmenistan's Cheleken Peninsula (left) points into the Caspian Sea, which at 1.4 million square miles (3.6 million square km), is the largest inland sea (or lake, depending on definitions) on the planet.

ABOVE: Southern Brazil's Lagoa dos Patos is protected from the sea by a sandbar five miles wide, shown here on the Atlantic side. Dunes dominate the sandbar, their crescents opening towards the dominant winds.

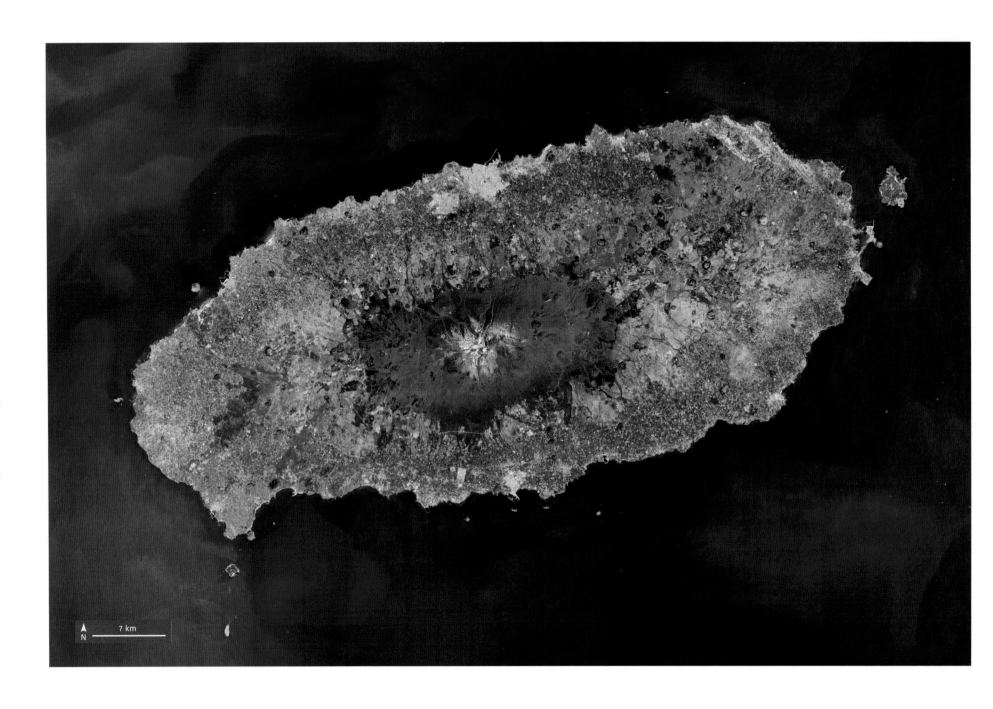

7 km
N

ABOVE: Jeju is the largest
of Korea's islands. It is
volcanic in origin, and the
peak of Mount Hallasan
is clearly visible here,
surrounded by dark lava
plains. The island is thought
to be 2 million years old.

OPPOSITE: The fault line leading
right from the patch of green
marks the edge of B-44, an
Antarctic iceberg of 72 square
miles (186 square km) that
calved from Pine Island Glacier
in September 2017. A month
later, it had disintegrated.

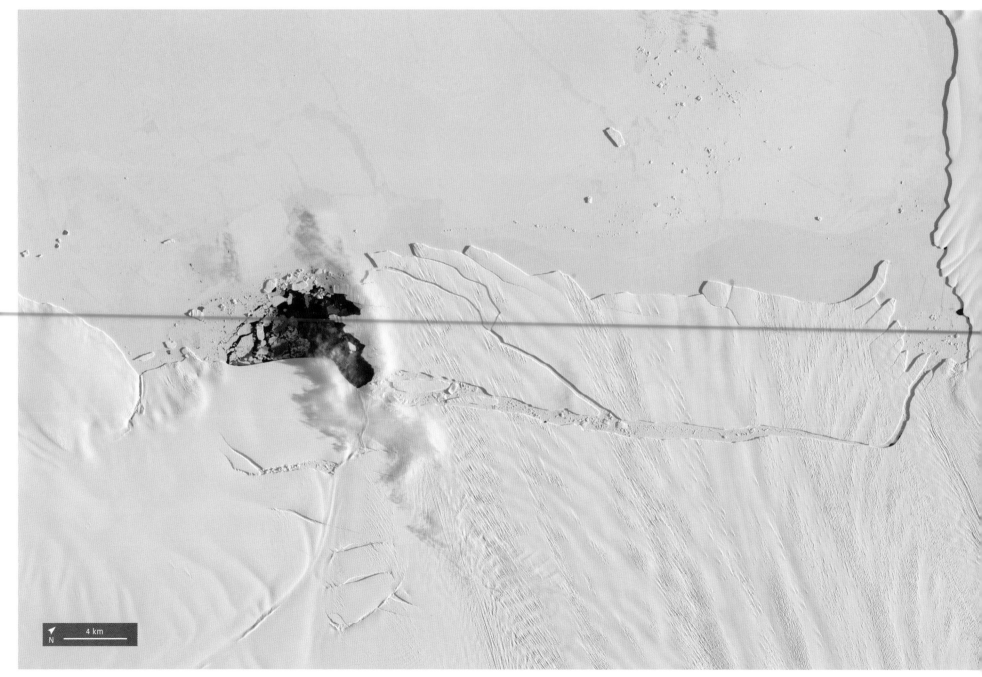

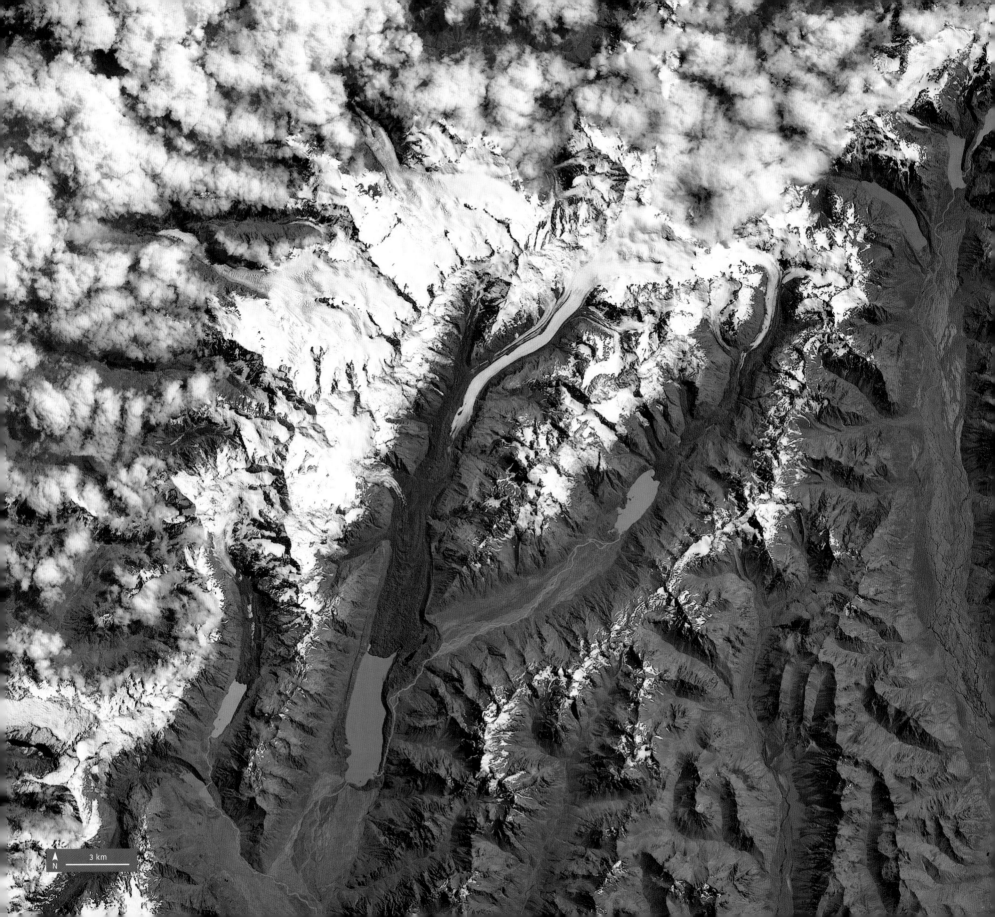

OPPOSITE: The lake just left of centre towards the bottom of this image – it looks a little like the rear view of a seated cat – is New Zealand's Tasman Lake. It has grown as a result of the shrinking of Tasman Glacier, which has decreased in size by several miles in the last 27 years.

RIGHT: These star-shaped dunes, rising up to 490 feet (150m) can be found in Erg Chebbi, an orange sea of dunes located in southeastern Morocco. The surrounding geology prevents the water table rising here, so the dunes remain dry in contrast to the neighbouring land.

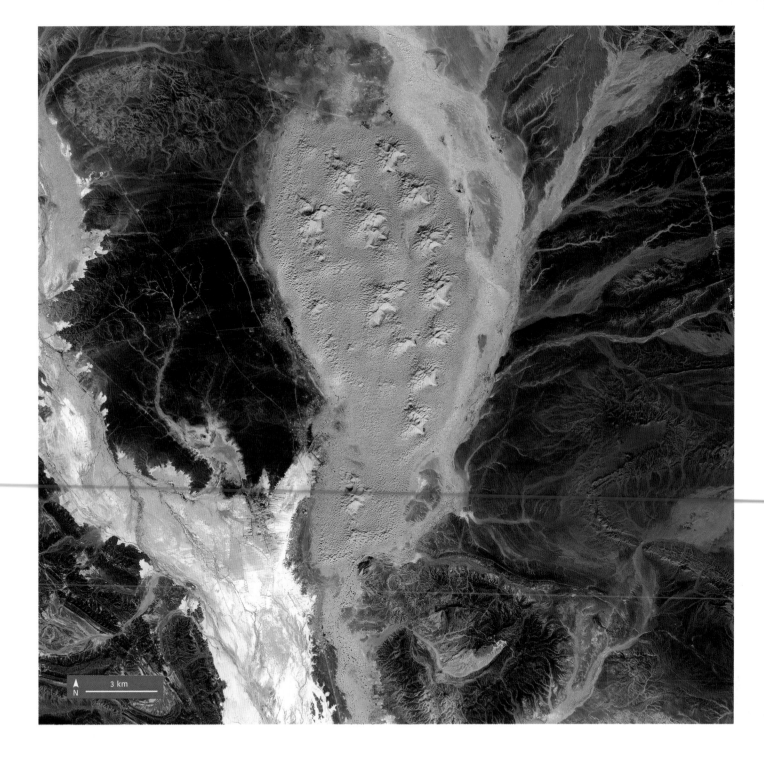

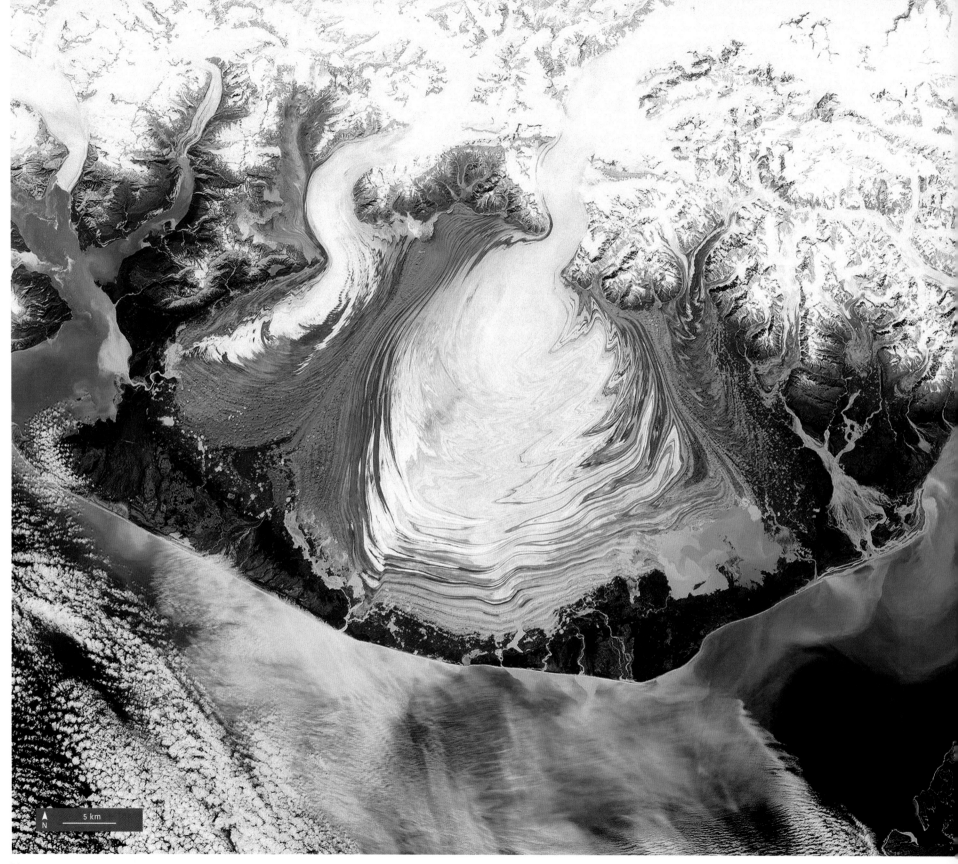

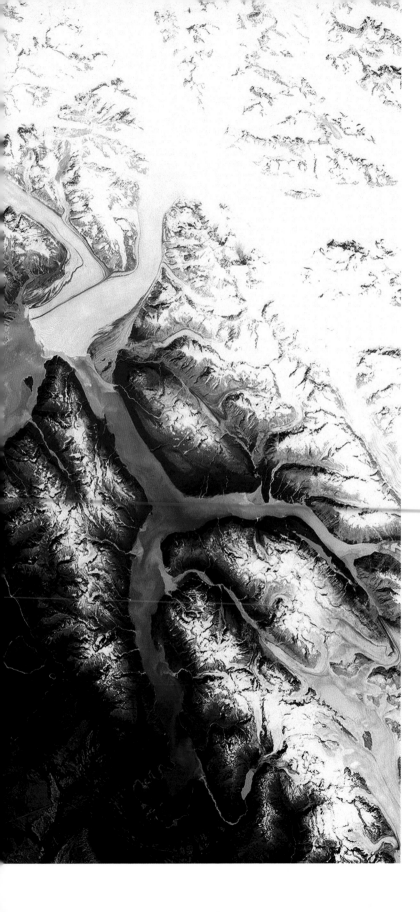

The huge glacier spreading over the plains and down almost towards the sea, dominating this image, is Alaska's Malaspina Glacier. It is the largest of its type – a piedmont glacier – in the world. Around 40 miles (64km) wide and almost 30 miles (48km) long, it is more than a third of a mile (500m) thick in places. Like most glaciers, it is melting swiftly.

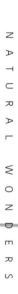

ABOVE: These black, swirling lines off the coast of Brazil are not sediment, but phytoplankton, microscopic plant life that drifts in water currents. The city of Caraguatatuba nestles in the bay at bottom left.

OPPOSITE: The varied light-blue patches in this image show the wide spread of coral reefs around the coast of Fiji's second-largest island, Vanua Levu. The island is thought to have been settled for some 3,000 years.

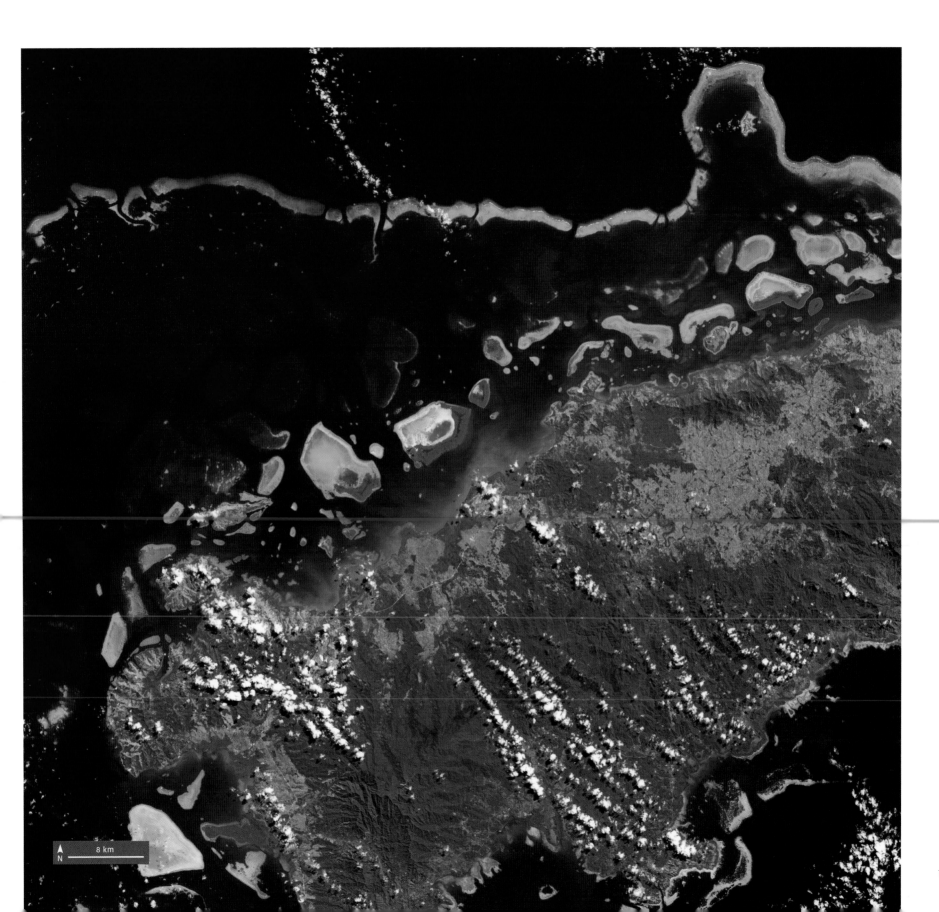

8 km

N

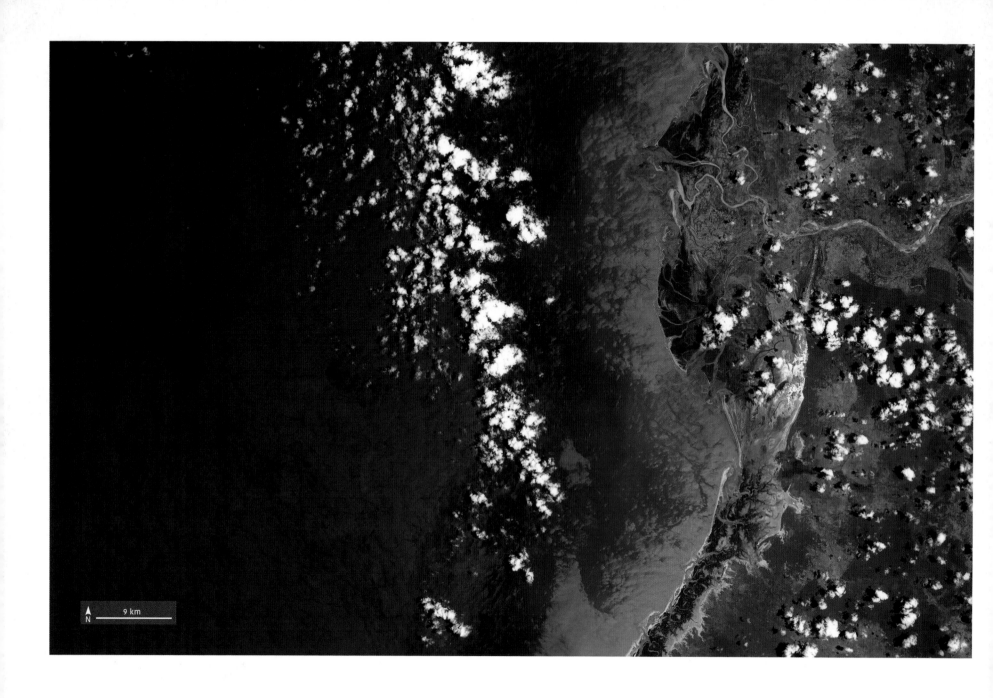

ABOVE: Madagascar's west
coast faces the Mozambique
Channel. The region
contains a wide number
of ecosystems and many
important species, including
Baobab trees and more
than ten species of lemurs
indigenous to the area.

OPPOSITE: Chile's Salar de
Atacama, the large, even-
coloured patch in the lower
portion of this image, is
the world's third-largest
salt plain. The turquoise,
glitch-like spots inside it
are evaporation ponds for
extracting lithium and boron.

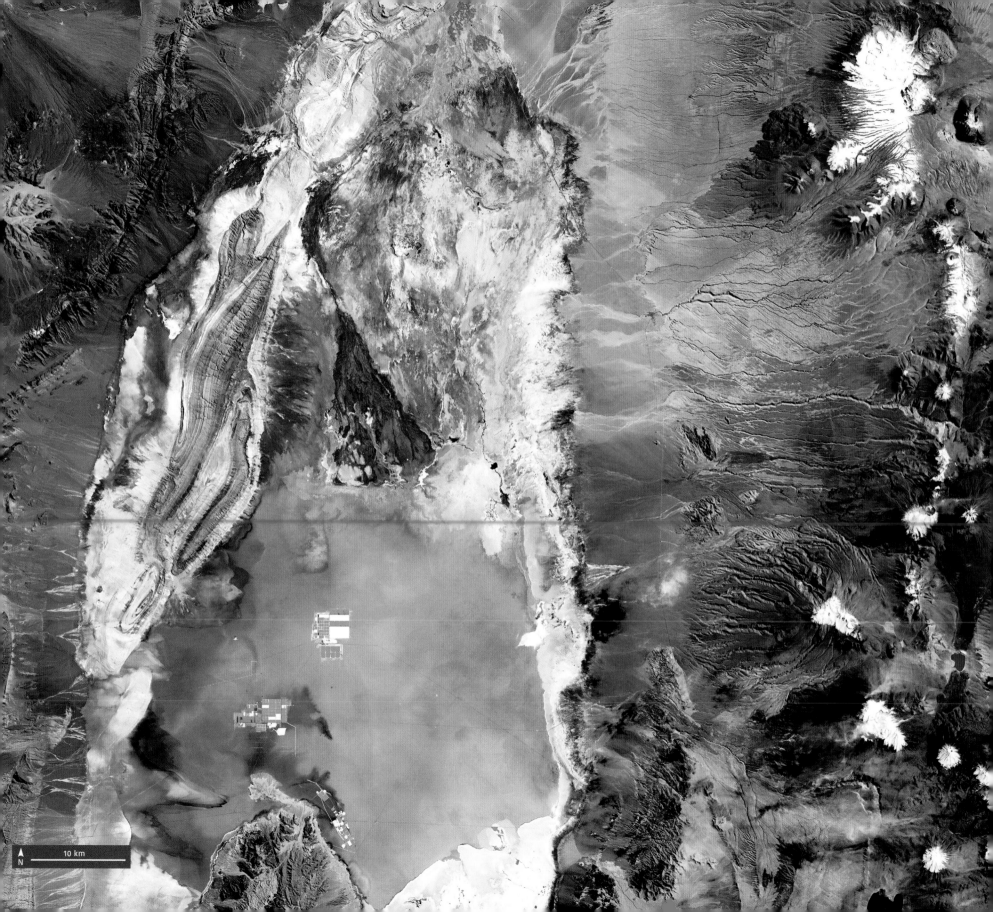

RIGHT: The San Juan River winds through the Navajo Nation in north-western New Mexico. The black spot at the heart of the image is Tsé Bit'a'i, also known as Shiprock, an abrupt mountain rising 1,500 feet (457m) from the plain.

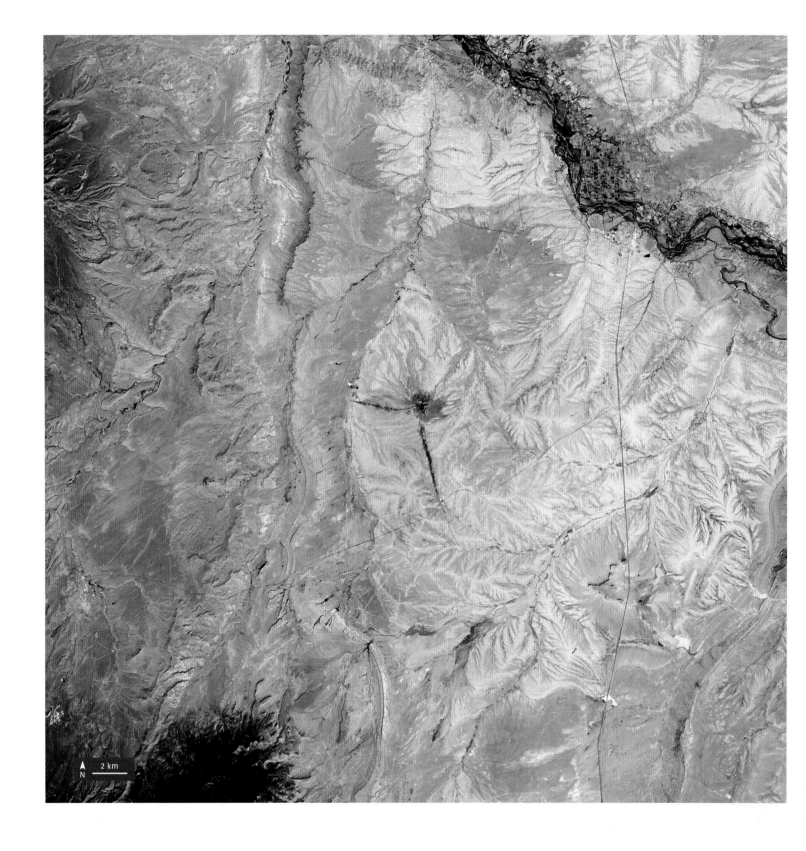

LEFT: The Ojo de Liebra lagoon lies on Mexico's Baja California peninsula. The area around it is part of the El Vizcaíno Biosphere Reserve, which shelters grey whales, migrating waterfowl, and Sonora Desert species.

11 km
N

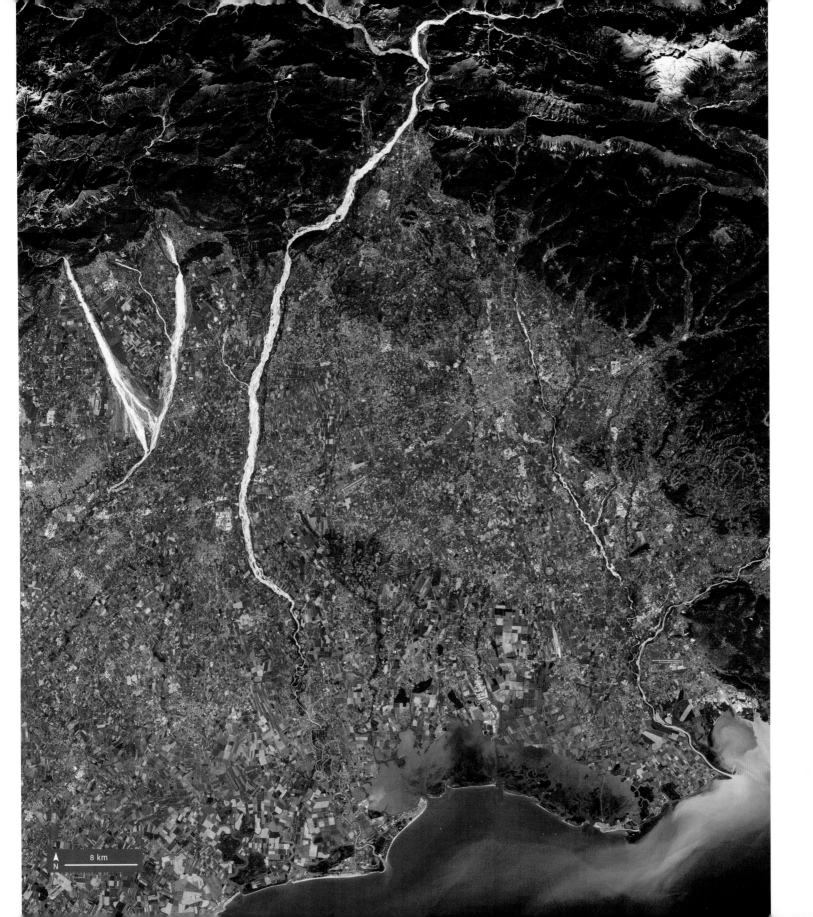

LEFT: The wide, pale gravel river beds of the Cellina, Meduna and Tagliamento rivers (centre image, from left to right) drain mountain run-off down over the Italian plains towards the north edge of the Adriatic Sea.

8 km

N

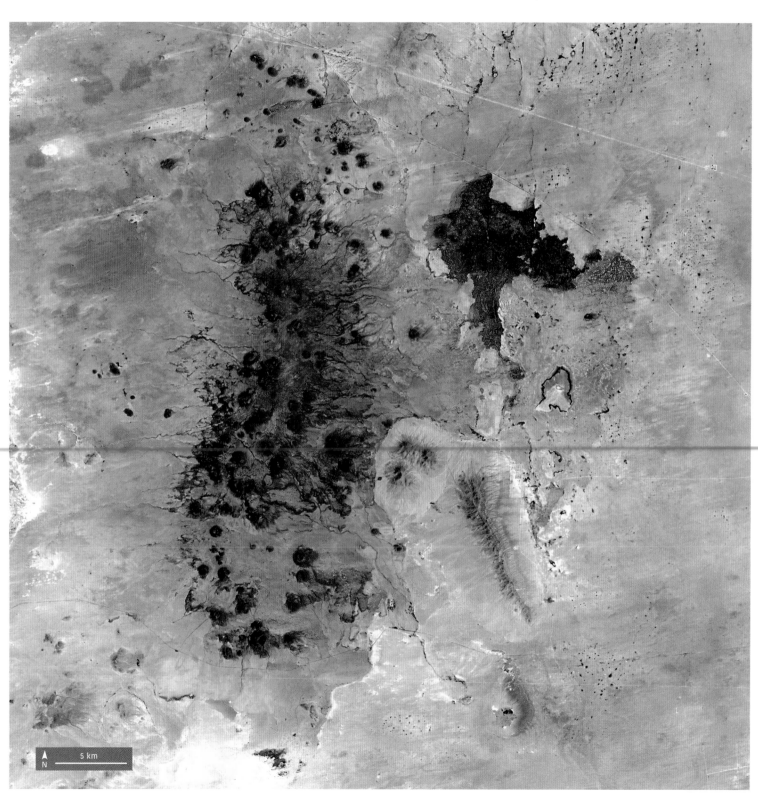

RIGHT: The Potrillo volcanic field, located south of Las Cruces in New Mexico, USA, is a tectonically active area made up of solidified lava. In 2017, the site was used by researchers to test out instruments that could be used by astronauts to study volcanic features on Mars.

5 km

N

RIGHT: Mount Erebus, at the centre of this image, is the world's southernmost active volcano. It sits on Ross Island, just off western Antarctica. The Earth's crust is thin here, and Erebus has had a lake of lava since 1972.

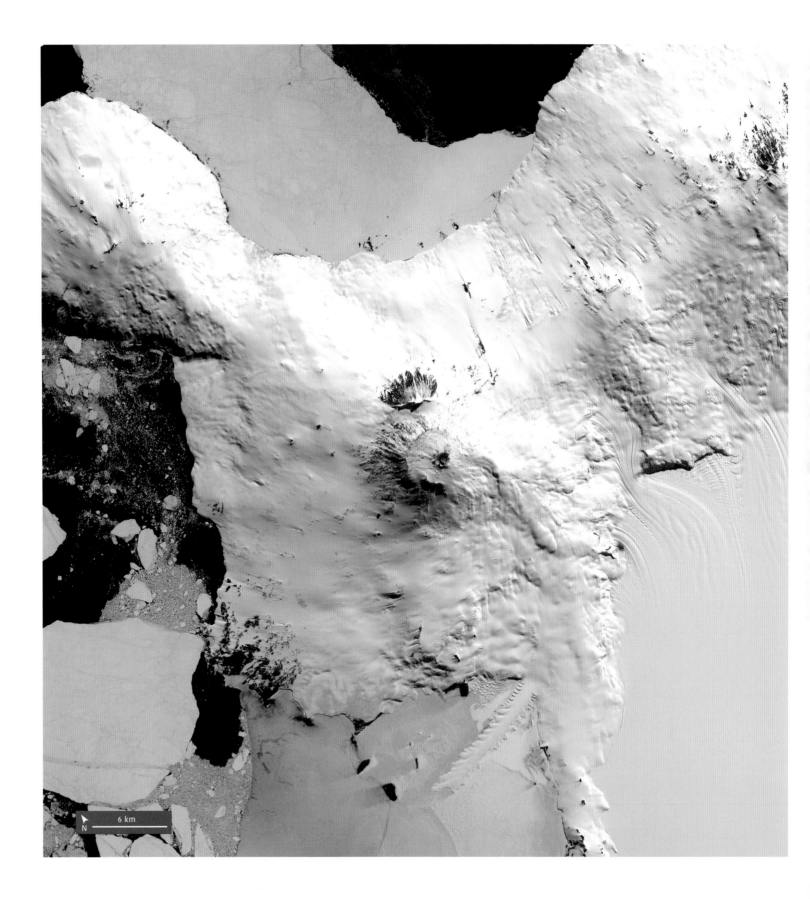

6 km

N

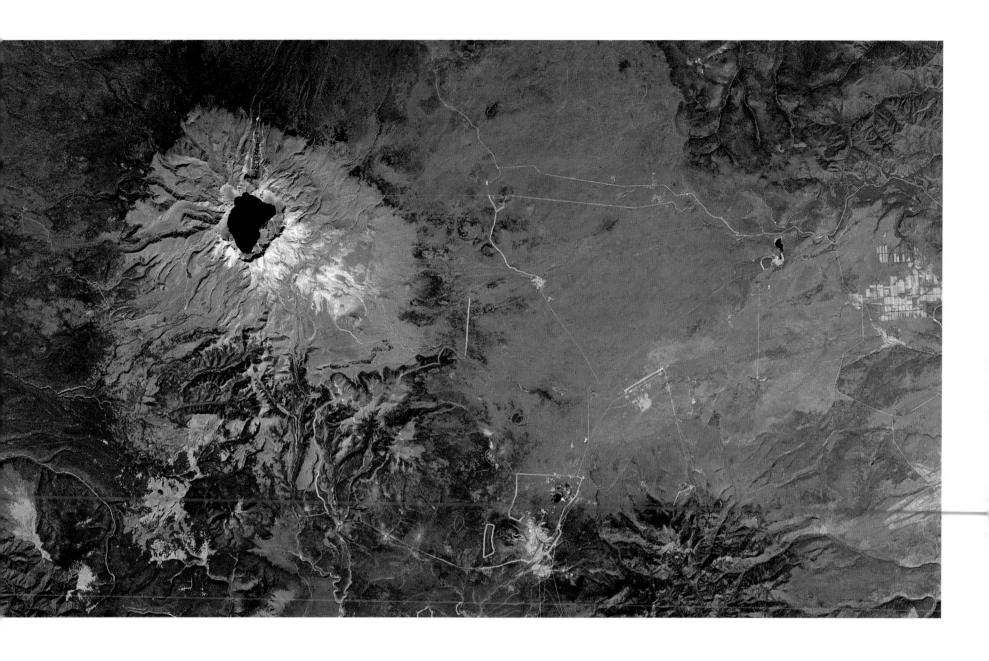

ABOVE: Mount Paektu, on the border between China and North Korea, is towards the top left of this image. Heaven Lake, which sits in its caldera, is the result of a colossal eruption just over a thousand years ago.

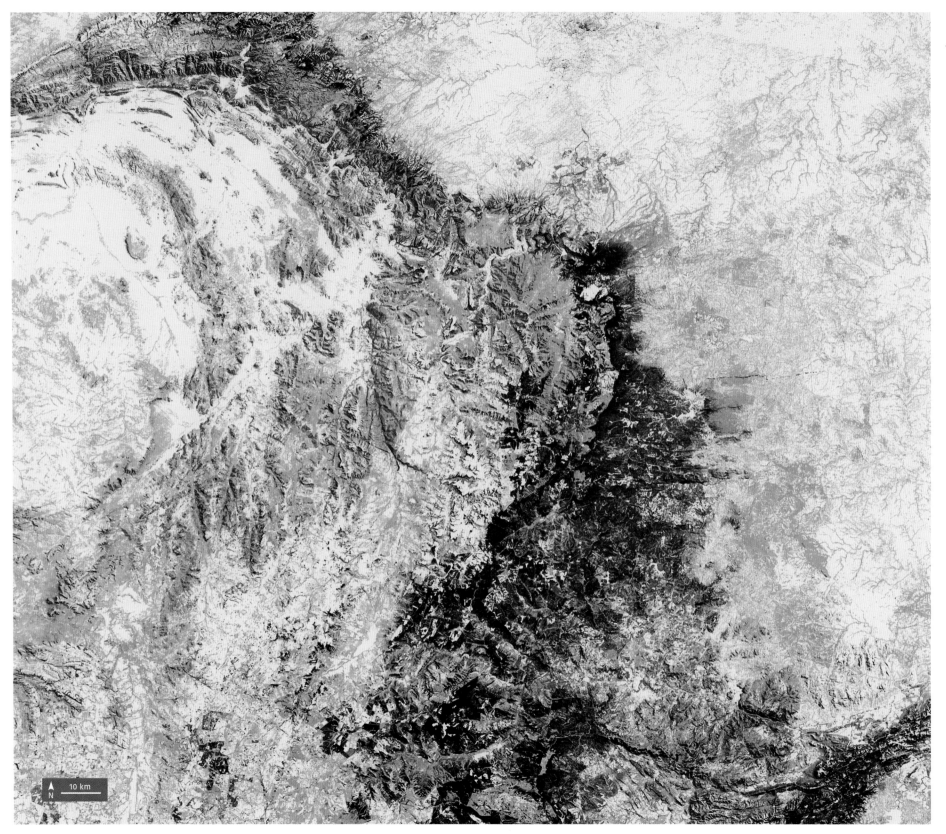

OPPOSITE: South Africa's Mpumalanga province is a major source of commercial logging and timber exploitation. The trees farmed here, along the base of the Great Escarpment, are mostly eucalyptus and pine.

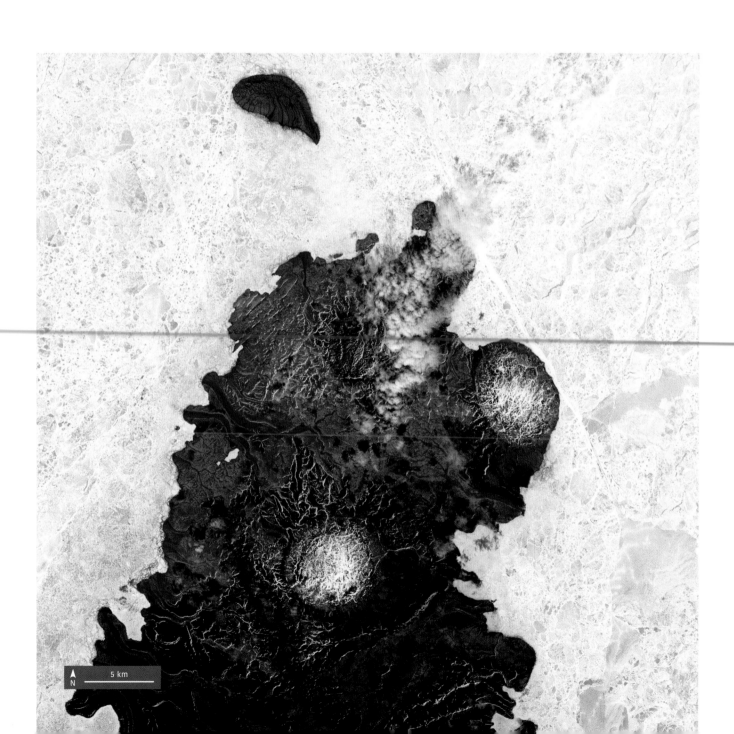

RIGHT: These white crater-like formations on Canada's Melville Island are salt domes, or diapirs. Salt domes form when overlying sediment pushes the salt beneath it together. Over time and under the right conditions, the dome pierces the surface.

5 km

N

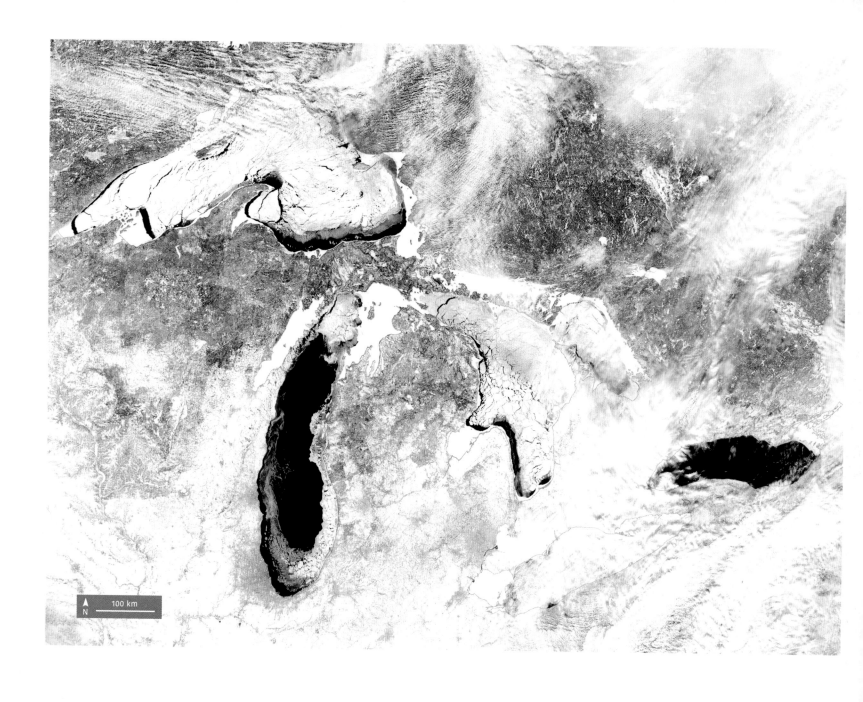

100 km
N

ABOVE: In mid-February 2014, North America's Great Lakes were 88 per cent covered with ice – the highest coverage since 1994. Lake Erie at the south of this image can scarcely be made out against the snow-covered surroundings.

OPPOSITE: Pakistan's Indus River Delta empties into the Arabian Sea. Extensive irrigation up-river has been steadily decreasing the water in the area for decades, bringing ecological collapse and rising depopulation.

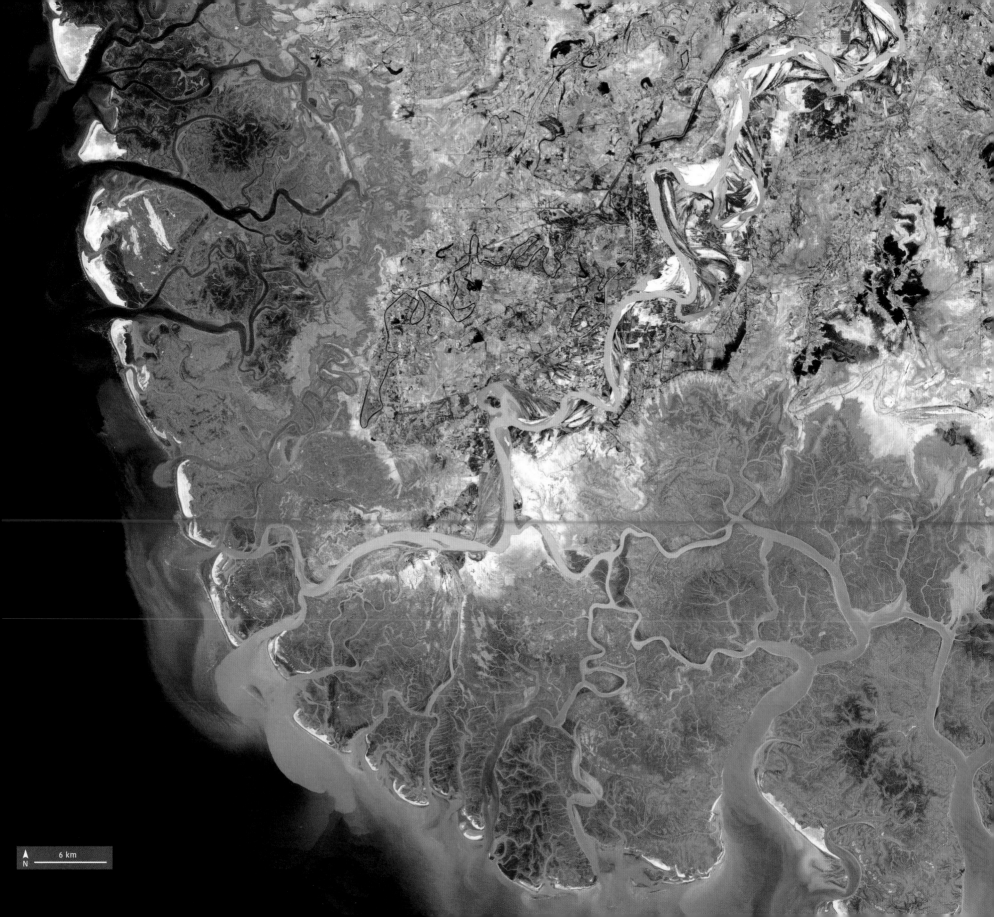

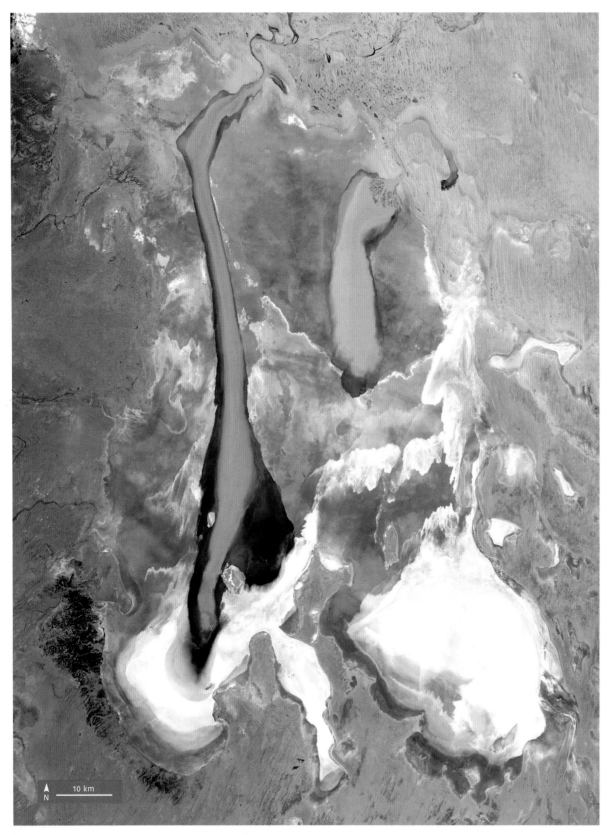

10 km
N

LEFT: Australia's Lake Eyre is shallow at best, and often completely dry. Extensive rains in northern Australia in 2009 allowed the lake to partially fill. Sediments and algae give the water its range of interesting colours.

OPPOSITE: The Senegal River curls around the dark green expanse of the Djoudj National Bird Sanctuary as it turns south to head to the ocean. It provides a vital respite for over 400 bird species migrating across the Sahara.

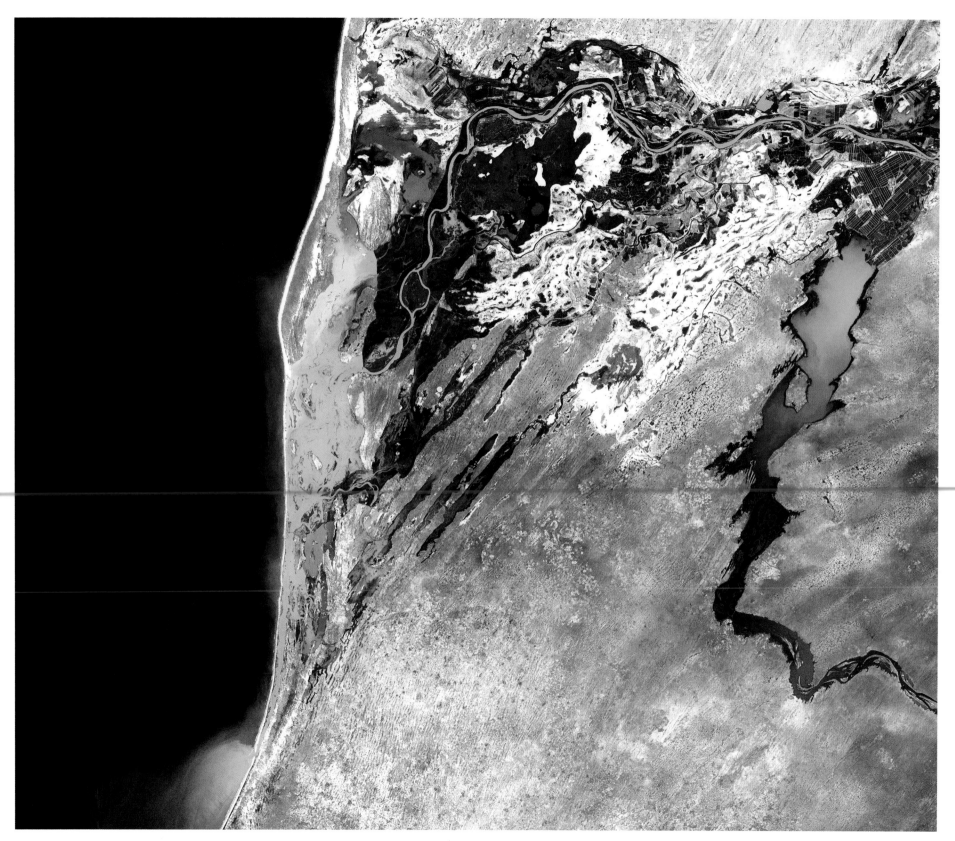

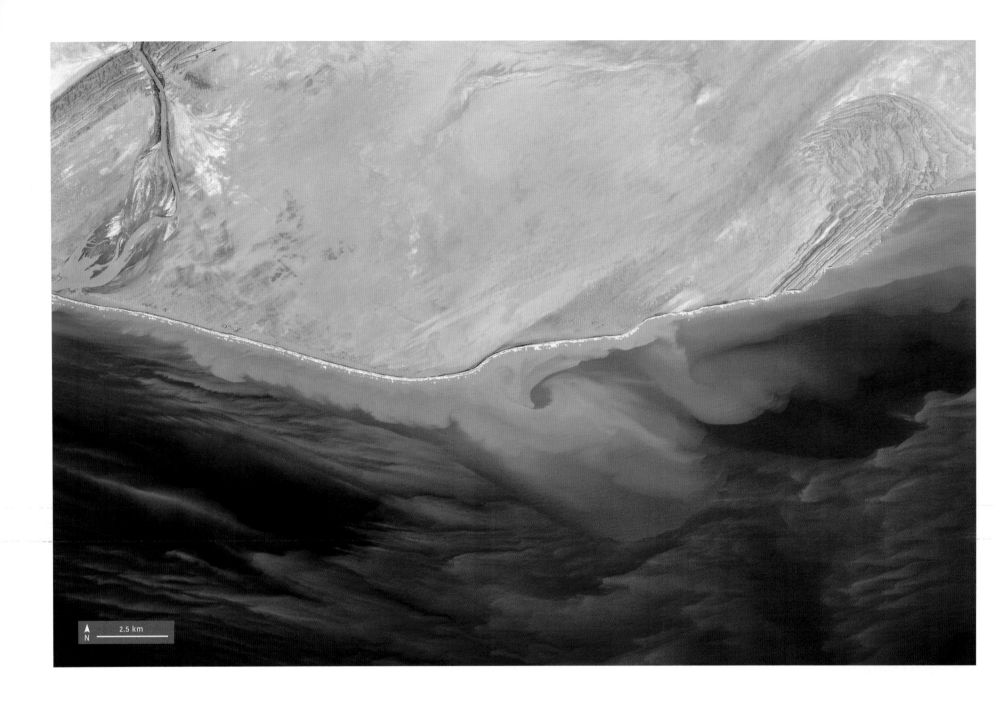

A 2.5 km
N

ABOVE: Sediment flooded along Pakistan's Makran Coast and out into the Arabian Sea in May 2017, after unusual rains swelled the waters of the Hingol River, visible curving around the top-left corner of this image.

OPPOSITE: The Whitsunday Islands separate the Great Barrier Reef from mainland Australia. The very white beach curving near the image's centre is Whitsunday Island's Whitehaven Beach, which consists of almost pure silica.

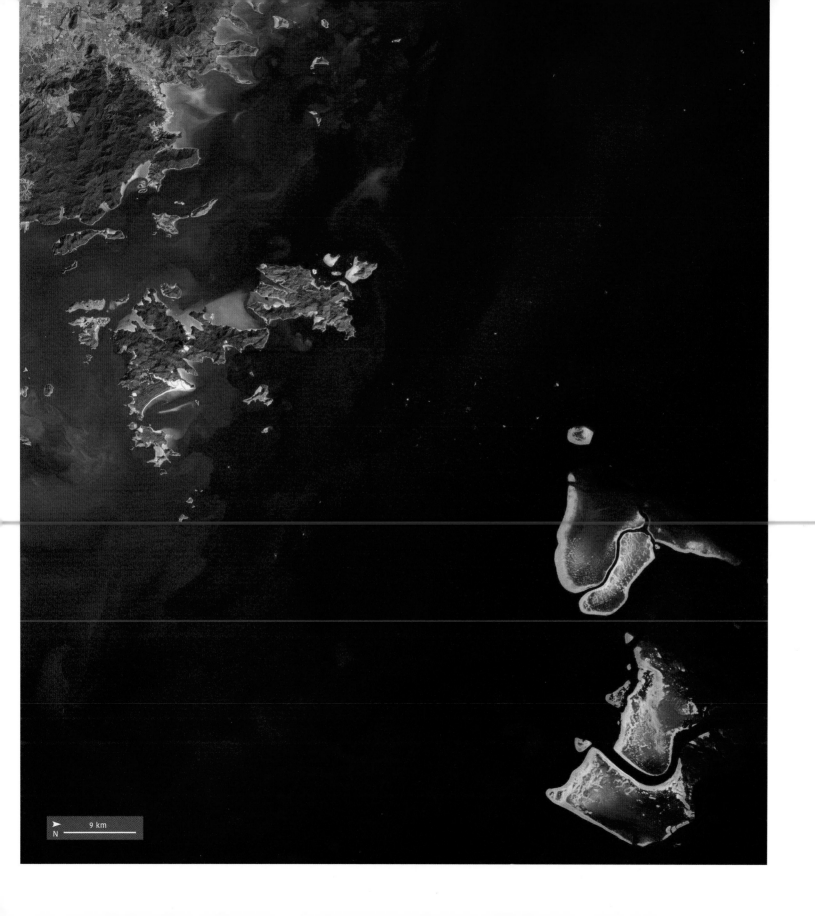

9 km

N

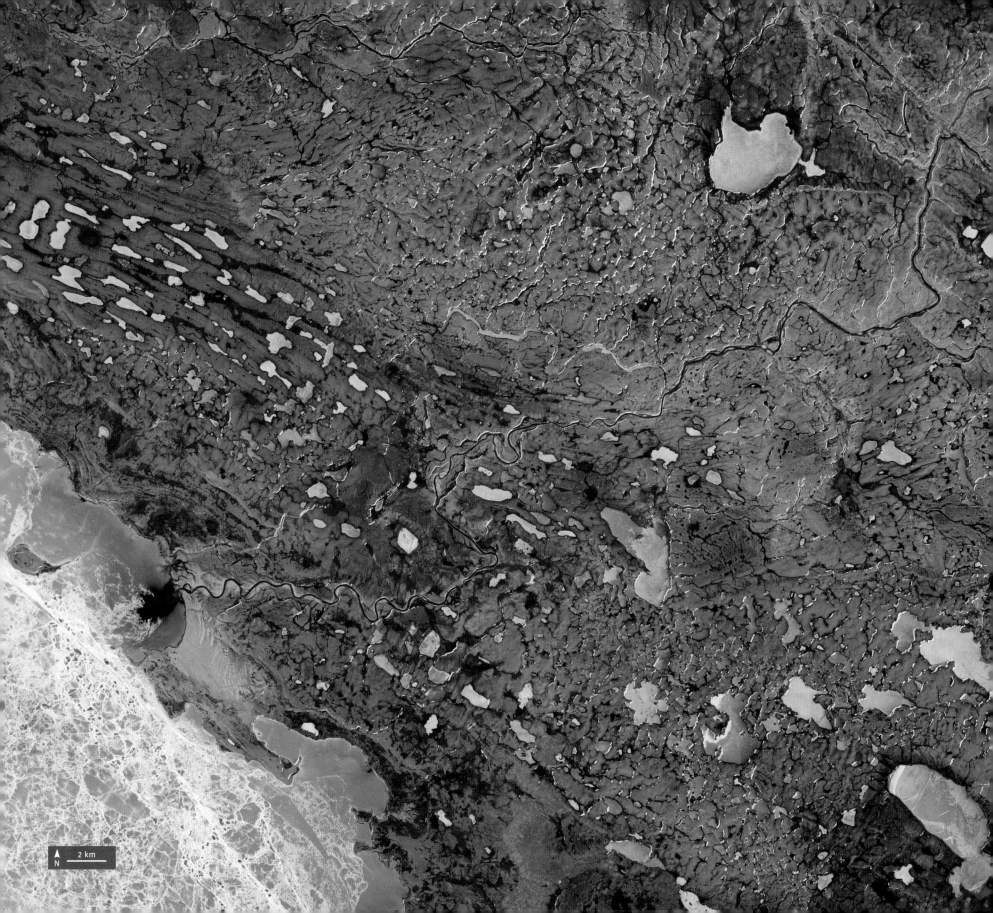

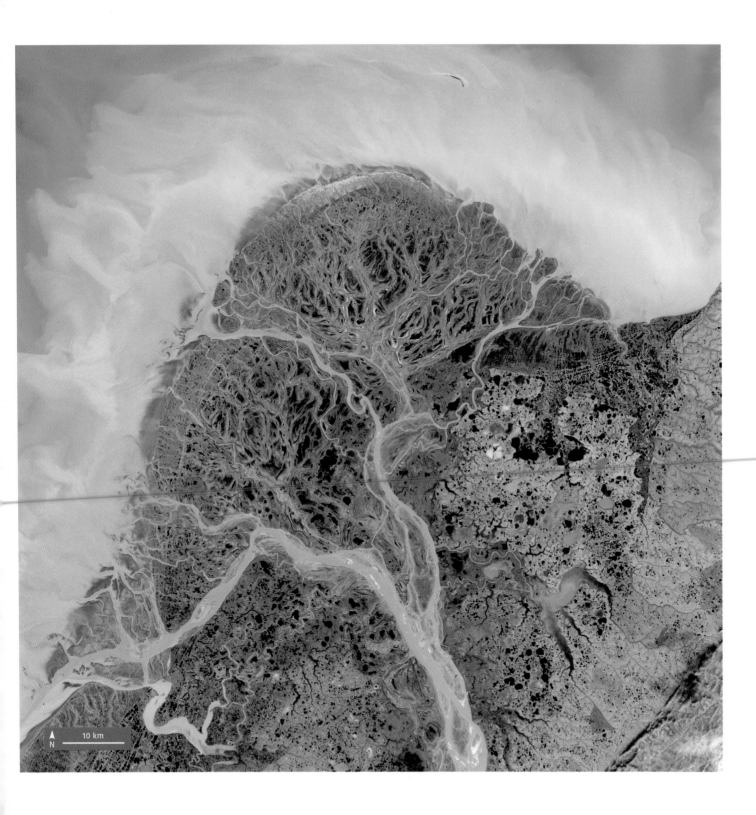

FAR LEFT: The fragmented landscape of Victoria Island, Canada, shows the results of glaciation. The Kugaluk River meanders across the plain in this image, opening onto Penny Bay, where its dark water shows in the ice.

LEFT: Alaska's Yukon River Delta opens onto the Bering Sea. This is a natural-colour image, highlighting the meandering striations of the sediment-laden river and the dark pools and lakes it has formed.

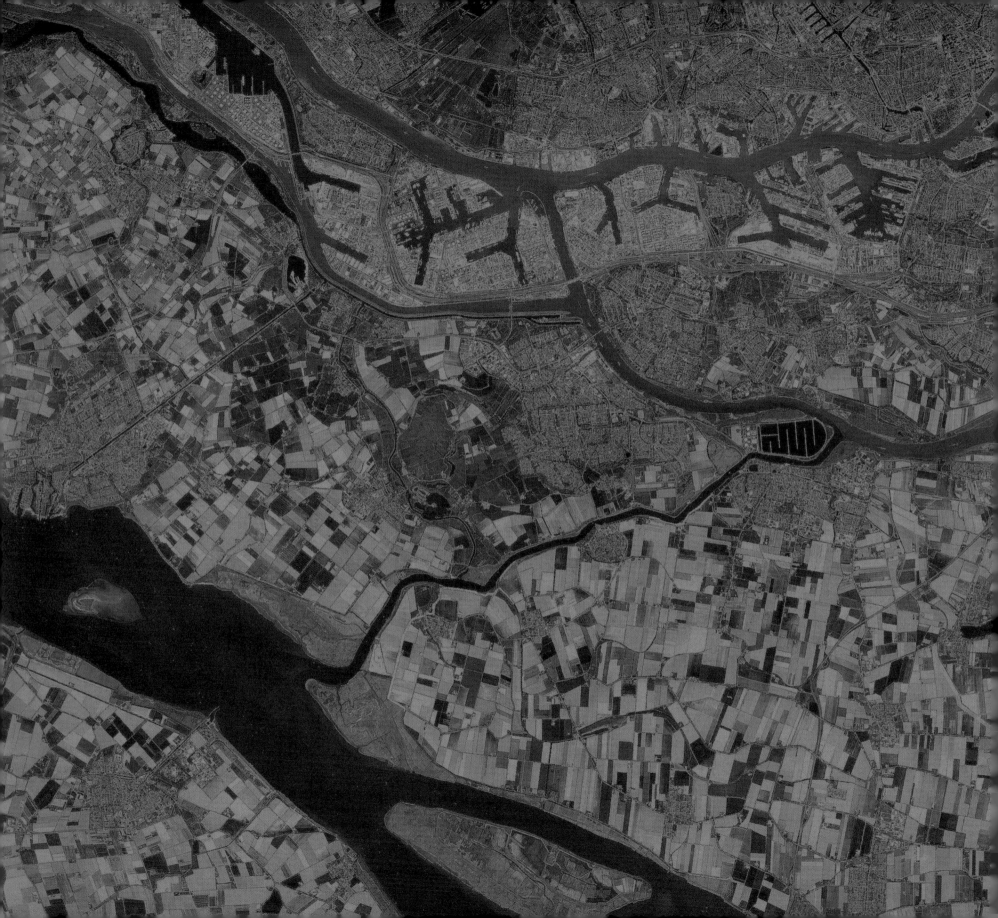

HUMAN
LANDSCAPES

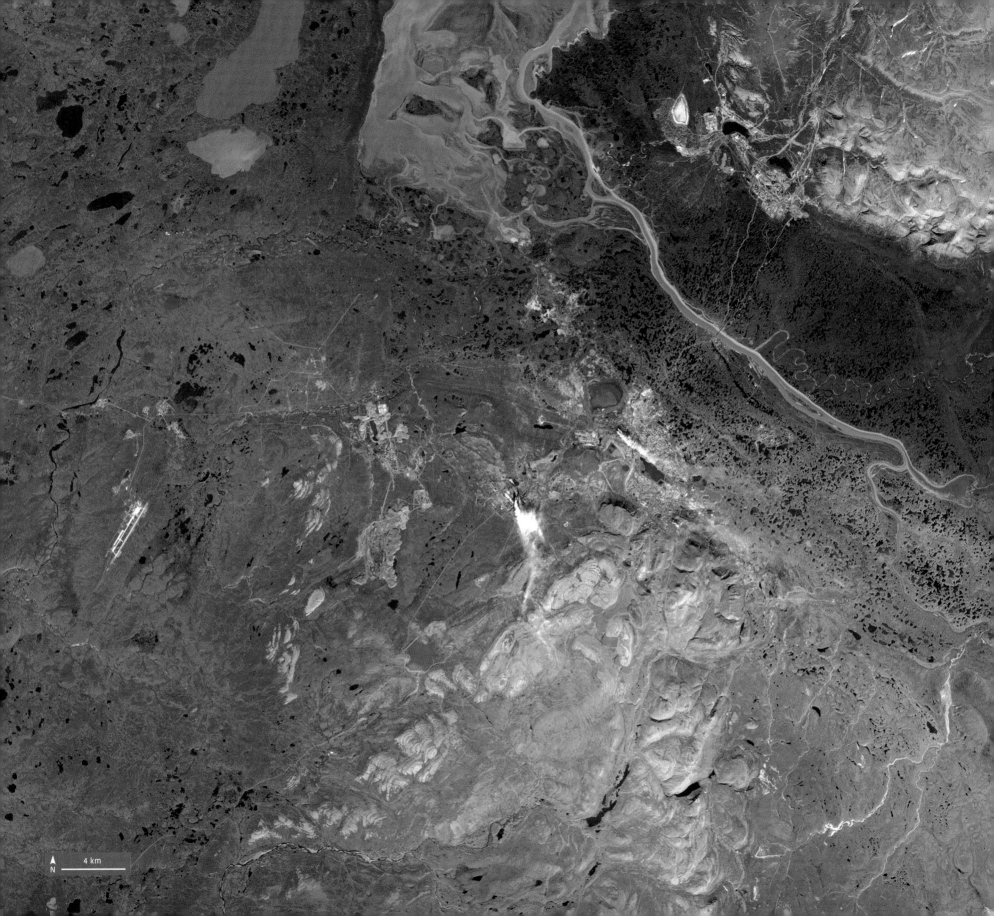

OPPOSITE: The red spot towards
the bottom of this image
is Tailings Pond, below the
Daldykan river in Siberia, Russia,
which turned blood red in 2016.
This dramatic hue is thought to
be caused by waste materials
from a nearby metal plant.

BELOW: The development of
oil fires, 29 May to 17 August
2016, in the Qayyarah oil field
near the Tigris river in Iraq.

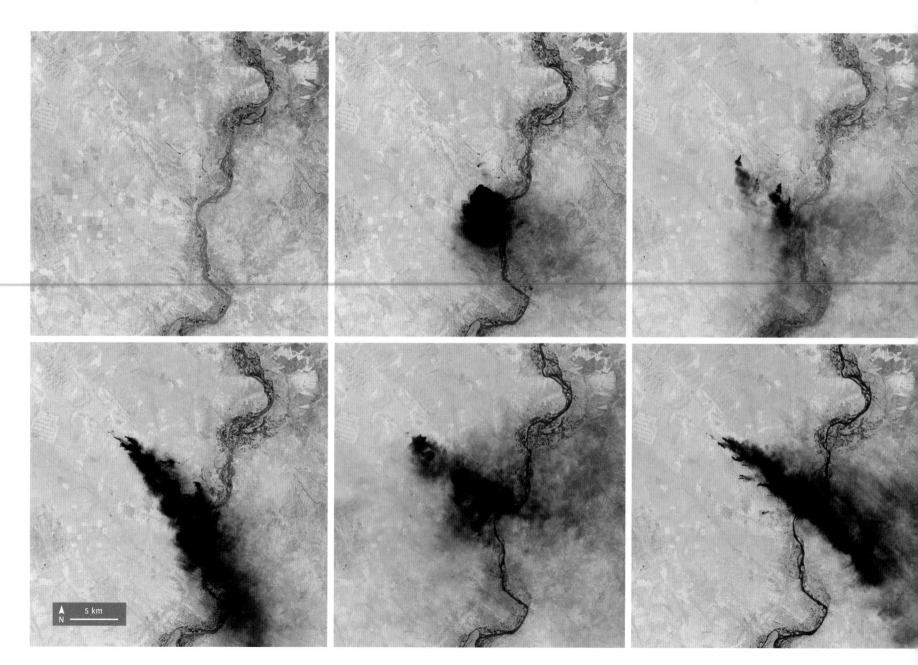

5 km

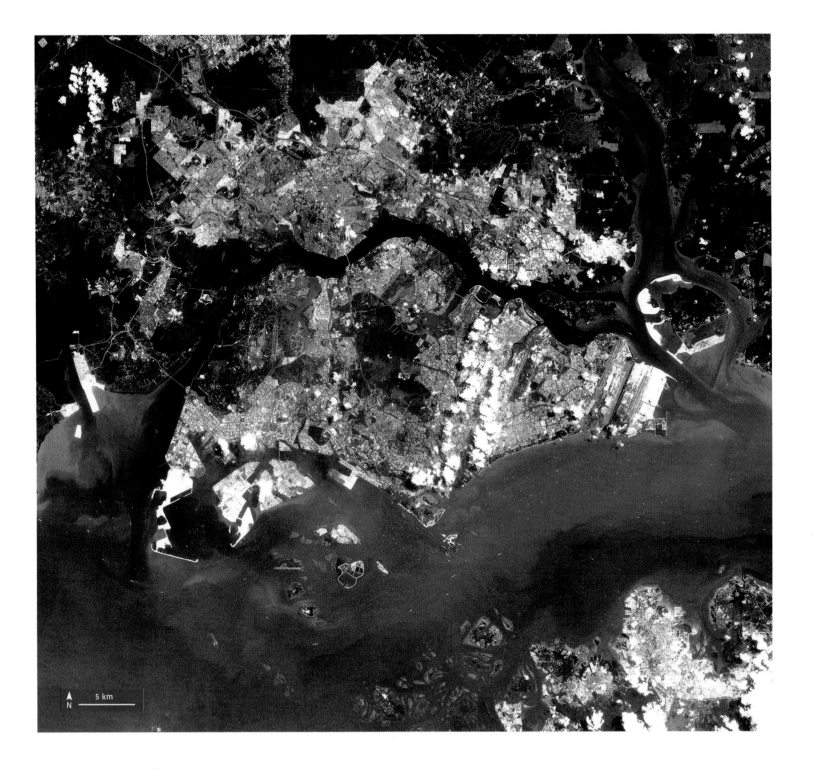

5 km

N

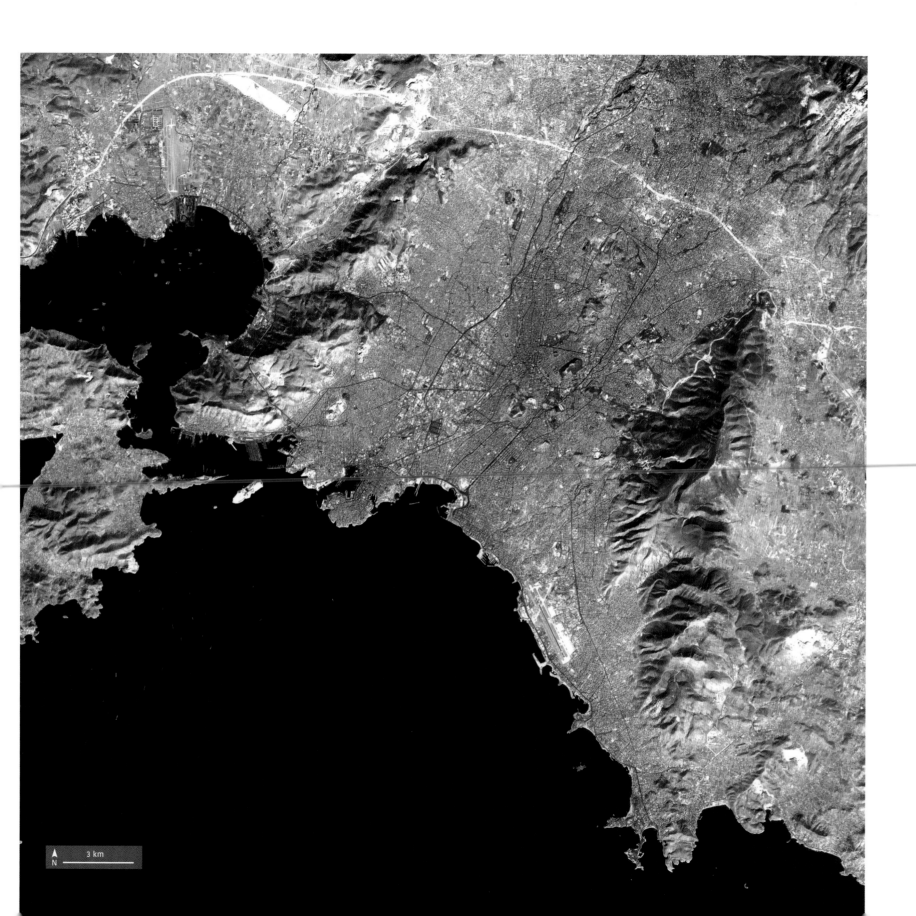

▲
N 3 km

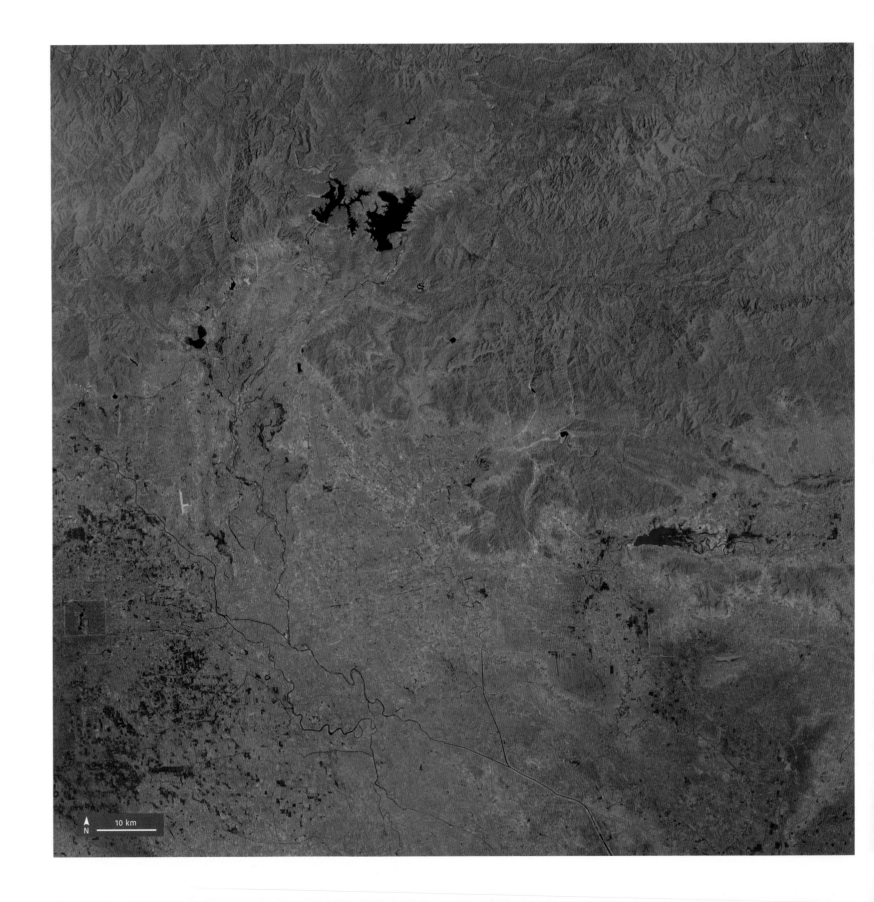

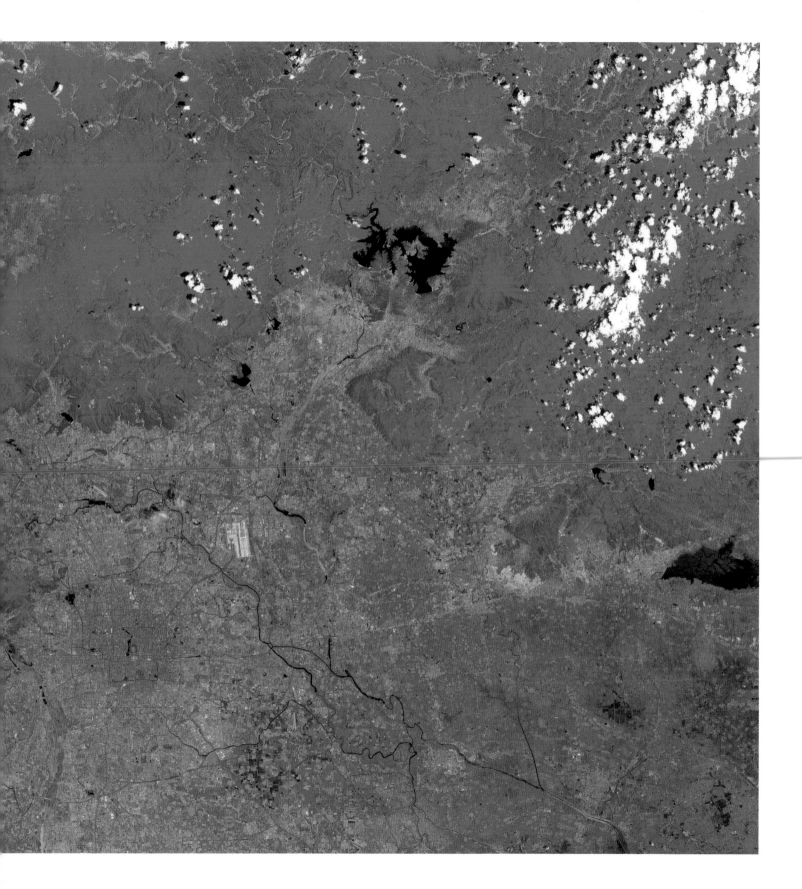

A false-colour image of Beijing city, the capital of China, in 1978 (left) and 2011 (right). The economic reforms that have flourished in China since the 1970s have helped the city grow to over twenty million people. The Taihang Mountains to the northwest have pushed the city south-eastwards, over the coastal plains.

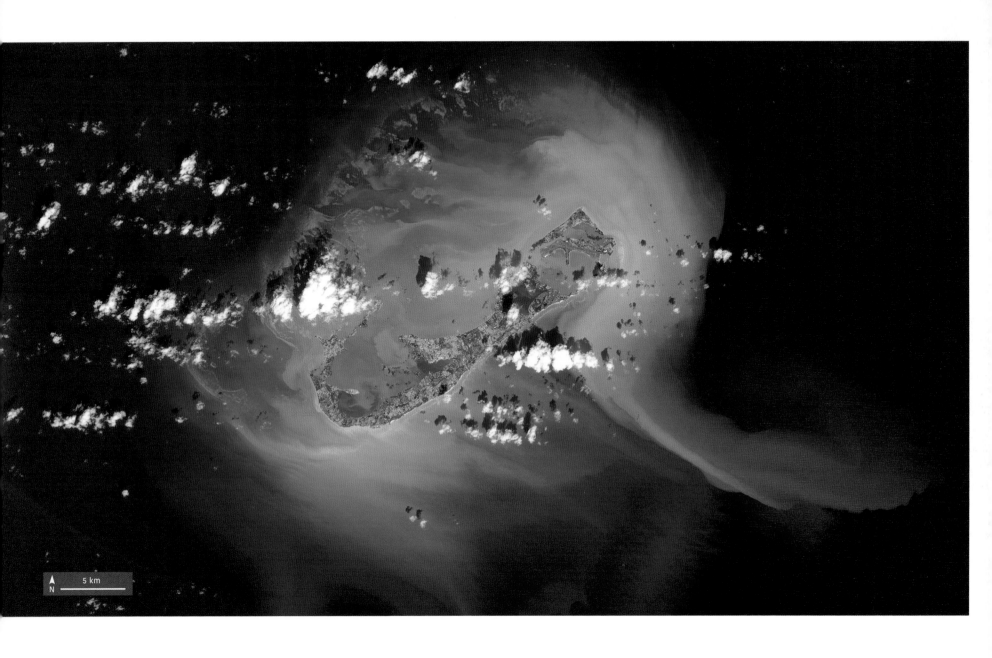

5 km

N

ABOVE: In 2014, Hurricane Gonzalo swept over Bermuda, causing up to $400 million in building damage. Despite its severity, no one was killed. In this image, taken a day later on 18 October, vast plumes of chalk sediment tint the water as far as 20 miles (32km) out.

OPPOSITE: The waters near Vancouver, Canada turned green during August 2016. High concentrations of harmless plankton developed, giving the Strait of Georgia a very unusual hue.

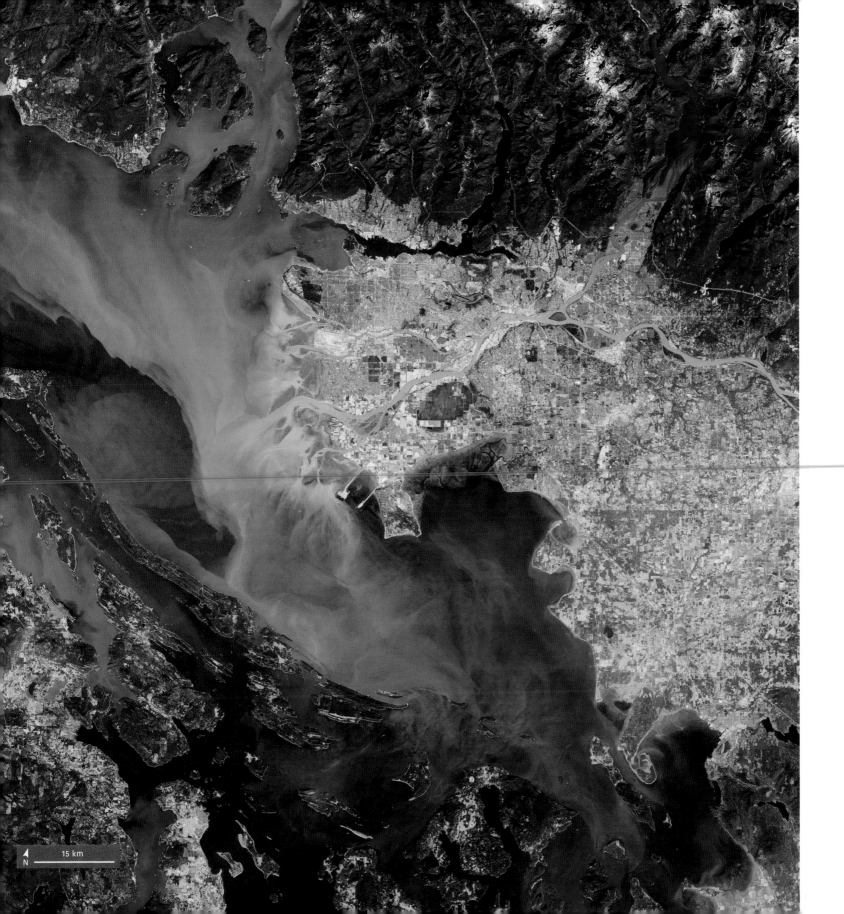

15 km

N

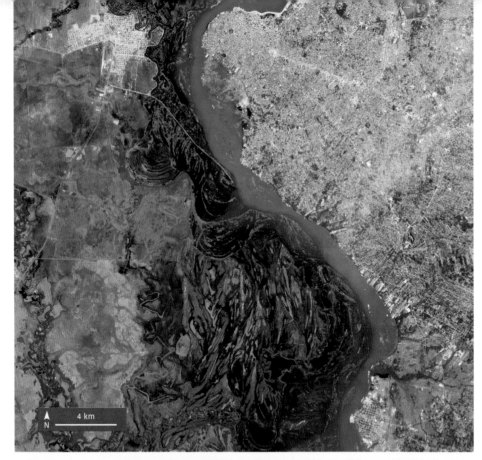

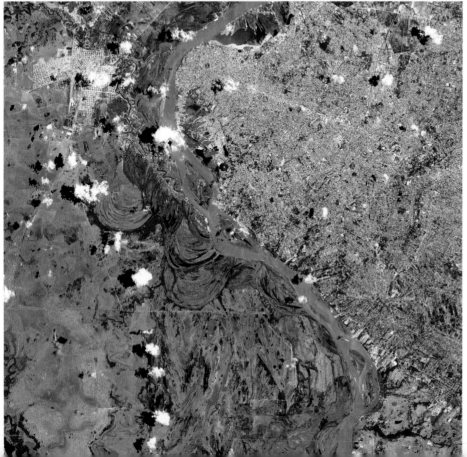

LEFT: In 2016, El Niño brought 25-foot (7.6m) floods to Paraguay's capital, Asunción. The top image shows the swollen Paraguay River and flood-darkened farmland, compared to 2014's normal terrain (below).

OPPOSITE: These oil and gas rigs are in the Bay of Campeche, on the southern edge of the Gulf of Mexico, north of the Mexican state of Tabasco. The plume you see is smoke from excess gas being burned off to reduce pressure.

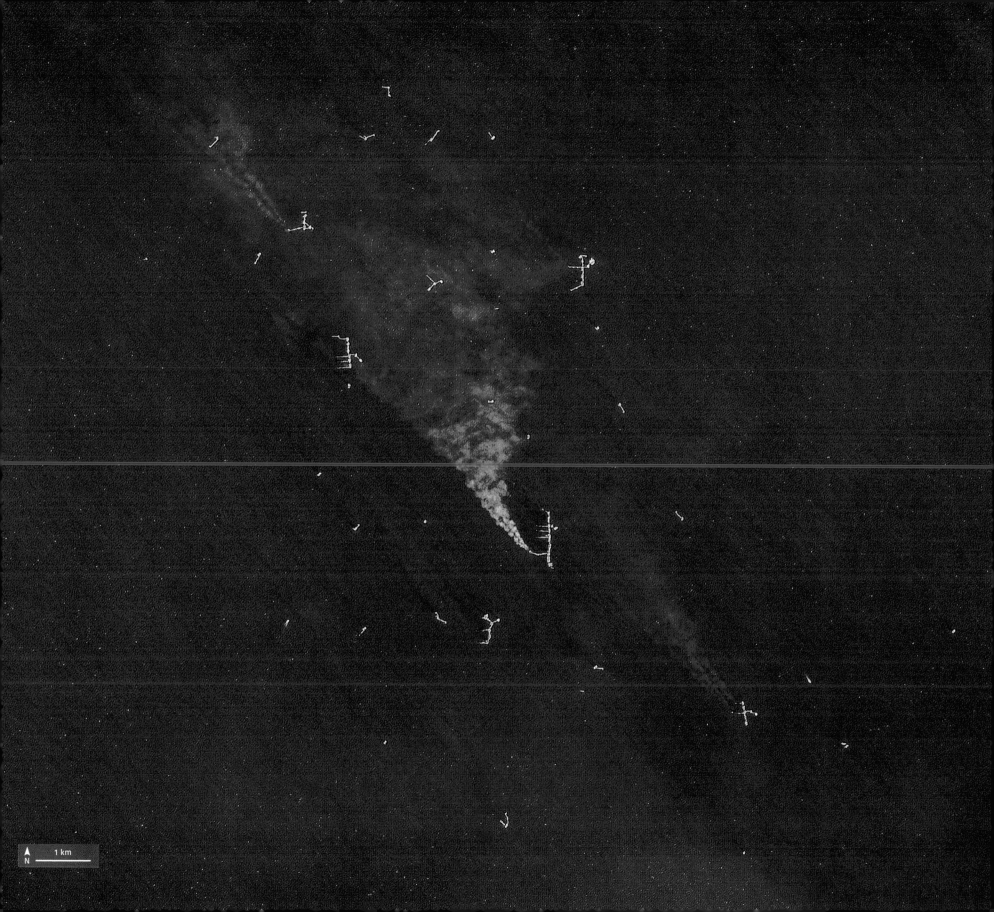

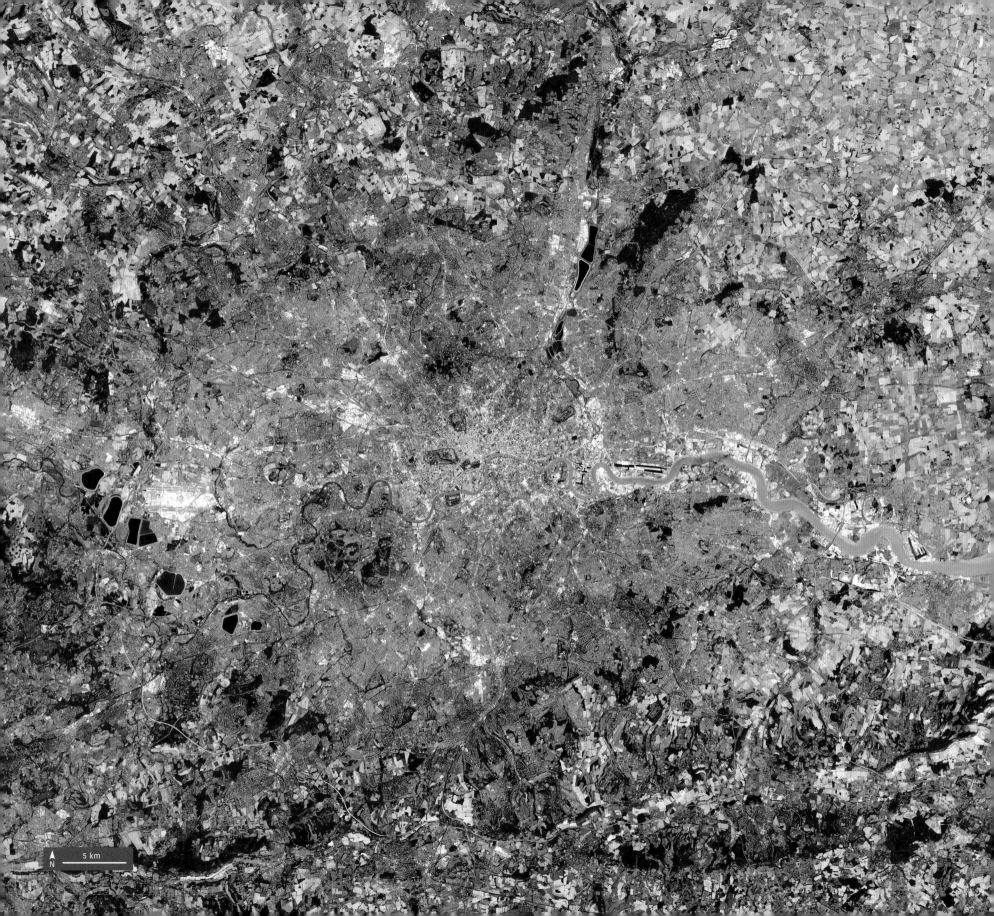

5 km

N

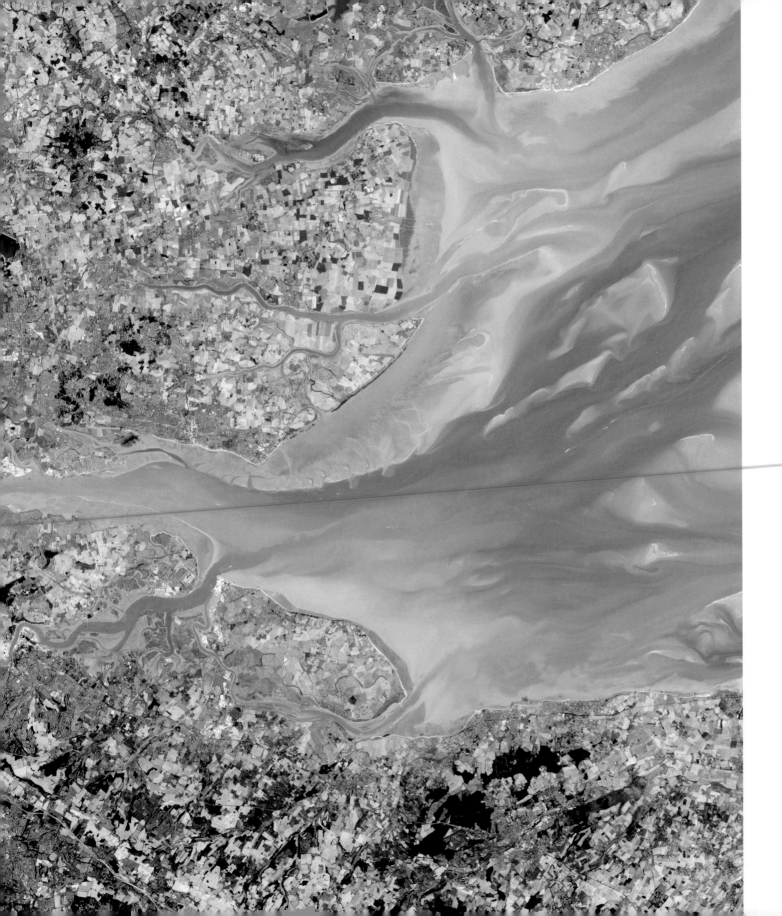

London, the capital city of the United Kingdom, has a population of 8.5 million. A chain of dark blue reservoirs can be seen just to the southwest of Heathrow Airport, and the ancient Epping Forest is clearly visible to the northeast. To the east, the Thames delta opens out past Essex and Kent, and into the North Sea.

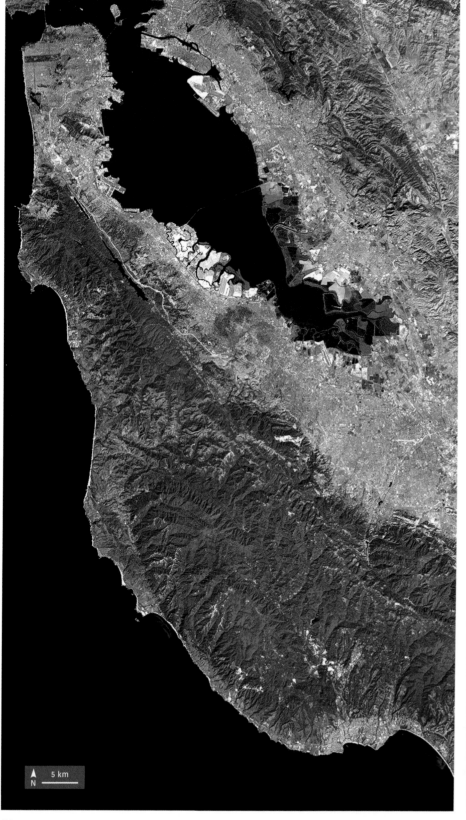
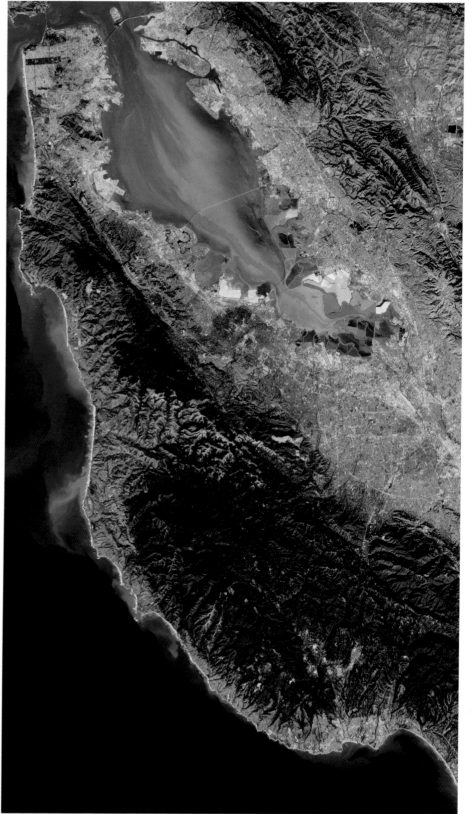

OPPOSITE: California's Silicon Valley is the heart of America's computer industry. Geography kept the sprawl from growing much between 1972 (on the left) and 2016 (on the right), but the newer image is much crisper. On the left, the false colour shows infrared, and highlights vegetation.

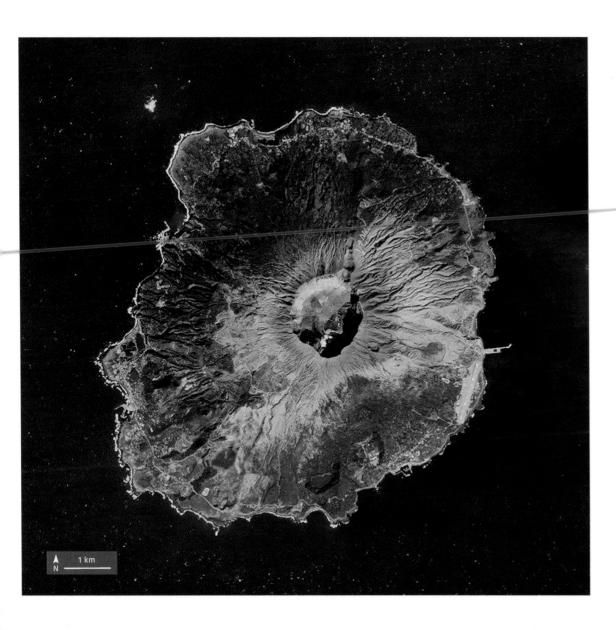

LEFT: Mount Oyama dominates the small Japanese island of Miyakejima, evacuated in 2000 when the volcano erupted. By 2015, almost 3,000 people had returned – but must still carry gas masks at all times.

N
1 km

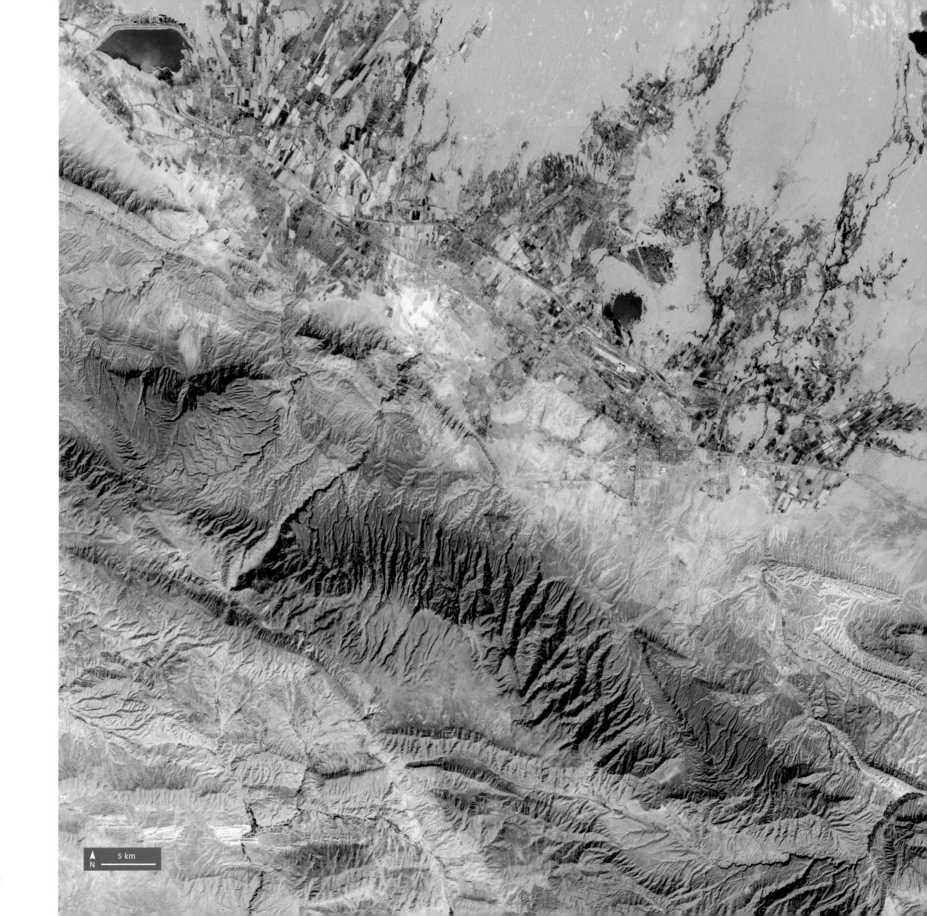

OPPOSITE: Ashgabat, the capital of Turkmenistan, forms a diagonal slash nestling between the vast Karakum Desert to the northeast and the Kopet Dag mountains to the southwest.

BELOW: Las Vegas, Nevada, keeps on growing. These pictures show just 25 years of expansion, and use infrared to highlight plant life in green. The famous strip is the purple slash at the city's heart.

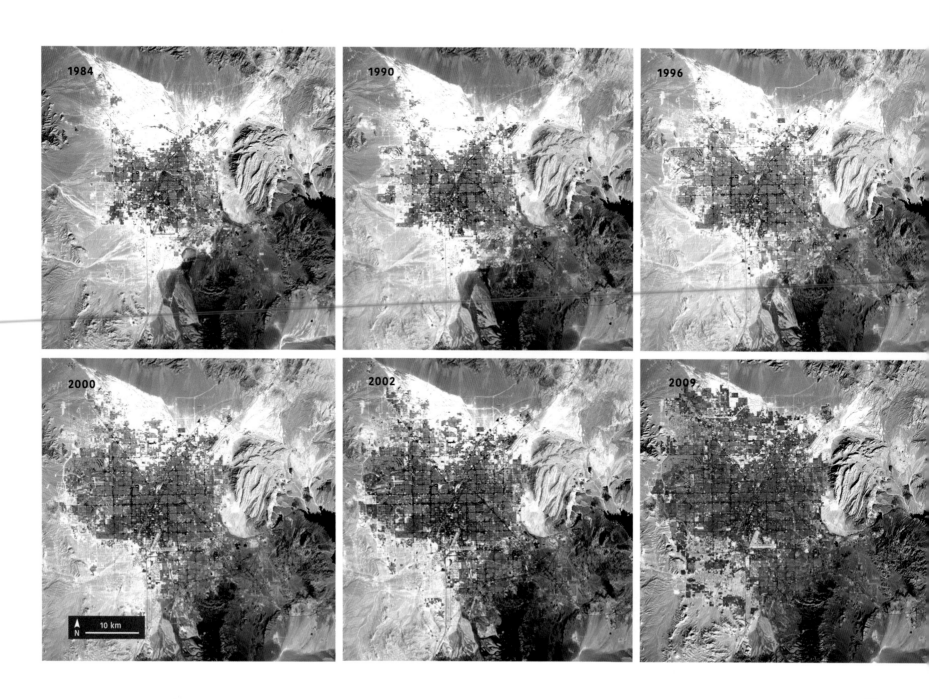

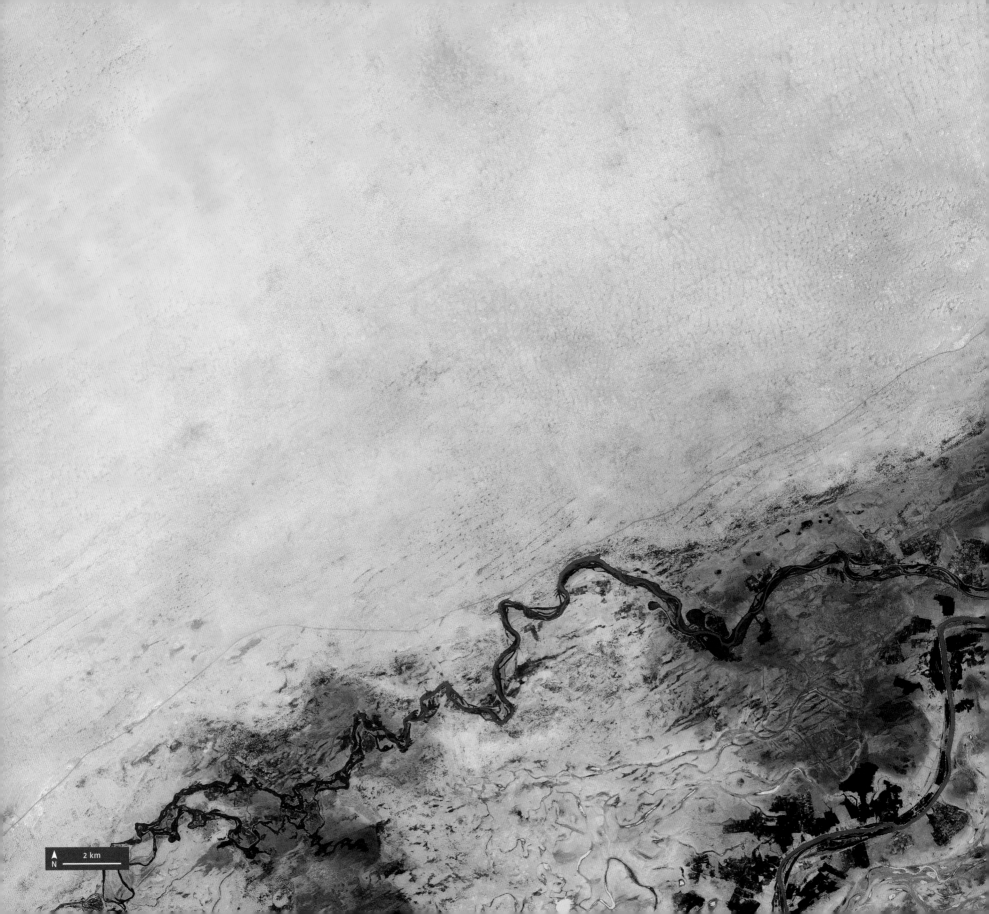

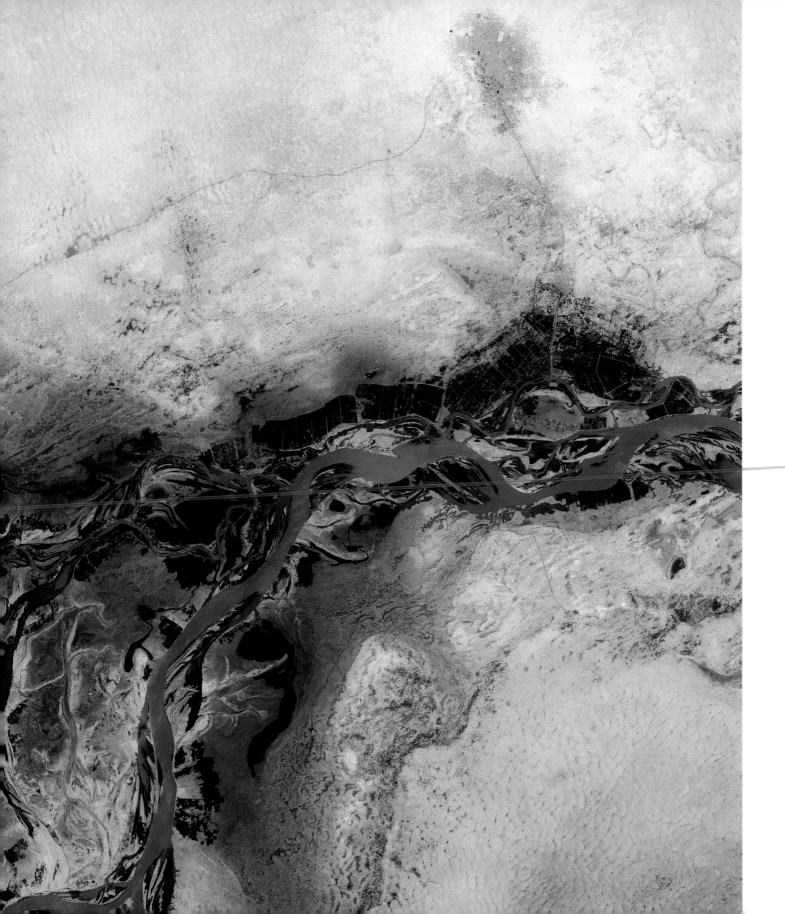

Timbuktu lies on the edge of the Sahara Desert, near the Niger River in Mali. Long suspected of being mythical in the West, the city was a hub of trade and learning for centuries. The red roads leading to it take their colour from the high concentrations of iron in the region's rock and soil.

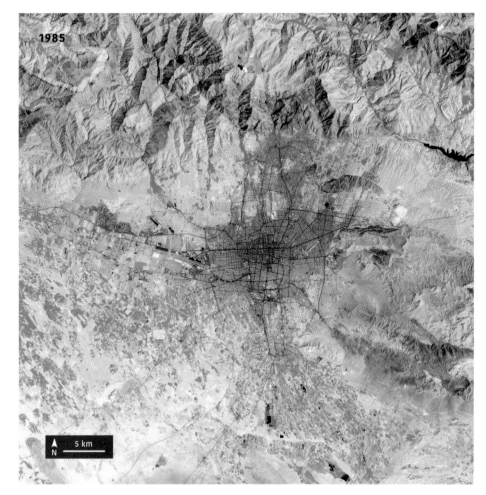

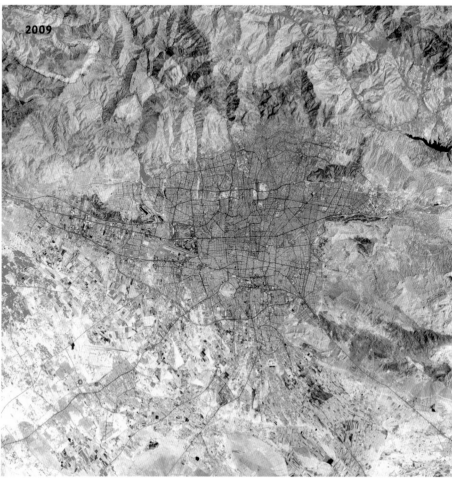

1985

2009

5 km
N

ABOVE LEFT AND RIGHT: Iran's capital is among the fastest-growing cities in the world. These images show Tehran in 1985, at about 5 million people (left-hand image), and at 10 million in 2009. It's grown another 50 per cent since then.

OPPOSITE: The Seine river snakes through the very heart of Paris. Patches of deep green show where the French capital has retained areas of forest around its edges, with fields forming patchworks beyond.

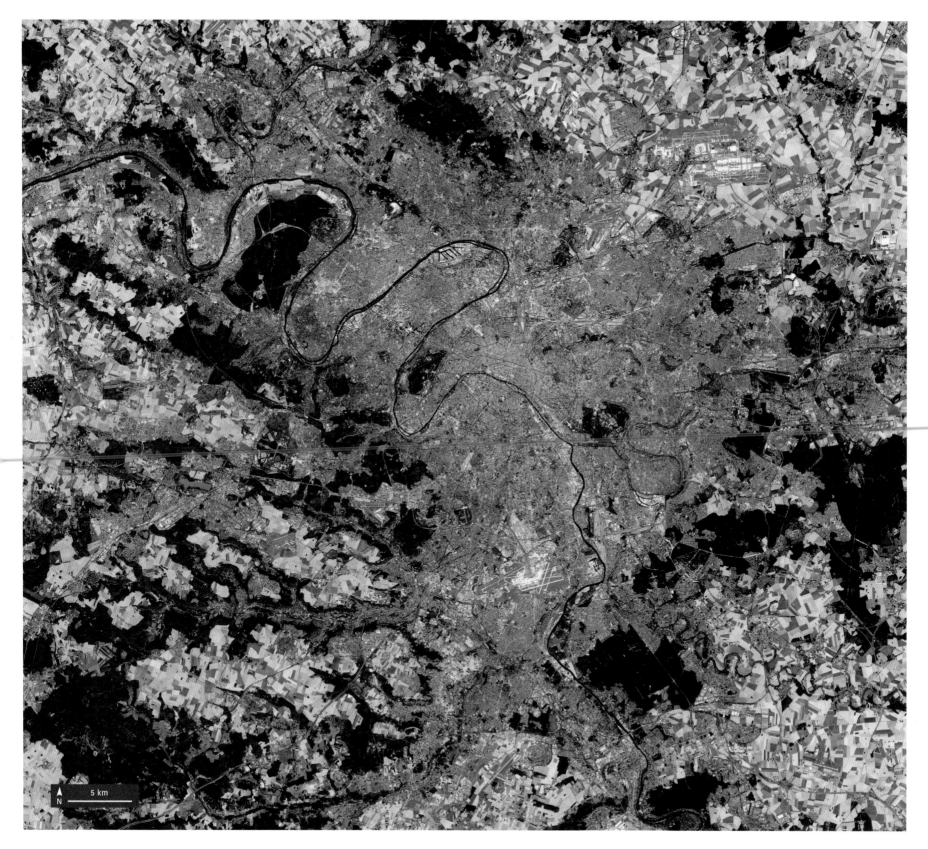

5 km

N

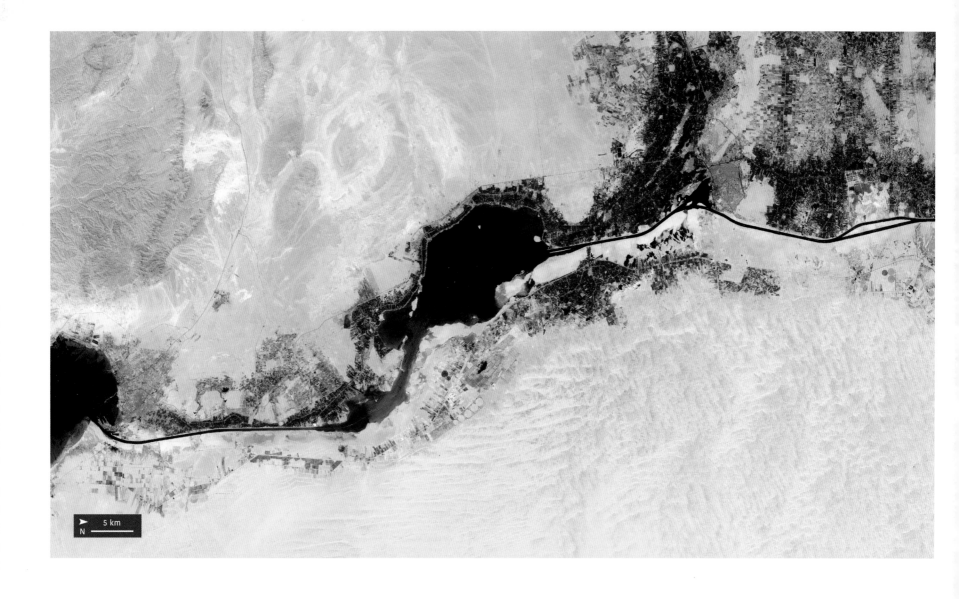

ABOVE: The Suez Canal was completed in 1869, cutting 120 miles (193km) through Egypt to connect the Mediterranean and the Red Seas. In 2015, a second parallel stretch was added at the city of Ismailia.

OPPOSITE: The Pearl River flows into the South China Sea, through one of the world's densest urban regions, home to more than 50 million people. Hong Kong is on the eastern side of the estuary and Zhuhai, also known as the Chinese Riviera, is on the western side.

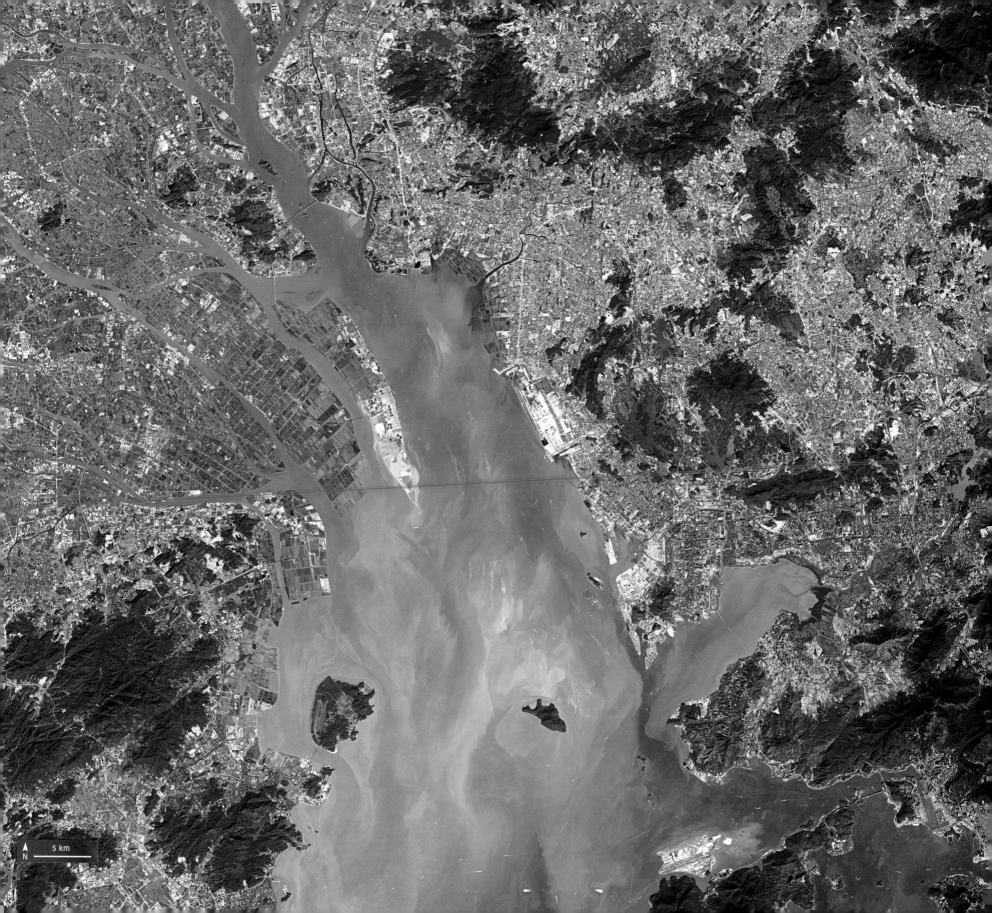

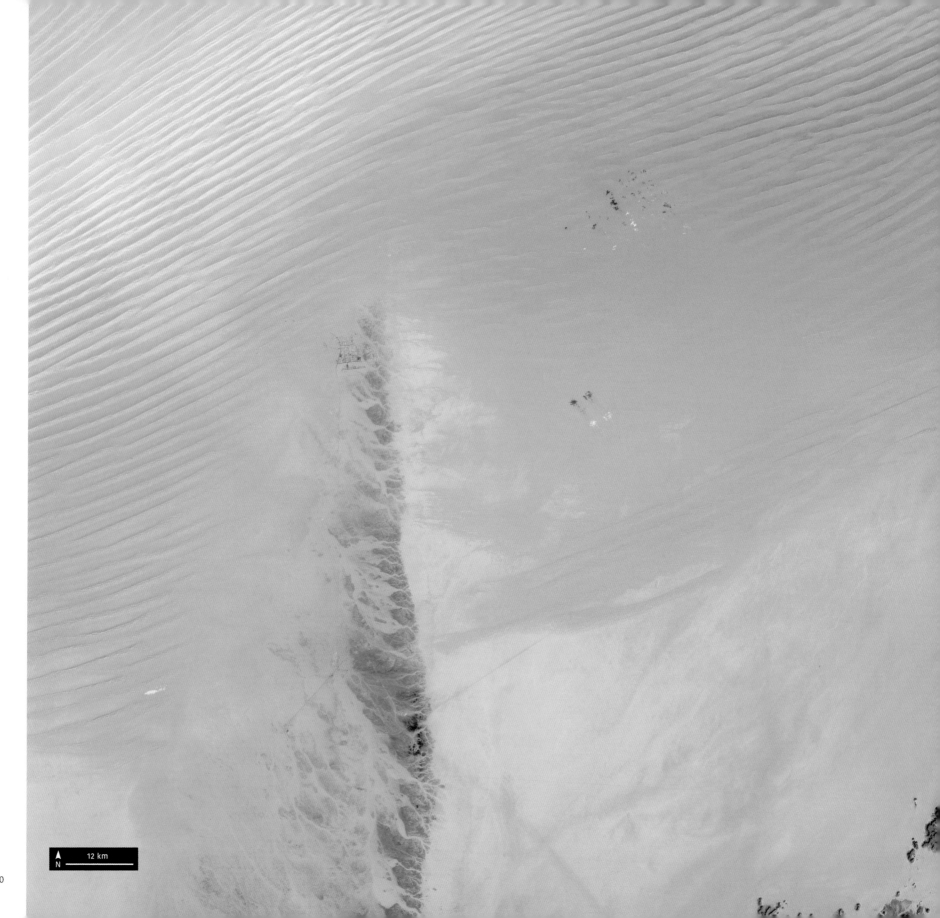

12 km

N

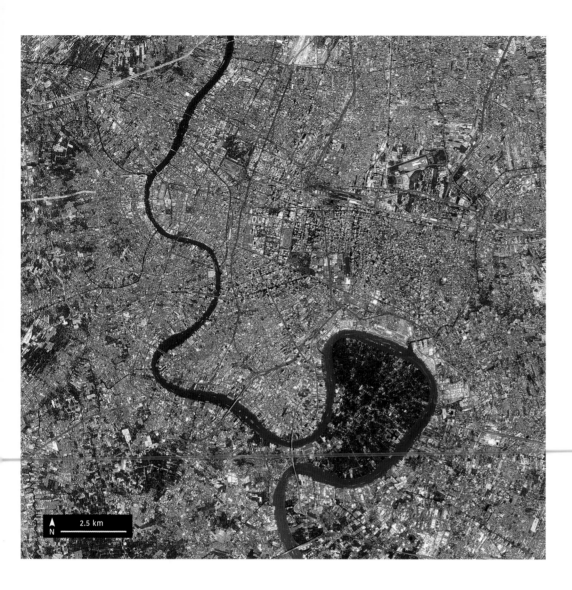

LEFT: Bang Kachao, the green area in the river loop, is a literal jungle at the heart of the very urban jungle of Bangkok, Thailand's capital. Known as the Green Lung, the 5,000 acres (20 square km) are legally protected.

OPPOSITE: The Arabian Peninsula's Rub' al Khali, the Empty Quarter, is the world's largest sea of sand, about the same size as France. Sharurah, shown here, is a small border town and airport between Saudi Arabia and Yemen. Very few make their home here due to the heat and scarcity of water.

FAR RIGHT: The islands of New York Harbor, with Manhattan Island to the northeast and Brooklyn to the east. Once the site of vast oyster beds, Ellis Island became the gateway for immigrants to the USA in the late 19th century.

RIGHT: America's Chesapeake Bay, on the East Coast, is threatened by erosion, rising sea levels, and sinking tectonic plates. In 1998 (above), the US Army began rebuilding Poplar Island, part of Maryland. By 2011 (below) the island is restored and vegetation is returning. By 2026, the island should be 50 per cent larger again.

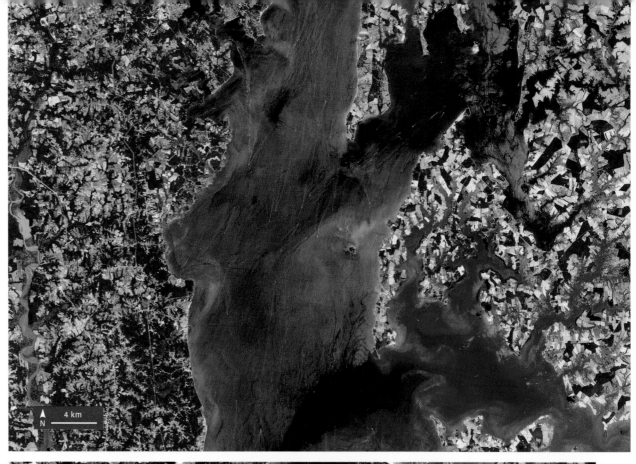

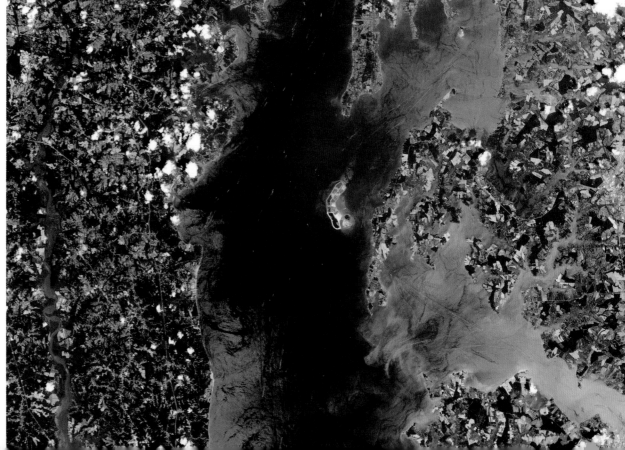

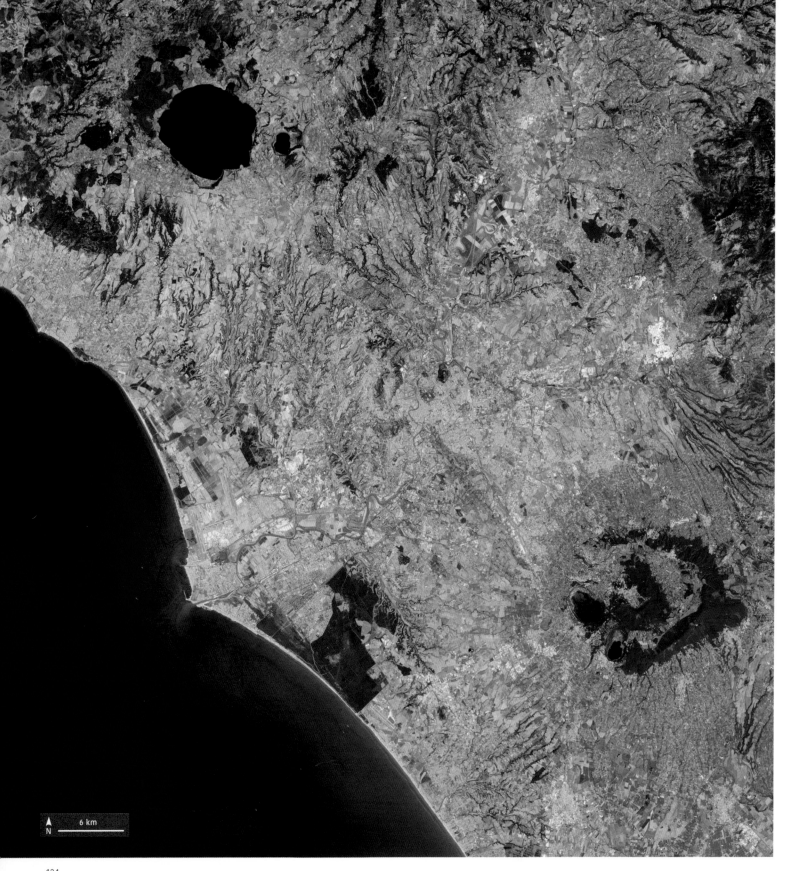

LEFT: Rome, the capital of Italy, nestles between the extinct volcanoes of Lake Bracciano to the northwest and Monte Cavo in the southeast. Ostia on the Tiber river, the ancient city's port, lies at the coast's sharp bow-point toward bottom left.

OPPOSITE: Prague, the historic capital of the Czech Republic, grew out from castles built on either side of the Vltava river in the 9th–10th centuries. Unlike most old European cities, it survived the 20th century nearly intact.

6 km

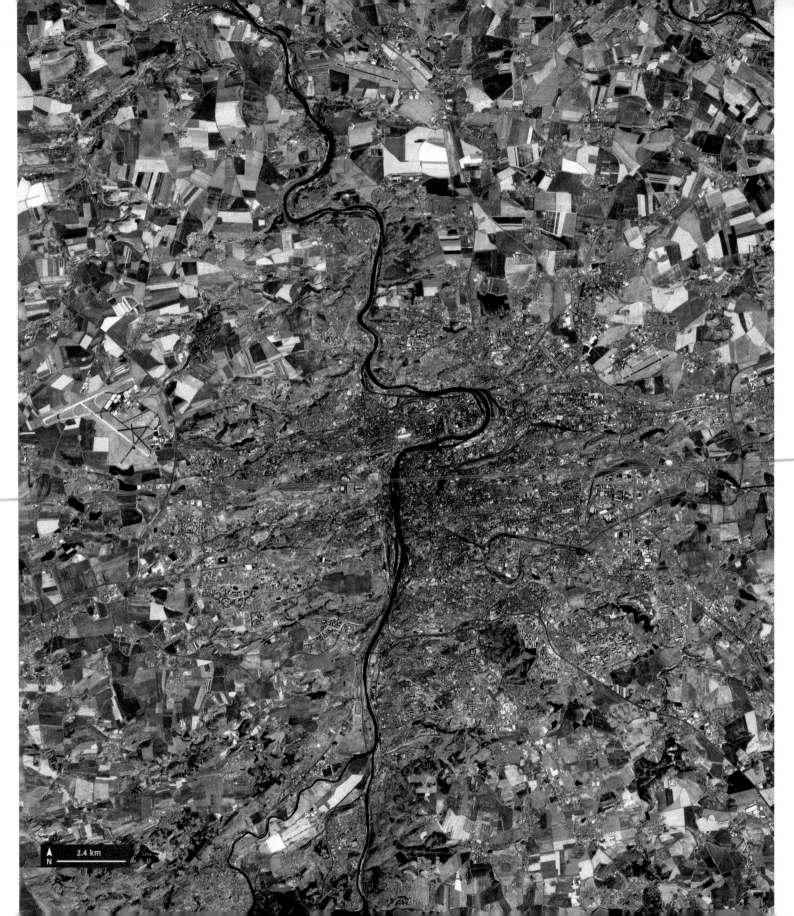

2.4 km

N

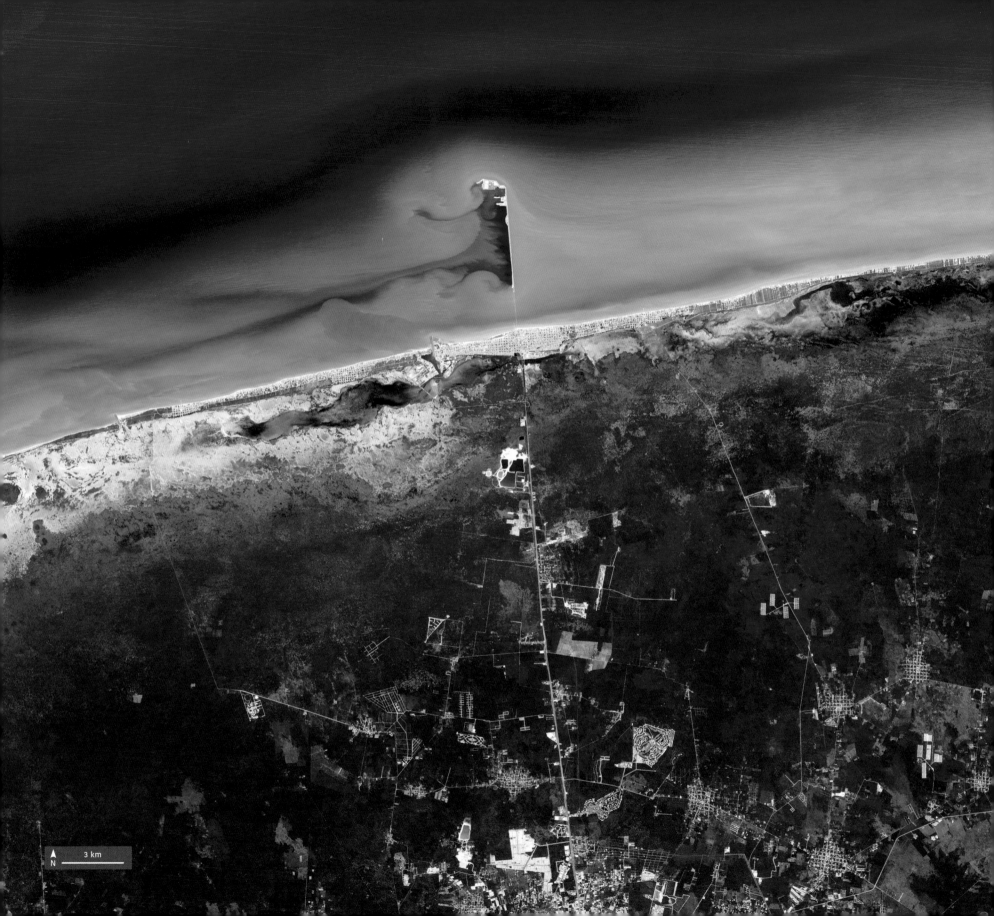

BELOW: Chittagong is the second-largest city in Bangladesh, and its port is the largest on the Bay of Bengal. Along the bay's shore north of the city, unwanted ships are beached for local metal-scavengers to recycle.

OPPOSITE: The pier of Progreso in Mexico stretches four miles into the Gulf of Mexico. The darker waters alongside it show where the newer, solid section stops sediment from flowing west, eroding the sea bed.

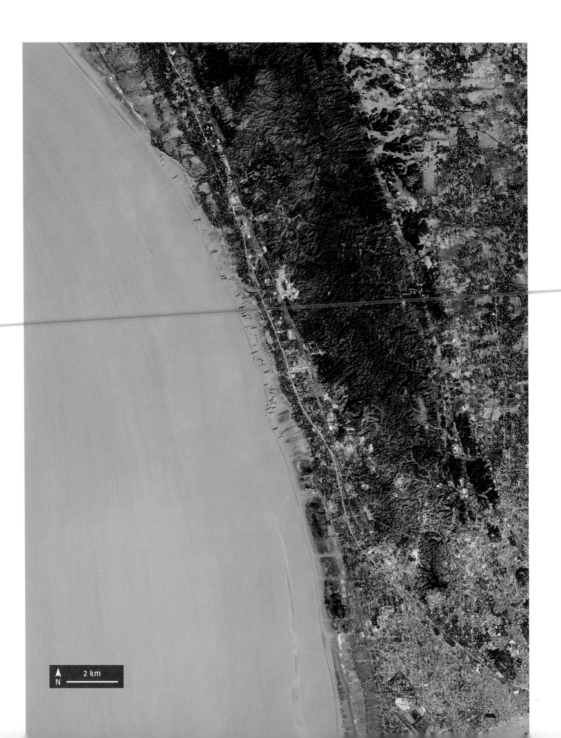

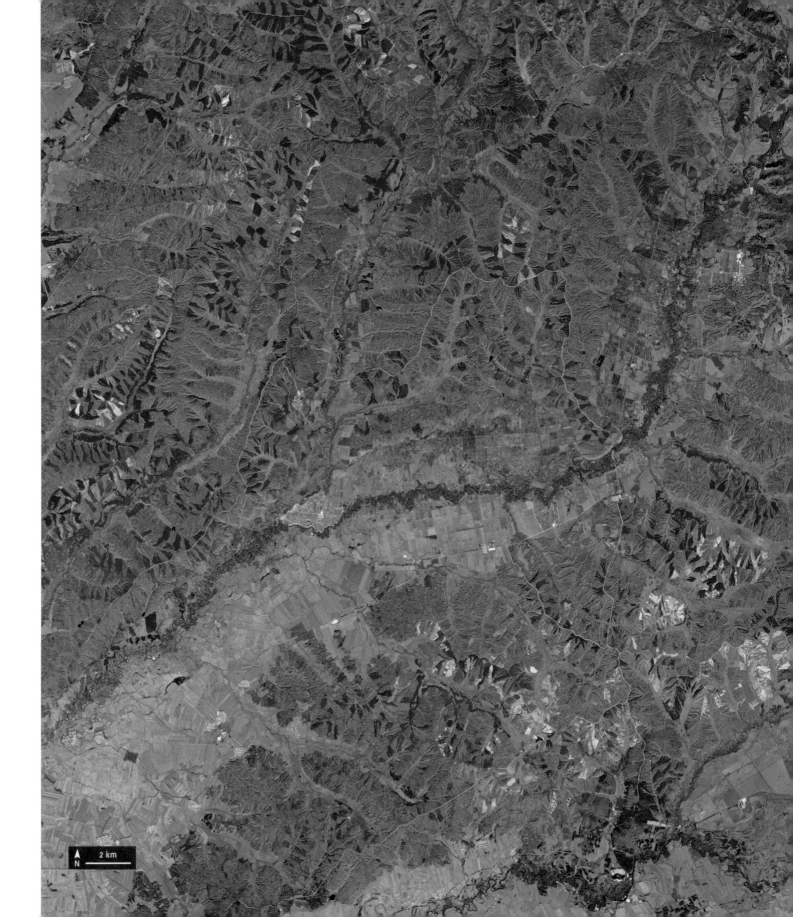

RIGHT: The blue and yellow patches in this photograph of Northern China's Heilongjiang province are not water or crops – they are artificial covers, used in ginseng farms, as it can only grow in shade.

2 km
N

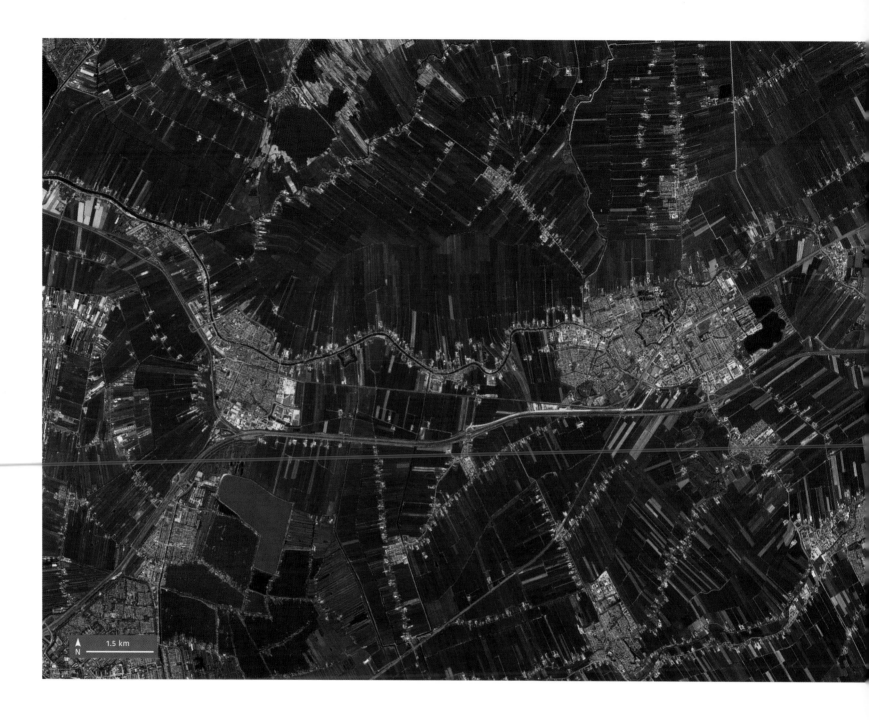

1.5 km

N

ABOVE: The green fields of Naaldwijk and Bleiswijk in the Netherlands tessellate across the countryside south of Den Haag and Leiden. The area is famous for its fields of tulips and other flowers, which pop with colour in late April.

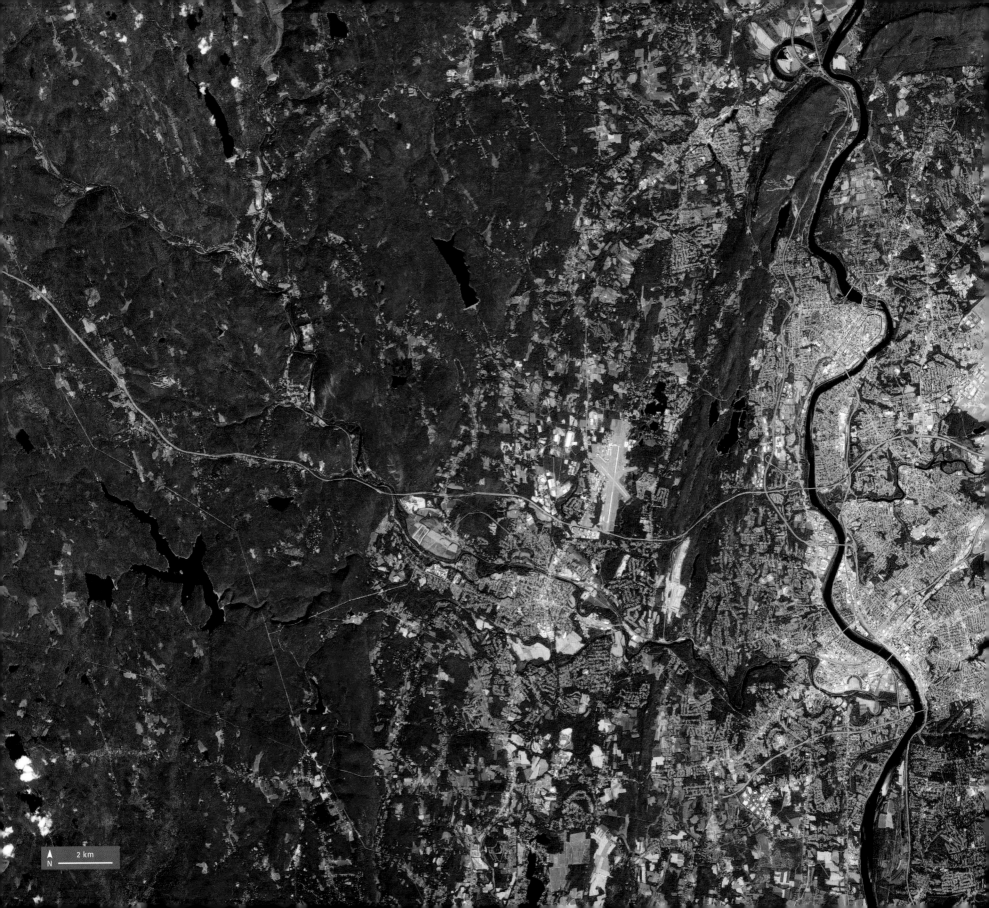

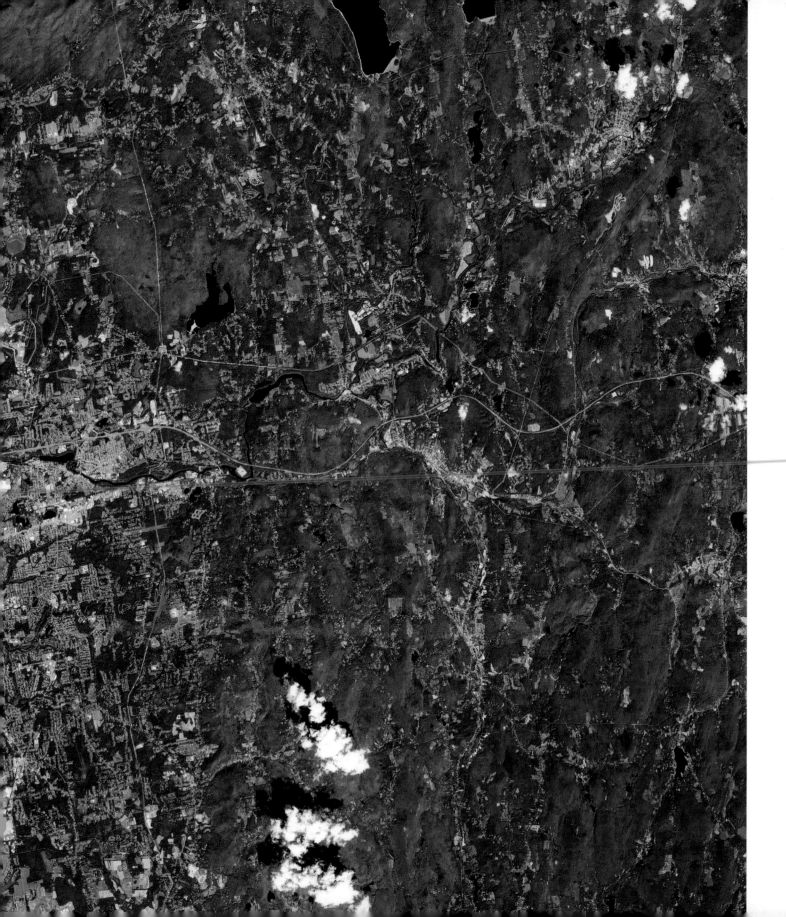

Springfield, Massachusetts lies on the Connecticut River. Named after founder William Pynchon's birth town in Essex, England, it is the home of basketball, vulcanized rubber, and the first American dictionary. The area stretching downriver to Hartford, Connecticut, is known as Knowledge Corridor, after its 32 universities and colleges.

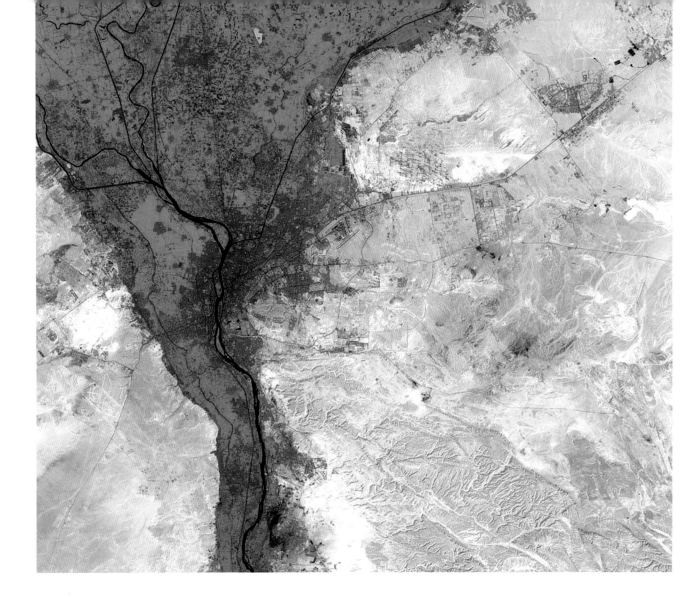

RIGHT: It is impossible to overestimate the vital importance of the Nile river and its delta to Cairo, shown at the centre of this image in brown and purple. Thanks to it, Egypt's capital city has a history stretching back five thousand years. The green extent of the Nile's life-giving fertility is in sharp contrast to the sterile wastes of the Sahara desert surrounding it.

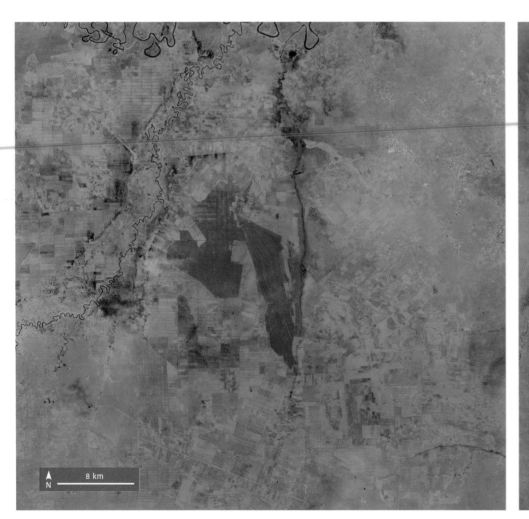

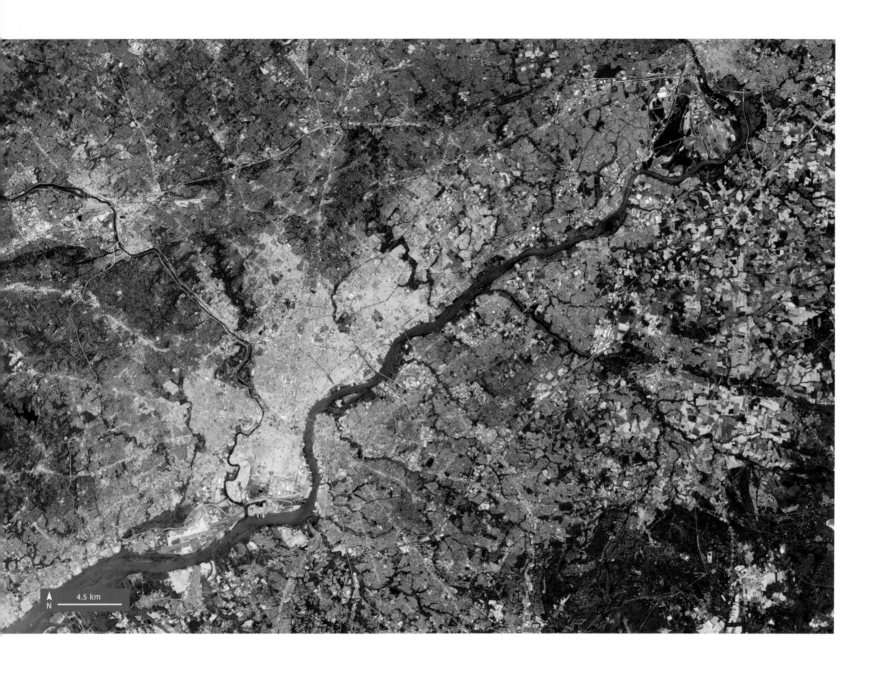

ABOVE: Philadelphia, the city of brotherly love, is where the Founding Fathers signed the Declaration of Independence and the Constitution. It lies on the northwest side of the Delaware River, facing New Jersey.

4.5 km
N

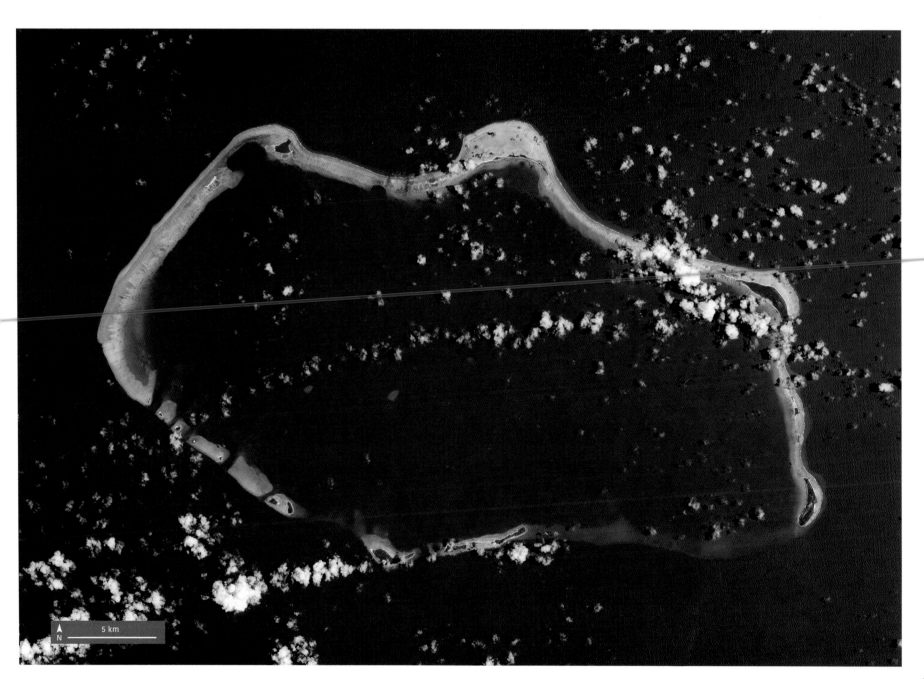

BELOW: The reef system of Bikini Atoll, a chain of 23 islets, is located in the Republic of the Marshall Islands in the Pacific Ocean. The crater located in the top left of the chain was formed by a thermonuclear bomb test conducted by the US Army in March 1954.

5 km

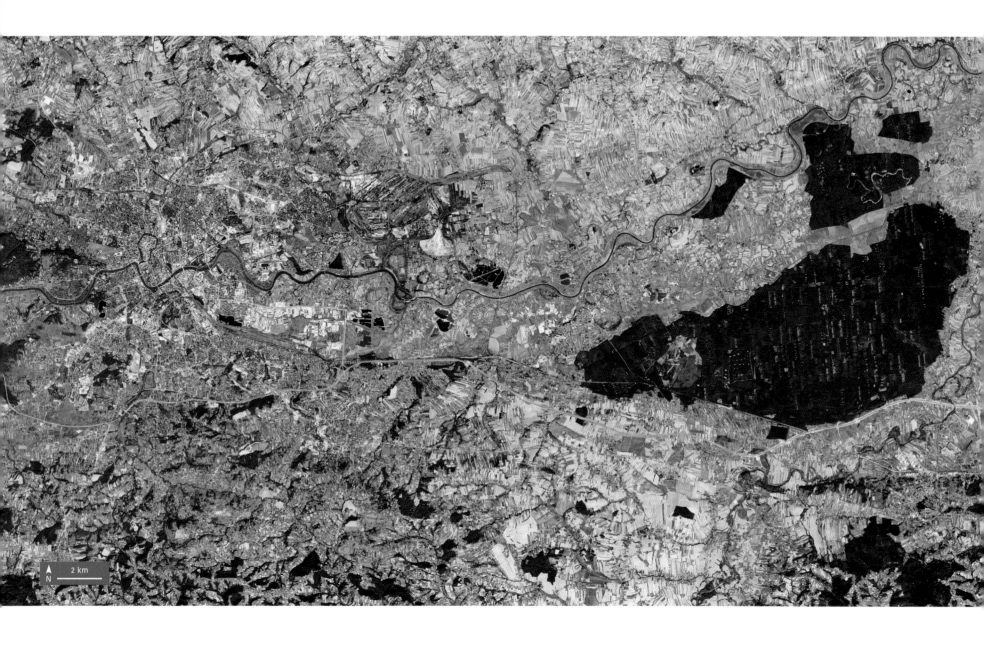

ABOVE: Niepołomice Forest is about 20 miles (46km) east of the Polish city of Kraków, and its name means "impossible to destroy". It was a popular medieval hunting ground, and remains a state possession.

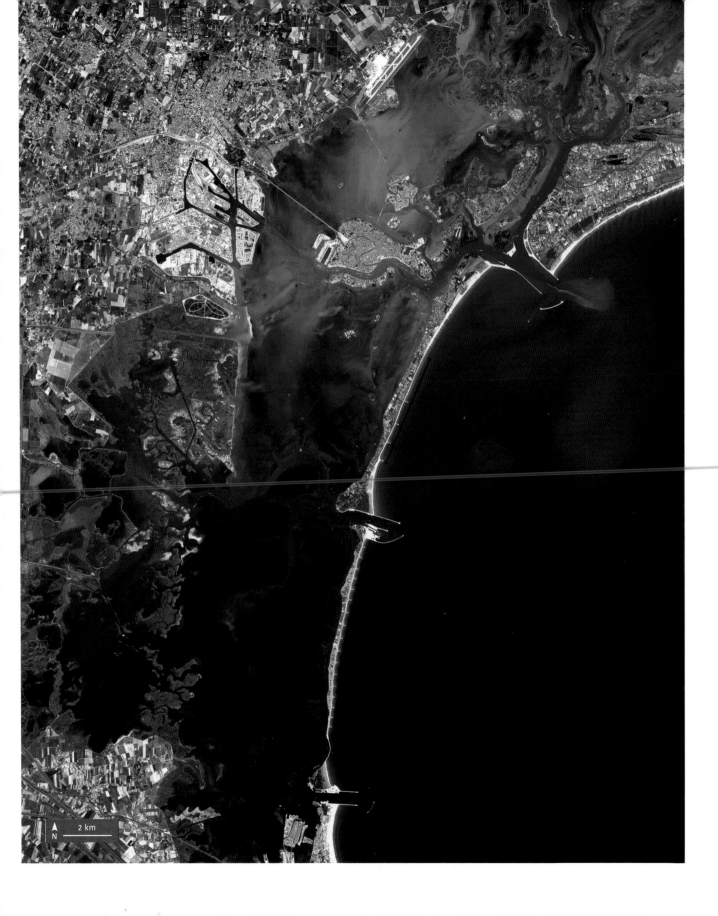

LEFT: Pumping of nearby gas and ground-water has lowered Venice's 118 islands. The 28-mile (45-km) barrier island chain that separates the lagoon from the Adriatic can now be sealed at all three inlets if the tide is high.

2 km

N

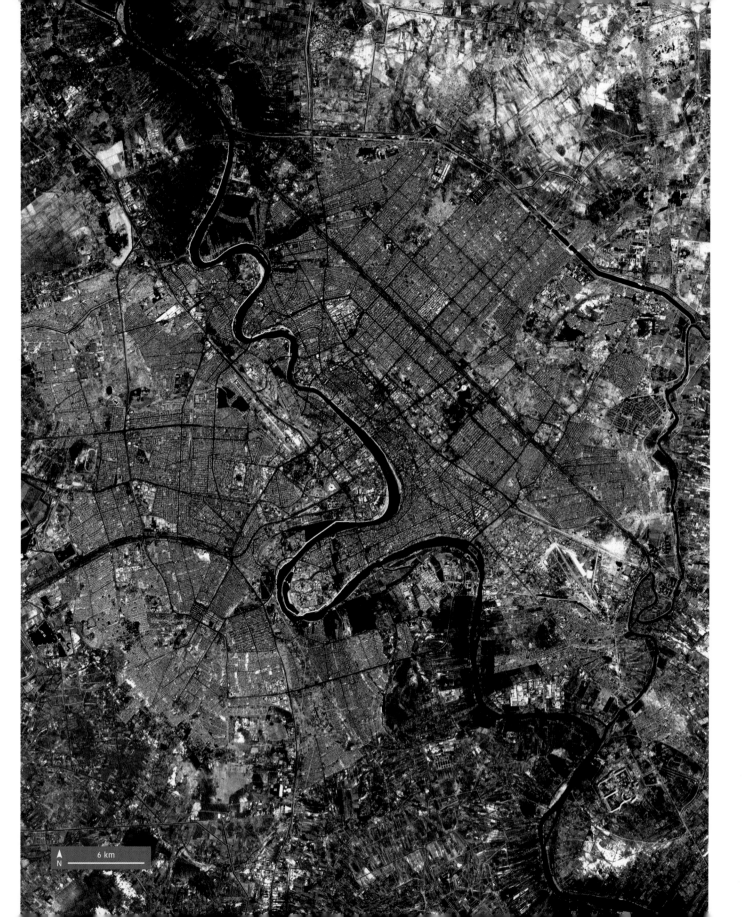

6 km

N

LEFT and OPPOSITE: Baghdad, the capital city of Iraq, and previous home of the dictator Saddam Hussein. The picture on the left, from March 2003, provides a clear view of the city with the Tigris river snaking through it. In the facing picture, taken a month later, black smoke from oil wells set on fire blankets the city. This was a deliberate act by Iraqis to hamper US air forces.

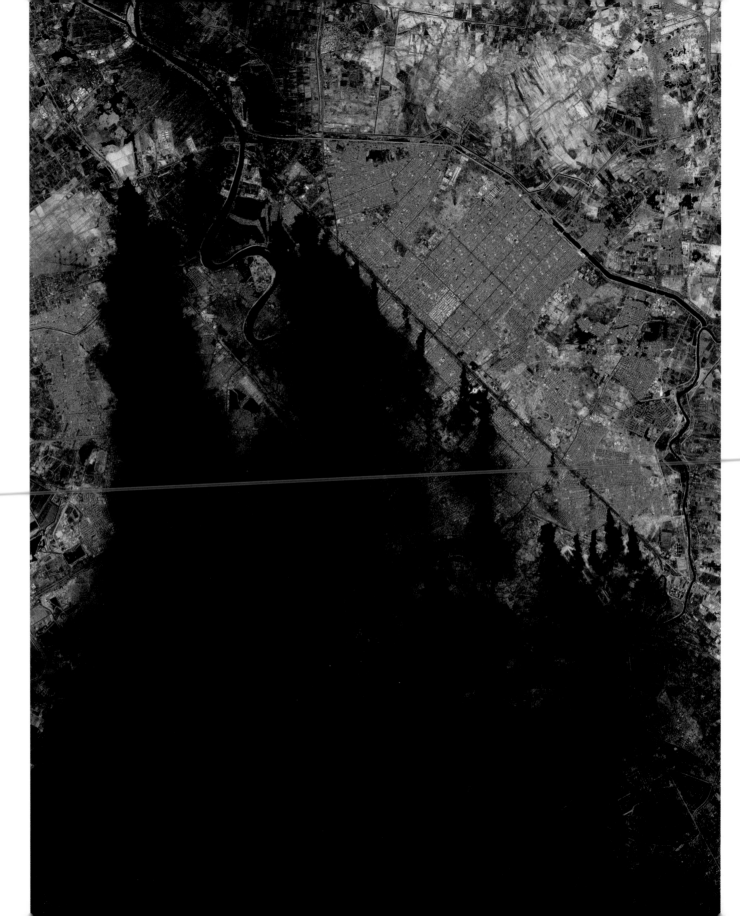

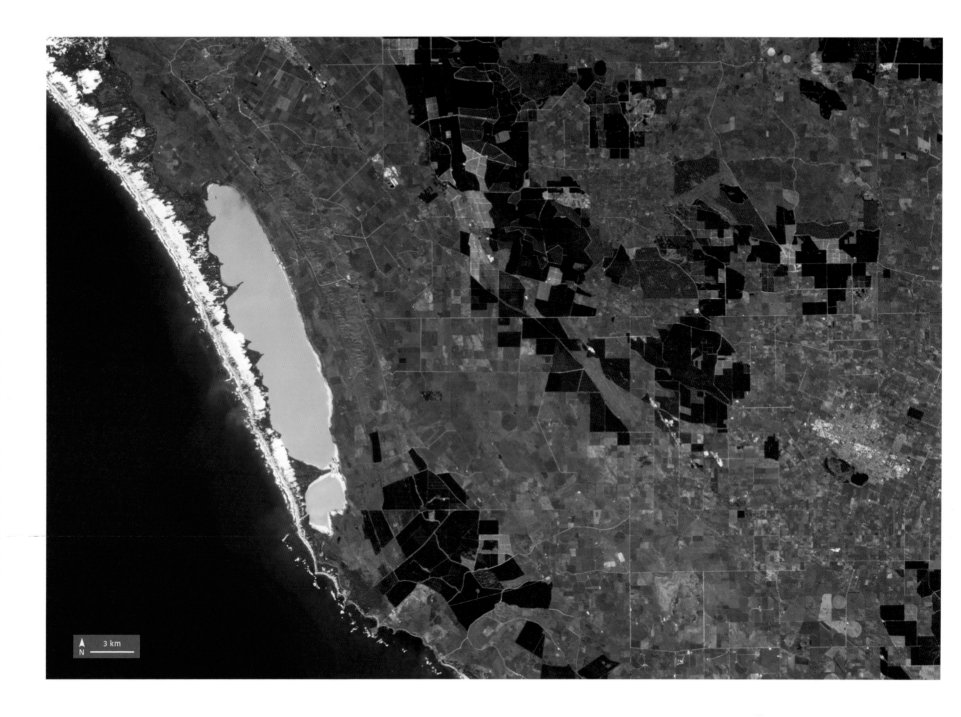

ABOVE: South Australia's
Limestone Coast has been
settled for millennia, with
European colonists most
recently moving in during the
1840s. It is the largest source
of Australian fossils and home
to the Naracoorte Caves.

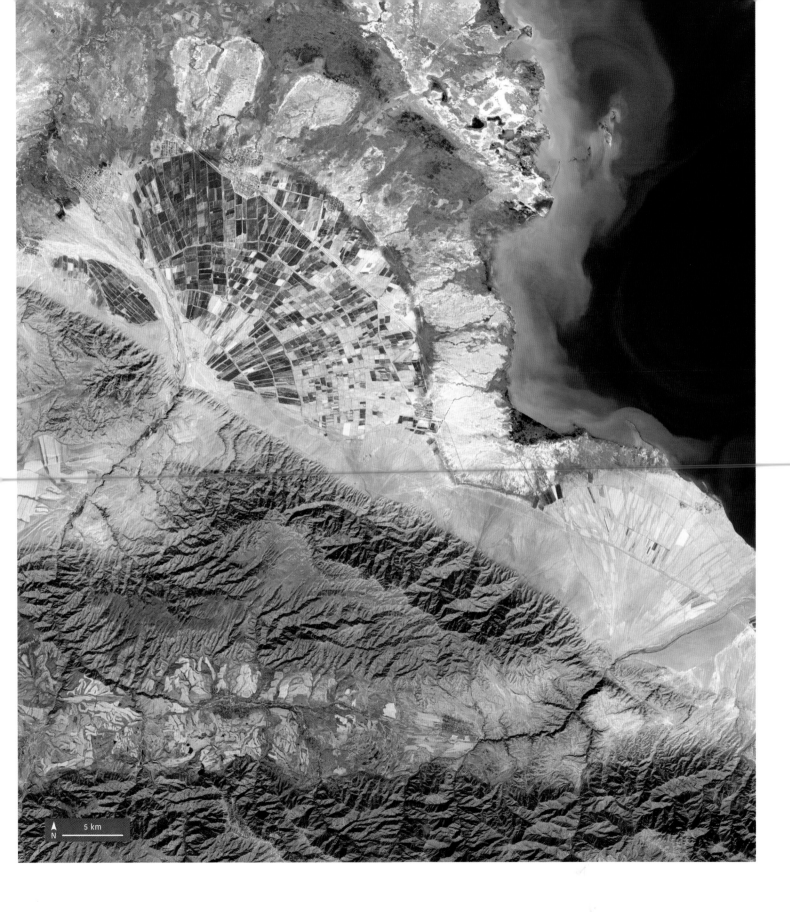

LEFT: The Tente River escapes the Dzungarian Alatau mountains of Kazhakstan's Almaty near Lake Alakol, spreading out into an alluvial fan of braided streams, and providing a vital chance for local agriculture.

5 km

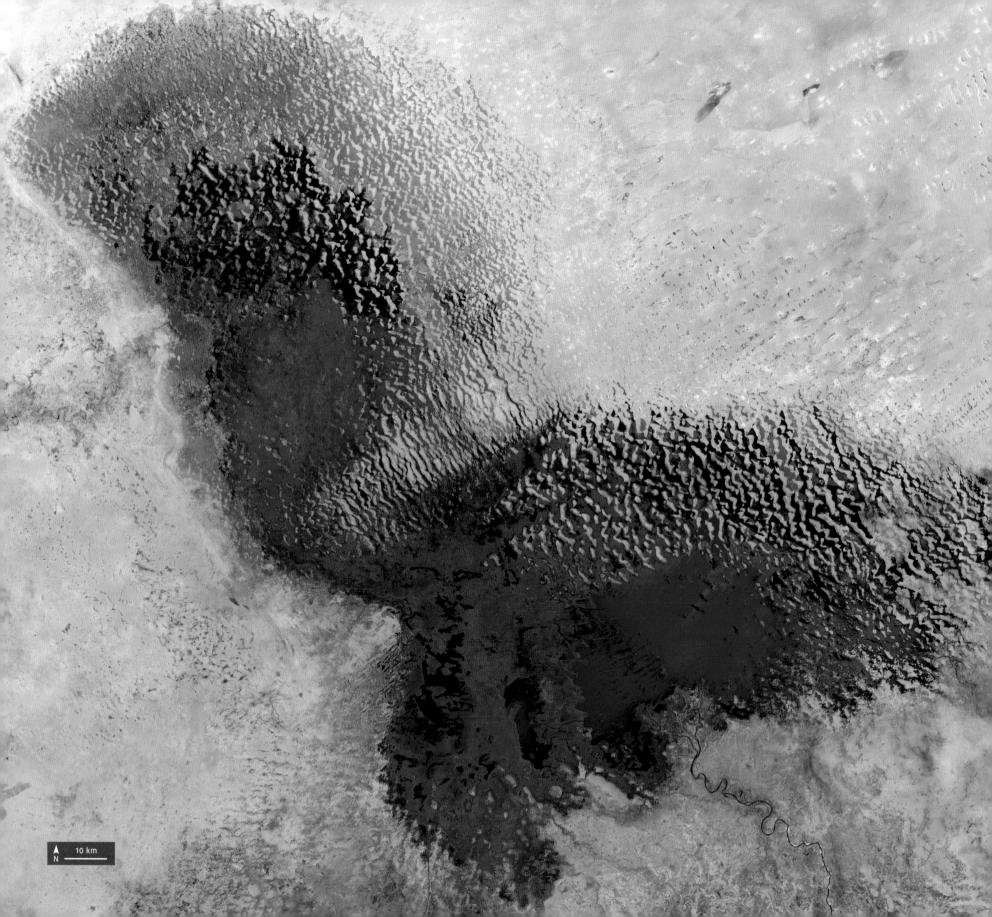

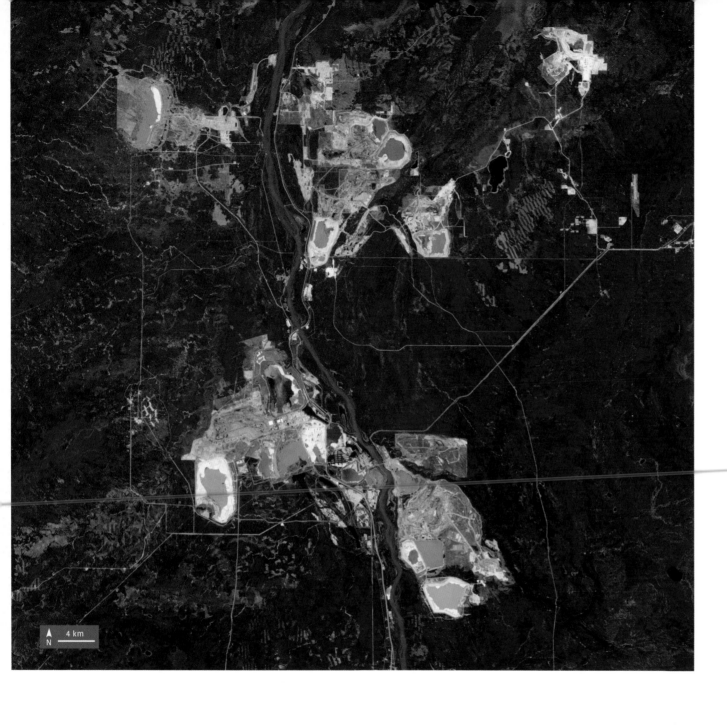

LEFT: Athabasca Oil Sands in Alberta, Canada, is the world's largest oil sands deposit. The area has been mined since 1967 and provides a stable source of oil for North America.

OPPOSITE: A false-colour image of Lake Chad, in west-central Africa, which is now less than a tenth as large as it was in the 1960s. Thirty million people depend on it, but the blue patch of water once extended over the entire red area of vegetation.

143

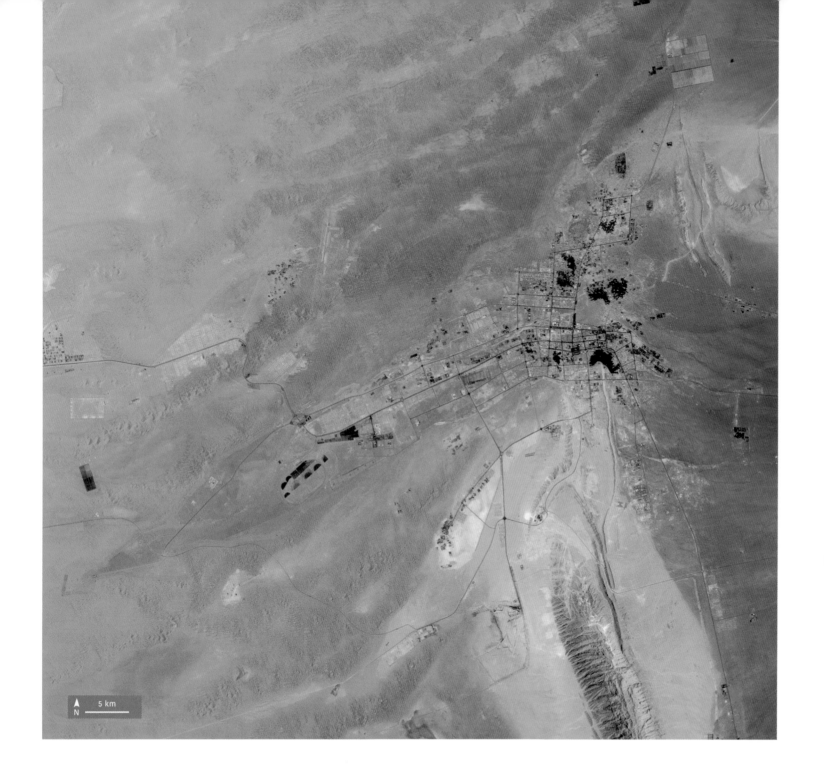

LEFT: In 1975, Al-'Ain was a small, dry city of 50,000 people in the United Arab Emirates. Since then, it has blossomed to have 130 million square feet (12 million square m) of irrigated land and a population of 650,000.

5 km
N

OPPOSITE: The remote Peruvian region of Madre de Dios attracts illegal gold-miners, particularly noticeable in the bottom-left of this image. The process uses mercury, so as well as deforestation, it poisons the land, wildlife, and people for miles around. Were it not for such images, it is likely this activity would have gone unnoticed.

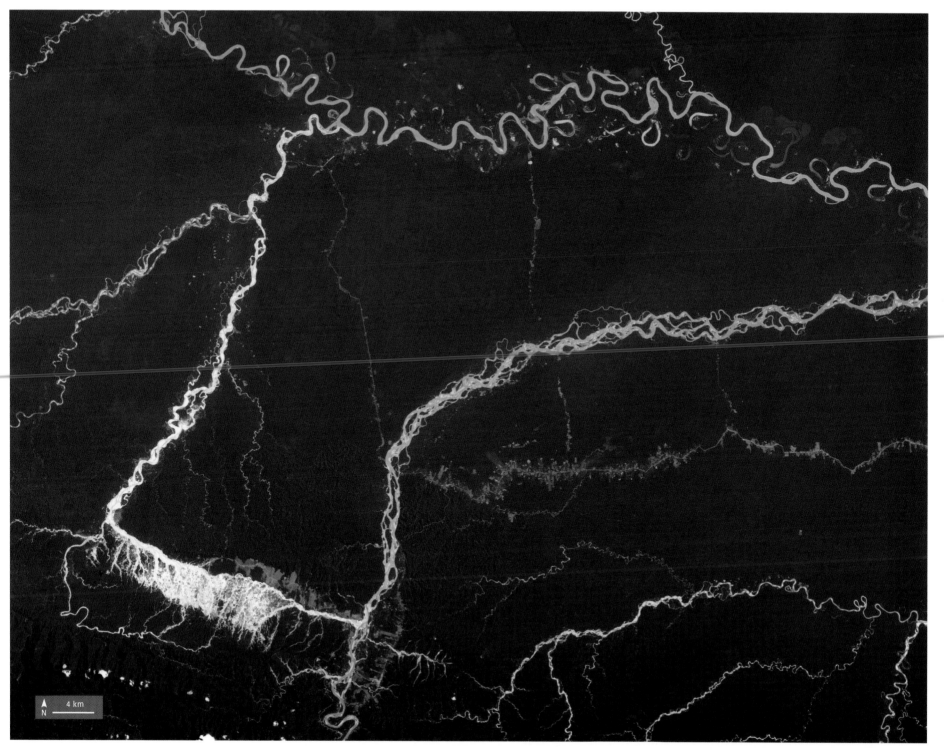

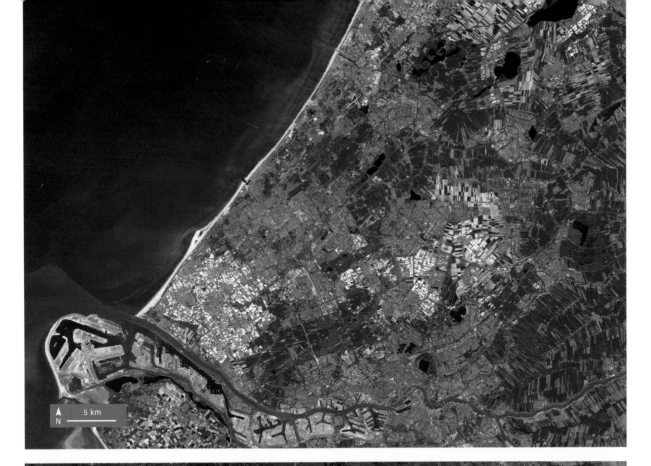

LEFT: When the Calvinist pilgrims first fled England, they turned to the Netherlands, eventually settling on the city of Leiden near the centre of this image. It was from there that they departed for the New World.

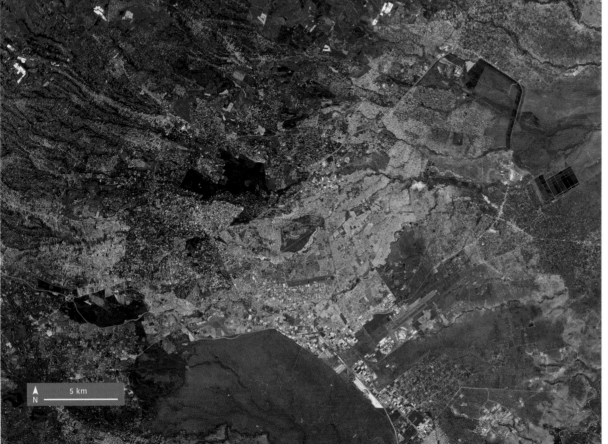

LEFT: Since 1986, the Kenyan capital of Nairobi has more than quadrupled its population, to over 6.5 million people. In this, it mirrors most African cities, which are rapidly expanding.

OPPOSITE: This area, home to Sweden's most northerly town, Kiruna, is also the site of a vast iron-ore mine. Subsistence caused by drilling has meant the entire town is in danger of sinking into the ground and plans are now afoot to relocate the town and its inhabitants 2 miles (3km) away.

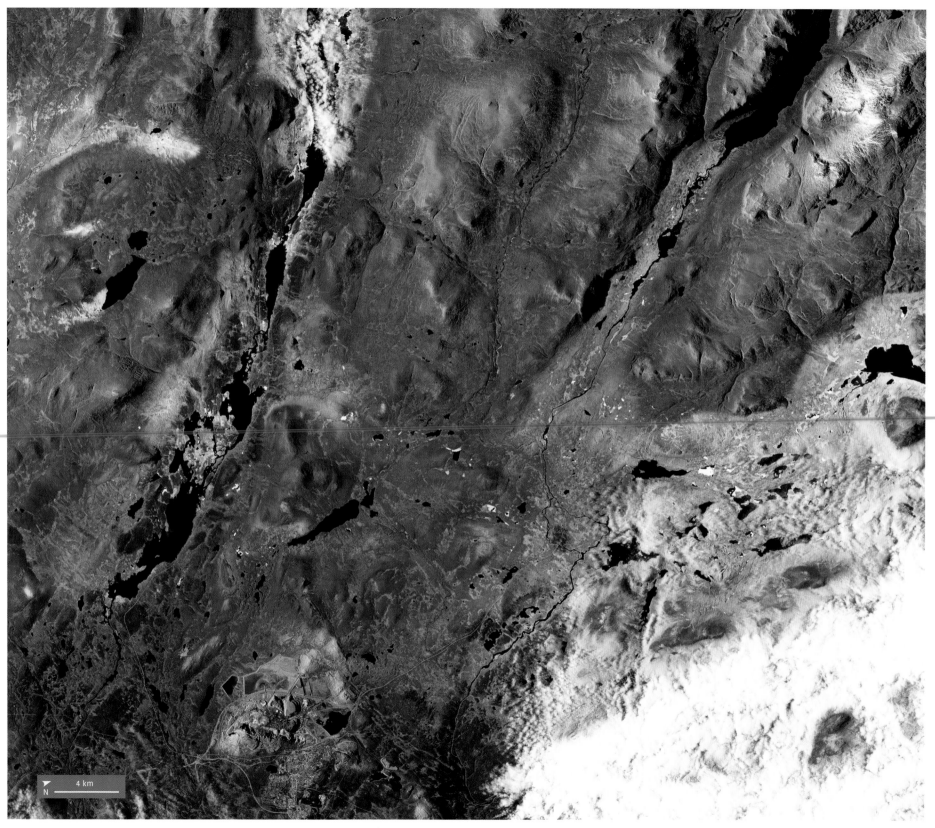

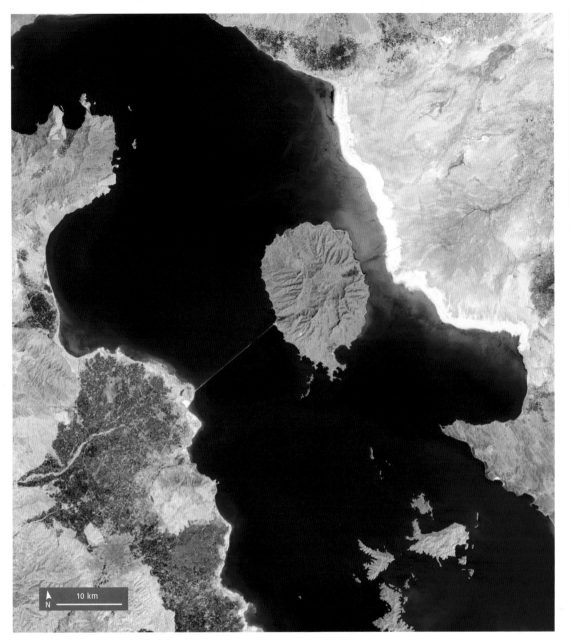

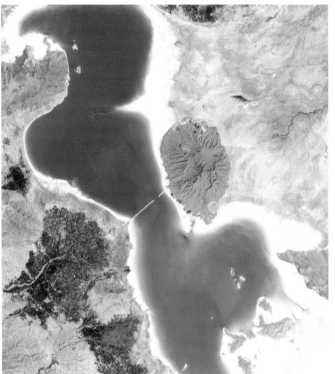

LEFT and ABOVE: Iran's salty Lake Orumiyeh is shrinking, thanks to climate change and irrigation. Islami Island in the left-hand 1998 image is clearly part of the shore by 2011 (above), but the gold colour is reflected sunlight.

OPPOSITE: The Indus River fragments and meanders on either side of Pakistan's Guddu Barrage, a dam just south of the Punjab Province/ Sindh Province border. The Indus irrigates millions of acres along its length.

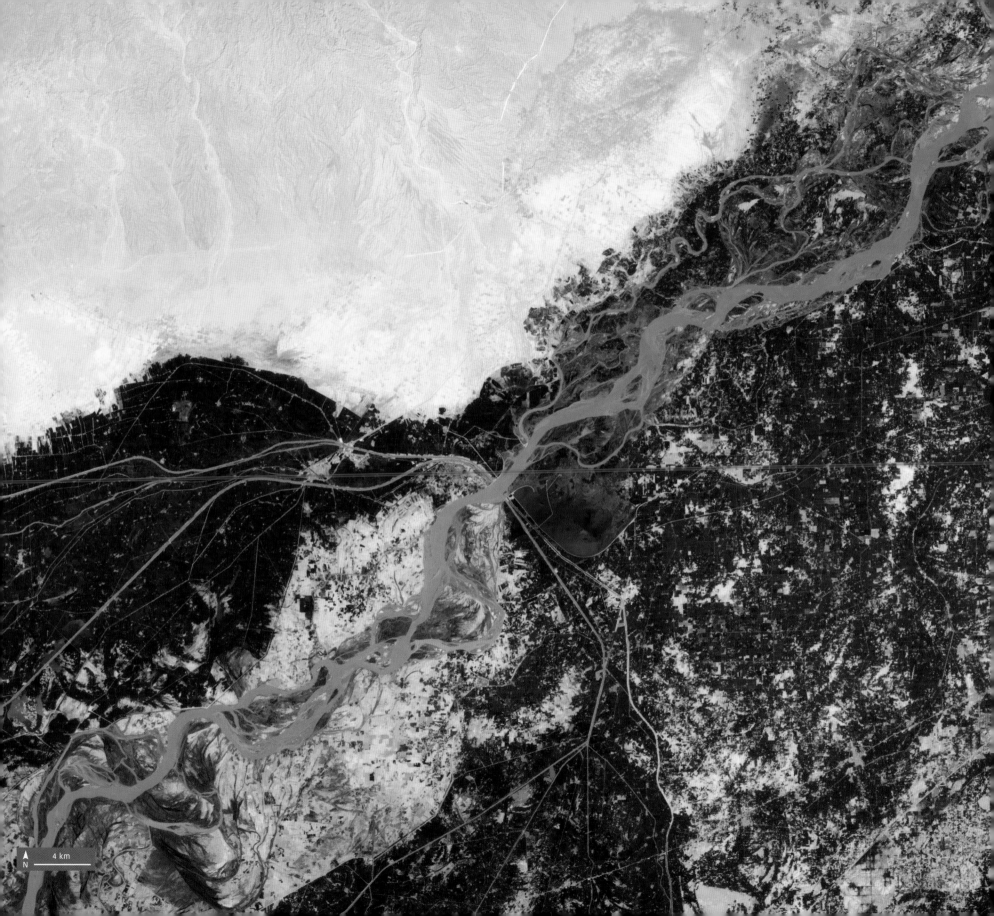

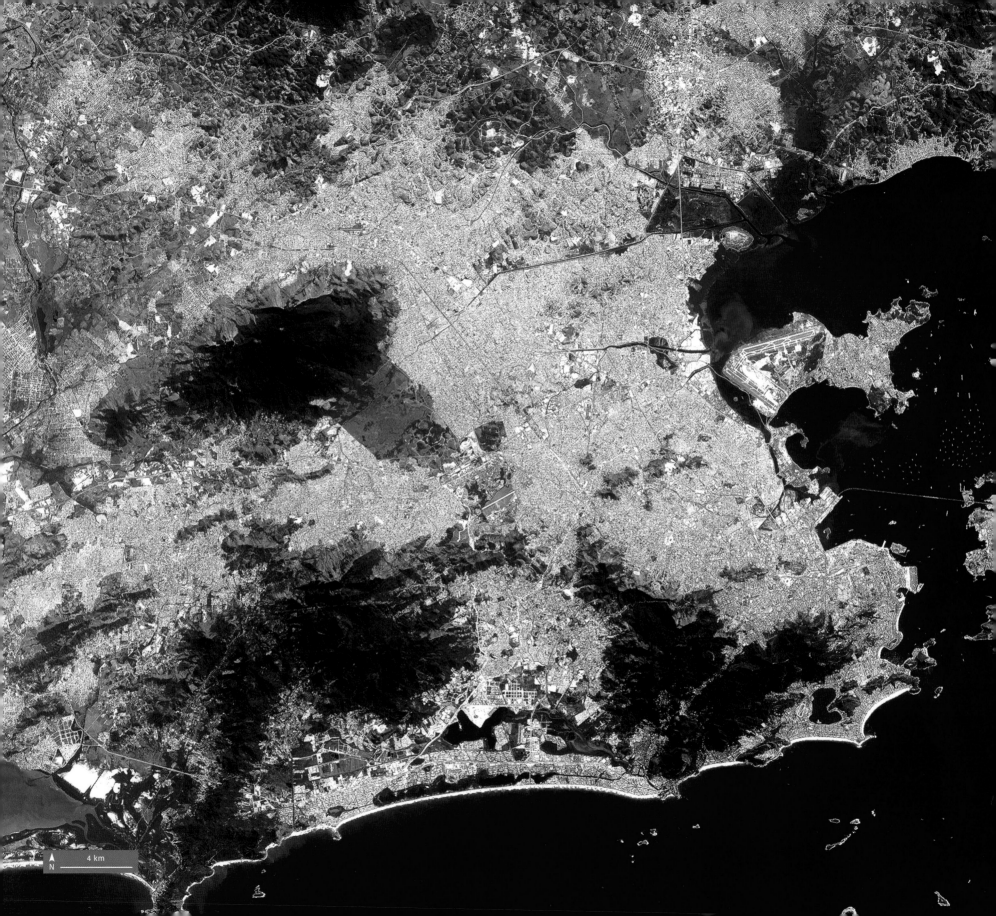

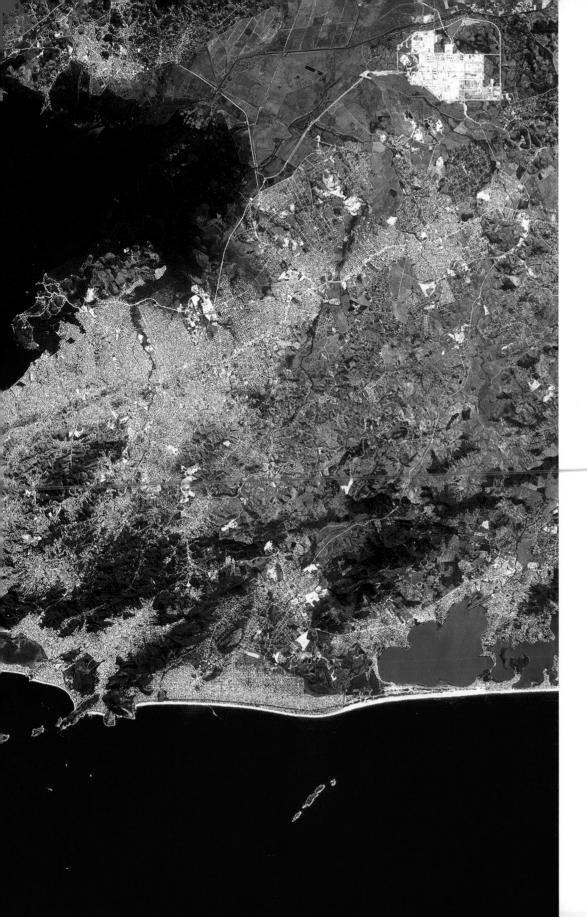

The second-largest city in Brazil after São Paulo, Rio de Janeiro is home to more than 12 million people. It is also one of the Southern Hemisphere's most popular tourist destinations. The 2016 Summer Olympics and Paralympics led to a lot of infrastructural expansion, but the city is still prone to landslides, floods and occasional major droughts.

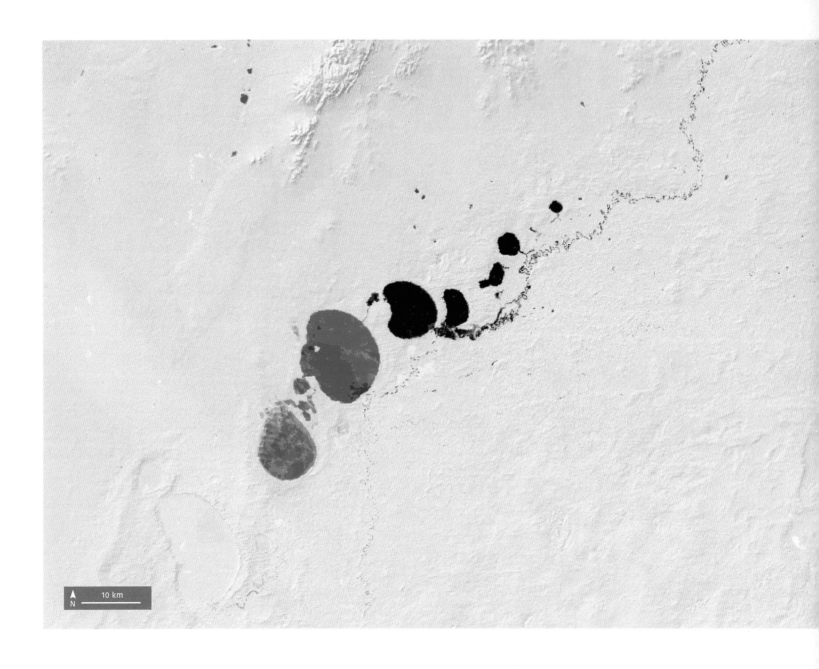

10 km

N

ABOVE: This inundation-frequency map of the Menindee Lakes in Australia's New South Wales shows the fragility of the continent's rainfall. The deeper the blue, the more often in 2010 that spot was under water. The lakes are an important water storage system for nearby residents.

OPPOSITE: The delta of the Irrawaddy River supplies Myanmar with most of the nation's rice. Paddies (fallow here, in pink) have displaced most of the mangrove forest, greatly increasing flood risks.

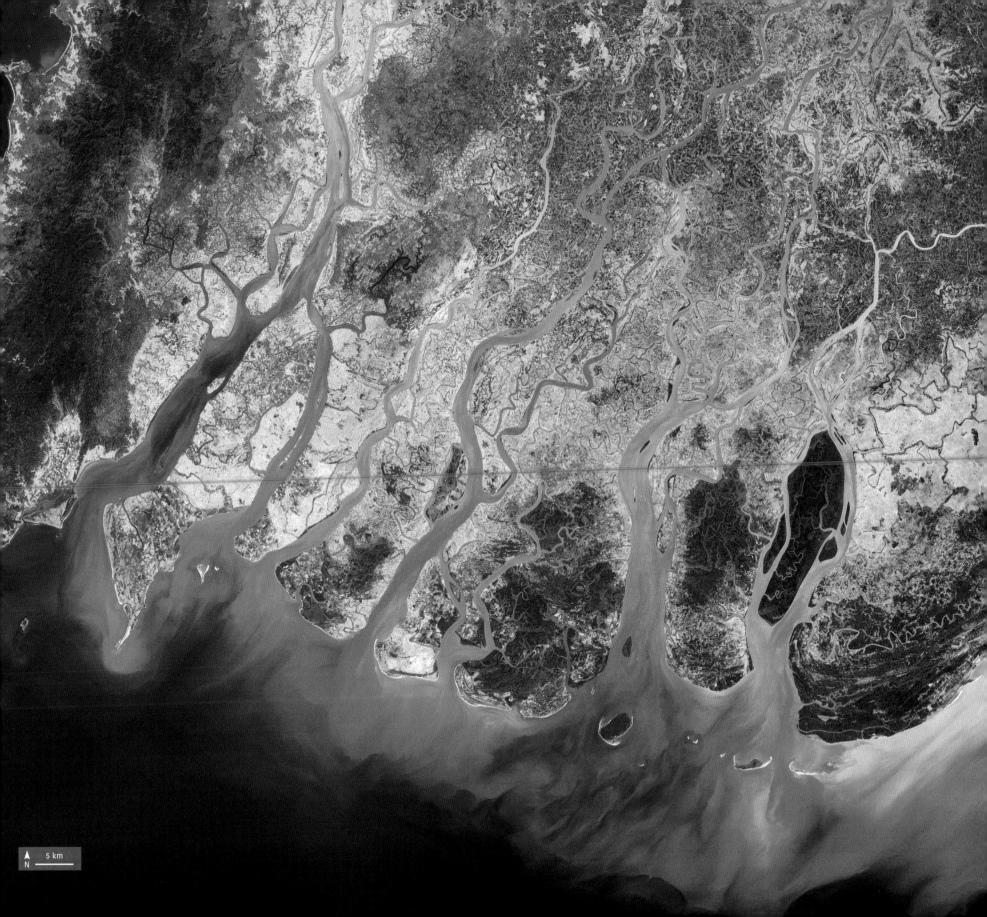

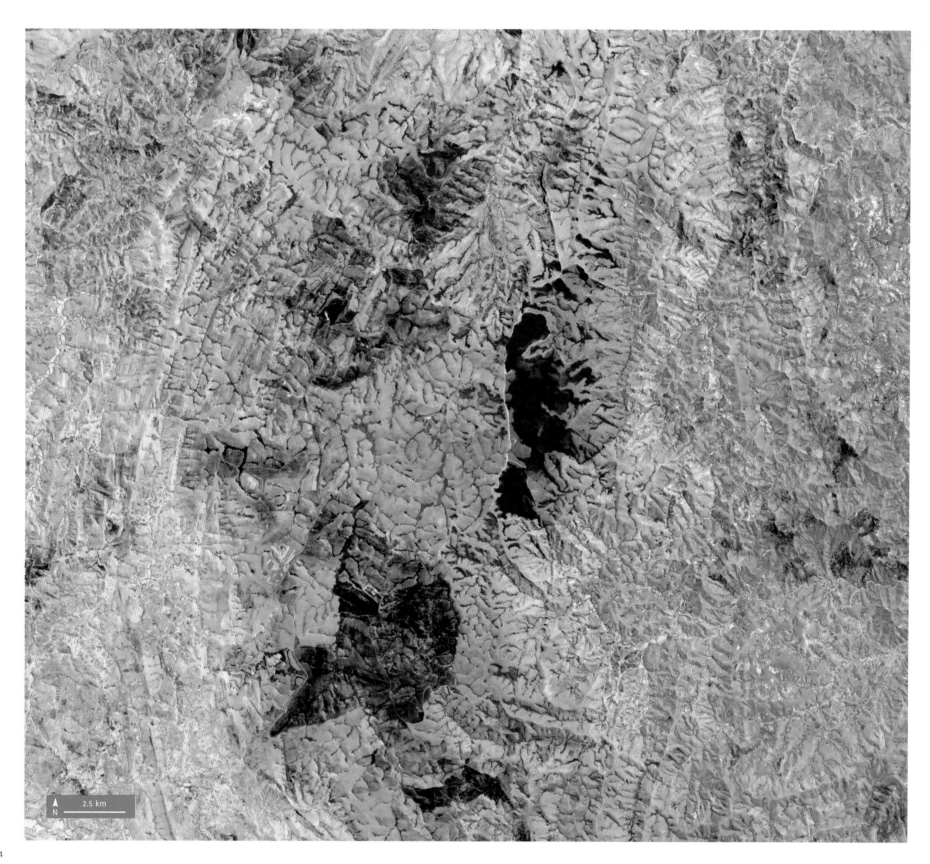

2.5 km
N

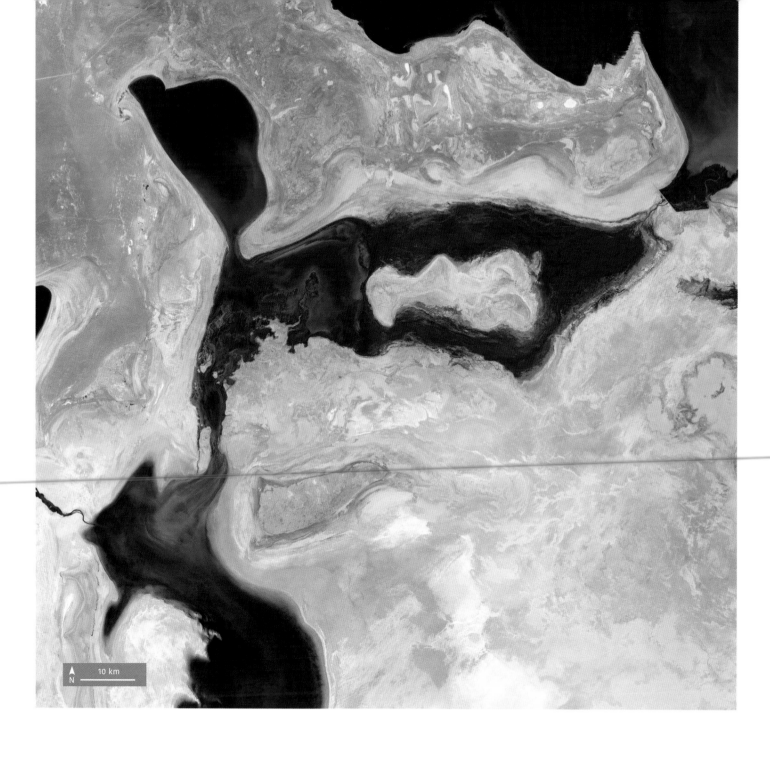

OPPOSITE: The Ambohitantely Reserve – the green patch just right of centre – is the last of Madagascar's central forest, owing to deforestation for agriculture and logging. The other dark areas are from fires sweeping through the grassland that replaced it.

RIGHT: In the 1950s, Central Asia's Aral Sea was the fourth-largest lake in the world. In the 1950s and 1960s, the former Soviet Union's irrigation projects diverted water away from it, and now less than ten per cent remains, barely half of that able to support fish.

N 10 km

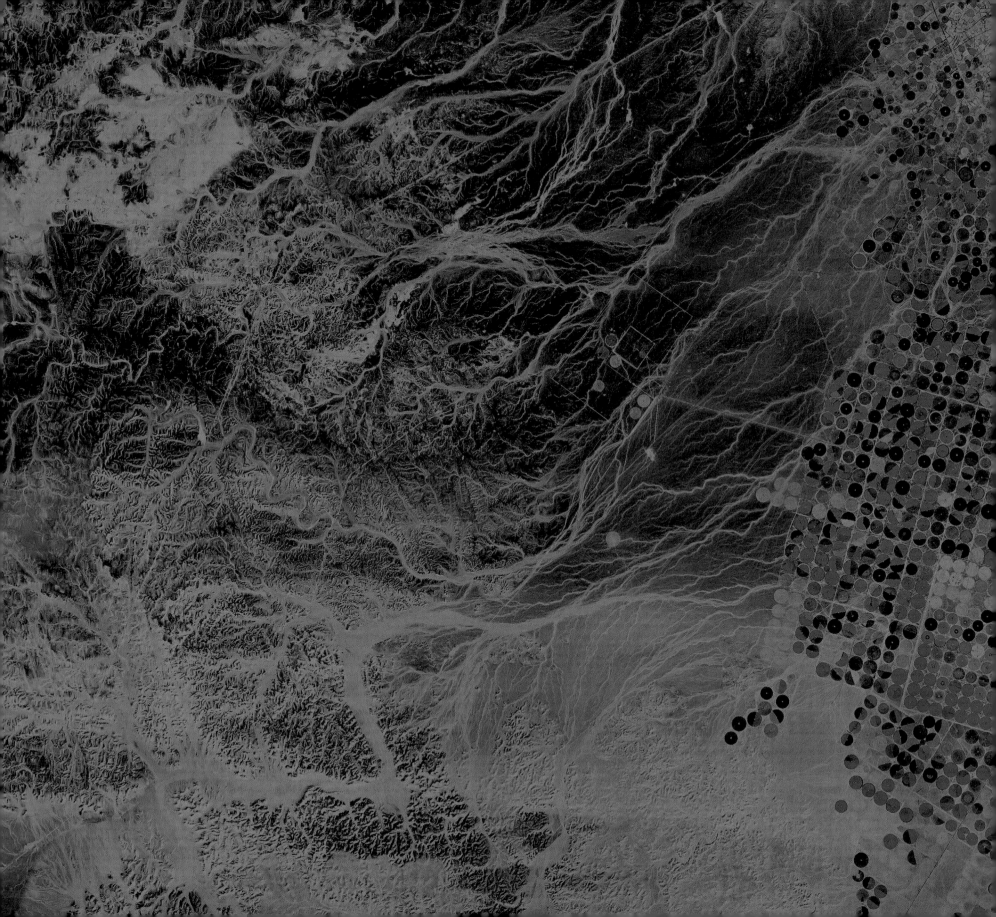

HIDDEN PATTERNS

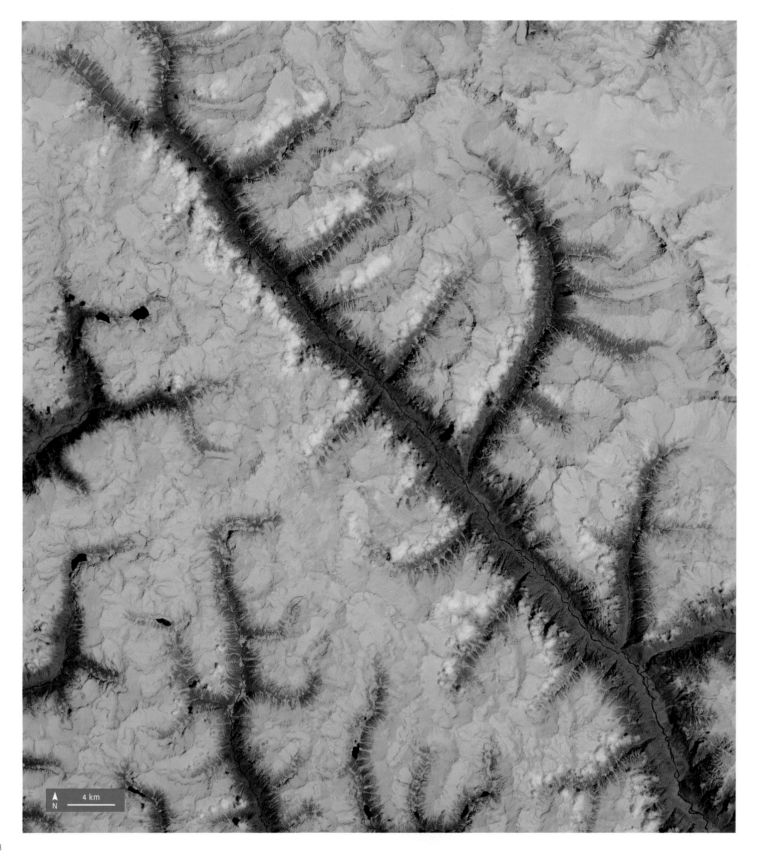

LEFT: In this stunning false-colour image of the mountains in south-eastern Tibet, vegetated valleys are shown in green, while snow and ice show as turquoise, and the patches of deep blue are mountainous lakes.

4 km
N

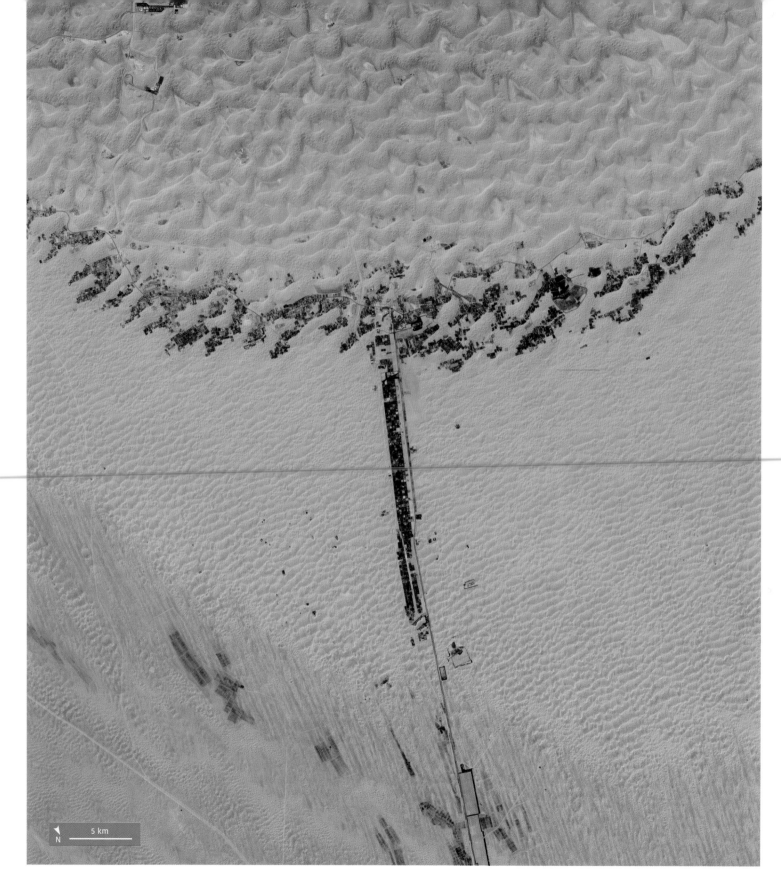

RIGHT: In the United Arab Emirates, the roads around Abu Dhabi's Liwa oasis (the arc) and the E45 highway leading to it (the straight line) are lined with the dark green of date tree plantations.

5 km

N

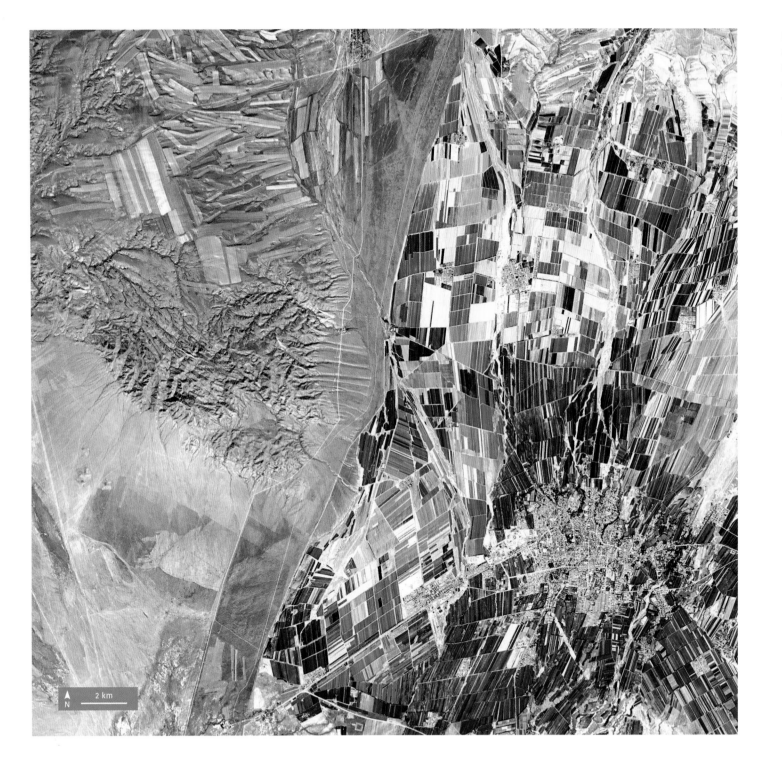

LEFT: Political borders can be abrupt in real life. China's Qoqek city, on the right, is in an area of intensely irrigated farmland, while Kazakhstan's Lake Balkhash is naturally, and only sparsely, farmed.

OPPOSITE: The Mississippi River has snaked hundreds of miles to and fro over the centuries. With New Orleans, Baton Rouge, and many smaller cities now spread across its delta, keeping it in place is vital.

2 km

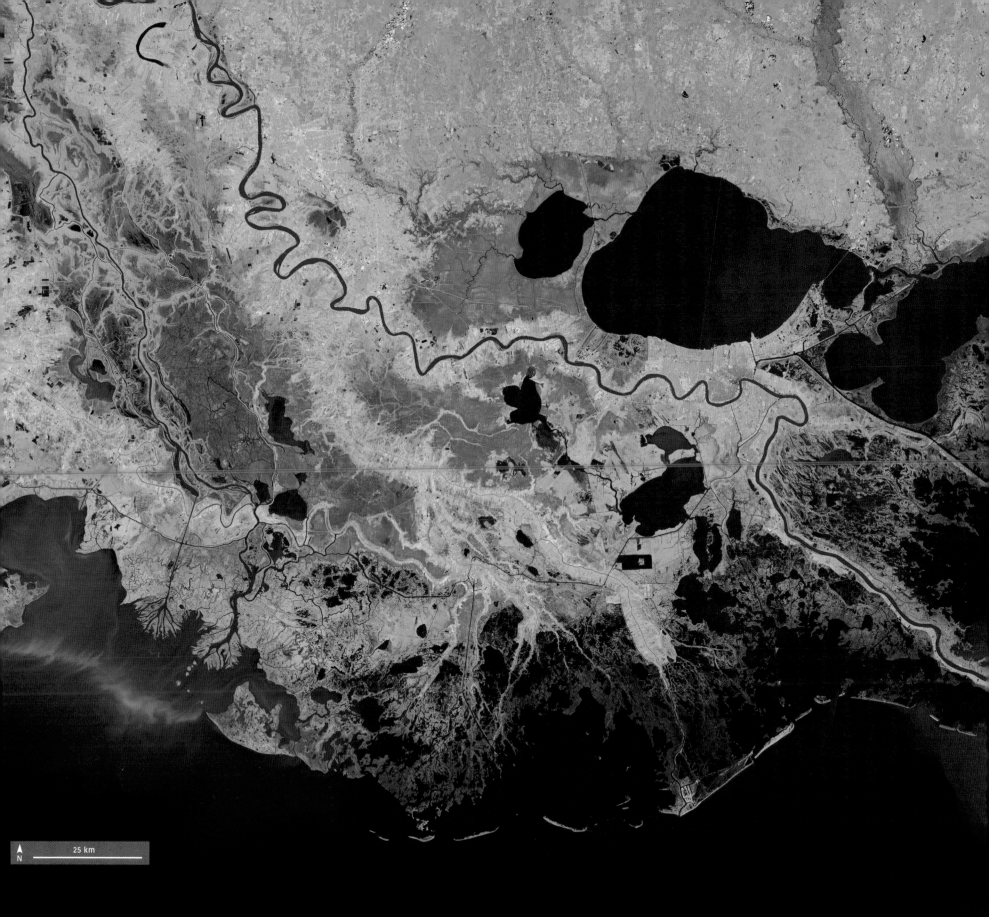

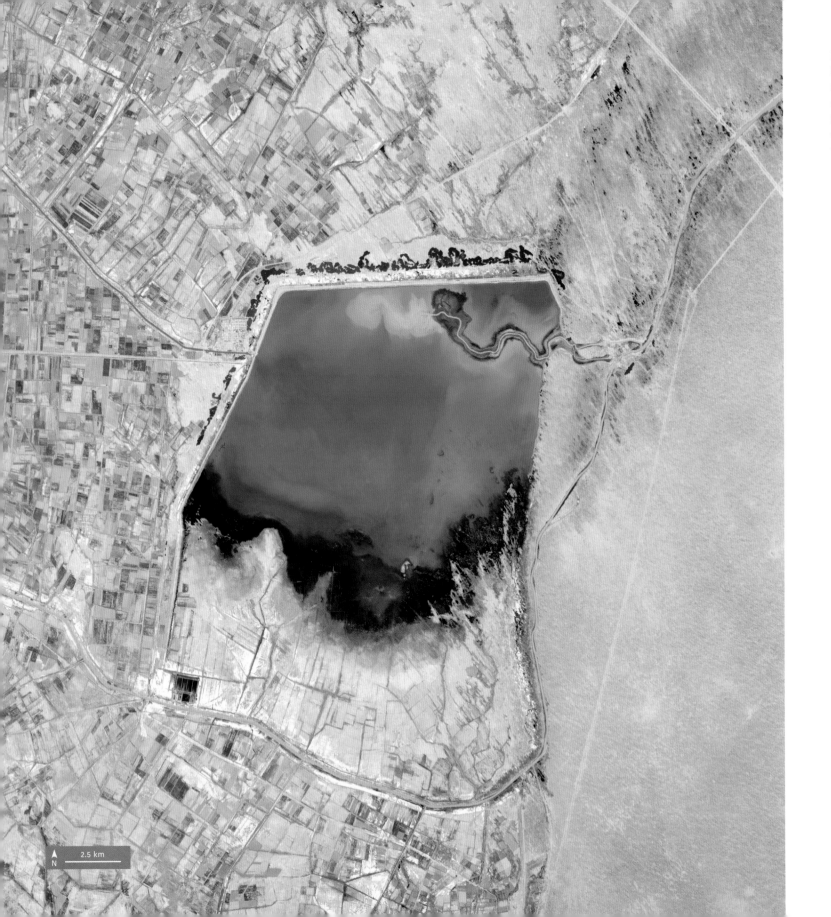

LEFT: Turkmenistan's Hanhowuz Reservoir is a water store for the Garagum Canal, a Soviet project to open the Karakum Desert to farming. It worked, but largely destroyed the Aral Sea in the process.

2.5 km

N

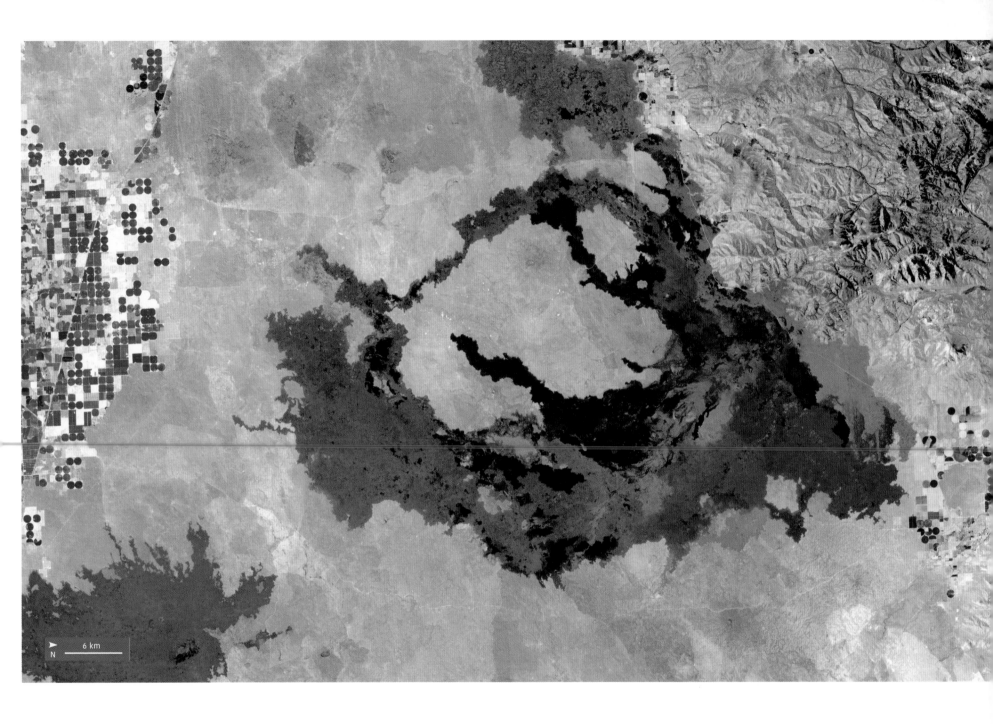

ABOVE: The black ink-like stains spreading over the Snake River Plain in Idaho are known as the Craters of the Moon. They are made up of sixty-plus lava flows emitted by open rift cracks over the last 15,000 years.

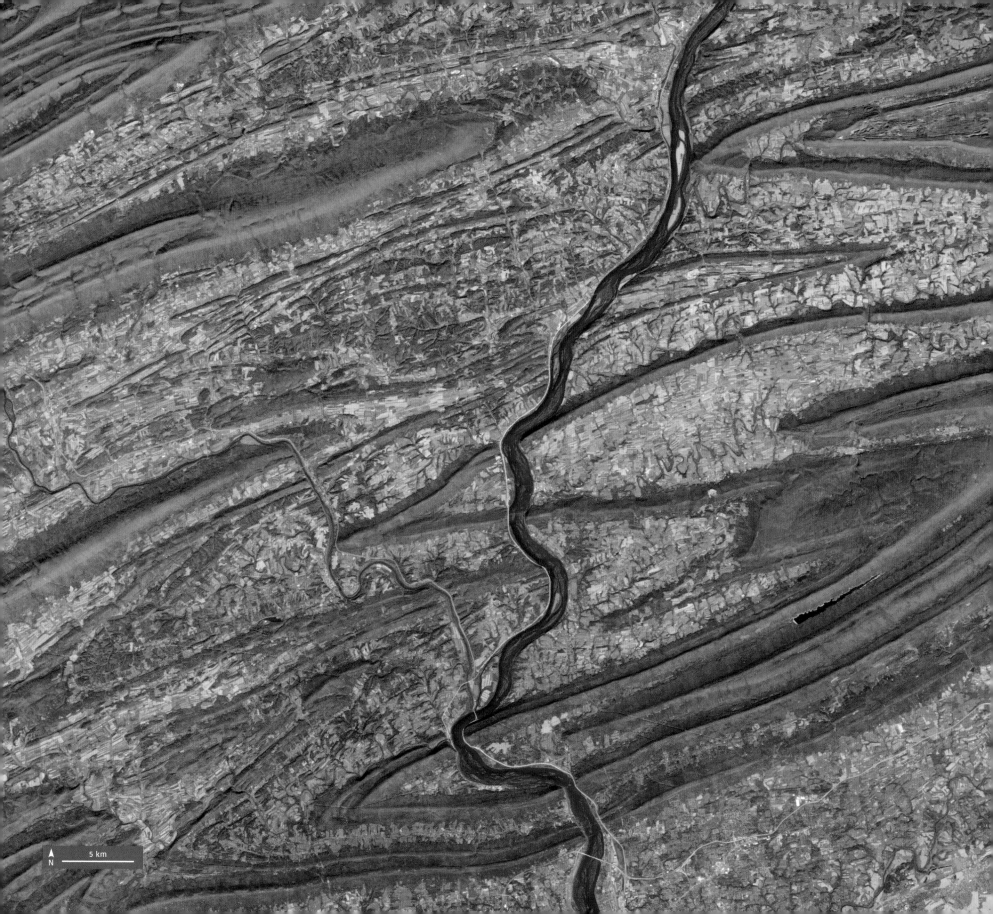

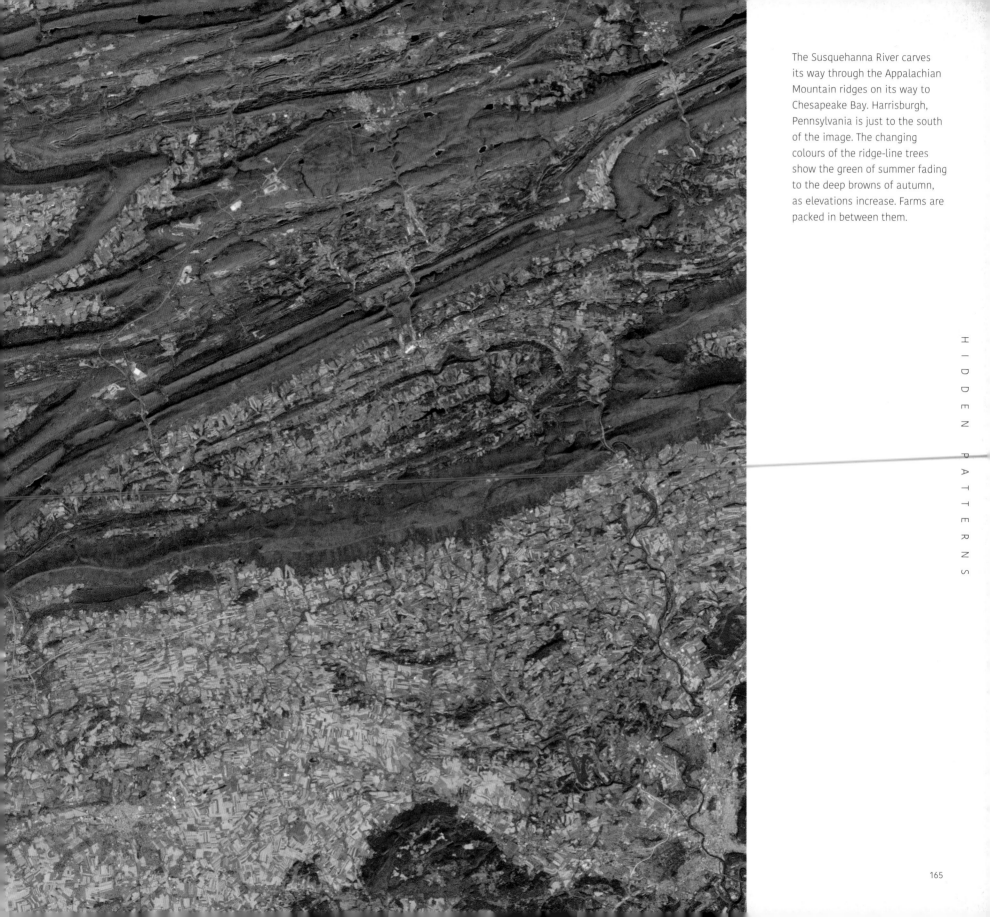

The Susquehanna River carves its way through the Appalachian Mountain ridges on its way to Chesapeake Bay. Harrisburgh, Pennsylvania is just to the south of the image. The changing colours of the ridge-line trees show the green of summer fading to the deep browns of autumn, as elevations increase. Farms are packed in between them.

RIGHT: The Antarctic coast gives way to thick permanent sea ice, which is bordered by thinner, impermanent ice that, in turn, breaks into fragments. The large chunks that speckle the thick ice are icebergs, locked in place.

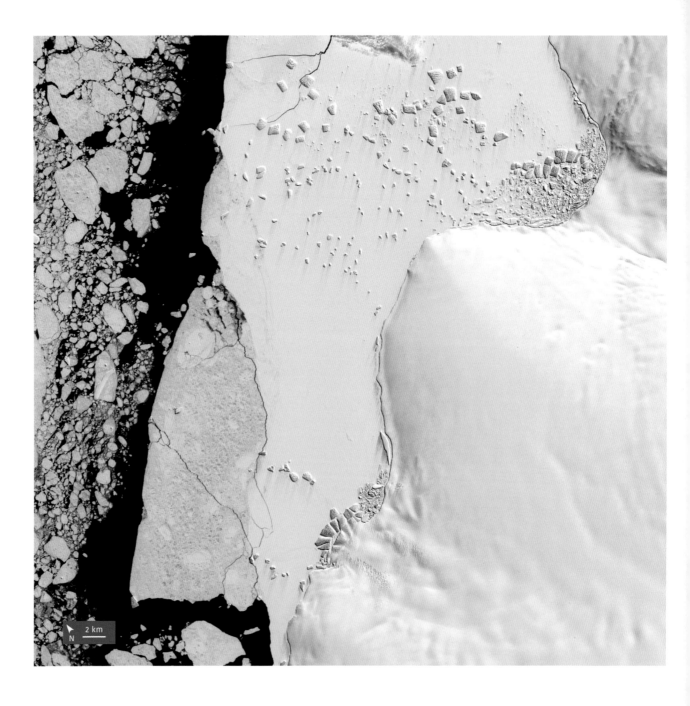

2 km

N

OPPOSITE: Ulban Bay, in the far east of Russia, opens out onto the Sea of Okhotsk, a sheltered part of the northern Pacific. Mostly uninhabited by people, the bay is a popular feeding ground for whales.

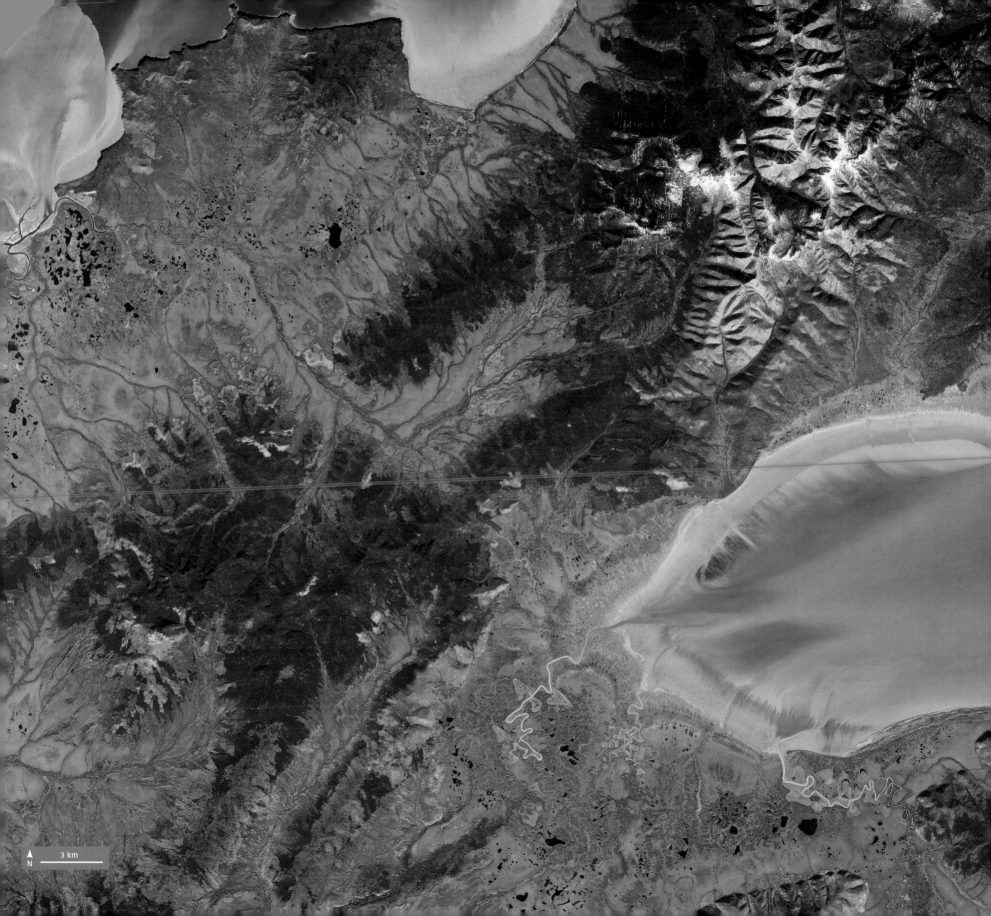

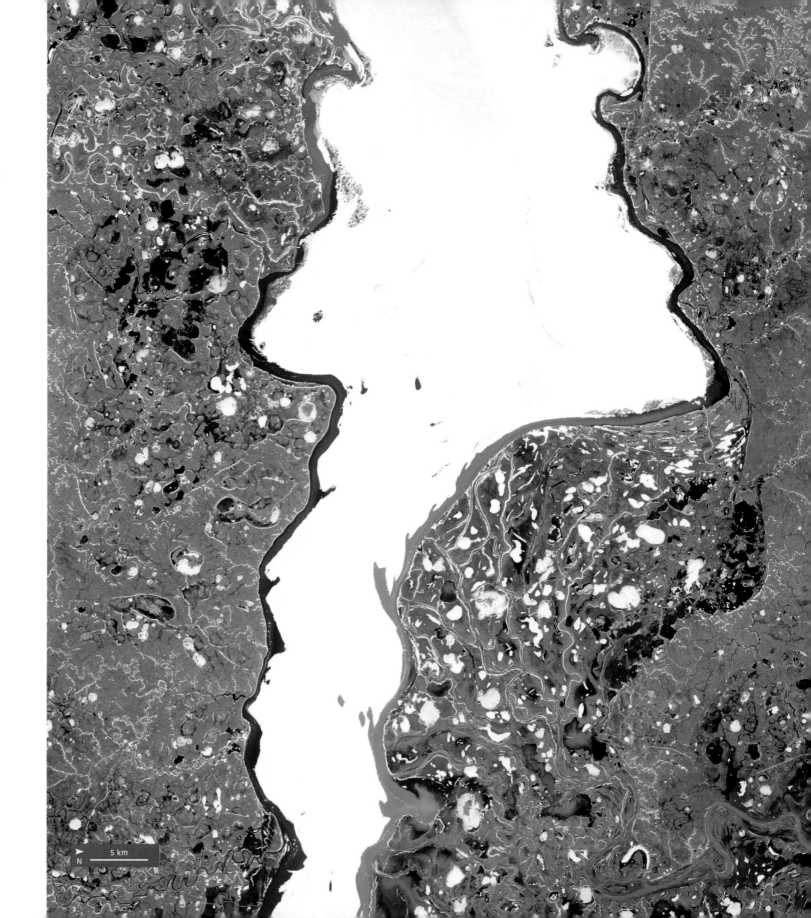

RIGHT: The Taz River in West Siberia's Yamalo-Nenets Autonomous Okrug feeds into the Gulf of Ob, and from there to the northern Pacific. It remains frozen as late in the year as June, becoming ice-clear by July. Surrounding the river is an intricate pattern of frozen tributaries and wetlands.

5 km

N

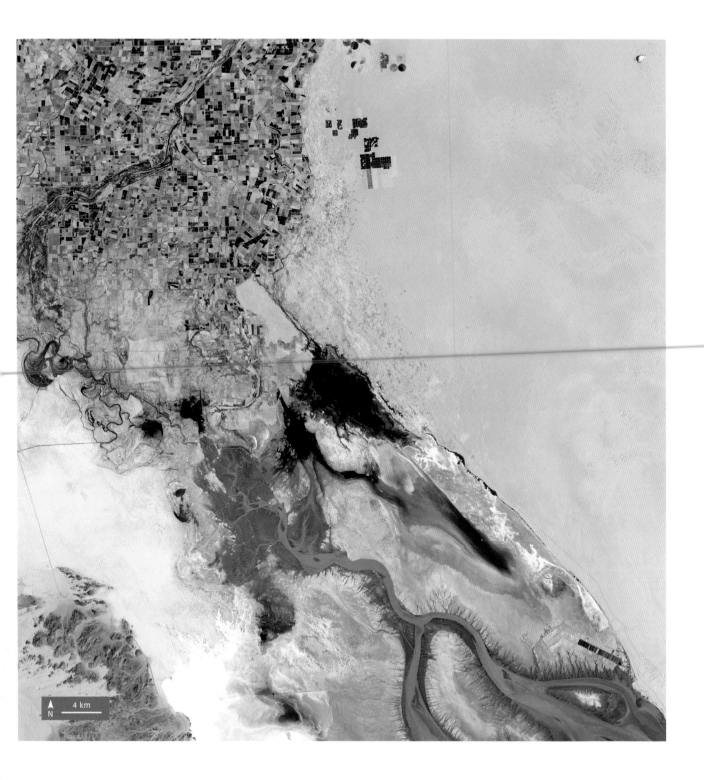

LEFT: South of the city of Mexicali in Baja California, Mexico, the Colorado River winds towards the Gulf of California. It rarely gets there, as its water is diverted to Mexicali by the Morelos dam.

4 km
N

OPPOSITE: The rolling sand dunes or ergs of western Algeria's province of Adrar, known as the Erg Iabès, are formed by strong winds. This gives them the form of long, mostly parallel lines.

RIGHT: Despite being in the hyper-arid eastern Sahara, west Egypt's Sharq El Owainat uses fossil water from the Nubian Sandstone Aquifer to farm more than 100,000 acres (405 square km) of former desert, mostly for wheat. The circles are formed by the irrigation method: sprinklers rotating around a central pivot.

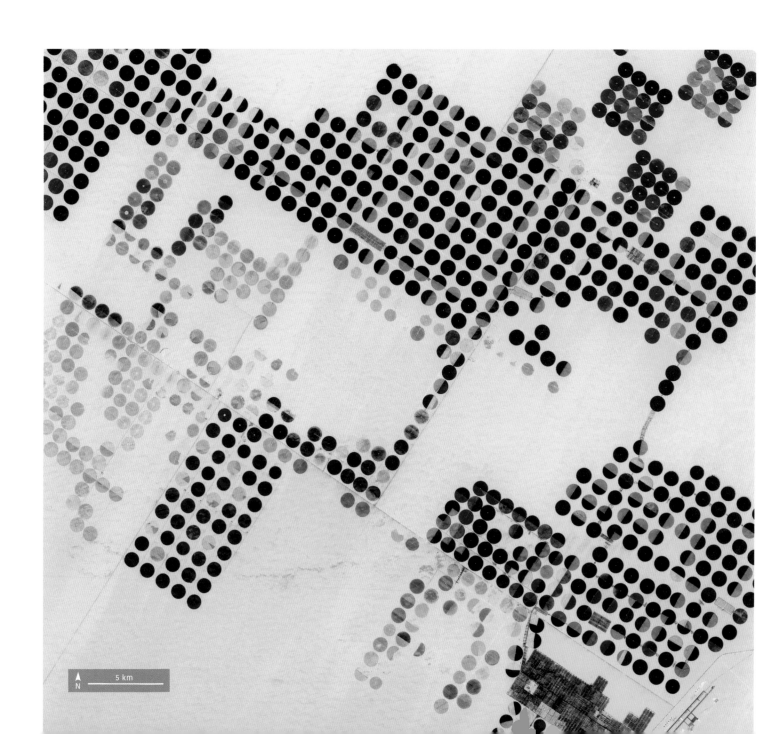

5 km
N

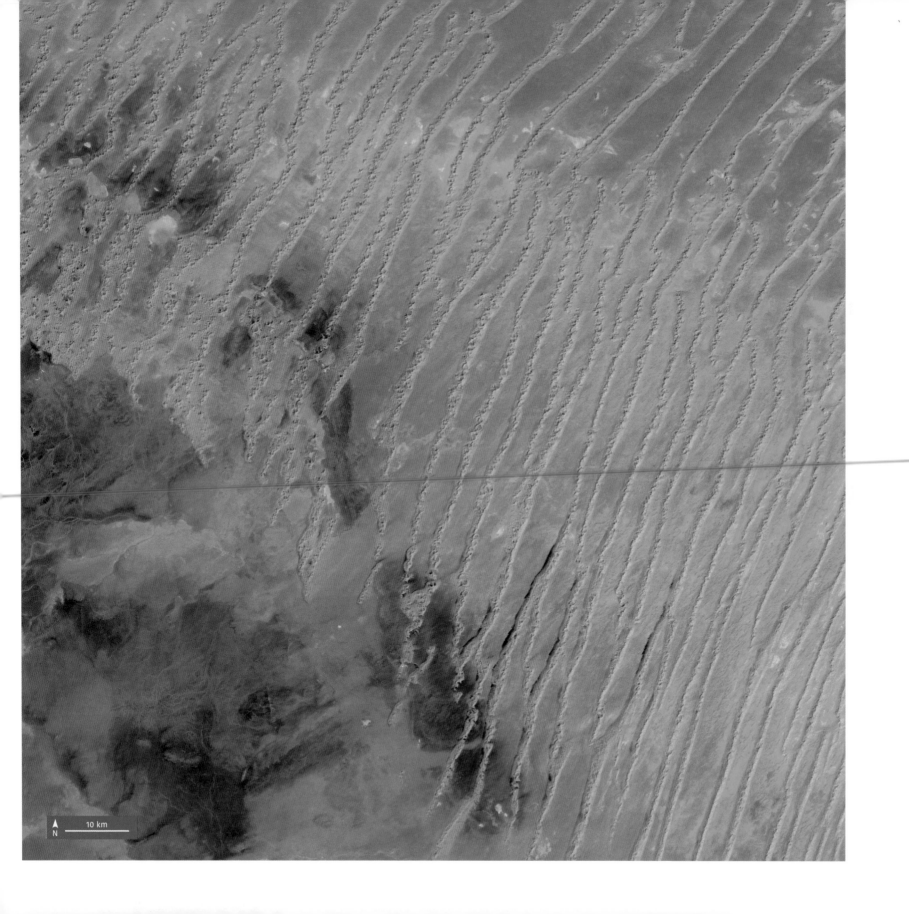

10 km

N

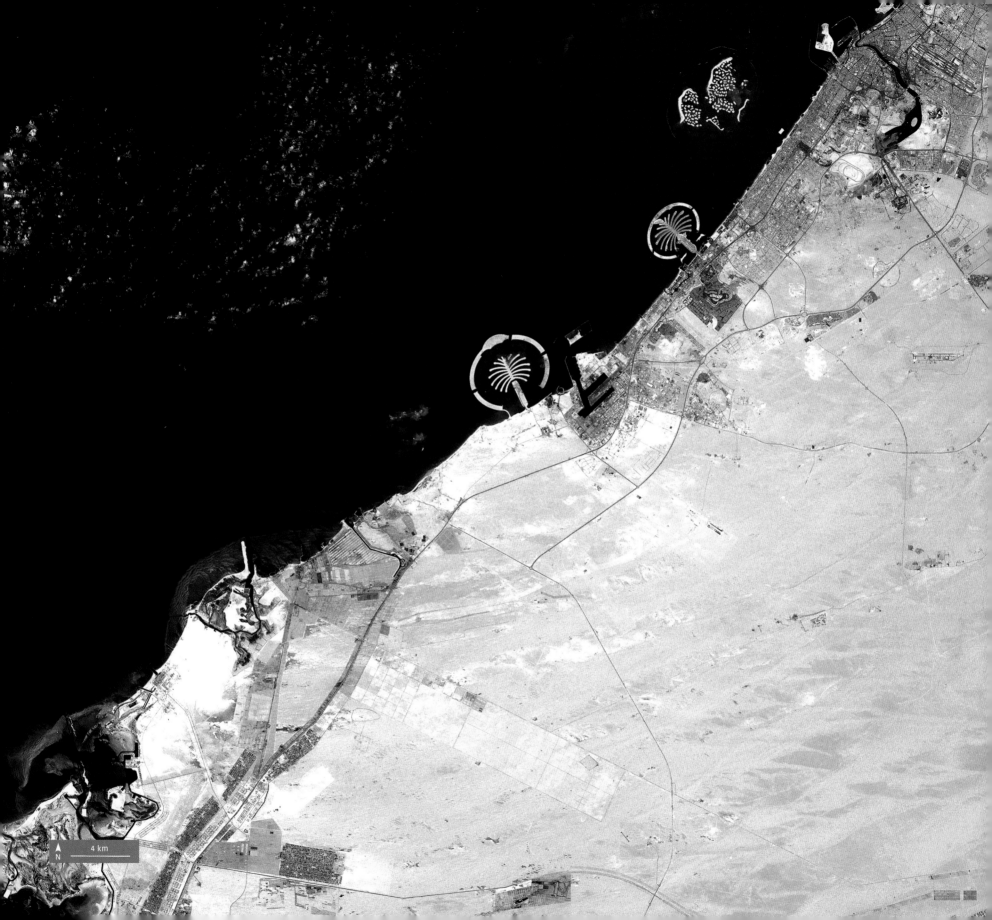

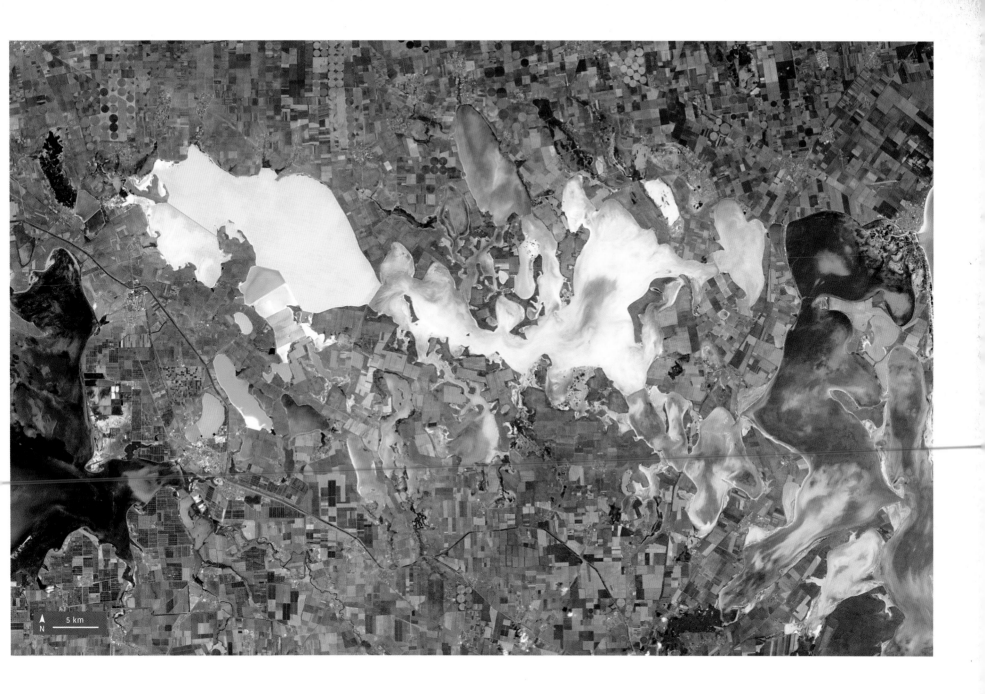

OPPOSITE: Dubai in the United Arab Emirates is a global city synonymous with lavish development. The artificial archipelagos of the Palm Jebel Ali and Palm Jumeirah, and The World Islands, add about 750 miles (1,207km) of beach to the UAE.

ABOVE: Where the Crimea meets mainland Ukraine, the land gives way to the Sivash lagoons, known as the Rotten Sea. The lagoons are shallow and have very varied composition, giving many of them unearthly colours.

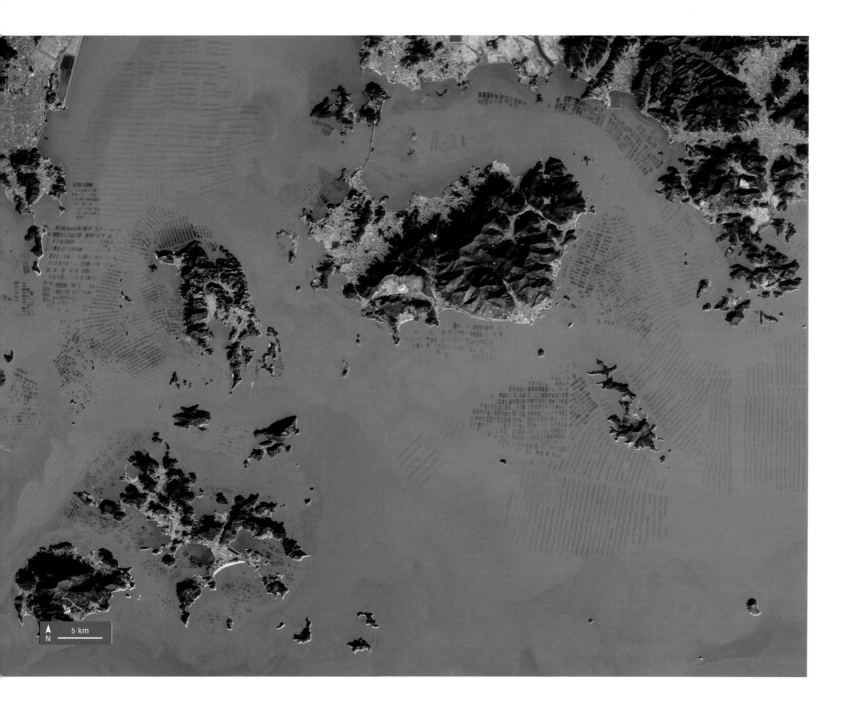

5 km
N

OPPOSITE: Niger's Aïr Mountains rise 7,000 feet (2,134m) out of the sands of the Sahara Desert, like islands. Their habitats and water holes support all sorts of life, including the Addax, a critically endangered antelope.

174

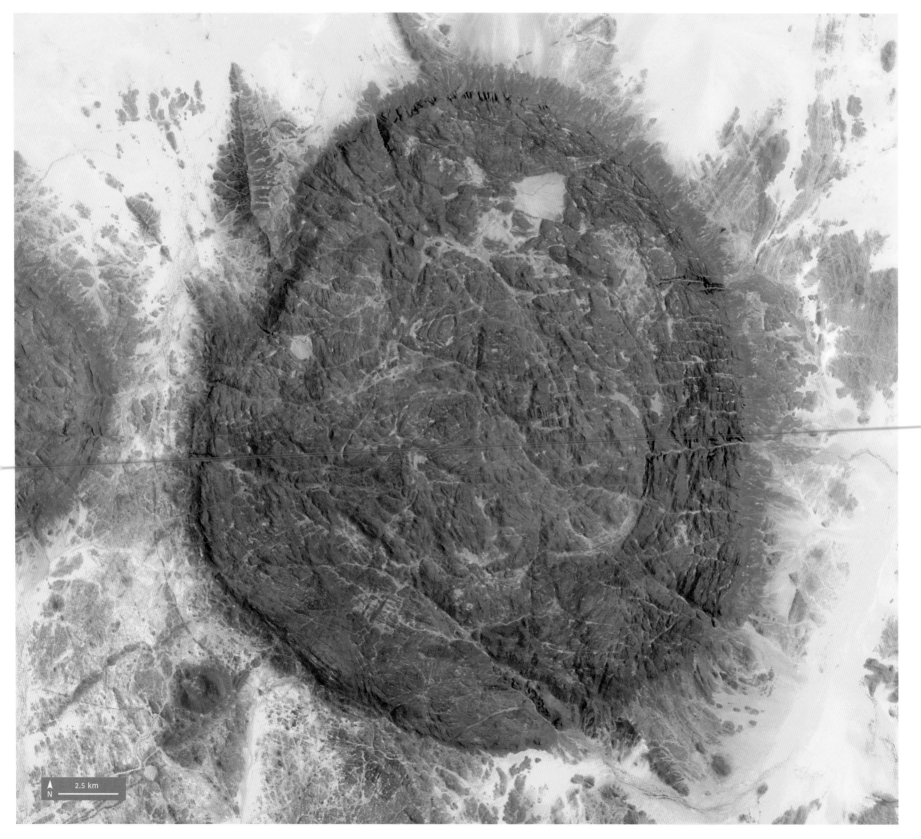

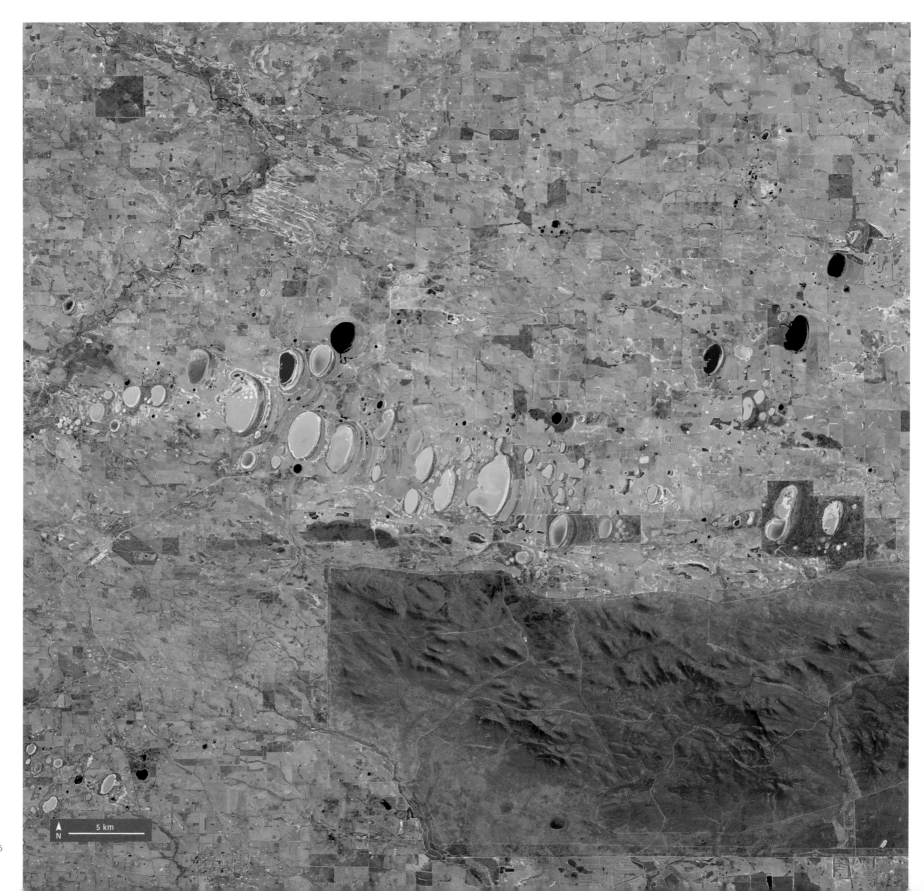

5 km

N

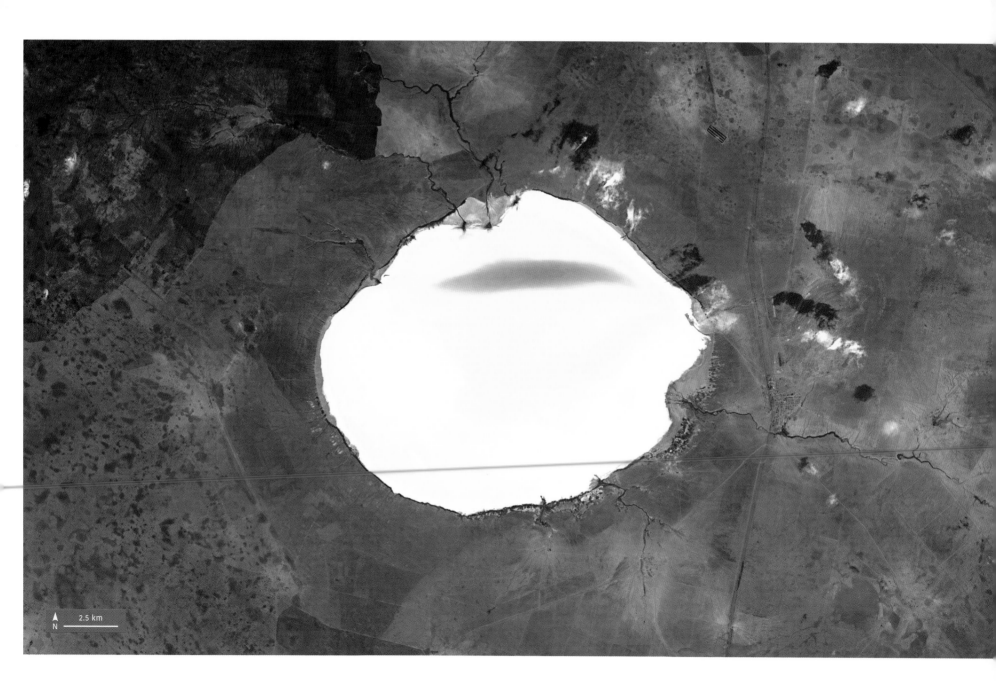

ABOVE: Lake Elton, in western Russia, is one of the saltiest lakes in Europe, and just 1–2 feet (0.3–0.6m) deep. It gets shallower – and more reflective – in summer, and salt has been excavated from it since the 1500s.

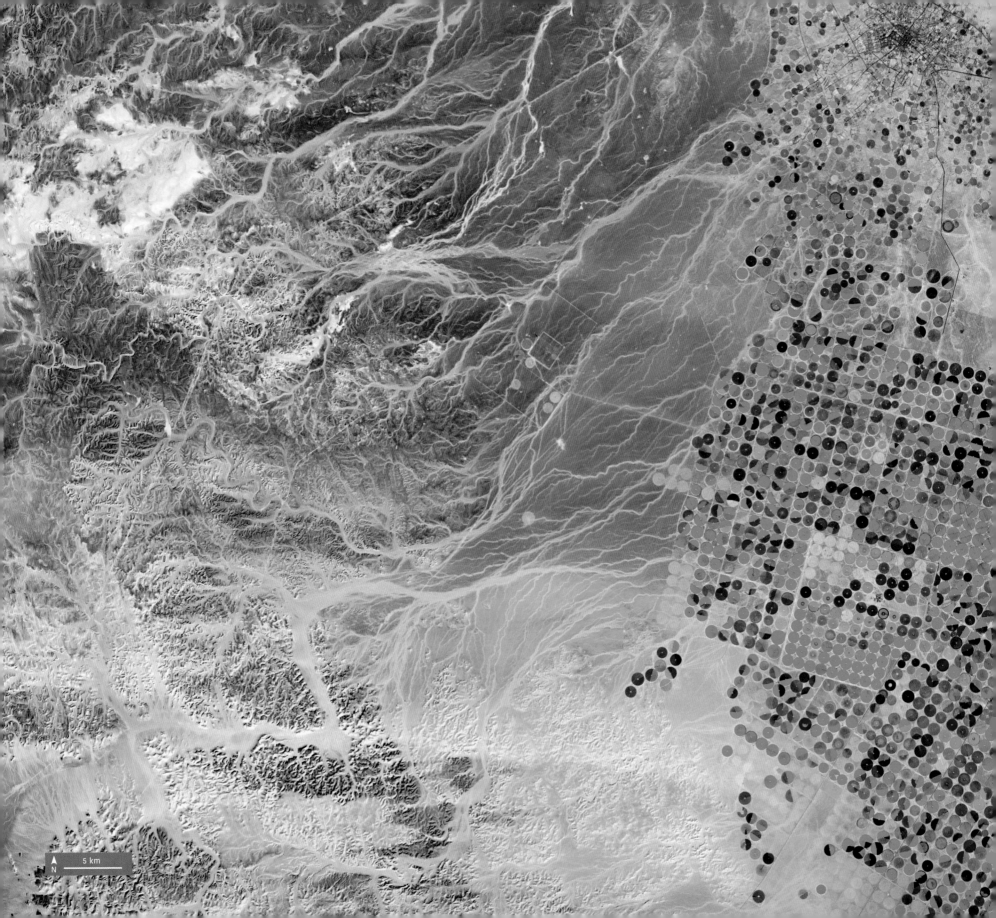

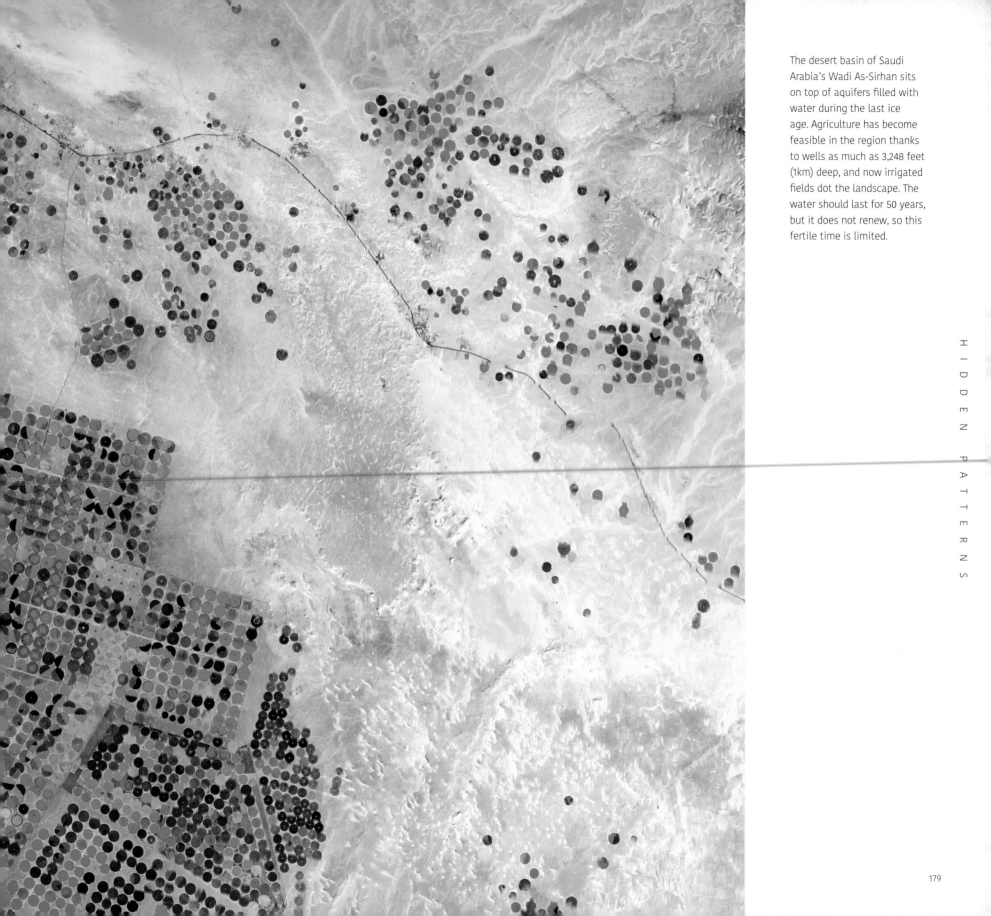

The desert basin of Saudi Arabia's Wadi As-Sirhan sits on top of aquifers filled with water during the last ice age. Agriculture has become feasible in the region thanks to wells as much as 3,248 feet (1km) deep, and now irrigated fields dot the landscape. The water should last for 50 years, but it does not renew, so this fertile time is limited.

BELOW: Iran's Dasht-e-Kavir, the Great Salt Desert, is what remains of an ancient sea bed. A 4 mile/6.4km-thick layer of salt lies beneath the sands, and in places, reflective domes of it rise up like mountains.

OPPOSITE: Freckles of snow dust the Netherlands near to large industrial areas in this image from January 2017. Water vapour produced by industry can form fogs which then turn into light snowfall in freezing conditions.

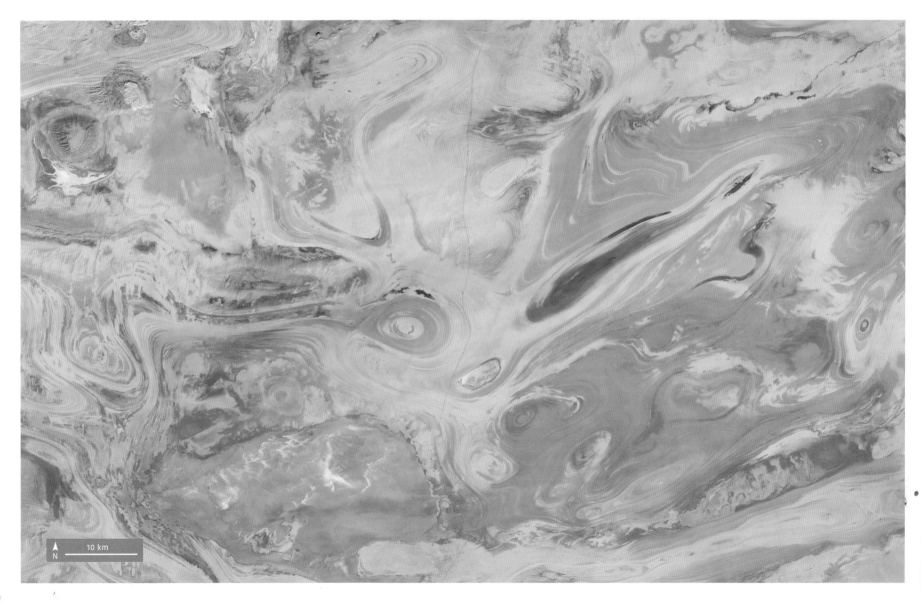

10 km

N

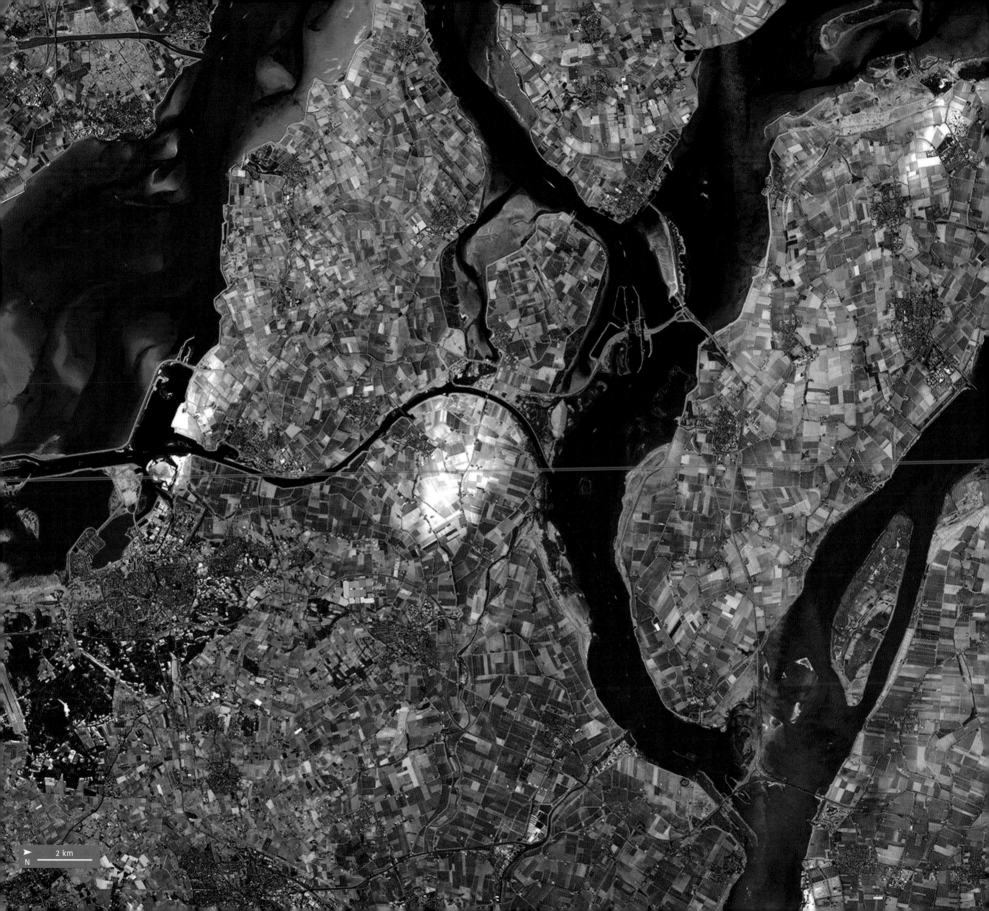

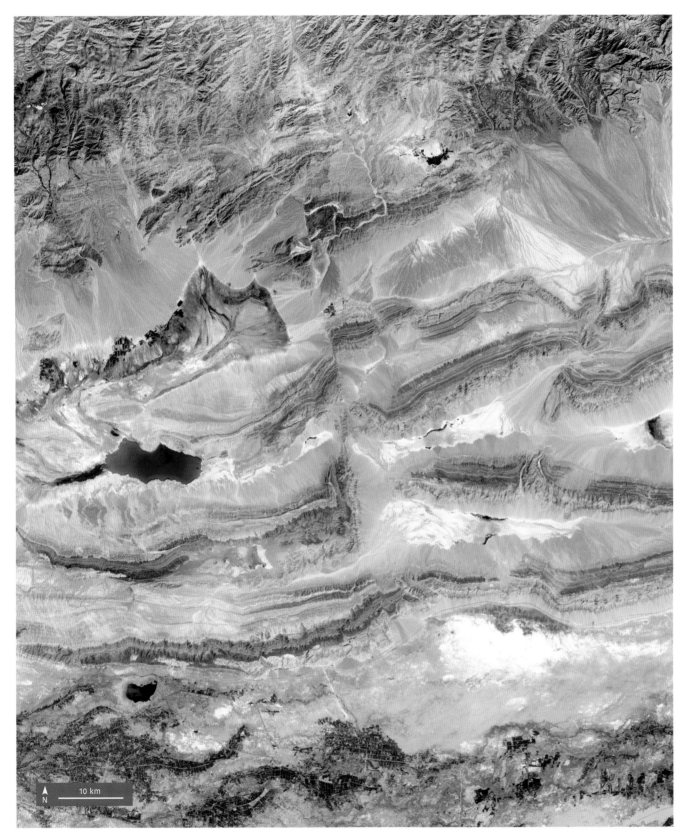

LEFT: The rippled ridges of the Keping Shan belt, just south of the Tien Shan mountains in extreme north-west China, show bands of rock formed by 250 million years of different tectonic plates colliding.

OPPOSITE: Argentina's Lake Epecuén, in the centre of this false-colour image, is highly salty. People used to flock to Villa Epecuén, a spa town on the north-east shore. In the 1980s, years of high rainfall left the town submerged under 30ft (9.1m) of water. As the climate changes, the ruins are starting to re-emerge from the lake, crusted in salt.

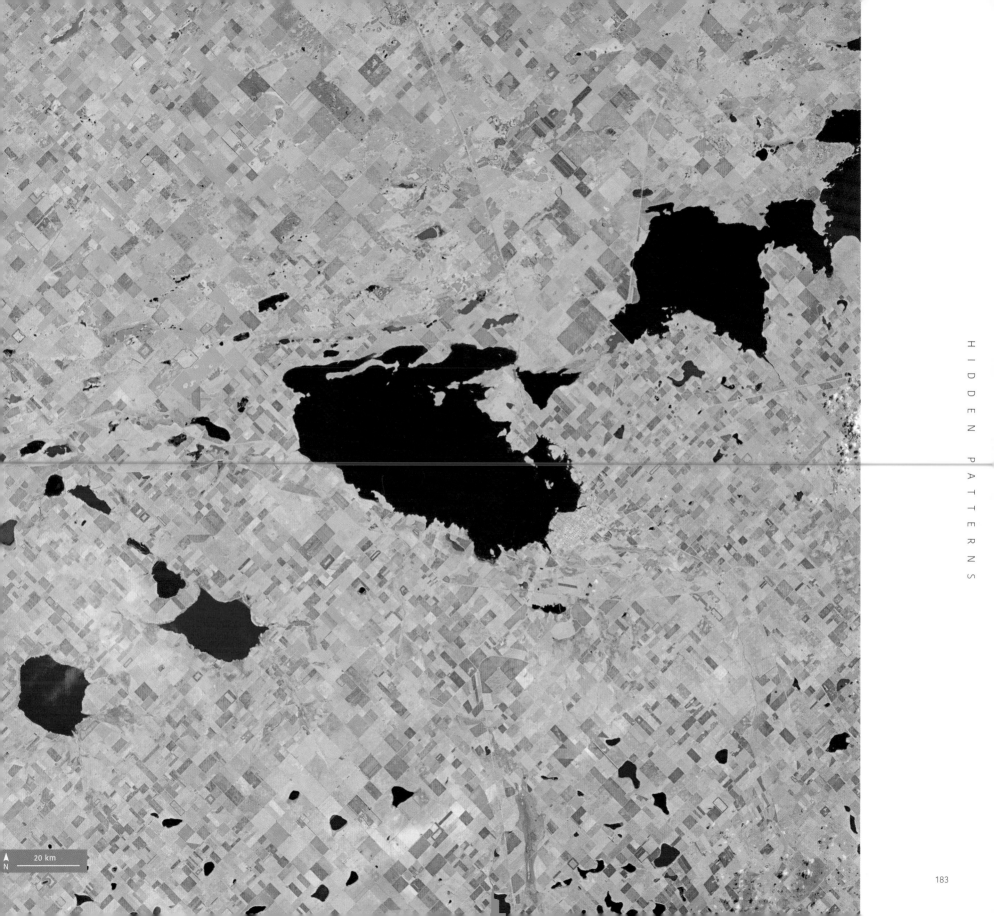

20 km

N

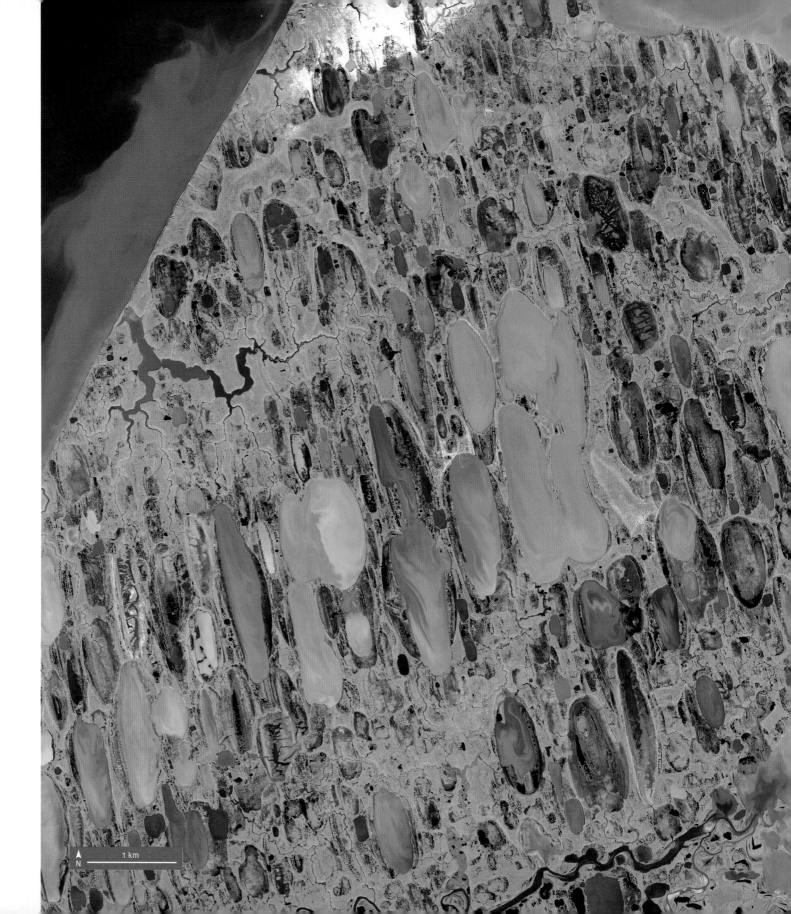

The north shore of the USA's National Petroleum Reserve–Alaska is protected from the Beaufort Sea by the thin, narrow barriers of the Tapkaluk Islands. The wetlands that form the spotted pattern are an important nesting ground for migratory birds.

1 km

N

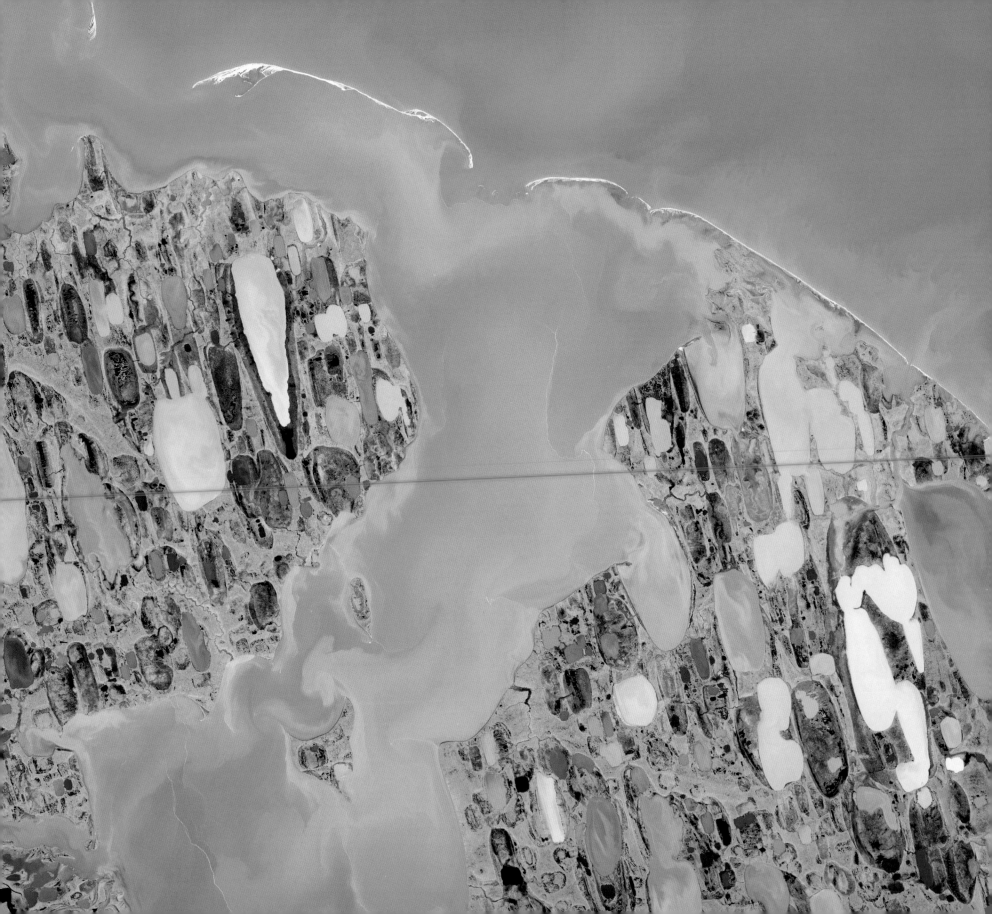

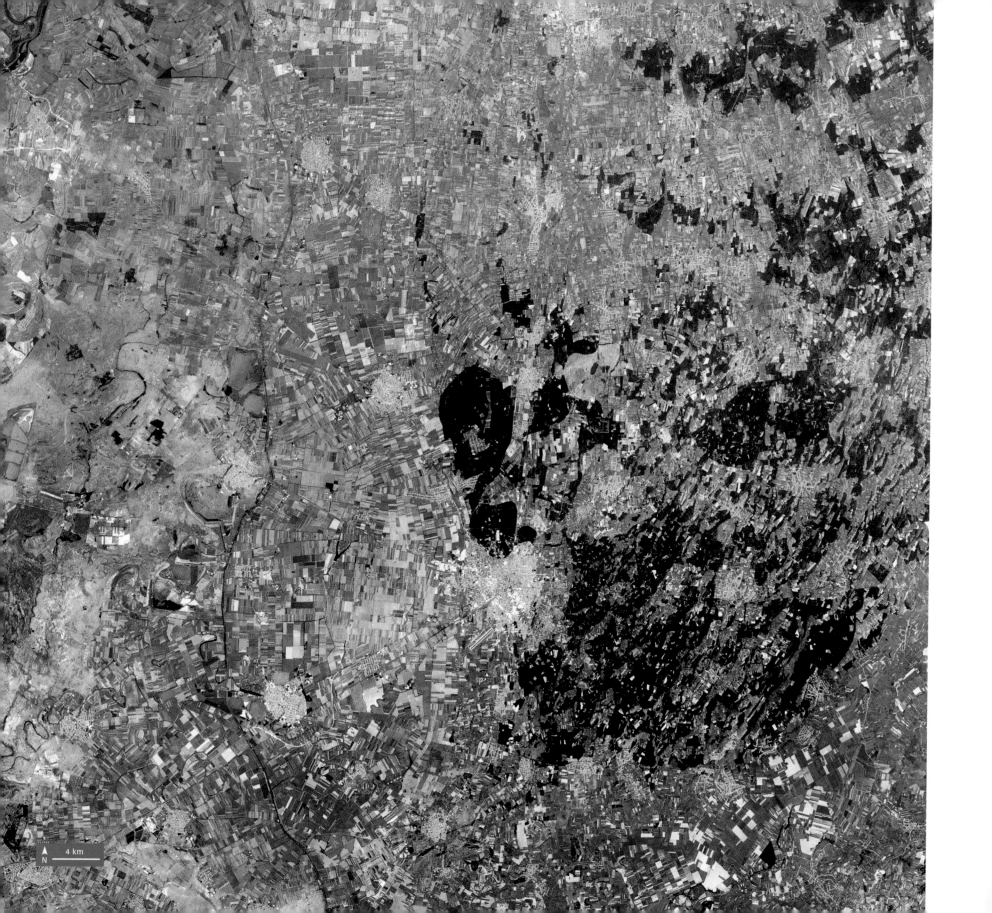

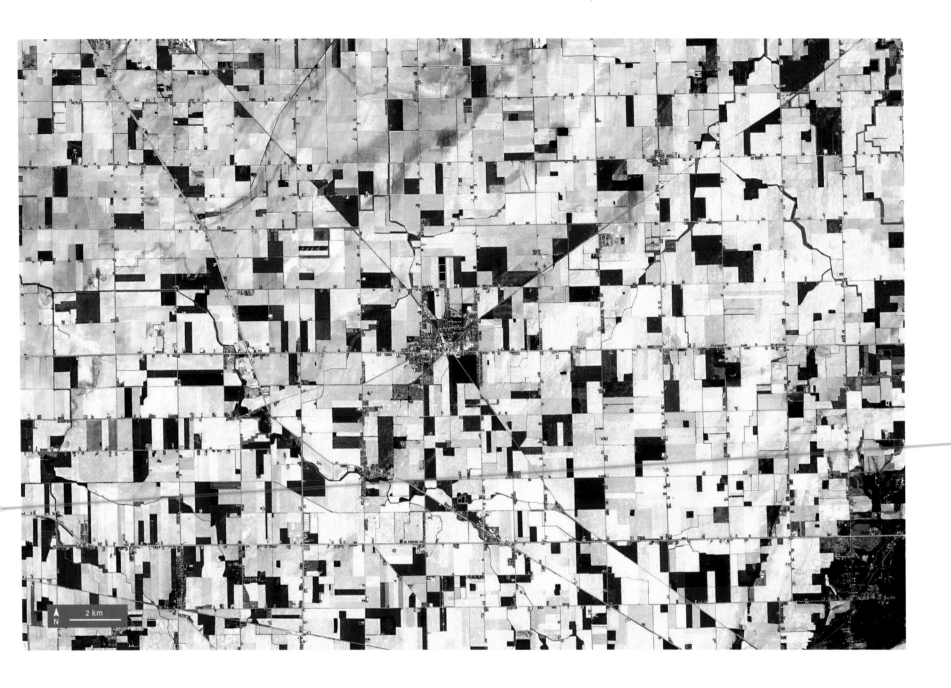

OPPOSITE: The Hungarian town of Hajdúböszörmény, just below the forest at the centre of this image, was a reward. The local Haiduk took arms for the Prince of Transylvania, and were gifted self-government here.

ABOVE: Reese, Michigan sits where a large X of railway tracks cross at the M-81 highway. Local field boundaries pick out the diagonal tracks, but the larger square pattern reflects the USA's Homestead Act of 1862.

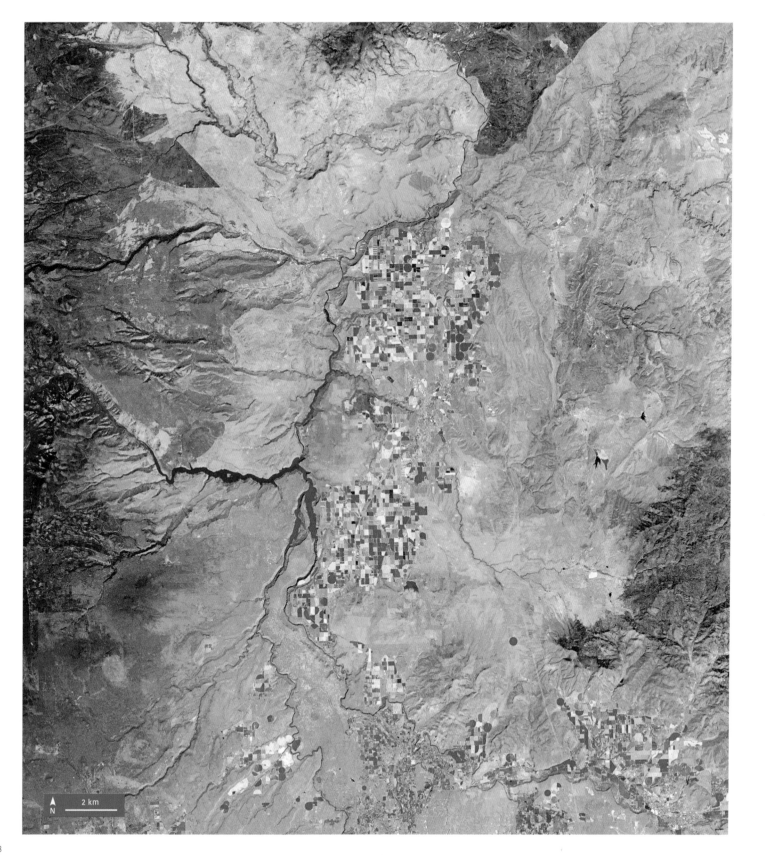

LEFT: The city of Madras, Oregon in the USA sits at the centre of this image. Its arable land ends north and west at the borders of the Warm Springs Indian Reservation, which was on fire for much of 2017.

OPPOSITE: Western China's largest salt lake, Lake Cha'erhan, is mostly dry a lot of the time. The green rectangular areas are evaporation ponds for mineral collection. Dabuxun Lake, the plume on the left, is permanently wet.

2 km
N

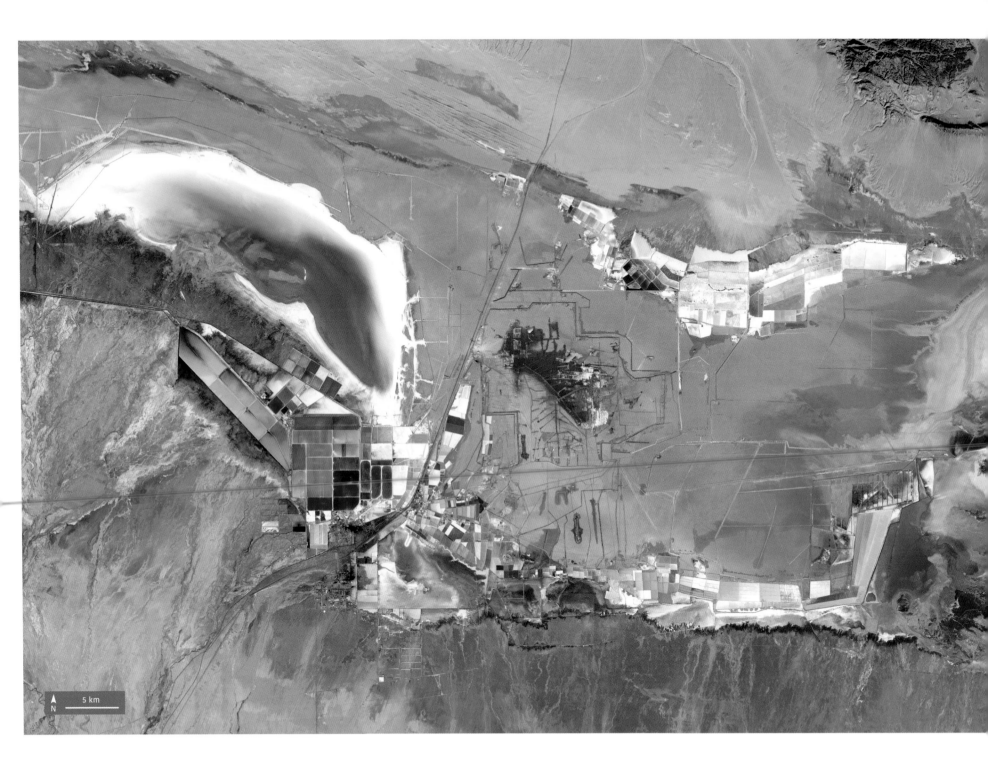

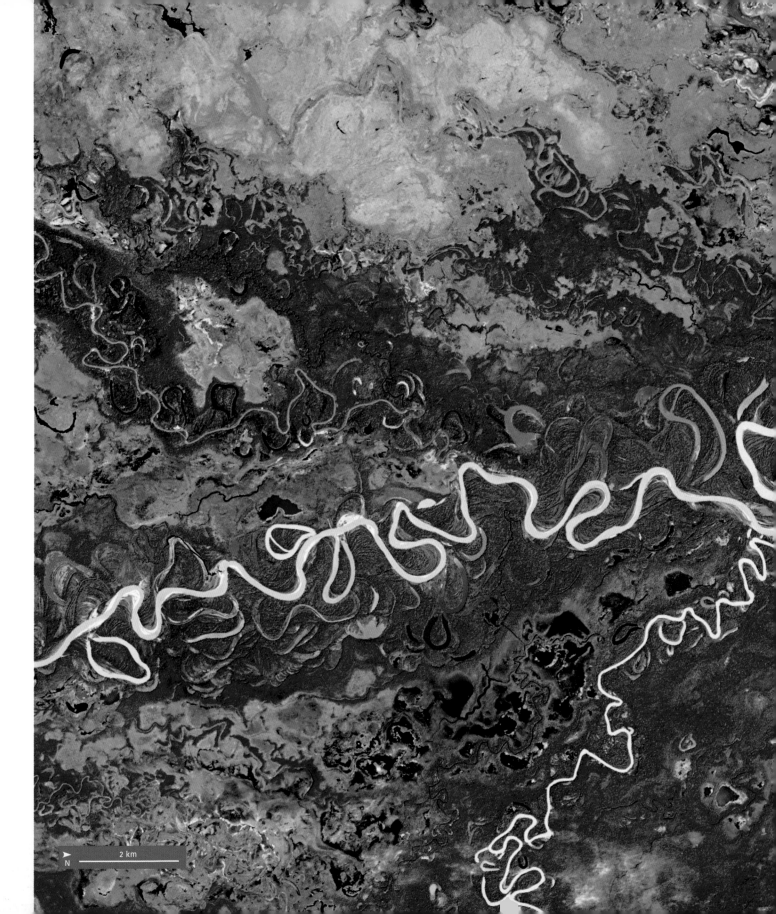

The Rio Mamoré meanders across this image of the Amazon Basin, with the Rio Grande wandering towards it from below. Rivers meander more as the amount of sediment they contain increases. The channels cut into the forest around the rivers clearly show how their courses have switched around over the decades.

2 km

N

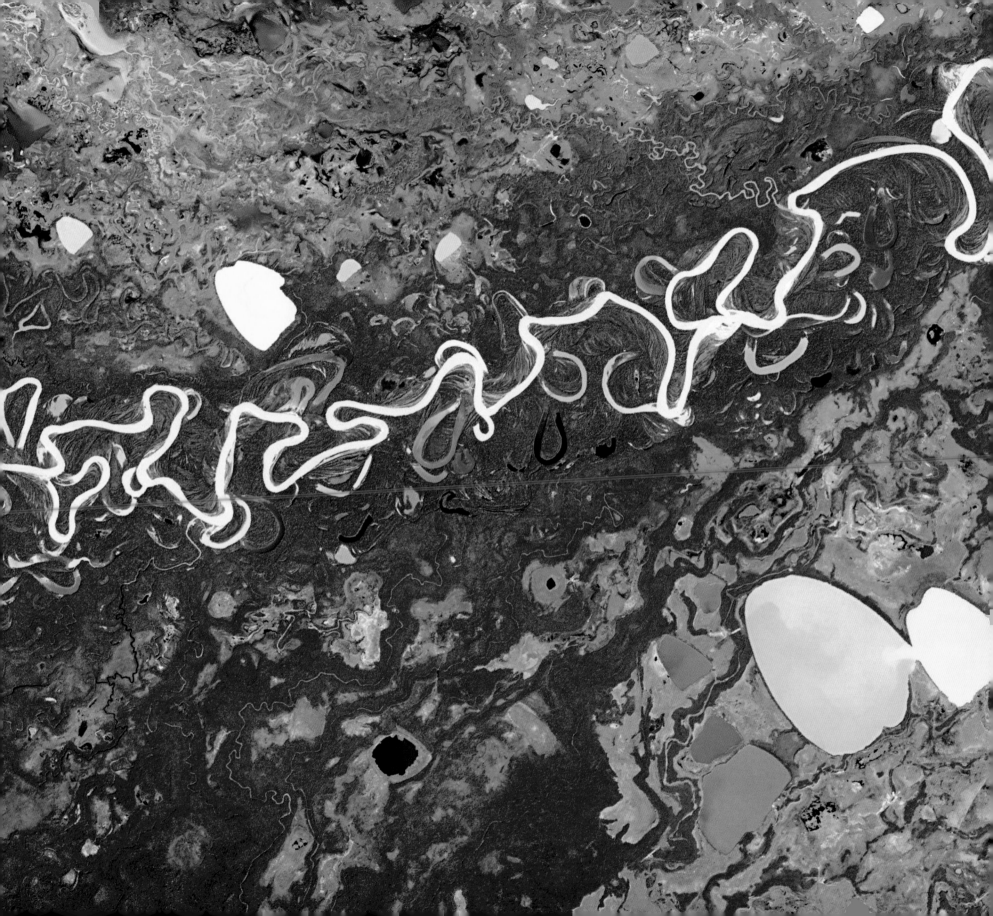

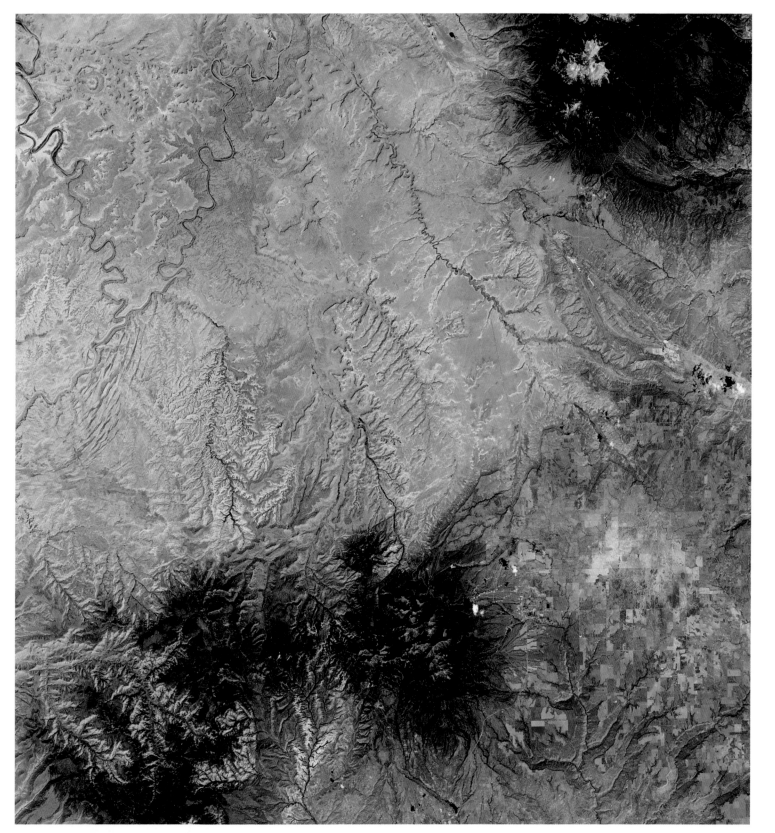

LEFT: Utah's Canyonlands National Park contains some of the most inaccessible terrain in the USA. The dark patches shown are mountains, but the region is known for its eroded canyons, buttes and mesas.

OPPOSITE: The Southern Four Lakes of east China's Shandong Province – from top to bottom, Nanyang Lake, the ridge-separated pair of Dushan and Zhaoyang Lakes, and Nansi Lake – are widely used for fish farming.

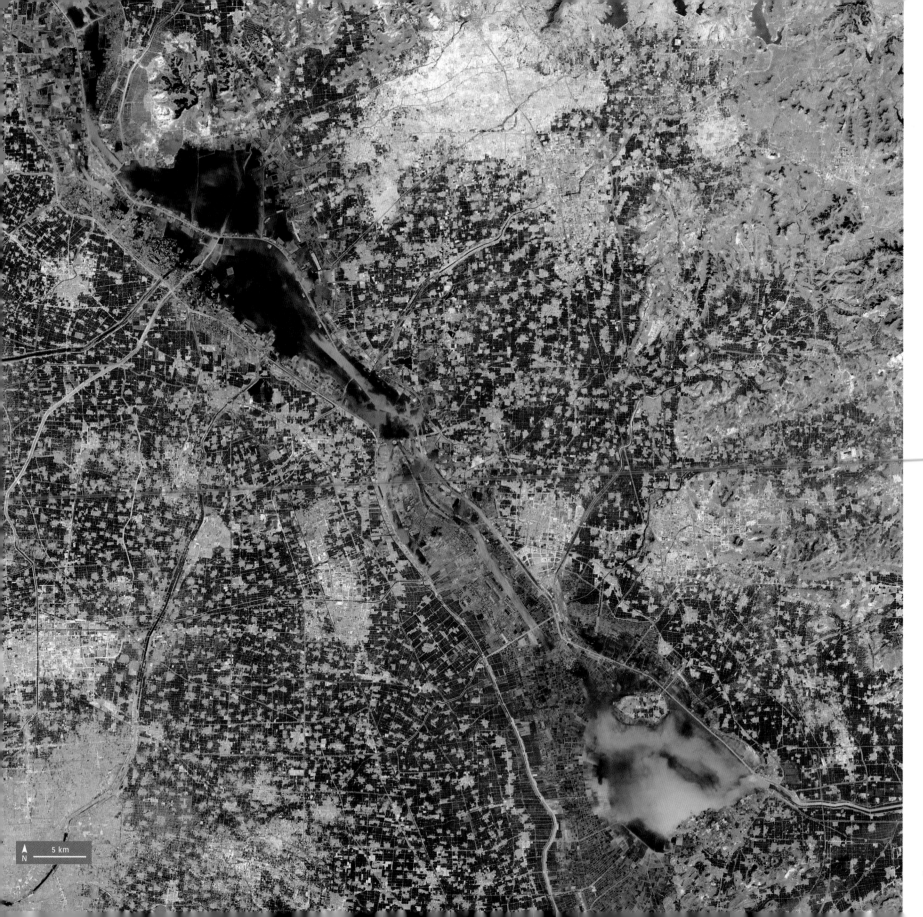

5 km

N

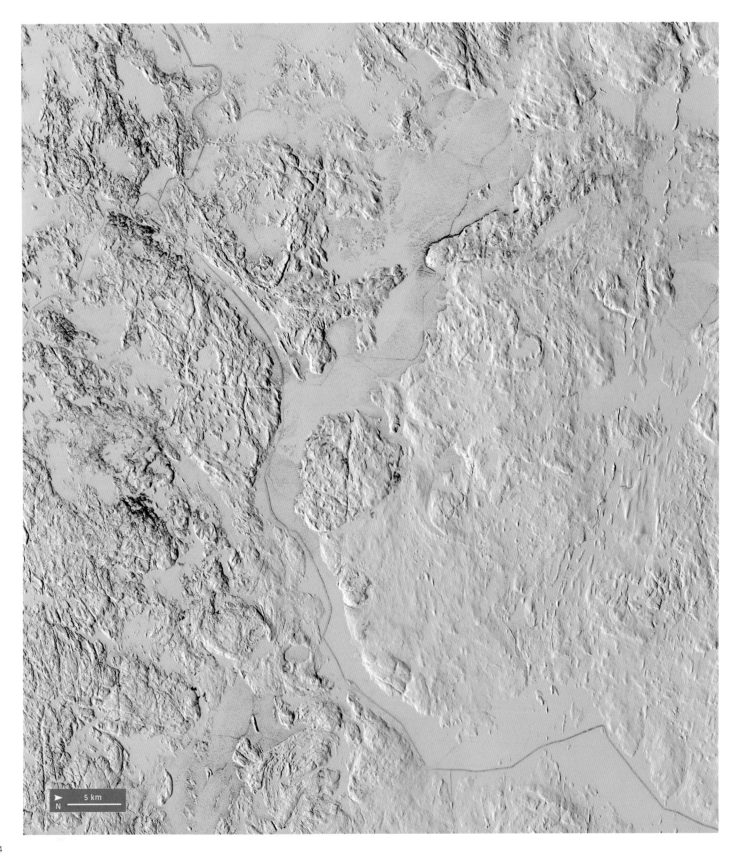

LEFT: The Tibbit to Contwoyto Winter Road, in Canada's Northwest Territories, is set up on frozen lakes. It is usually passable by slow trucks in February and March, taking fuel and material to the northern diamond mines.

5 km

N

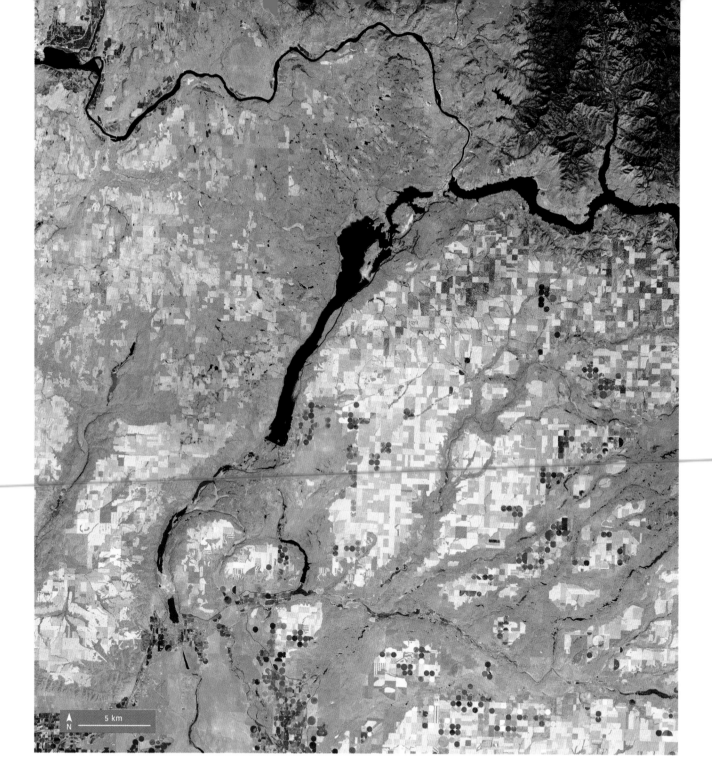

RIGHT: The Columbia River provides the USA's largest hydroelectric plant at Washington State's Grand Coulee Dam, which narrows the river northwards at the top of this image. Banks Lake reservoir stretches south-west of the dam.

5 km

N

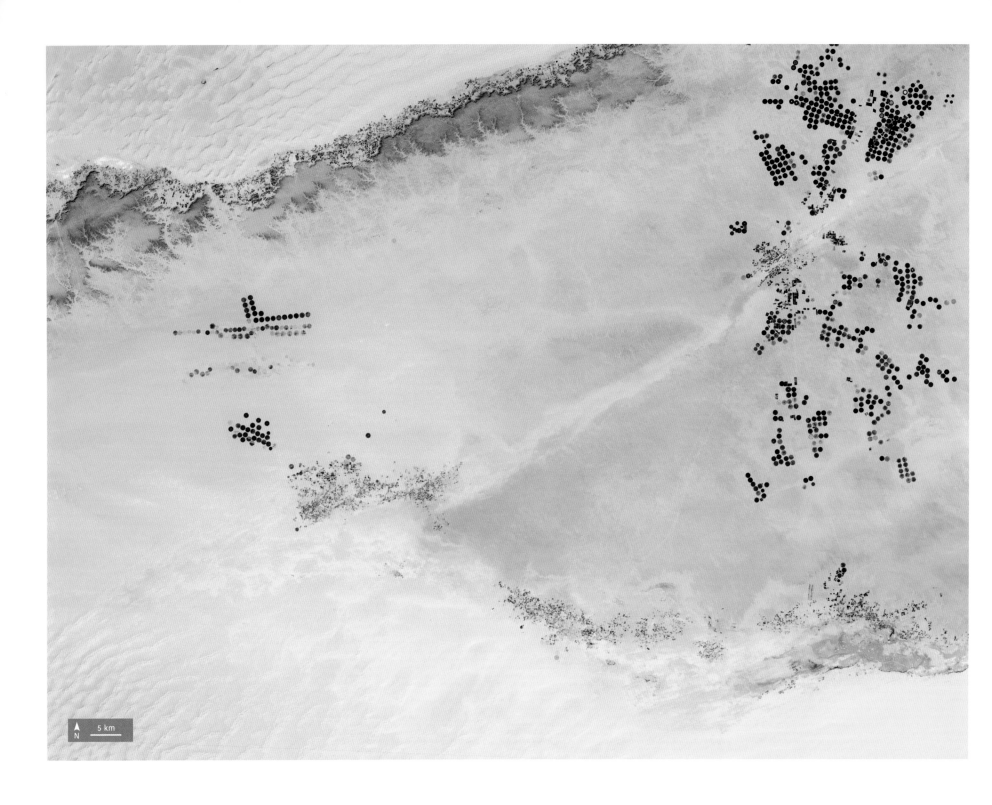

BELOW: The city of Ouarzazate, just to the west of the sprawling lake of the same name, is known as The Door of the Desert. It is one of Morocco's largest and most important hubs for international film shoots.

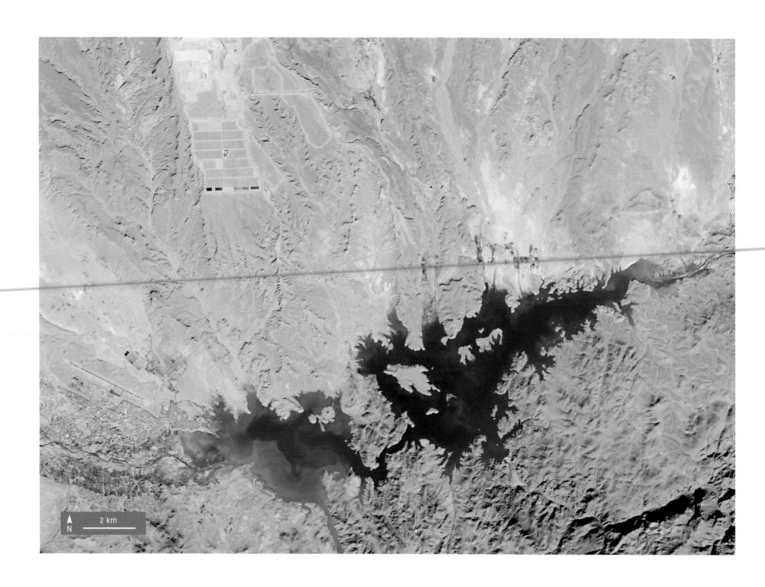

OPPOSITE: The Murzuq Desert, in southern Libya. Irrigated farms follow highways that run from Taraghin (bottom right) north towards Sabha, and west through Murzuq and then Dujal before cutting north towards Germa.

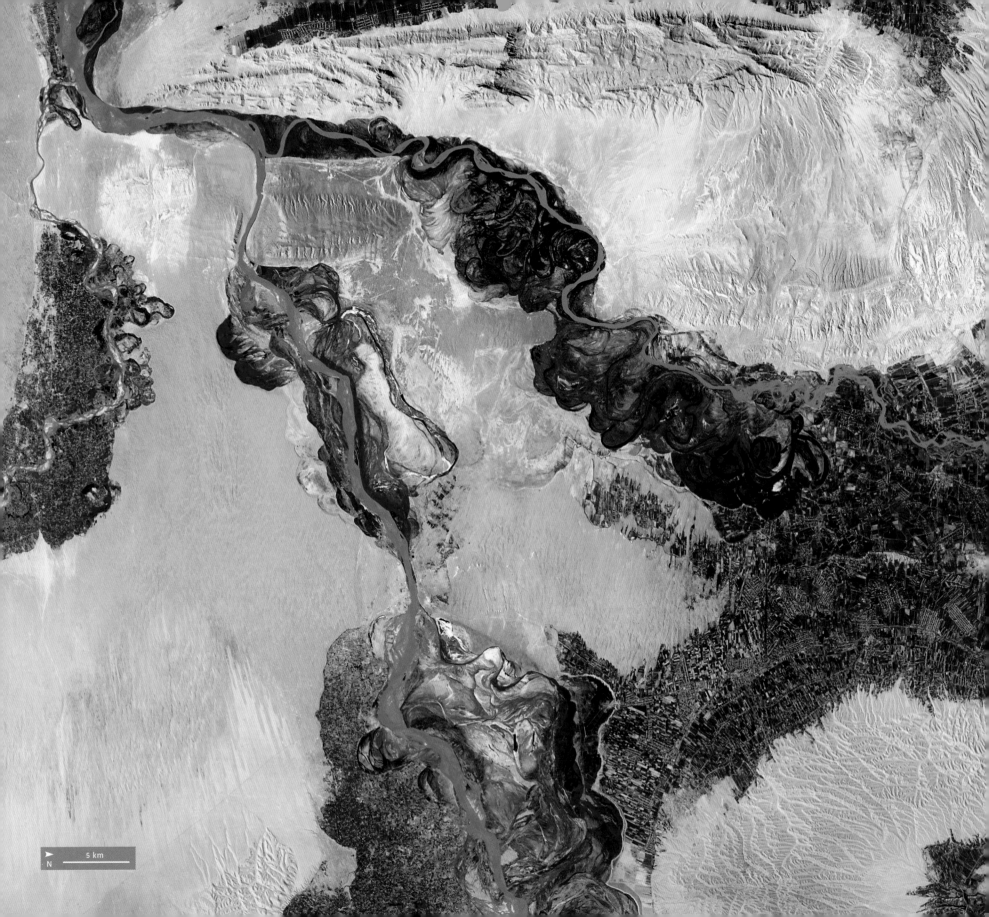

OPPOSITE: Tajikistan and
Afghanistan are divided
by the Panj River, shown
here running vertically up,
with Tajikistan on the right.
The Vakhsh River feeds
into it, forming an
important floodplain.

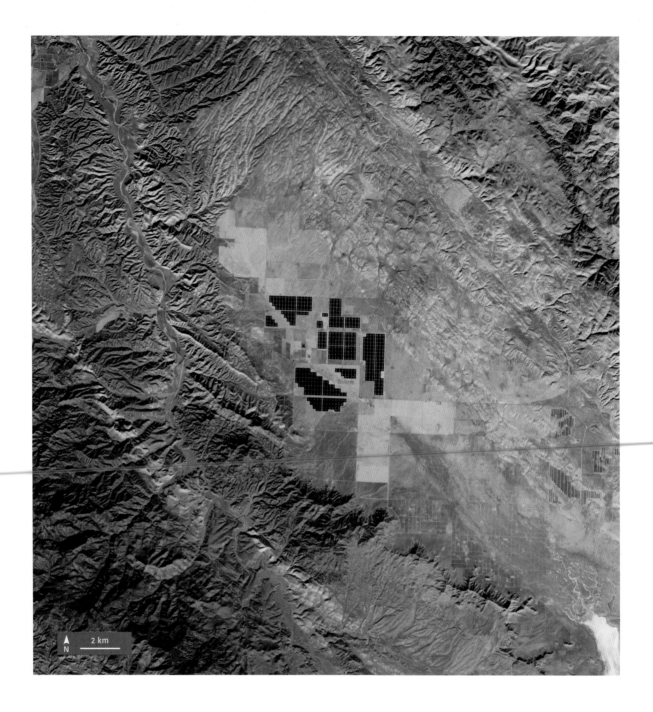

ABOVE: The Carrizo Plain in
southern California is home
to one the fourth-largest solar
power plants in the world, the
Topaz Solar Farm. At around 10
square miles (26 square km), it
is clearly visible in the centre
of this image.

BELOW: The Uinta Mountains run across the north-east of Utah and just into Wyoming. They're the tallest east-west mountain chain in the USA. The snow here perfectly emphasizes their snaking heights.

OPPOSITE: Shawnee National Forest in south Illinois, centre-left of the long Ohio River here, is one of the USA's largest federal forests. Its Garden of the Gods featured on three hundred million coins in 2016.

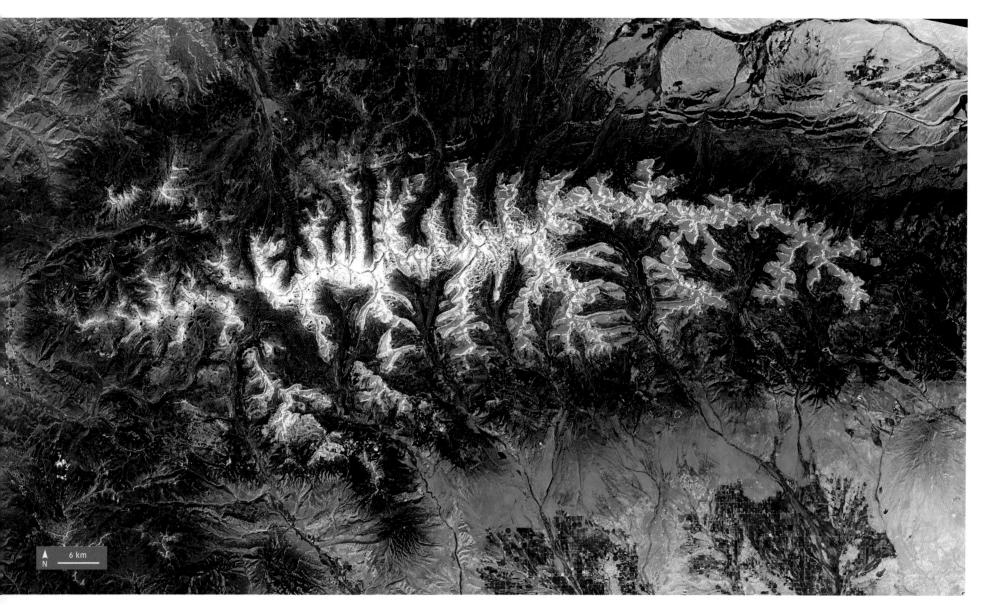

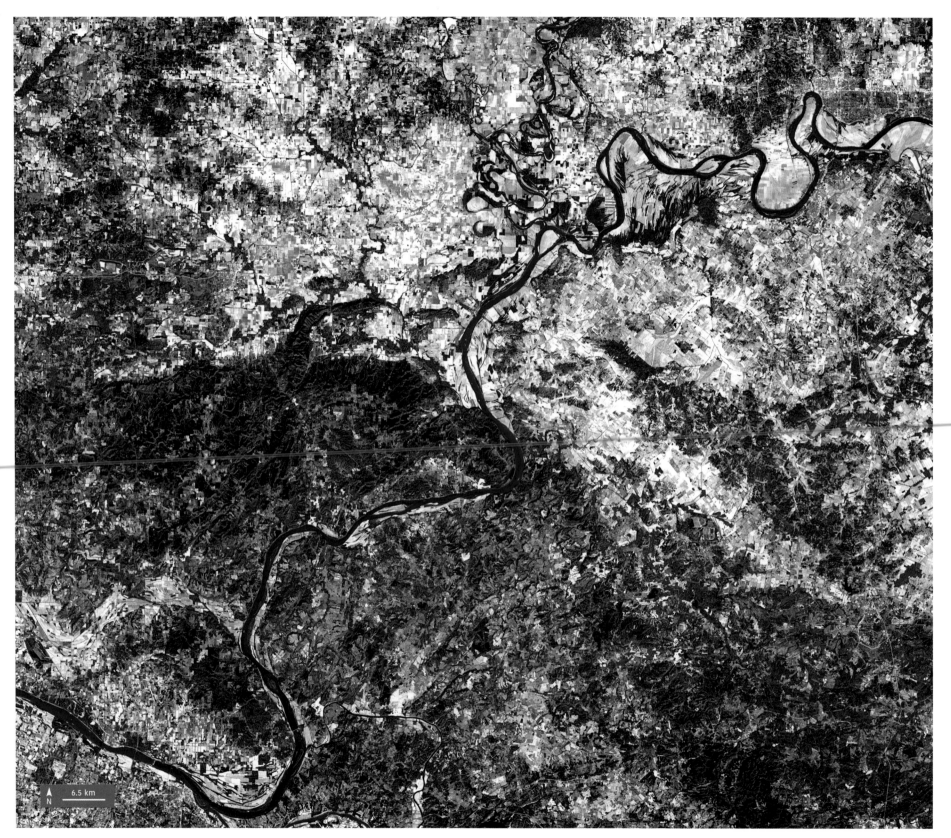

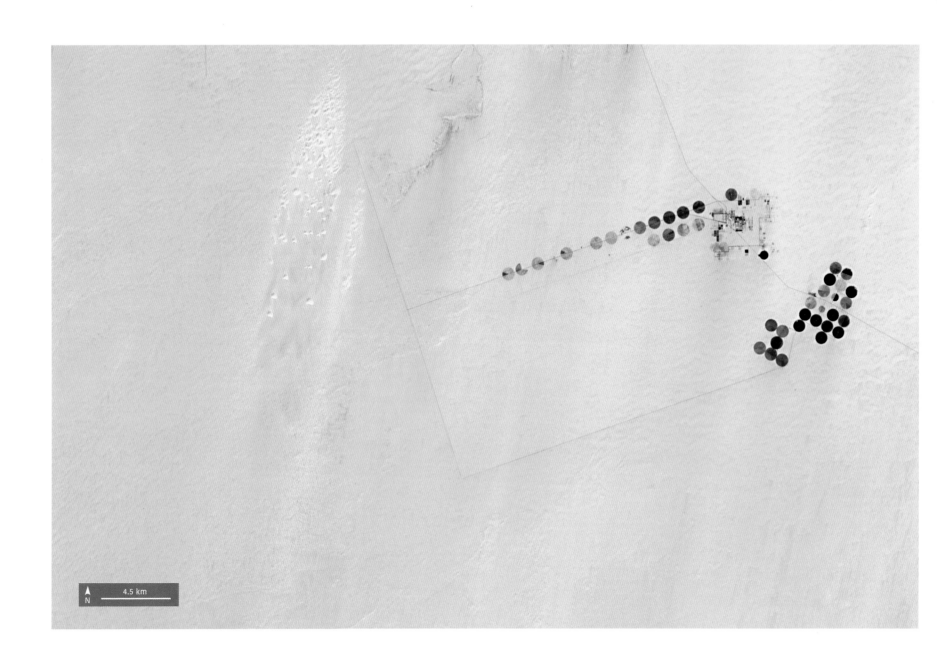

N

4.5 km

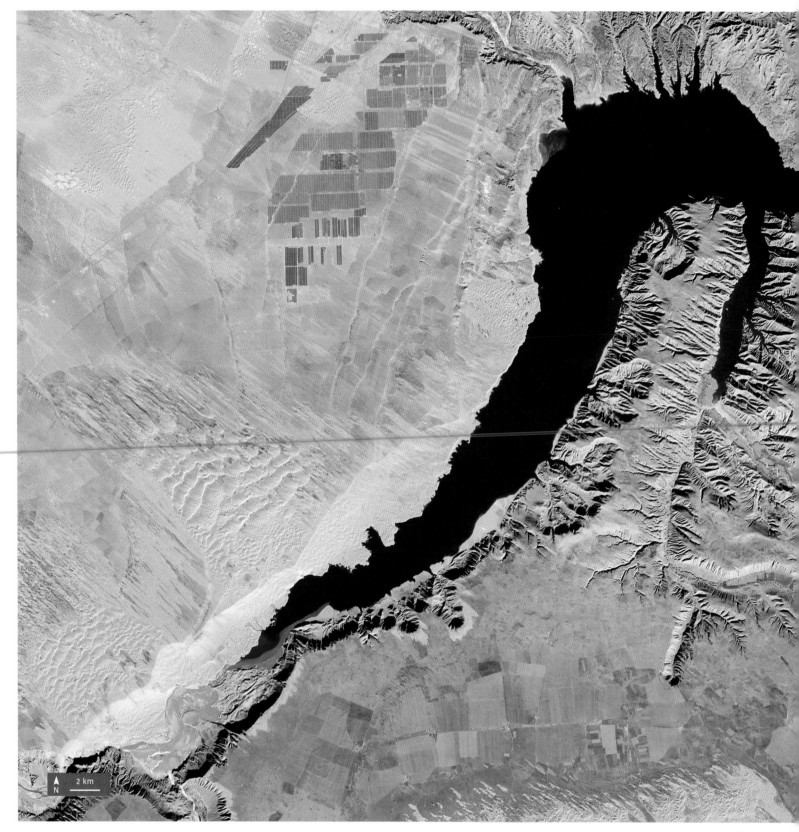

OPPOSITE: In the last ice age, the Sahara desert was a thriving savannah. Aquifers deep under the sand hold water from that time. These fields in southern Egypt rely on such "fossil" water.

RIGHT: The Longyanxia Dam, at the bottom left, regulates the Yellow River in China's central Qinghai Province. A vast solar farm to the north of the reservoir adds to the hydroelectric power station's huge output.

2 km

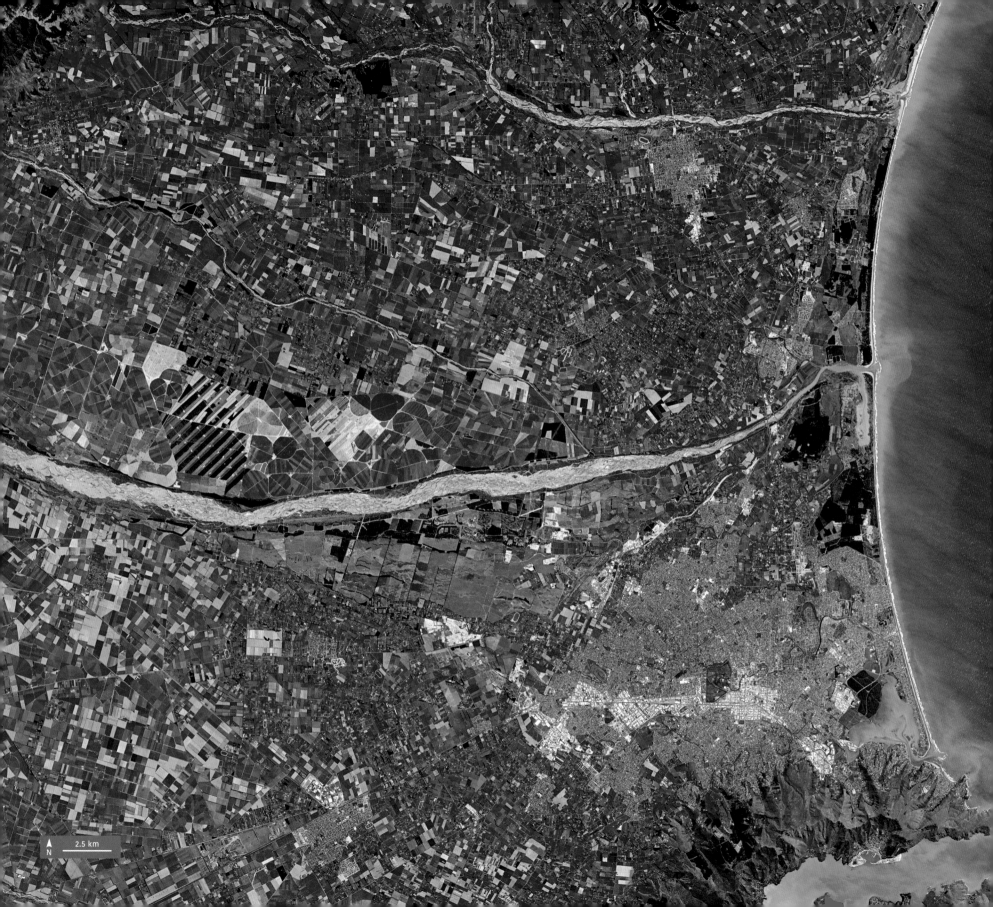

FAR LEFT: Christchurch, the largest city of New Zealand's South Island, sits in the lower right, below the braided riverbed of the Waimakariri River. Dairy farms on the river plains provide the city with much of its milk.

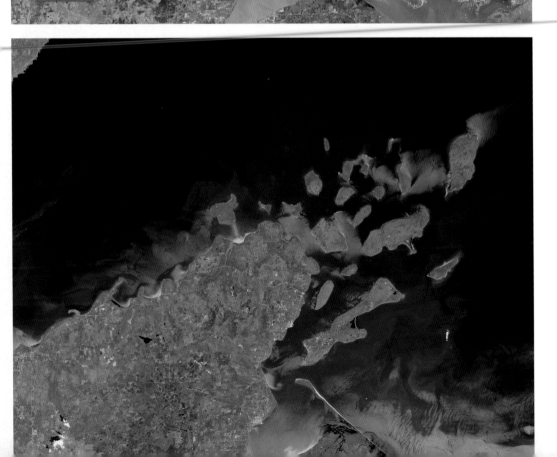

LEFT: The Apostle Islands in May (top) and June (bottom) in 2014. The islands scatter out from the northernmost tip of Wisconsin, USA, into Lake Superior. Famed for their lighthouses and sea-caves, the islands are sometimes still ice-dusted as late as June.

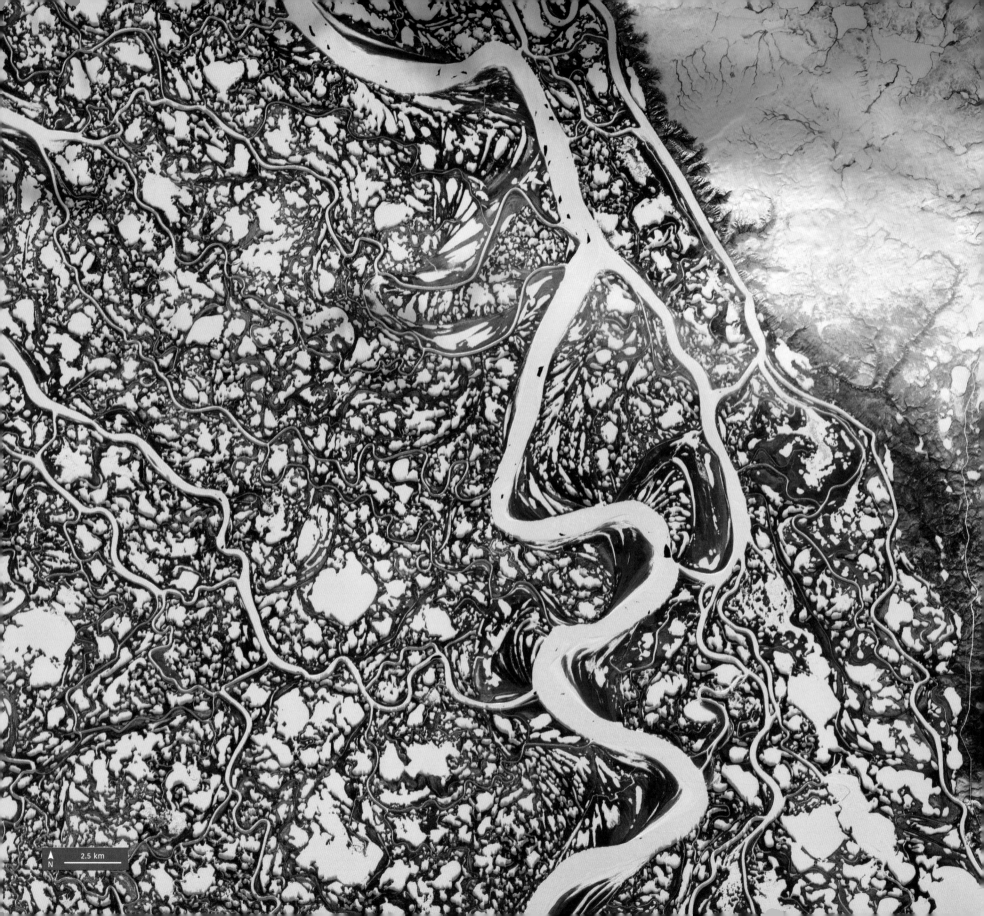

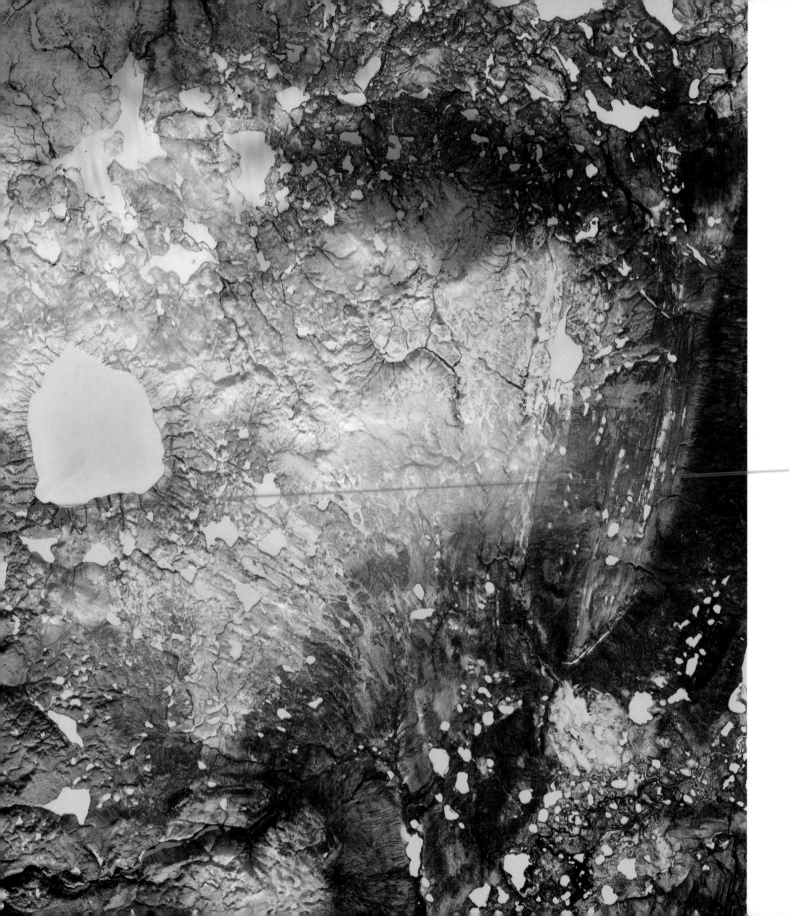

Inuvik is the small Canadian town at the base of this image, where the snow-dappled delta gives way to hills. Until late 2017, it was the furthest north you could drive in the summer. Further progress to the coastal hamlet of Tuktoyaktuk required the freezing of the MacKenzie River, which snakes up through the delta to the Arctic Sea.

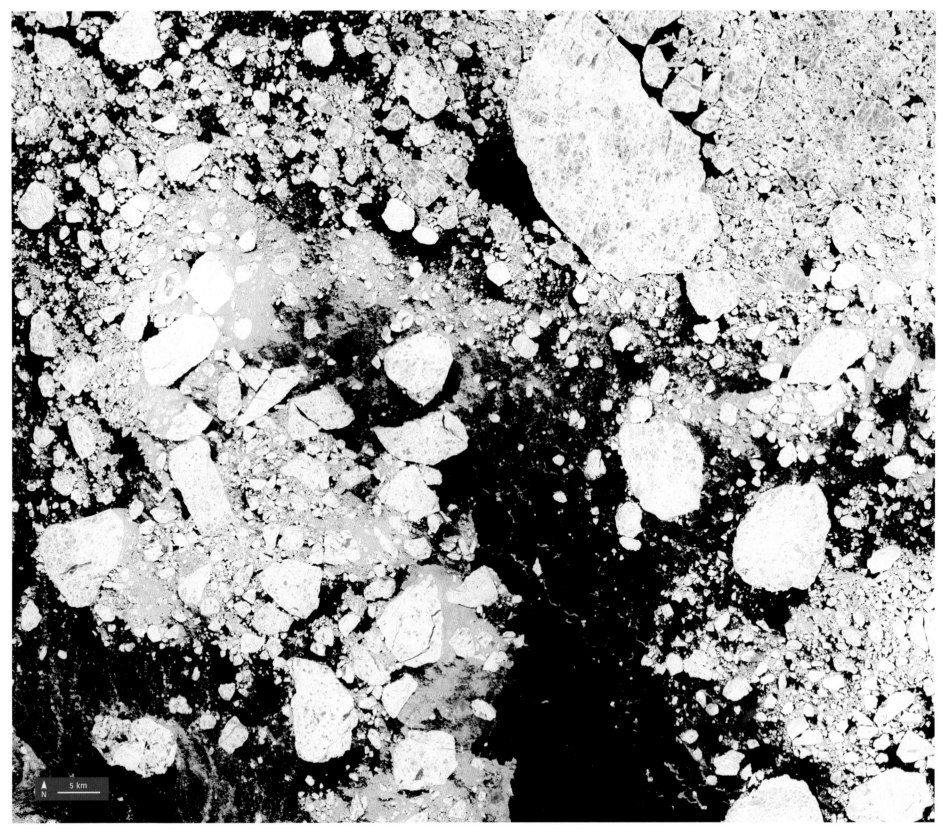

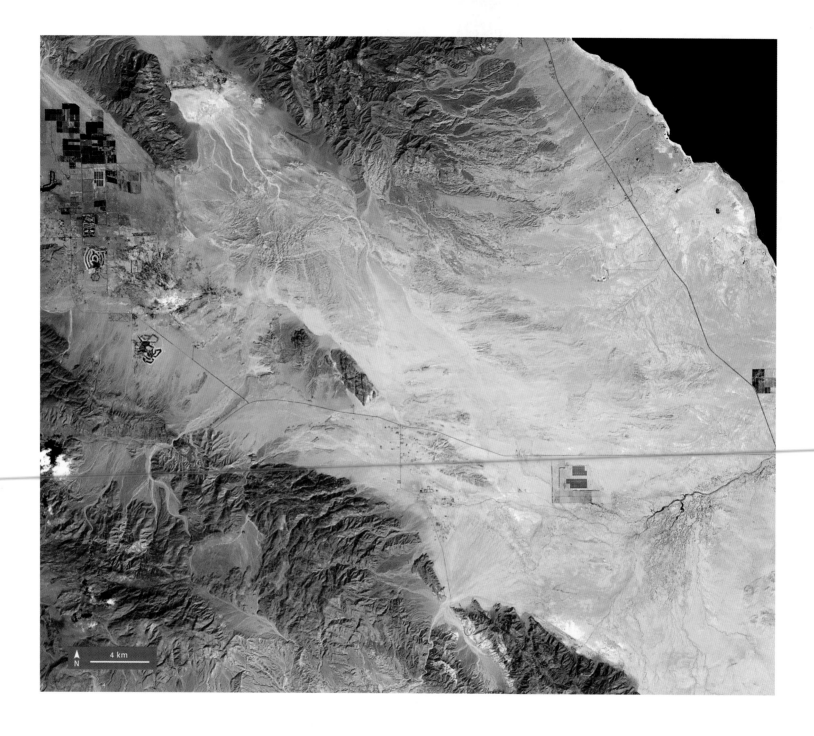

ABOVE: California's Anza-Borrego Desert State Park is the second-largest park in the mainland USA, and runs alongside the inland Salton Sea (top right). Parts of the park are up to 200ft (61m) below sea level.

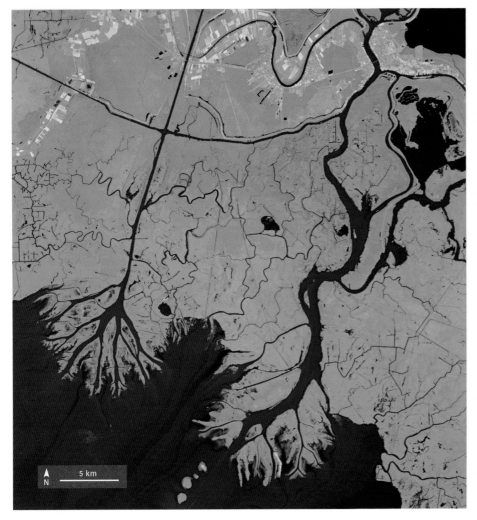

5 km
N

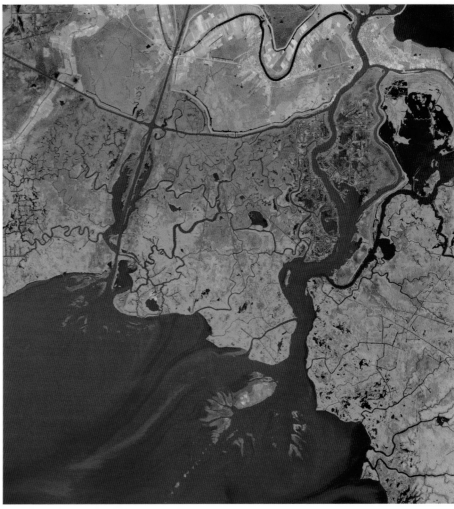

The Mississippi River Delta is mostly eroding, but the coastline of the Atchafalaya Bay is bucking the trend, and growing steadily. These false-colour images show vegetation in green, bare earth in pink, and water in blue. There is significantly more land fronding out in the 2014 image (left) than was present in 1984 (right).

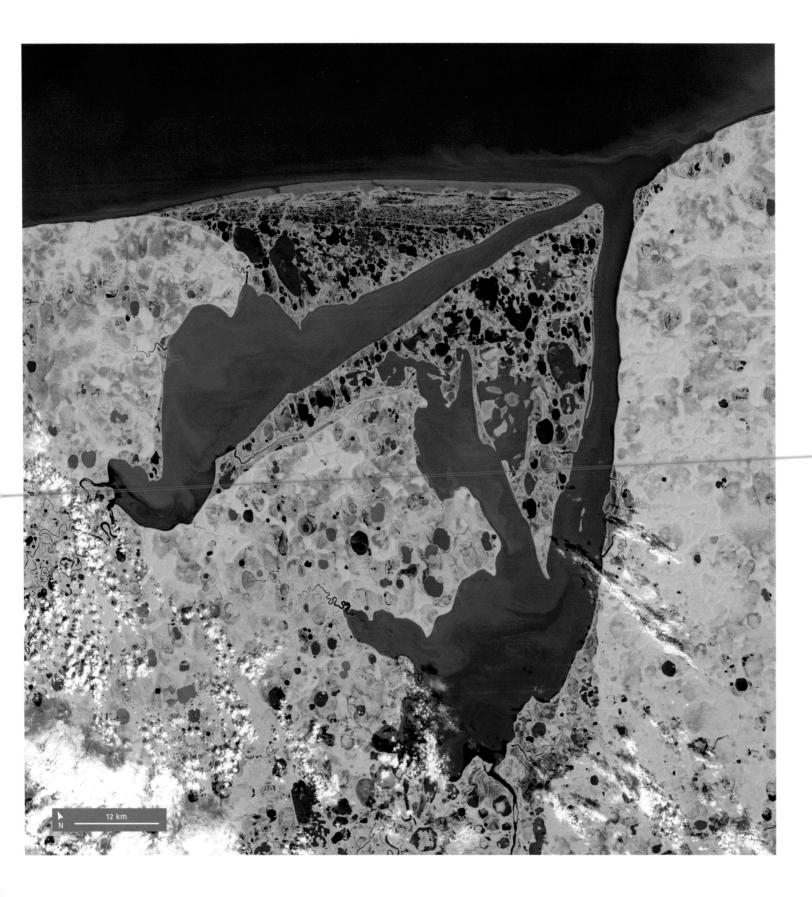

12 km

N

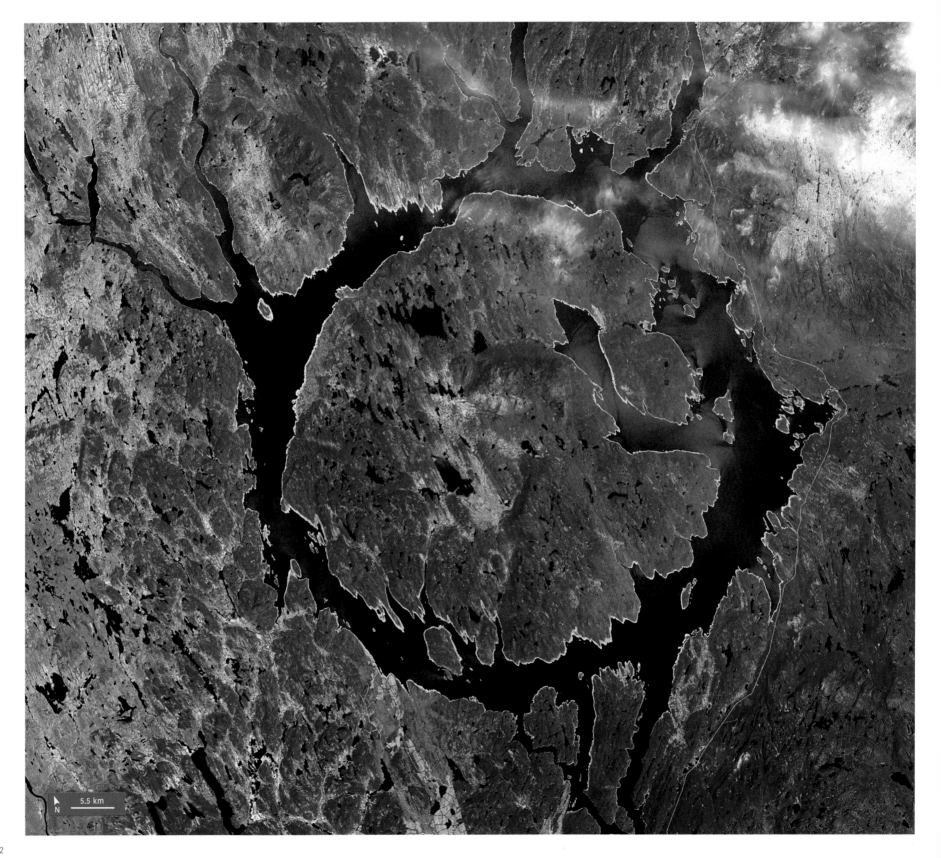

N
5.5 km

RIGHT: The Chaco of north Argentina is some of the fastest-vanishing forest in the world. Some traditional use is visibly dotted at the right of this image, but the land is being burned and squared off for plantations.

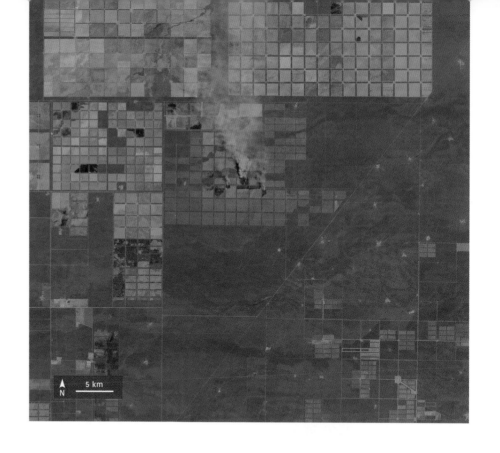

OPPOSITE: Lake Manicouagan in central Quebec, Canada, was formed by the impact of a meteorite, believed to have struck the planet's surface around 212 million years ago. Viewed from above, the lake forms an unbroken ring.

RIGHT: The Clearwater Lakes in Quebec, Canada are the result of meteorite impacts 200 million years apart. The smaller lake is the older, at 470 million years. The two form one body of water.

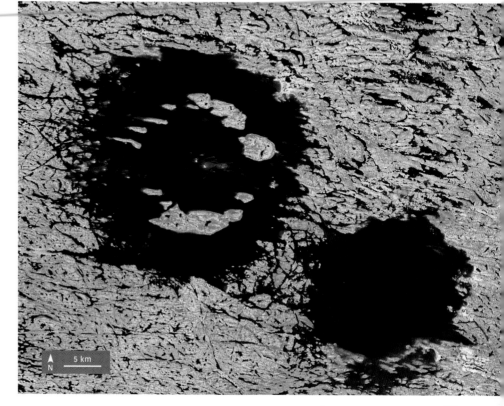

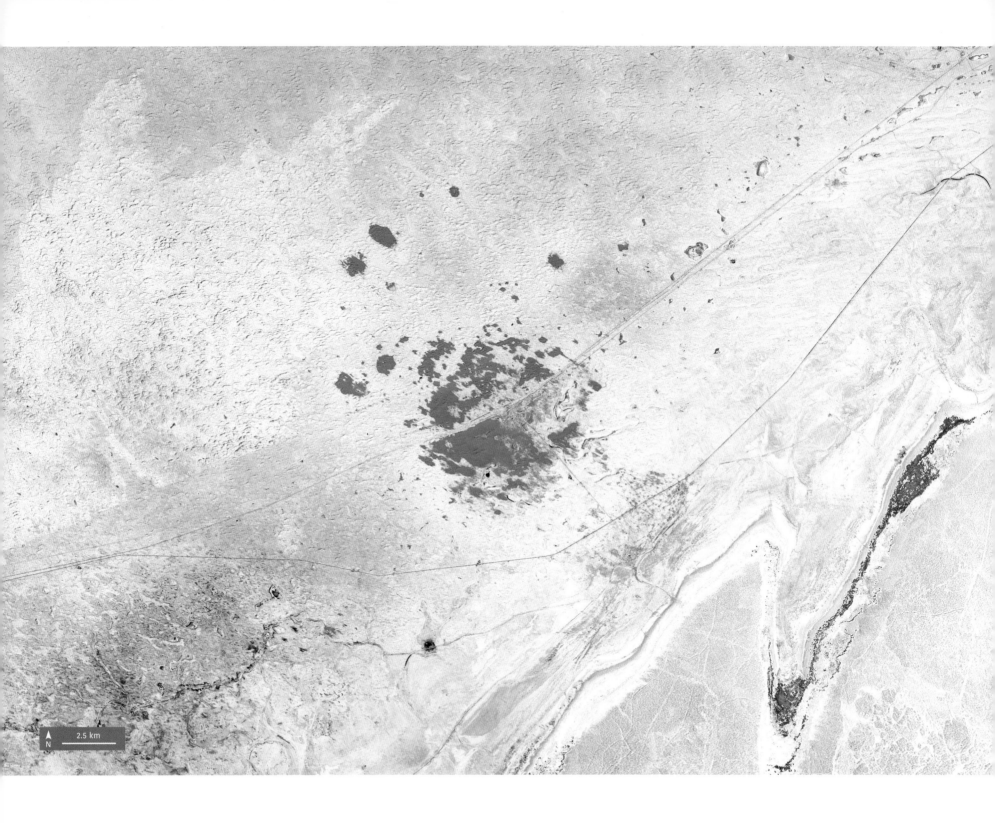

RIGHT: The Wembo-Nyama Feature in the Democratic Republic of Congo is circled by the Unia River. It is thought to be a meteoric impact crater, and at around 25 miles (40km) wide, one of the world's largest.

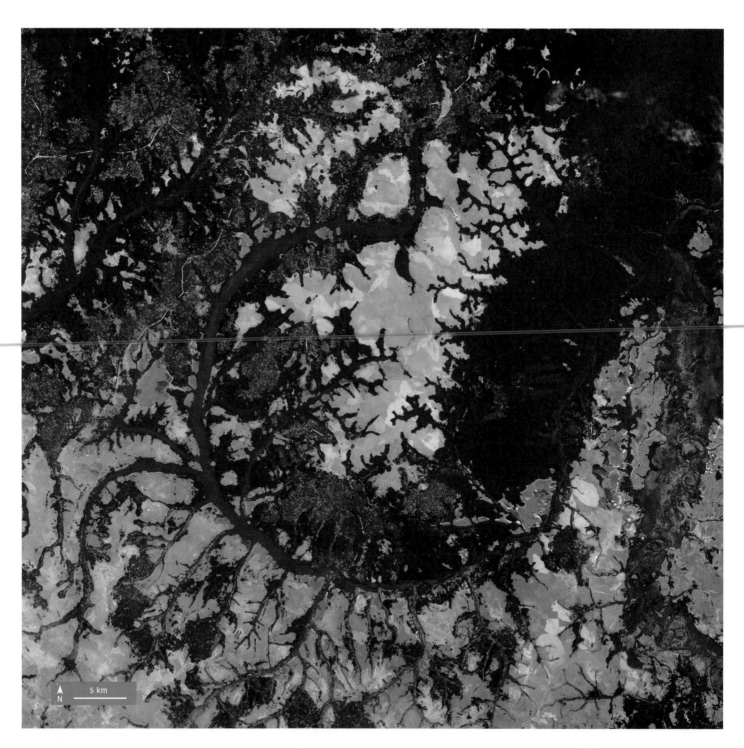

OPPOSITE: Isatay, a few miles north-west of the Caspian Sea (bottom right), is in the far west of Kazakhstan. Sand dunes, clearly visible against the snowy, arid plains, cluster around the village, and constantly threaten it.

5 km
N

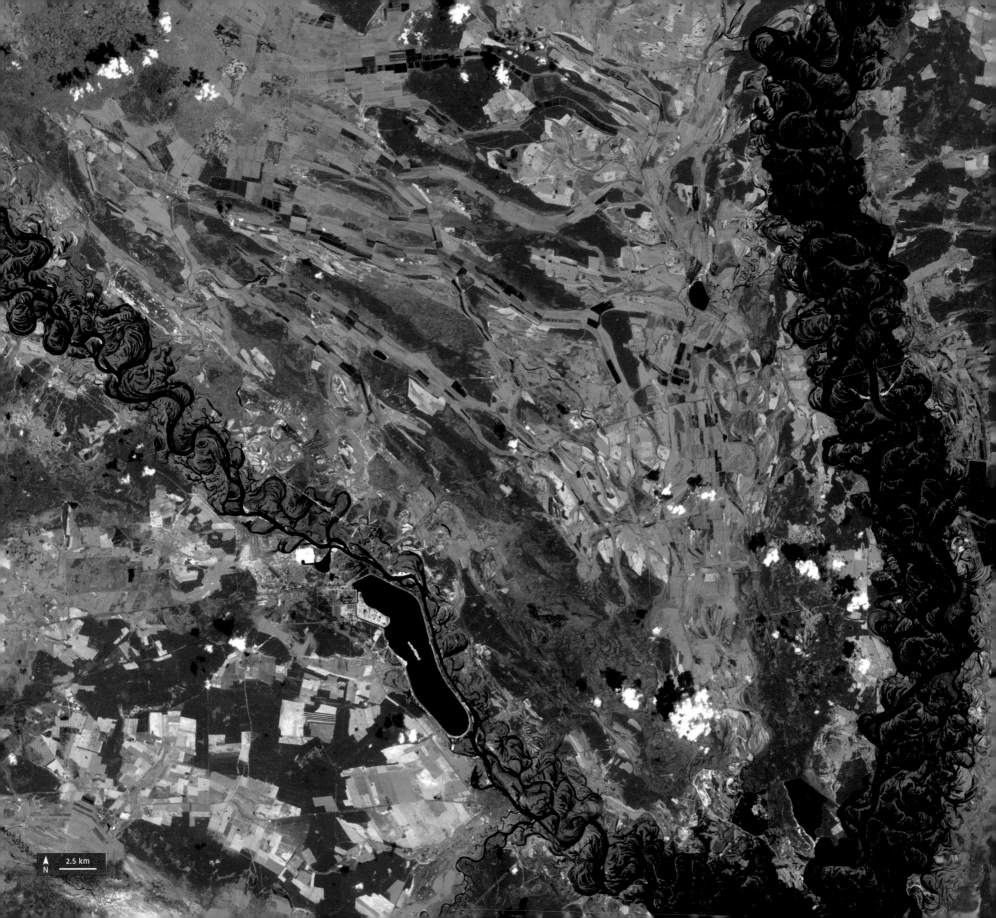

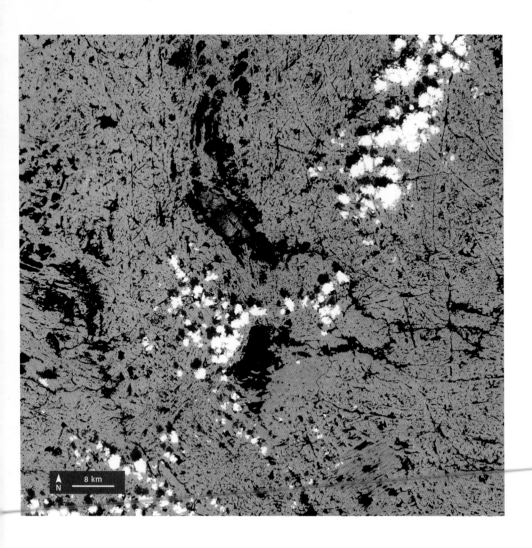

8 km
N

LEFT: The area surrounding Lac La Potherie in Canada is covered by grasslands. This false-colour image of the area shows the vegetation in red – the deeper the hue, the more dense the vegetation.

OPPOSITE: This false-colour image shows north Ukraine's Chernobyl power plant on the Pripyat River, just three days after the 1986 disaster that destroyed it and blighted so many lives. The image shows the extensive agricultural development at that time, but the land around Chernobyl – the Zone – will not be safe for human habitation for 20,000 years.

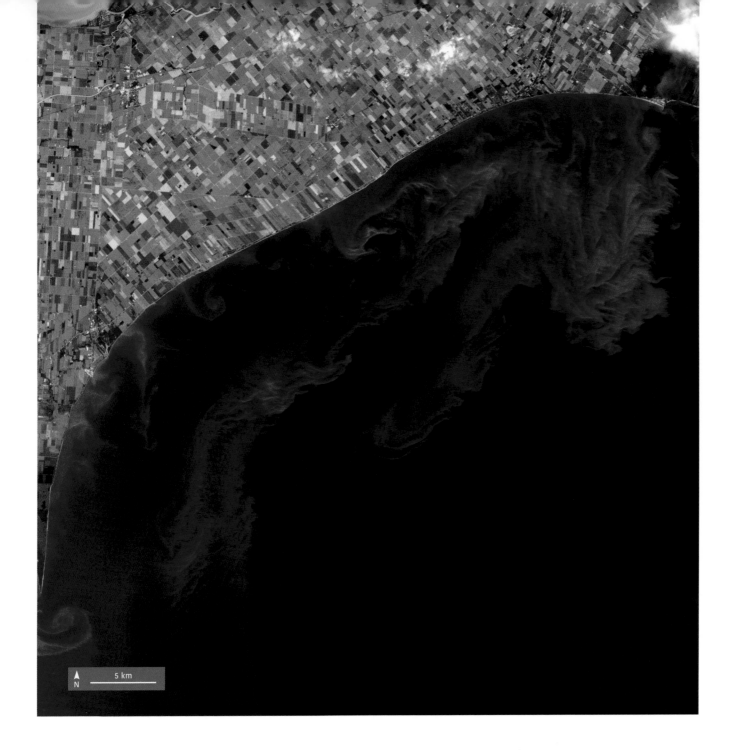

5 km

LEFT: This image of the northern shore of Lake Erie, bordered by Ontario, Canada, shows a giant algae bloom that formed in 2011. From above it appears as a benign green swirl, but this algae is toxic to mammals and thought to have been caused by water polluted from surrounding land.

OPPOSITE: This beautiful pattern is created by swirls of marine bacteria blooming in the Baltic Sea. The blooms may contain cyanobacteria, or blue-green algae, which, when out of control, can be toxic to humans and animals.

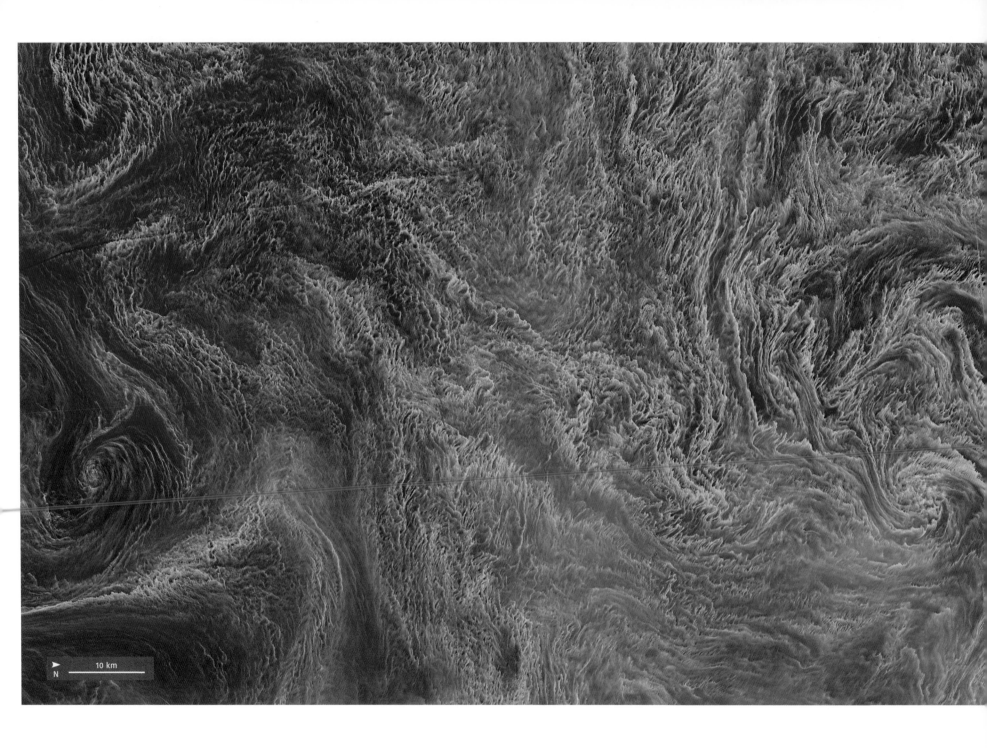

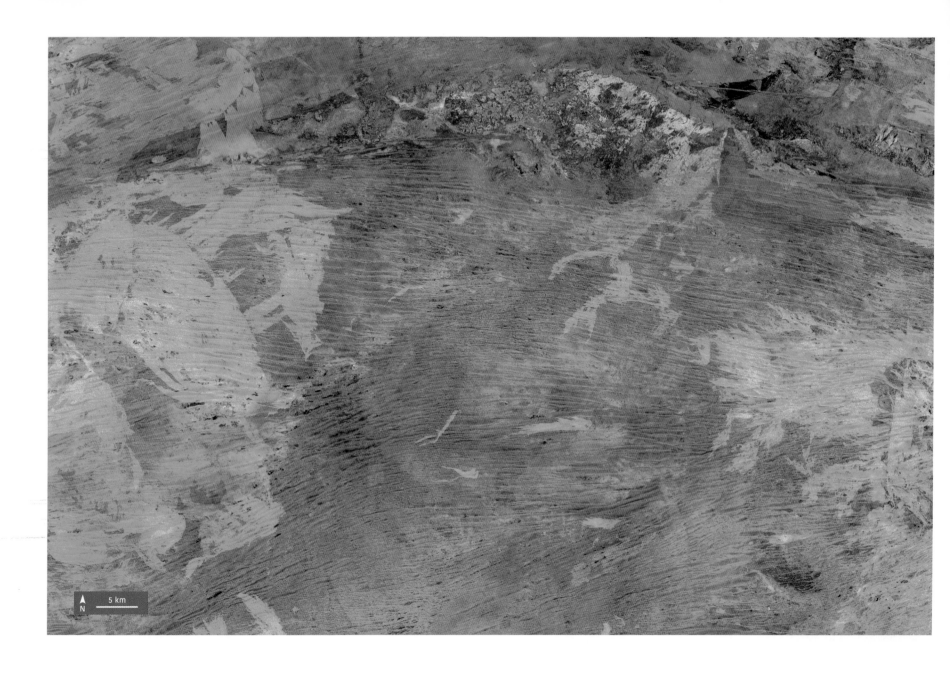

5 km

N

ABOVE: This area of the Gibson Desert in Western Australia is home to the Aboriginal group the Pintupi, most of whom now live in small settlements. This harsh landscape is made up of dunes, desert pavement and sandy planes and is marked with burn scars where fires have been lit to encourage future plant growth.

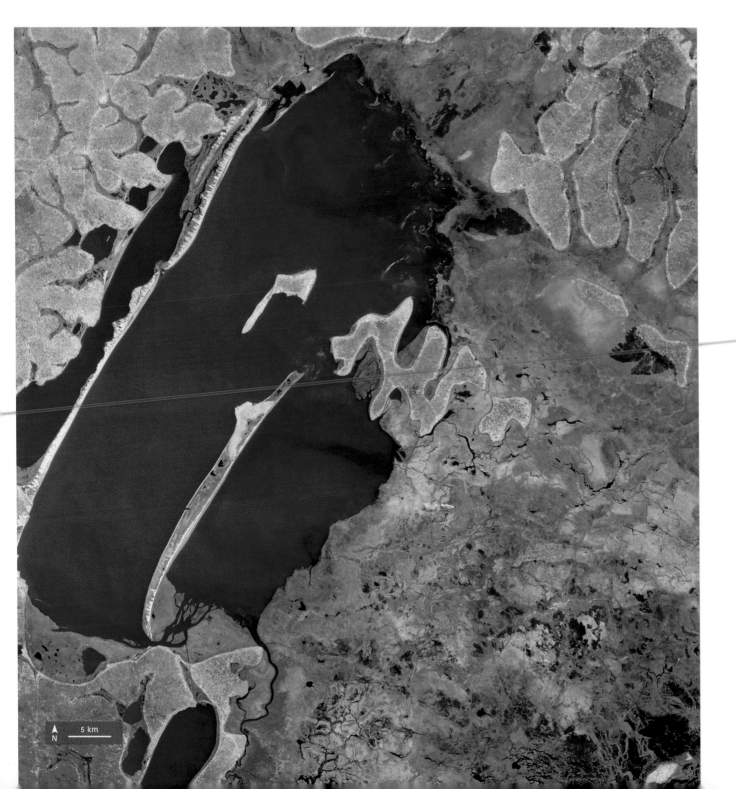

LEFT: This image was taken by an astronaut aboard the International Space Station in August 2015. It shows the unusual shapes of Zambia's Chilubi Island coastline – an area with a thriving fishing industry.

5 km
N

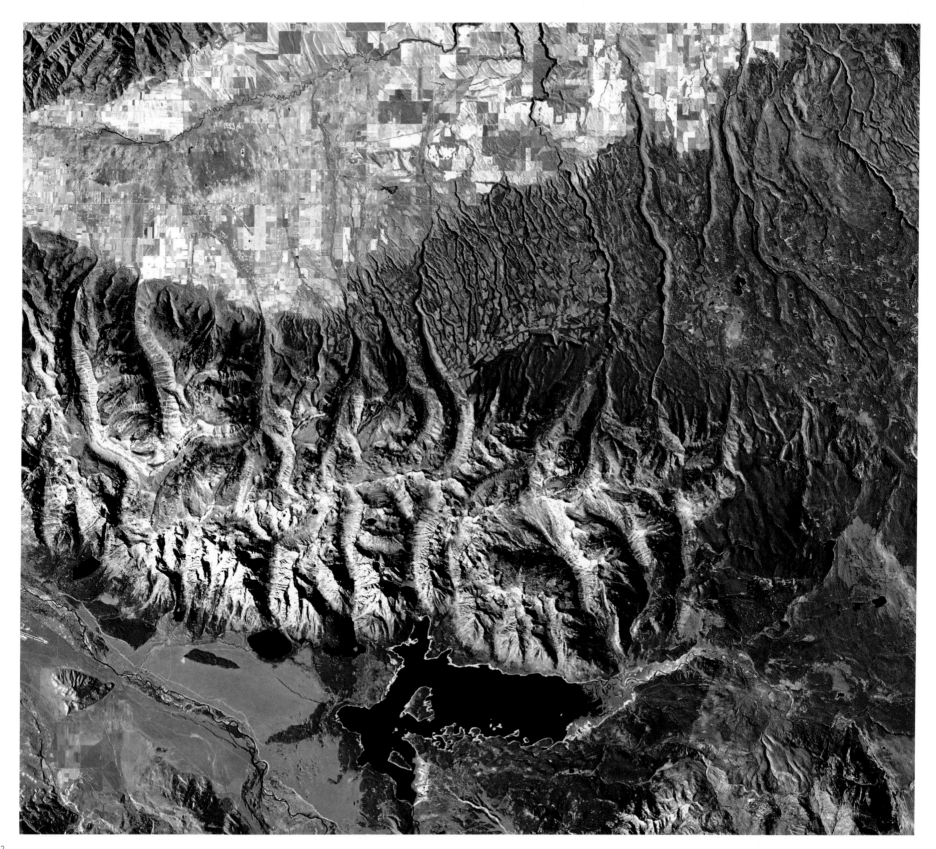

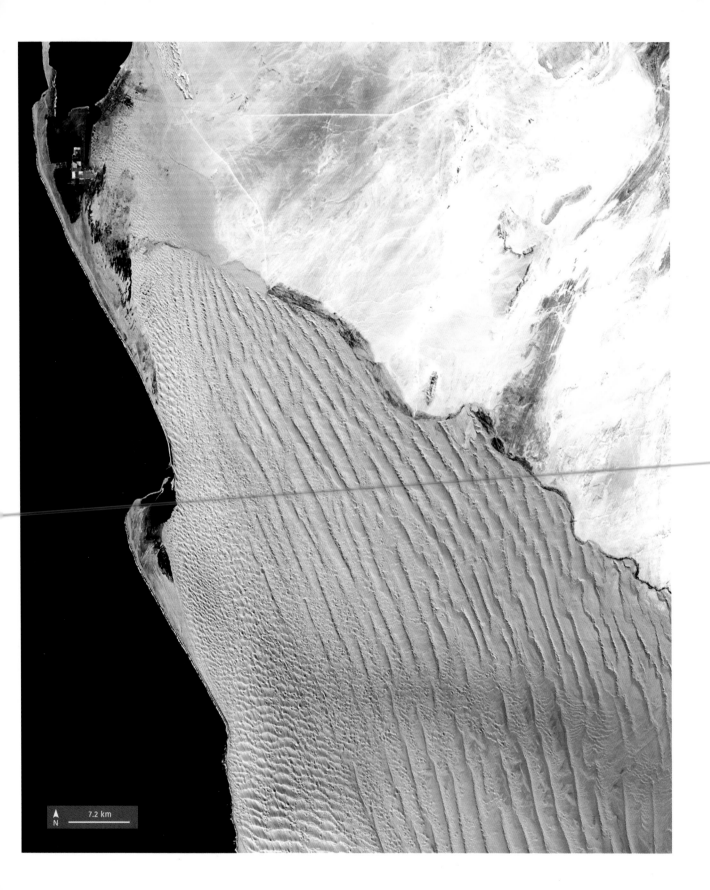

FAR LEFT: The peaks of the
Teton Range, part of the Rocky
Mountains, extend through
the state of Wyoming, south
of Yellowstone National Park.
Snow-covered in this image, the
range rises dramatically
to 7,000 feet (2,134m) above
the valley below.

LEFT: Namib-Naukluft National
Park sits in the Namib Desert
in southwest Africa and is
the largest nature reserve in
Namibia. The ridges of sand
are formed by the force of
southwesterly winds.

7.2 km

223

INDEX

ACKNOWLEDGEMENTS

The publishers would like to thank Darrell Williams for the excellent foreword, TIm Dedopulos for the caption text and Ginger Butcher and Michael P. Taylor at NASA Goddard Space Flight Center for their kind assistance and advice. For more information on Landsat's history, see *Landsat's Enduring Legacy*, published in 2017.